THE TECHNIQUE

of

LIGHTING FOR TELEVISION
AND MOTION PICTURES

THE LIBRARY OF
COMMUNICATION TECHNIQUES

FILM

√ THE TECHNIQUE OF DOCUMENTARY FILM PRODUCTION
By W. Hugh Baddeley

THE TECHNIQUE OF EDITING 16 mm FILMS
By John Burder

THE TECHNIQUE OF FILM ANIMATION
By John Halas and Roger Manvell

THE TECHNIQUE OF THE FILM CUTTING ROOM
By Ernest Walter

THE TECHNIQUE OF FILM EDITING
Compiled by Karel Reisz and Gavin Millar

THE TECHNIQUE OF FILM MUSIC
By John Huntley and Roger Manvell

THE TECHNIQUE OF FILM AND TELEVISION MAKE-UP
By Vincent J-R. Kehoe

THE TECHNIQUE OF THE MOTION PICTURE CAMERA
By H. Mario Raimondo Souto

√ THE TECHNIQUE OF SPECIAL EFFECTS
CINEMATOGRAPHY
By Raymond Fielding

TELEVISION

THE TECHNIQUE OF LIGHTING FOR TELEVISION
AND MOTION PICTURES
By Gerald Millerson

THE TECHNIQUE OF SPECIAL EFFECTS IN TELEVISION
By Bernard Wilkie

THE TECHNIQUE OF THE TELEVISION CAMERAMAN
By Peter Jones

THE TECHNIQUE OF TELEVISION NEWS
By Ivor Yorke

THE TECHNIQUE OF TELEVISION PRODUCTION
By Gerald Millerson

SOUND

THE TECHNIQUE OF RADIO PRODUCTION
By Robert McLeish

THE TECHNIQUE OF THE SOUND STUDIO
By Alec Nisbett

THE TECHNIQUE OF

LIGHTING FOR TELEVISION AND MOTION PICTURES

By
GERALD MILLERSON

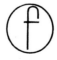

Focal Press · London

Focal/Hastings House · New York

ISBN (excl USA) 0 240 50722 3
ISBN (USA only) 0 8038 7110 4

First Edition 1972
Second Impression 1974
Third Impression 1977
Fourth Impression 1978

Illustrated by the Author

Printed in Great Britain by
Biddles Ltd, Guildford, Surrey

CONTENTS

PREFACE

Lighting is a fascinating process. And yet surprisingly little has been written to enable enthusiasts or careerists to develop a firm understanding of its nature and potentialities; particularly for lighting in its advanced forms. Lighting is too often carried out entirely empirically; sometimes achieving delightfully attractive results, but at others leaving a disappointed feeling that something is lacking in the picture's appeal. The aim of this book is to enable everyone working with light in photography, cinematography and TV, to build up a methodical, rational foundation for their techniques. From this their own personal creativity can grow.

We shall study the ways in which light behaves, and the characteristic effects it has upon portraiture, and our environment. And we shall see how differently the eye and the camera modify and interpret the same subject. All these principles can be applied, whether the assignment is a motion picture or TV production, an advertising campaign or a film group project.

People who work with light in photography, motion pictures and television, find themselves absorbed with its subtleties, its persuasive powers, its transformations. They discover its opportunities and its limitations. The fascination of lighting could never be conveyed fully in any book. One needs to experiment; to try for oneself. These chapters aim to set the student upon the right trail for this exploration.

It is no accident that details of particular current lighting equipment have not been included here. Apparatus changes all too readily with time and place. But principles and applications remain the same. Nor will we analyse carefully measured set-ups for particular photographic examples. These can encourage inappropriate imitation. It is far better to understand principles that enable one to tackle each new subject with confidence and preparedness.

An appreciation of the techniques of lighting can help not only

those who are themselves directly involved in the lighting process but productional and design staff, creators in all the visual arts.

After some twenty years' experience in lighting, it is scarcely possible to enumerate and acknowledge the countless sources to whom the author is indebted. Knowledge comes from personal trial and error, from continuous studies, from a close scrutiny of opinions and techniques, from training students. The author can only hope that this book will help others to derive similar pleasure from the persuasive magic of lighting.

The author thanks the Director of Engineering of the B.B.C. for permission to publish this book.

ACKNOWLEDGMENTS

The photographs and drawings in this book are by the author, with the following exceptions, for which he would like to express his appreciation. Page 302, still from *Great Expectations*, and pages 303, 305, 306, 307, stills from *Oliver Twist*, by courtesy of The Rank Organisation Ltd. Colour transparencies for Plates III, VI, VII and VIII were taken on Kodak Ektachrome film.

The designers for the studio settings used by the author for his demonstrations were: Sally Hulke—*Sinister Street*; pages 196, 197, 290, 291; Peter Kindred—*Christ Recrucified*; pages 185, 234, 296, 297, 300, 301; Colin Shaw—*Ryan International*; pages 203, 204, 205, 206, 279.

Figure 1.3, Pt 3, after H. R. Condit and F. Grum (*J. Opt. Soc. Amer.*, 1964).

The author is also indebted to the British Broadcasting Corporation for the facilities afforded him in the preparation of this book, and would like to thank his colleagues for their help and encouragement.

1

THE NATURE OF LIGHT

Of course we take *light* for granted. It is part of our everyday world; a phenomenon so familiar that we cease to notice it. Light becomes incidental. If we cannot see clearly enough, we add more—by switching on a nearby lamp. This is the *utilitarian* aspect of lighting. One can measure and codify just how much light, of what kind, is needed to do a particular type of job, from embroidery to highway illumination.

Lighting plays a second role in our lives. In revealing the world around us, it provides us with our *clues* to texture, shape, distance and colour. We are not simply seeing that things are before us. We begin to form judgments about them and their relationship to the rest of the scene.

Lastly, lighting plays a subtly persuasive part in our lives, imperceptibly influencing our *feelings* towards what we see. And this aspect of lighting is its least understood—the most difficult to explain and demonstrate.

When we look around us, we do not categorise light in these ways, we simply have an impression, however transitory. But that impression has been conditioned, sometimes formed entirely, by the way in which light has caused the scene to appear to us. And here we reach the frontiers of creative lighting techniques—the art of arranging and controlling light. Light is an elusive medium. It enhances or uglifies, depending upon how we use it. It can intrigue, frustrate, proclaim, subtly imply, coarsen, as we choose.

One does not need a science course to take a snapshot. We can get a surprisingly long way barely knowing how to operate a camera. But for the enthusiast or the professional, this just is not enough. He wants to avoid the disappointments the amateur shrugs off as inevitable. He wants to control the medium, to anticipate its hazards, conquer its shortcomings. He wants the best and the most persuasive results possible. To do this, he must become familiar with the underlying nature of the medium.

The electromagnetic spectrum

Energy is radiated from many natural and man-made sources. This *electromagnetic radiation* is transmitted in the form of wave motions, at the incredible speed of over 186,000 miles per second (3×10^9 m/sec.), from sources as diverse as the Sun, radio transmitters, radioactive ores, electric lamps. Depending upon the energy's vibrational rate (frequency) the characteristic nature of this radiation will change. Thus, relatively slow-vibrating sources propagate heat waves predominantly, while others higher up the scale produce the penetrating radiation we denote as X-rays. Visible light represents only a tiny part of this vast range, as we see in Figure 1.1.

FIGURE 1.1 THE ELECTROMAGNETIC SPECTRUM Electromagnetic energy is propagated over an extremely wide frequency range, from almost zero to over 1×10^{22} hertz (cosmic rays). Visible light occupies only a minute segment of this spectrum; the visible spectrum comprising gradual transitions from one hue to the next. Hues are identified by wavelength measurement. Various units are used: nanometers or millimicrons (10^{-9} metre), or Ångstrom units (10^{-10} M).

Our eye perceives this *visible spectrum* as a whole, as 'white light'—although the prism reveals that this effect is really the result of our seeing simultaneously a series of imperceptibly merging pure spectral colours (Figure 1.2). We isolate specific

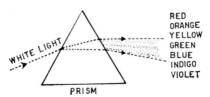

FIGURE 1.2 THE PRISM The speed of light changes with the medium through which it travels. Passing from one substance to another, e.g. air to glass, its path is deflected (refraction). When a narrow light beam is interrupted by a prism, its component colours become refracted to differing degrees, and spread in a spectral band. Regions of this displayed spectrum are strong or weak, according to hue proportions in the analysed light.

regions of the spectrum, and call these *spectral hues* (see Table 1-I). Radiation beyond the visible spectrum is undetected by our eyes, although readily recorded by the camera, various measuring instruments, and the eyes of certain animals and insects.

TABLE 1-I

APPROXIMATE SPECTRAL HUE CLASSIFICATION

Wavelength in 10^{-9} metres (nm)	760 740 720 700 680 660 640		620 600	580 560
Frequency hertz $\times 10^{12}$	395 405 417 429 441 455 469		484 500	517 536
		RED	ORANGE	YELLOW

Wavelength in 10^{-9} metres (nm)	540	520 500	480 460	440 420 400 380
Frequency hertz $\times 10^{12}$	556	577 600	625 652	682 714 750 789
	GREEN	BLUE-GREEN	BLUE	VIOLET

As *frequency* (in *hertz* or *cycles per second*) is less readily measured over much of the electromagnetic spectrum, we usually refer instead to the energy's *wavelength*, the distance between one wave-crest and the next. As the speed of light is constant in a given material, frequency is inversely proportional to the wavelength.

White light

The eye accepts a remarkable range of luminants as providing us with 'white light'. The eye can be deceived—it can adapt itself, as we shall see—but the camera cannot adapt. That is why it becomes vital that we should recognise such variations and anticipate their effects upon our pictures.

Figure 1.3 shows a series of typical luminants that all give 'white light'. As we can see, the proportions of the spectral colours they contain are extremely variable. Note how deficient in the blue end or in the red end these different sources can be. None of them is an equal-energy source, where emitted radiation is equally distributed over the entire spectrum.

Colour temperature

To discuss and compare the colour quality of light sources, we could refer to spectral curves of the type in Figure 1.3. But we

need a more convenient 'shorthand' method for general use. Such a system is *colour temperature* measurement. This is based upon the concept of heating a 'perfect black-body radiator' (an enclosed carbon block not reflecting incident light) and noting the spectral

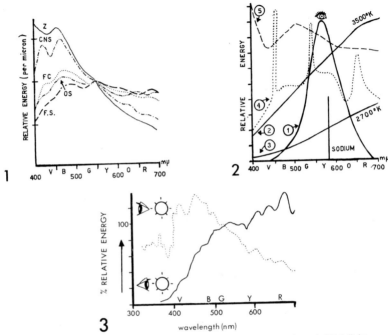

FIGURE 1.3 WHITE LIGHT Many luminants are accepted as 'white' light although their actual spectral ranges differ considerably.
1 Variations in colour quality of daylight (Northern Hemisphere): *Z* Clear zenith sky; *CNS* Clear northern sky; *FC* Full sun with clear sky; *OS* Overcast sky; *FS* Full, direct sun.
2 Variations in typical luminants compared with the response of the eye. (1) The eye's response. (2) High colour temperature incandescent lamp (e.g. overrun lamp, studio-type lamps). (3) Low colour temperature incandescent lamp (e.g. domestic 40–75 W type). (4) Fluorescent lamp, showing peaks in spectrum lines (from mercury vapour filling) within smooth spectrum from fluorescent coating. (5) Carbon-arc projector.
3 The colour quality of light can vary too, with our position relative to the sun.

distribution of its emitted light at progressive temperatures (if we heat a metal rod in a fire, watching its dull red glow brighten to a brilliant yellow-white, we meet an allied change in colour quality). Figure 1.4 shows a series of resultant light qualities. We classify the curves according to the temperature from which each derives. Because the temperatures involved are so high, the *Kelvin scale* is

14

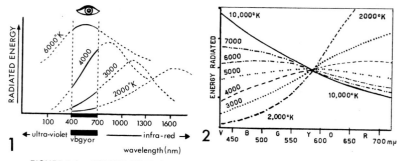

FIGURE 1.4 COLOUR TEMPERATURE The colour quality of a light source can be classified by comparing it with the standard of a black body radiator. The particular spectral distribution is measured on a scale of kelvin units which is the temperature, on the absolute scale, to which the black bodied radiator is heated.

Although overall energy alters as well as spectral distribution (1) it is more convenient to centre the set of curves (around an arbitrary 580 mμ in this case) to compare their relative spectra (2).

used; an absolute scale in which zero °K is -273 °C. Any practical light source with similar spectral quality can then be classed as having these 'colour temperatures', although their actual working temperatures may be quite different.

For tungsten lamps, the spectral distribution is substantially similar to that of the black-body standard (tungsten melts at around 3650°K, with a colour temperature of 3600 K). But for discharge lamps and fluorescent sources, their irregular, dissimilar spectra prevent the colour temperature from being compared accurately. Any reference to 'colour temperature' for such sources is a purely subjective one. Natural daylight colour quality, too, only approximates to Kelvin scale classifications, as in comparison between Figures 1.3 and 1.4 will reveal.

The colour temperature of a tungsten light alters with the amount of current passed through it. When full voltage is applied, it will achieve its maximum Kelvin temperature according to its design (e.g. 2600–3500 K). Lamps designed to operate on lower voltage supplies (100–115 v) produce light some 100 K above equal-power lamps designed for higher supplies (220–250 v).

As we dim a lamp by reducing the supply voltage, its colour temperature falls and the quality of the light changes from a cold bluish to a reddish-yellow colour. A lamp rated for 115 v operation increases about 10 K in colour temperature for every volt increase in the supply.

15

TABLE 1-II
TYPICAL COLOUR TEMPERATURES (KELVINS)

Standard candle	1,930
Household tungsten lamps* (25–250 w)	2,600– 2,900
Projector bulbs*	3,200
Studio tungsten lamps* 500–1,000 w	3,000
Studio tungsten lamps* 2,000	3,275
Studio tungsten lamps* 5 kw, 10 kw	3,380
Tungsten-halogen lamps*	3,300– 3,400
Overrun tungsten lamps*	3,400– 3,500
High-intensity arcs	6,000
Sunrise, sunset	2,000– 3,000
Sunless daylight	4,500– 4,800
Midday sun	5,000– 5,400
Overcast sky	6,800– 7,500
Hazy sky	8,000
Clear blue north sky	10,000–20,000

* Run at their correct, full voltage. Lamps at supply voltage below 240 volts operate at higher colour temperatures (e.g. 50–100 K).

TABLE 1-III
STANDARD LUMINANTS

Physical sources: classifications used for calculation purposes

Luminant A	2854 K	Whiteness of tungsten filament lamp
Luminant B*	4870 K	Whiteness of sunlight
Luminant C*	6500 K	Whiteness of overcast sky (colour TV picture tube)

Spectral energy distributions: classifications used for viewing specification; suitable for fluorescing pigments and dyes

Luminant D$_{5500}$	5500 K	Sunlight plus skylight
Luminant D$_{6500}$	6500 K	Standard, or typical average daylight
Luminant D$_{7500}$	7500 K	Typical north skylight
Luminant E		Hypothetical equal energy spectral distribution

* Deficient below 400 nm (violet). Modified forms of luminant A.

TABLE 1-IV
MIRED SHIFT

Kelvins	0	100	200	300	400	500	600	700	800	900
2000	500	476	455	435	417	400	385	370	357	345
3000	333	323	312	303	294	286	278	270	263	256
4000	250	244	238	233	227	222	217	213	208	204
5000	200	196	192	189	185	182	179	175	172	169
6000	167	164	161	159	156	154	152	149	147	145

How noticeable such changes are, depends upon the colour system involved, and the subject. In critical applications, up to ± 100 K variations may generally be regarded as satisfactory on small to medium areas of neutrals, which betray colour temperature deviations most rapidly. But on prominent or large-area neutrals, even a ± 50 K change may be discernible.

Most people have noticed how the appearance of a coloured surface changes when lit by colour light. It is not surprising to find that if light quality is 'coloured' relative to that for which the colour film is designed, the resultant record itself will have an inaccurate colour rendering. There are several solutions when light source and film colour qualities are unmatched.

1 The source colour temperature can be modified (by raising or lowering its supply voltage, or by placing a compensating filter over it).
2 A different colour temperature source can be employed.
3 A filter can be placed over the camera lens.
4 A change can be made to colour film of a more appropriate colour standard (the TV camera's colour balance is readily changed, but for film only limited standard selection is practicable).

Any filter over the light source will modify its colour. But *energy-converting* (light-balancing) filters, cannot be used haphazardly. The spectral response of the converting filter should match into the spectrum of the source, to produce a combination similar to the required colour temperature source. Specially manufactured Wratten filters can be clipped over the camera-lens to achieve fairly close overall correction, but gelatin filters placed over light sources will normally be very approximate. All involve light loss.

Theoretically, a series of filters could enable us to take any prevailing colour temperature condition and convert it to the one needed. First colour temperatures are translated into *mired* units (a million divided by its degrees Kelvin). This mired value enables the colour shift required (mired shift) to be readily calculated independently of the initial colour temperatures. So if a light source of 5000 K (200 mireds) is to be converted to 3000 K (333 mireds) the required shift is $333 - 200 = 133$ mireds. (See Table 1-IV.)

The extent to which a given filter will convert depends on the present colour temperature of the light. The same filter provides a series of conversions. Thus, a 48-mired filter would equally well convert 4000–5000 K (250–200 mireds) and 3000–3500 K (a value within 10 mireds of the ideal will suffice). Filters can be combined—e.g. a Wratten 82B at $-33\frac{1}{2}$ and a Wratten 82C at $-44\frac{1}{2}$, to provide the -76 mireds needed to raise a 2700 K light to an effective 3400 K. A yellowish filter will raise the mired value (positive shift); a bluish filter lowers the mired value (negative shift).

Thanks to colour temperature conversion filters of this kind, it becomes possible for a lighting cameraman shooting under differing light conditions to compensate for variations in colour temperature, and obtain reasonably consistent colour quality.

Basic light attributes

Human vision is highly adaptable. Consequently, one has always to distinguish between the *subjective* effect the eye thinks it sees, and the *objective* effect that instruments, including the camera, will detect. The two aspects can be substantially different. We have only to recall how bright the light from a single candle can appear in a dark room, and how insignificant in bright sunlight. And yet the candle is still emitting the same quantity of light. The 'colours' we think we see when white light is made to flicker at certain regular intervals, are not even there at all!

Aspects of light

In specifying or measuring colour, three aspects should be considered: hue, saturation and brightness.

HUE is the predominant sensation of colour; i.e. whether it is red, blue, green, etc. This normally corresponds to a narrow spectral band or *dominant wavelength*. (A surface entirely lacking colour is termed *neutral*, or *achromatic*.)

SATURATION (also called its *chroma*, *intensity* or *purity*) is the extent to which the colour has been 'diluted' (paled or greyed-off) by the addition of white light (see Fig. 1.5). 100% saturation represents the pure, undiluted colour.

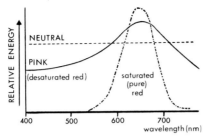

FIGURE 1.5 SATURATION As a pure hue becomes admixed with white light it displays a less-defined chromatic character. A 'white' surface reflects all spectral colours; a 'pink' surface predominantly reflects red light, together with a proportion of all others; a 'red' surface reflects only a limited spectral range.

BRIGHTNESS is the term still widely used to indicate the quantity of light received from the subject. But, as subjective and objective impressions of 'brightness' are easily confused, especially when colour is involved, terms have been evolved which describe these distinctions:

1 *Luminance*, for true brightness (hence double the illumination intensity produces double the surface luminance). Snow has a high luminance, black velvet extremely low luminance. Being colour-free neutrals, they both have zero saturation.
2 For perceived brightness, the terms are *lightness* for surface colours and *luminosity* for light sources. (In the U.S.A. 'brightness' is often used to denote luminosity.)
3 *Value* is used by the Munsell system (Figure 1.21) to indicate subjective 'brightness'.

Brightness and saturation are liable to be wrongly assessed subjectively. Although the eye can detect hue differences readily enough, it is often less able to decide whether a particular effect is due to brightness differences alone, or to saturation differences also. The most familiar example is encountered with deep-blue skies, which have all the appearance of being the result of high saturation. In fact, analysis reveals that they are really a case of low brightness. Highly saturated colours, paradoxically enough, are often described in error as appearing 'bright'.

We shall encounter various other items in wide but uncertain use. These are: *tint* (hue diluted with white), *tone* (a greyed hue) and *shade* (hue mixed with black).

Further descriptions, such as brilliant, pastel, deep, pale, vivid,

19

are rather too subjective, for they arise from both brightness and saturation effects.

Achromatic values

From complete darkness, one can build up a progressive scale of brightnesses from black, through dark grey, light grey, up to white. These are very arbitrary designations indeed. A surface we assess as light grey under one set of conditions, we could refer to as 'black' or 'white' under others. Nevertheless, the concept of a 'brightness scale' provides an invaluable means of comparing relative lightnesses of surfaces.

FIGURE 1.6 ACHROMATIC VALUES A continuous tonal wedge displays a progressive series of tonal values between black and white. A step wedge takes regular tonal intervals, and forms tonal blocks, each proportionally lighter than the one below. (a) This tonal scale can be calibrated for reference purposes. Too many steps (b) would make individual selection and matching difficult. Too few steps (c) would provide only a coarse indication of a system's reproduction of tonal gradation. Where a system cannot reproduce the entire range (d) tonal extremes become merged.

Such an *achromatic* or *grey-scale* is seen in Figure 1.6a. This is a continuous tonal wedge, or tonal scale. Because the tonal transitions merge so imperceptibly from one to the next, and intermediary points are less readily identified, this form of grey-scale has certain more specialised applications. In television, such a scale placed across the field of view of a camera, slide scanner or telecine machine enables us to assess the tonal reproduction of the system (its transfer characteristic). The resultant video-signal is termed a 'sawtooth'. This continuous scale serves a similar

purpose in sensitometry where film emulsions are being examined.

If, instead of a continuous wedge, specimen tones at regular intervals are selected between the extremes the system can accommodate (its *contrast range*), a *step wedge* is obtained (Figure 1.6*b*).

This is arranged so that the steps appear equidistant to the eye (their actual luminance will vary in an approximately logarithmic fashion, for sensation changes as the logarithm of the stimulus). Slight steps would be too difficult to distinguish for a tone needs to be some 2% brighter than its neighbour (in daylight) for us to detect any difference at all. The actual number chosen for a scale will depend upon its purpose. For many applications, 10 steps provide a good indication of a system's performance; for others 20 or more may be required.

A 10-step grey-scale has been used for many years in certain TV networks, both as a check to equipment performance, and a means of classification for staging and lighting practices where these are controlled. A typical grey-scale of this type is shown in Figure 1.7. When examined by a TV camera, the video appears as a series of well-defined steps in a *staircase waveform*, each of which can be measured to ascertain camera-calibration.

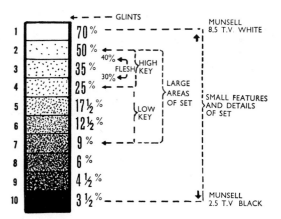

FIGURE 1.7 THE GREY SCALE The figures on the left of the scale indicate grey steps; those on the right, the percentage relative light reflectance. Overall contrast range is about 20 : 1, with each step $\sqrt{2}$ times the brightness of the next. The logarithmic scale looks linear to the eye. Thus, what appears to the eye as mid-grey, is only $17\frac{1}{2}$% reflectance, not the 50% that might be supposed.

Tonal gradation and tonal contrast

No picture reproduction system can, without adjustment, handle the variations of light intensity encountered in the world about us. Our eyes automatically 'iris down' (stop down) in bright light, and 'open up' under dim conditions. Even then they may need dark sunglasses to reduce effective light levels. In the camera we adjust the *exposure* similarly, using the lens iris (*stop* or *lens aperture*) variations to regulate the average amount of light falling upon the

DEPTH OF FIELD As a lens aperture
is reduced, the visible depth increases,
although more light is necessary. *Top
left:* At f.22, depth is considerable.
From near to distant subjects are
clearly focused. *Bottom left:* At f.3.5
depth is shallow; subjects can be
selectively defocused (differential
focusing). *Top right:* This has practical
application when planes are distract-
ingly sharp, or conflicting. *Bottom
right:* A larger aperture reduces the
background to a blur.

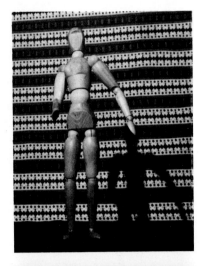

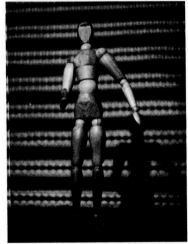

camera's light-sensitive surface. We may need dark filters too for
very bright conditions. Conversely, there may be too little light
for our system to function effectively or, indeed, at all.

It is rather easier, perhaps, to imagine tonal effects in a black-
and-white picture than in a colour one. Once we consider colour,
a series of complications creep in and confuse the issue.

The range of tones in a subject, its *contrast range* or *subject
brightness range*, can vary considerably according to its own
inherent surfaces and the prevailing lighting (Figure 1.8). The

23

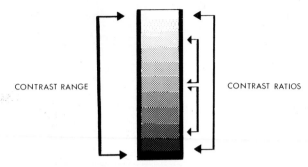

CONTRAST RANGE CONTRAST RATIOS

FIGURE 1.8 TONAL CONTRAST The contrast range (brightness range) of this tonal scale is shown (*left*). In any tonal comparison (*right*), we assess relative contrast ratios. One may be three times the lightness of another; a 3 : 1 contrast ratio.

brightest part of a subject could exceed by a million times the value of the darkest area, while in another subject the tonal variation might be only fractional.

The contrast range that can be accommodated, from extreme highlights to darkest shadow, depends largely upon the picture reproduction process. A film negative may be able to register a ratio up to 200 : 1. A glossy bromide print may reach 60 : 1. A projected transparency can encompass 160 : 1. Estimates for motion pictures suggest that a maximum contrast between adjacent tones of about 35 : 1 to 40 : 1 is attainable. Similar television screen contrasts are around 10 : 1 to 20 : 1 for adjacent tones, and 30 : 1 on widely spaced areas.

But contrast ranges attainable by a system tell only part of the story. They often do not indicate how well half-tones are reproduced between these extremes. As subject contrast is increased beyond a system's limits, tonal reproduction becomes coarsened, for highlight gradation and shadow detail become merged and lost.

Any statistical quotes can only be a guide to actual system performance, for various factors (e.g. flare, ambient light, subjective illusions, etc.) will affect the usable contrast range. How far the inevitable restriction of contrast matters in practice will depend upon tonal distribution in the subject, and upon the extent and importance of tones within that range. A scene with a distribution of tones over the whole contrast range will, of course, be more demanding than another with the same contrast range but encompassing only a few half-tones. We may be primarily

24

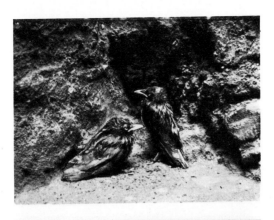

NATURAL LIGHTING CONTRAST *Top:* Where the subject, its significance or attitude, preoccupy our attention, the precise nature of the lighting may be unimportant—provided that the subject can be clearly discerned. *Centre:* Where emphasis is to be upon form or structure, harsh lighting may be ideal. *Bottom:* Subtle half-tones created by soft light may best convey the delicacy of a high-key picture.

concerned with tonal gradation in the highlights or in the shadows and care little about accuracy in intermediate tones. In special applications, reproduction of the black-and-white extremes alone are required, and high-contrast techniques and processing are employed to this end.

Pictorial effect can be strongly influenced by the proportion and range of tones involved. Bold, well-defined, high-contrast effects may have arresting vigour—or appear harsh and 'unsympathetic'. A picture with a large number of grey values may appear delicately subtle, or lack brilliance, appearing dull and somewhat flat. High contrast can convey depth; but equally it can destroy the subtle gradation that suggests form and texture.

Scenes in which mid- to lightest-tones predominate, with little or no shadow detail, are termed *high-key* subjects, while scenes in which mid- to lowest-tones predominate, with few highlight details, are known as *low-key* subjects.

Quite often we are primarily interested in the *contrast ratio* of two tones, i.e. in their relative brightnesses. Particularly in portraiture, the ratios of the lightest and darkest areas of the face, and of the facial tones to their background, are all-important, as we shall see later.

Definition

When we refer to the *definition* (*resolution*) of reproduced picture detail, we are really considering how readily we can distinguish between tiny adjacent areas of differing tones; in electronic terms, how rapidly the system can change from one tonal level to another during the television scanning process.

Detail becomes most crisp when we see a series of tonal demarcations within a small angle of our field of view (i.e. fine pattern near by, or somewhat greater tonal variation at a greater distance). Even with quite solid, clear-cut subjects, borders or edges (boundary transitions) may be quite difficult to distinguish from their surroundings unless there is a strong tonal contrast between them. This not only makes it harder to focus upon them, but such areas quickly merge with distance, or as sharpness of focus falls off.

Sharpness in details can have a marked effect on general picture quality, on two accounts. When close patterns defocus, they 'average-out'. Black-and-white bars defocus to a grey; close

colour patterns mix to a new hue (the principle of the shadow-mask colour TV tube). Tonal gradation, too, is diminished, and subtle contours merge and are lost when defocused.

These factors are of greatest significance when working at a large lens aperture (e.g. f. 1.9), because depth of field is shallow, and surfaces are seen sharply defined in some shots and softly focused in another. When such pictures are intercut, subjective brightness and colour may, therefore, be seen to change.

Surface brightness

The apparent brightness of a surface is not the simple matter one might suppose but is affected by a variety of factors:

INCIDENT LIGHT Its intensity—luminant strength, distance (Figures 1.9, 1.10). Its quality—hard or soft (Figure 1.14). Its colour (Figures 1.17, 1.18, 1.19).

SURFACE FORM Contour, material, texture, tone, hue (Figures 1.11, 1.12, 1.13).

SURFACE AREA Relative to adjacent areas; relative to the field of view.

SURFACE ANGLE The angle of the surface to incident light (Cosine law) (Figure 1.15).

SURROUNDINGS Adjacent tones and colours (Figure 2.3, Plates IV and V).

CLARITY Sharpness of focus; atmospheric haze.

POLARISATION (Figure 1.16).

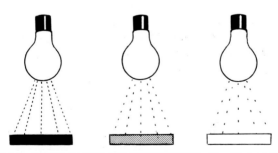

FIGURE 1.9 INCIDENT LIGHT AND SURFACE TONE The effective brightness of a surface depends upon the incident light level relative to its tone. In each case here, they could appear equally bright (providing constancy effects do not arise).

FIGURE 1.10 INVERSE SQUARE LAW With increased distance, the light emitted from a given part of a point source will fall rapidly, as it spreads over a progressively larger area. This fall-off in light level is inversely proportional to the distance squared, i.e. $\frac{1}{d^2}$. Thus, doubling the lamp distance would reduce the light to $\frac{1}{4}$. A lens at f. 6·3 would need to open to f. 3·2 to compensate. This law is only strictly true for the uniformly diverging rays from a point source, unmodified by a lens or reflector. Nor does it apply to parallel light rays, which ideally do not decrease in intensity with distance.

The effects of these features can vary with the viewpoint of eye or camera, or as the direction of lighting is altered. Indeed, the complete appearance of a subject—or even the entire scene—can become transformed on cutting between different camera positions as relative surface brightnesses change.

One can precisely measure the light levels falling upon a surface, and the proportion being reflected towards our viewpoint. But when creating pictures, these measurements tell only part of the final story. They can guide our treatment, but not define the pictorial result.

Technically we are concerned with the actual quantities of light reflected from the scene. Artistically we are concerned with the *apparent* brightness of tones within the picture, their significance, and their contribution to the effect we are seeking.

Over preoccupation with technicalities or atmosphere alone can produce sterile, unsatisfying results. A picture can possess mechanical perfection but have little artistic appeal. Alternatively, it may be highly atmospheric but so marred through its physical imperfections that these distract from its real purpose. A suitable balance has to be achieved according to each picture's application.

Strictly speaking, over-light or over-dark tones are only a *technical* embarrassment which they introduce or reveal limitations and restrictions in the system. Where a light-toned area reflects more light than the reproduction process can handle, the

28

TABLE 1-V

COLOUR TV PAINTS REFLECTANCE RANGE

	Munsell value	% Reflectance	Typical colours
Maximum picture white	8	58	White
			Cream
Light values		51·5	Ochre
	7·5	50	Eau de Nil
		48	Golden Yellow
		47	French Blue
		45	Lime
		45	Pink
		45	Powder Blue
	7	43	Light Grey
(light skin)		43	Grey-Green
		43	Rose
		42	Mustard
		42	Cement
		42	Blue-Grey
		41	Light Stone
		37	Wedgwood Blue
		37	Buff
	6·5	35	Orange
		33	Sea Green
Medium values		32	Pastel Blue
		31	Jade
	6	30	Cobalt
(dark skin)		29	Lavender
		27	Dove Grey
		26	Beige
	5·5	25	Mushroom
		24	Tan
		23	Copper
		22	Vermilion
		22	Lilac
	5	20	Sage
		17	Scarlet
	4·5	15	Dark Coffee
Dark values	4	12	Indian Red
		11	Maroon
		10	Ultramarine
	3·5	9	Burnt Sienna
		8	Prussian Blue
		7	Purple
		7	Dark Grey
	2	3	Black

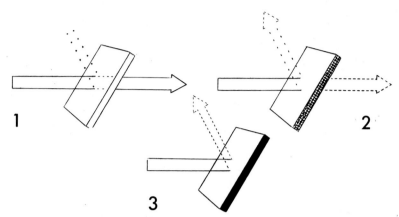

FIGURE 1.11 TRANSMISSION OF MATERIALS
1 Transparent medium (specular transmission). As light meets a transparent material, some is reflected, a little is absorbed, most passes through. A coloured medium transmits its own colour, and absorbs all others. The proportion passed is its transmission factor (transmittance). Transmission of 100% equals a transparency of 1. A glass–air surface transmits about 96–90% of the incident light.
2 Translucent medium (diffuse transmission). Translucent material permits some light to pass, but prevents clear visibility through the medium (e.g. frosted glass). Opacity denotes the proportion of light passed by a material. If $\frac{1}{3}$ passes, its opacity is 3; transparency $= \dfrac{1}{\text{opacity}}$; density $=$ log opacity.
3 Opaque medium. No light passes through an opaque medium. The amount reflected depends upon surface absorption, colour, texture, lighting angle, etc.

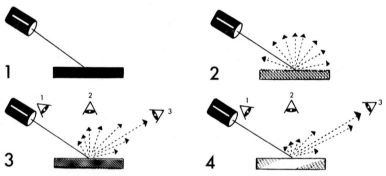

FIGURE 1.12 SURFACE REFLECTION Apparent surface brightness changes with the texture and finish of the surface, and the light and viewing angles.
1 Complete absorption (e.g. black velvet). Little or no reflection. Surface appears dark from all viewpoints.
2 Diffuse reflection (e.g. rough, irregular surfaces). Light scatters in all directions. Surface fairly bright from all viewpoints.
3 Spread reflection (e.g. glossy surfaces). Fairly dark at 1; fairly bright at 2; bright at 3.
4 Specular reflection (e.g. mirrors, polished metal). Surface appears fairly dark at 1 and 2; very bright at 3.

30

resultant picture may exhibit defects such as lens-flares, halation —and, in television, streaking, colour-fringes, trailing, and similar shortcomings.

Where an area reflects such a small amount of light that it does not come within the exposure range of the system (i.e. beneath the toe or the lowest exposure limits), differing low values will appear similar, and when adjacent, will merge together. The technical defects most likely to be encountered as a result are, in photographic processes, fog and blank even-toned picture areas; while in television pictures, pronounced video noise in the form of spurious scintillations fills the darker tones, adjacent highlights bleeding-over as noise-fringes and ghostly smearing.

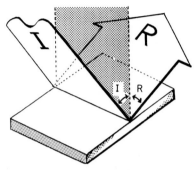

FIGURE 1.13 THE BASIC LAWS OF REFLECTION The light's reflected angle (R) is always equal to that of the incident light (I). The imaginary 'normal' plane is at right angles to the reflecting surface, where the rays meet. The (I), (R), and 'normal' always lie in the same plane. The reflected image appears laterally reversed, and is as far behind the reflecting surface as the subject is in front of it.

Our interpretation of tonal values is essentially a comparative one. We compare the specific object at which we are looking, with our own personal memory of what we believe is its normal appearance. However inaccurate that memory, it is nevertheless the yardstick by which we judge whether a subject looks 'right'. In adjusting the relative intensity of lights, we shall eventually choose proportions that suit this personal interpretation. A little brighter or a little dimmer, and the subject is less 'real', or less convincingly reproduced.

Although the factors that influence these judgments are themselves so tenuous, we can by studying them, obtain a clearer understanding of their impact, and the ways in which they modify our interpretations.

31

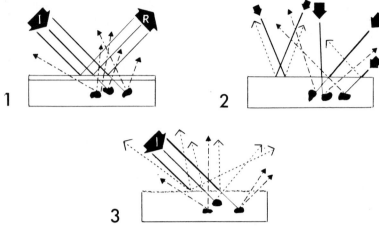

FIGURE 1.14 SATURATION AND SURFACE A glossy material comprises a smooth transparent surface, beneath which lie randomly shaped coloured pigments.

1 Under strongly directional lighting, reflection from the smooth surface layer is specular (of luminant hue) mainly in direction (R) with little absorption. Light reflected from sub-surface irregular pigments is scattered in all directions. From these, strong coloration is seen.

2 Under diffuse lighting, the multi-directional incident white light produces countless minute surface speculars, diluting the body colour reflections from all angles, so desaturating the total effective hue.

3 Matte surface reflection. Saturation changes are less with irregular surfaces, as their diffuse reflection creates desaturation under most lighting conditions. Surface smoothing (e.g. with water, varnish, oil) increases effective saturation.

One's impression of surface brightness can be influenced by the quality of the light falling upon the subject. Lit by 'hard light' sources, a subject may appear brighter than when illuminated by a 'soft light' source of equal intensity. This effect results chiefly from the contrasting light and shade of adjacent planes.

Paradoxically, where shadows and shading are prominent and strongly defined, we shall often find that the subjective brightness of the main light alone is greater than the overall effect obtained when we introduce additional light to illuminate the shadow regions. By reducing the visible contrast, the fill-light actually lessens the presumed subject brightness.

The shape and finish of a subject can have a considerable bearing on its apparent brightness. Whereas the brightness of a flat surface can vary markedly as it is angled to the light, the effect of such change is far less noticeable for a curved body. If, for

32

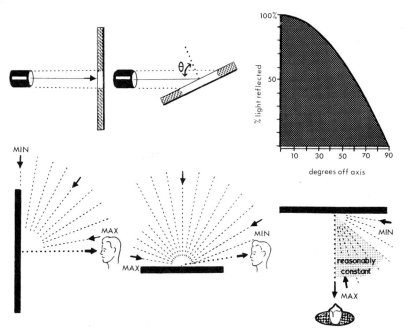

FIGURE 1.15 COSINE LAW When a surface is angled to a light beam, the same amount of light spreads over a larger area, so that it becomes less brightly illuminated. Illumination $(I) = \dfrac{\text{Lumens}}{(\text{Distance})^2} \times \cos \theta$. This means that for practical purposes up to 45° illumination is reasonably constant; 45–60° light falls to $\frac{1}{2}$ (1 stop open); 60–70° light falls to $\frac{1}{4}$ (2 stops open); 70–80° light falls to $\frac{1}{8}$ (3 stops open); 80–90° light falls to zero.

example, we arrange a playing card vertically, and light it from a side position, when it is turned, its brightness rises and falls dramatically. Replace the playing card with a ball, and we shall see that however much the object is turned, its brightness remains constant.

The flatter the surfaces of our subject, the more pronounced will brightness changes be, as we alter its position, our lighting angle, or our own viewpoint. Where the surface finish is smooth, variations will be greatest; the changes are less for matte finishes.

Any undulations in the surface of a subject must have a general effect upon local surface brightness, as its various planes present differing angles to the luminant. Also parts of a well-modelled subject cast shadows upon other parts of its surface. Furthermore, other nearby objects may cast shadows upon it. Only when these seemingly pedantic details are considered can it be seen how

33

TABLE 1-VI

TYPICAL SUBJECT REFLECTANCE VALUES

% Of light reflected	Subject
100%	Ideal reflector
97–93	Magnesium carbonate, fresh snow
92–87	Polished silver
90	White plaster
88–75	White gloss paint
85	Aluminium foil
80–60	White porcelain, china, white paper
65	Chromium
60–30	White cloth
40–30	Light skin tones
30–20	Cement
30–15	Green leaves
20	Bronzed skin tones
15–10	Brickwork
10– 5	Black paper
5– 1	Black paint
1	Black cloth
1– 0·3	Black velvet

a subject with an apparently restricted tonal range may quickly build up beyond the contrast limits of a system.

Distance can influence our interpretation of a subject's brightness. Usually, where a surface occupies only a small area of our picture, its impact will be less than when it fills a larger proportion of the screen. A distant face, for instance, will appear to be less bright than it does in a close-up, shot with identical lighting and exposure. As we shall subsequently see, one may need to compensate for such variations by using greater lighting intensity and contrast for distant subjects than for closer viewpoints.

Conversely, where a small or distant subject is seen distinctly and contrasts strongly with its surroundings, it may appear considerably brighter than when arranged nearer the camera.

Visual contrast results from tonal differences (as a white spot on a black background), from colour relationships (e.g. a scarlet spot on a light grey background). Even the intrinsic attractiveness of a subject may make one more aware of its tone; such awareness being engendered by subject isolation, its movement, its position in a compositional pattern, and so on.

Polarisation

Light polarisation is an intriguing scientific phenomenon. But in the practical field it has three valuable applications.

Firstly, it can help to clear away or reduce unwanted reflections in glass or water, that prevent our seeing objects beyond their surfaces. Secondly, it can control flares, specular reflections and hot-spots on glossy surfaces. Thirdly, it provides a means of darkening sky tones. And all this the *polarising filter* can do without substantially modifying colour quality although, admittedly, there is an overall light loss of one-half to two-thirds.

FIGURE 1.16 POLARISATION
1 (A) Light waves vibrate in all directions in a plane at right angles to their travel path. (B) Certain transparent materials contain minute crystalline structures that admit light vibrations of only one main direction. Other directional vibrations are suppressed, so light intensity is reduced. Now the emergent light is 'polarised', according to the filter's position. (C) This plane-polarised light would pass through another similarly positioned filter. But when either filter is rotated, the polarised light is progressively suppressed, all the original light's vibrations becoming blocked when the filter planes are at right angles (crossed axes).
2 Any light falling onto a shiny surface at a critical angle (20–50°), can become polarised. (Less completely at other angles.) Being plane-polarised it can be largely suppressed by a polarising filter. From matte surfaces the dispersed light is normally unpolarised.

As shown in Figure 1.16, ordinary light travels in a wave motion, vibrating in all directions in a plane at right angles to its direction of travel. Analogously, perhaps, this is easier to think of as a centre-bored disc of rhythmically fluctuating size, moving along a line which represents its travel-route. As in Figure 1.16, part 1, any polarising filter placed in the light path will obstruct most of these fluctuations and leave it *polarised* in a particular plane. In our analogy, the fluctuating disc has been reduced to a single directional motion—e.g. is now only rhythmically fluctuating horizontally, or 'horizontally polarised'.

We can polarise light deliberately by putting such a filter over a light source. Stereo photography makes use of this principle, and employs separate vertically and horizontally polarised pictures for the left and right eye-viewpoints. The result is two independent differently polarised pictures which are viewed through correspondingly polarised filters and fuse in the brain giving the illusion of solidity.

The polarisation of light takes place naturally in everyday life, whenever light strikes glossy and polished surfaces, glass, shiny leaves, calm water, etc., at around 20–50° to the surface. You can attempt to eliminate these reflections by placing a pola filter over the camera lens. But this polarisation is only partial, still leaving some radiation in other directions. Consequently we cannot expect under natural lighting conditions to suppress the entire reflection as with light polarised in one direction only. It may be necessary to experiment, rotating the filter for maximum effect because even polarised light can become modified on striking uneven surfaces. Though effective from one position, filtering may prove less successful from another. Nevertheless, for many purposes we can achieve an improvement that is not feasible by other means.

For more controlled situations, as when shooting subjects which are behind glass, or subjects with strong reflections, the most suitable approach may actually be to use polarised lighting, with a polarised lens-filter, to exclude unwanted reflections.

A polarising lens-filter also enables us to reduce haze, and to alter the apparent brightness of northern sky light, which is to a large degree polarised.

Polarisation increases the colour saturation of a shiny surface, as one would expect from Figure 1.14.

Coloured surfaces and coloured light

When light falls upon most surfaces it is *selectively absorbed*, and lost within them in the form of heat. So varying percentages of the spectrum are reflected, and this we recognise as the characteristic colour of that particular surface.* Figure 1.17 shows the reflectance colour range of typical surfaces.

* Further colour sources:

Interference Light reflected from inner and outer surfaces of thin films mutually adds/subtracts, creating spectral colours (oil films, bubbles, 'Newton's rings').

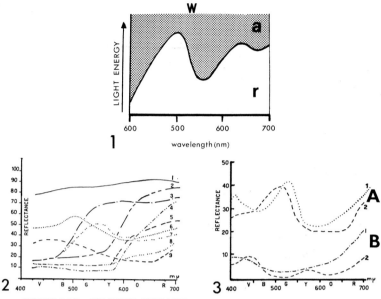

FIGURE 1.17 COLOURED SURFACES
1 (W) White light falls upon a surface. (a) Light is absorbed by the surface.
(r) Remaining light is reflected and recognised as surface colour.
2 Surfaces are seldom coloured in pure spectral hues. Most colours spread over
a wide portion of the spectrum. According to the relative proportions of hues, we
interpret subjects as having a particular colour: (1) White card (2) Orange
(3) Canary yellow (4) Red rose petal (5) Signal red (6) Pale blue (7) Light green
(8) Maroon (9) Sky blue.
3 Sometimes colours that match under one light (e.g. daylight) may appear
dissimilar under another (metameric) due to marked differences in extreme red
and blue content. Thus in (A) two green plastic materials differ and in (B) two blue-
green paints differ in spectrophotometric curves.

As we examine a spectral curve, general colour characteristics
are immediately apparent. The more level the curve, the more
even the percentage of all hues, and hence the more neutral the
result. If the overall curve is placed high on the graph, it will

Diffraction Spectral colours arising from fine, closely scribed grooves (iridescence on
beetles, diffraction gratings).
Dispersion Spectral light arising from 'prismatic dispersion' due to differences in the
refraction of transparent media to light of different wavelengths (rainbows, prisms).

Certain low-intensity sources are normally ineffectual before the colour camera:

Fluorescence Materials absorbing energy at one wavelength, and re-radiating it at
another while energised.
Photo-luminescence Materials excited into luminescence by electric fields.
Phosphorescence Materials that continue to glow after their excitation source is
removed. (Similarly, Electroluminescence, Cathodoluminescence, and Cathodophos-
phorescence are inapplicable concepts.)

37

represent light-toned values; while darker colours will have a generally low-curve position. A curve predominance at the blue end of the spectrum indicates a cool colour, while at the red end it shows a warmer hue. A steep, localised curve normally indicates a saturated, brilliant colour. More subdued pastel shades show flatter undulations.

Strictly speaking, the effective colour of a surface will be influenced by the eye's colour response, and the colour quality of the incident light. So for complex or less defined curves, it may be necessary to take these into account in interpreting spectral reflectance graphs.

Real-life surfaces reflect a surprisingly wide range of hues in addition to those we think of as their 'actual colour'. Green grass, for instance, reflects colours throughout the spectrum as well as this *dominant wavelength*, green. Change the proportions, and our impression of the kind of green changes. Change them further, and it may now appear blue.

Natural incident light has only limited colour variations; and these principally arise from *light scatter* due to water and dust in the atmosphere—hence blue skies and vivid sunsets. Strong light reflected from nearby surfaces can become coloured through their selective absorption, so that faces are liable to become lit with sweater-yellow, foliage-green or automobile-red (Plate VI). In close shots, where we can see the face without knowing the origin of the spurious colorations, the strange impact can be quite disturbing.

Coloured light is obtained from studio lamps by affixing *thin plastic sheets* (Cinemoid) of suitable colour-characteristics. With the heat of high-intensity sources, they will eventually change colour somewhat, and distort, but they have considerable adaptability, are self-extinguishing and water-repellent. Two or more filters can be superimposed, the combined effect of which is calculated by simply adding their individual spectral densities. Figure 1.18 shows a few representative colours and the spectral distribution of their light.

Other colour media are less suitable. Coloured lamps are available only in a restricted range of colours and are expensive because coated colour burns off. Coloured glass filters are costly and vulnerable. Gelatine is fragile, short-lived and a fire risk.

Where coloured light falls upon a coloured surface, its absorption pattern extracts from the light (subtractive mixing) as in

38

Figure 1.19. In a pure red light, for example, a white or red surface appears red. A green surface under the same red light reflects little or no light, and appears black; the green surface absorbs all red light, being able only to reflect green.

When lighting neutral surfaces, even slight luminant colora-

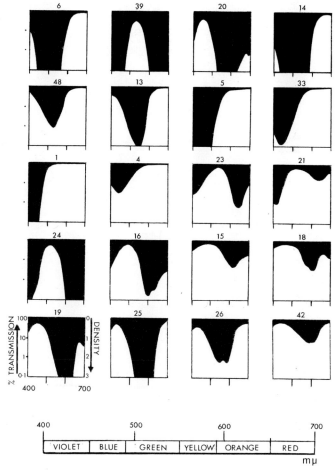

FIGURE 1.18 DENSITY AND TRANSMISSION CURVES FOR COLOURED LIGHT FILTERS These typical curves are based upon 'cinemoid' manufactured by Strand Electric. The clear area of the graph represents the spectral distribution of the coloured light transmitted. The shaded area shows absorption.
(6) Primary red (39) Primary green (20) Primary blue (14) Ruby (48) Bright rose (13) Magenta (5) Orange (33) Deep amber (1) Yellow (4) Medium amber (23) Light green (21) Pea green (24) Dark green (16) Blue-green (15) Peacock blue (18) Light blue (19) Dark blue (25) Purple (26) Mauve (42) Pale violet.

39

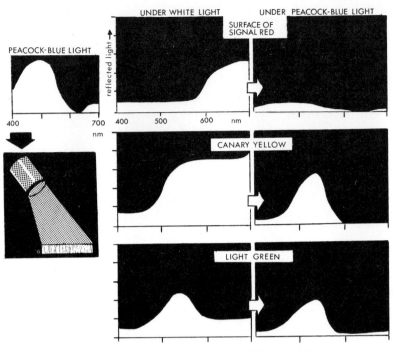

FIGURE 1.19 COLOURED LIGHT ON COLOURED SURFACES When coloured light falls upon a coloured surface the resultant effect arises from their combined spectral curves.

tion may be discernible. Supposing several identical lamps progressively light a large white background, but are placed at differing distances from it. Closer lamps will be over-bright, while distant ones require higher intensities to compensate for their longer throws. We match their relative brightnesses by dimmer adjustment; but this alters their corresponding colour temperatures. Now light from closer lamps is of comparatively yellow-orange hue, while that from distant lamps looks quite bluish. The overall effect is vari-coloured illumination. Improvements are possible, using diffusers, and equalised lamp-distances or power ratings.

Trichromatic colour mixture

Most colours can be matched by suitable mixtures of a set of three *primary* colours. The actual primaries chosen affect the range and accuracy of possible matching, but all hues, with the exception of

40

a few of high purity (i.e. fully saturated) can be reconstituted. This principle underlies all modern colour film and television processes.

There are two fundamental systems of colour mixing (see Figure 1.20):

ADDITIVE MIXING For coloured *light*, where the sensation of one colour adds to another's to produce a new colour-light mixture. The light primaries invariably used are red, green and blue.

SUBTRACTIVE MIXING This takes place whenever the resultant colour effect arises from selective absorption processes. As we saw earlier, when light impinges on a surface, the eye sees only the remaining light reflected, after this subtraction process. This is so, whether the surface colour is painted, dyed, inked or pigmented (Figure 1.17). If the absorption was total, we would see nothing and it would, in fact, look black. If the surface absorbs nothing, or little, it would look white. Equal absorption over the whole spectrum results in 'greying' to different degrees.

Any process is subtractive, whenever it involves a filtering action. Hence, when we shoot through colour filters, subtractive mixing takes place. When coloured media are placed over lamps, their function is again subtractive relative to the source light, as they absorb selectivity; although whenever the resulting light beams themselves are merged, the effect is additive at that point.

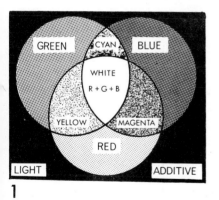
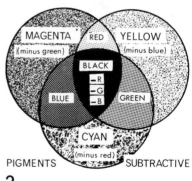

FIGURE 1.20 COLOUR MIXING
1 Additive mixing. When lights of differing hues are mixed, they add their respective parts of the spectrum to produce a new combination colour.
2 Subtractive mixing. When pigments of differing hues are mixed, they each absorb their respective parts of the spectrum from the incident light.

For pigments, the mixing together of separate colours juxtaposes a series of filtering particles, each subtracting its own corresponding region of the spectrum. If between them they absorb all colours, the result is a black surface. The corresponding primaries are yellow, magenta (a bluish-red) and cyan (a greenish-blue). Less familiar, perhaps, than our accustomed pre-blended watercolour paintbox colours, they provide the basic components offering a wider colour mixture and brightness range. They form the basis (supported by black to provide greater density) of much commercial colour printing.

Magenta is a mixture of the extreme red and blue limits of the spectrum, and so does not itself appear within the true spectrum. It is, therefore, termed *non-spectral*. Certain other apparently non-spectral colours are, in fact, spectral hues of low brightness set in much brighter surroundings. Thus, grey is a low-intensity white. Brown is a dim orange or yellow. Others, like pink, are really desaturated versions of a spectral range (Figure 1.5).

Certain colour mixing processes may not appear to fall too obviously into these categories.

It was stated earlier that if a pigment is spread on to a surface, its colour derives from a subtractive process. However, if you view from a distance tiny close patches of these same red and green pigments, the reflected light combines to give an *additive* effect—in this case looking yellow. Thus, here there is a dual effect.

In practice, subtractive processes in colour films have an inherently greater brightness efficiency, as the entire colour area takes part in the colour mixing, than obsolete additive processes employing a localised dot structure which provided colour through juxtaposed fusion. Colour television (shadow-mask tube), however, uses the additive process in creating all colour mixtures from varying brightnesses of a permanent pattern of minute red, green and blue phosphor dots.

Colour specification

For many everyday purposes we can identify colours by names with more or less widespread acceptance: 'scarlet, yellow ochre, ultramarine'. But fancies like 'tartan green' or 'pixie brown' can only serve to remind the initiated. Sample cards are useful for general applications (as for paint-matching), particularly when accompanied by *spectral analysis curves* as in Figure 1.17. Of

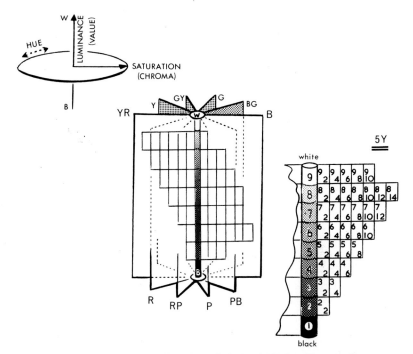

FIGURE 1.21 MUNSELL SYSTEM OF COLOUR NOTATION This classifies a
wide range of hues for varying degrees of saturation. On a vertical grey-scale of
eleven equidistant brightness steps Step 10 = white (100% reflectance), Step
0 = black (0% reflectance), Steps 1–9 being those used in practice.

A series of evenly spaced 'pages' pivot around this grey-scale, each analysing a
slightly different hue, in a series of sample 'chips'. From each grey-scale value on
the inner margin pivot a horizontal branch develops with evenly numbered steps
of progressively increasing colour purity, to a maximum saturation (chroma) for
that value.

Fullest saturation for different hues is achievable at different values; e.g. yellow
reaches chroma 12 at value 8. Blue-purple reaches chroma 12 at value 3. A blue-
green may never become more saturated than chroma 6.

Between each of the ten principal hues (each scaled as '5') lie sets of four
subdivisions (2.5, 5, 7.5, 10) giving a total of forty constant hue charts.

To specify a colour, quote: hue deviation; value (luminance); chroma
(saturation) steps. E.g. 7·5 G 7/10. (A slightly bluish green of light, strongly
saturated character.)

these matching-chip methods, the most sophisticated and widely
used notation is the *Munsell system* (Figure 1.21).

In *trichromatic matching* colour samples are matched to a light
mixture derived from standard red, green and blue sources. So it
becomes possible to tabulate the proportions of these known stan-
dards and from these derive chromaticity co-ordinates, from
which the original colour can be reconstituted.

43

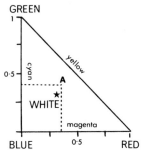

FIGURE 1.22 THE COLOUR TRIANGLE The entire hue range obtainable with three given primaries can be plotted if we know the strength of any two. Using trichromatic primaries (T), i.e. primaries equally proportioned to add to unity, equal energy white is derived. (A colour that is 0·4 green, 0·3 red, (0·25 blue) is shown at A.)

Tristimulus primaries

If the three colour-light primaries are set graphically at the corners of a *colour triangle*, within its bounds all colour-light mixtures can be plotted. Its centre-of-gravity represents *equal-energy white light* ($y = 0·33$ and $x = 0·33$).

By quoting the x and y co-ordinates, we specify any colour as $R + G + B = 1$ (i.e. unity). Exact colour matches are achievable for hues lying within the triangle. But what if our required colour falls outside these limits? In those circumstances a matching mixture in hue and luminosity is still possible but, when achieved, will be found to be noticeably paler (i.e. desaturated), as higher proportions of all the primaries have been involved.

The diagram reveals that not only can white light be derived from the *tristimulus* primaries but equally well by appropriately blending any complementary colours: magenta and green, or cyan and red, or blue and yellow light.

When any two colours are blended, their resultant mixture will be found to lie on the line joining these two colour points. Thus mixtures of red and blue light would be represented as points along the line $R - B$. No green light being present in these mixtures, the line $R - B$ can therefore be defined as a parameter in which $G = $ zero.

44

C.I.E. chromaticity diagram

The international C.I.E. system (Commission Internationale de l'Eclairage) derives from the colour triangle a more precise reference system enabling any hue to be specified on its *chromaticity*

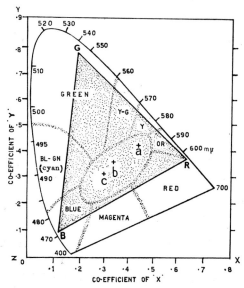

FIGURE 1.23 CHROMATICITY DIAGRAM All visible hues can be classified as points falling within the curved spectral locus. Colour TV primaries (N.T.S.C.) are plotted here as R.G.B., and reproduced TV colours lie within the triangle (gamut) formed. Subject hues falling outside the gamut are inaccurately reproduced, usually as desaturated. (Pure greens and cyans are rare in nature.)

Further gamuts could be drawn for ranges of printing inks, pigments, dyes, etc., although their shapes would be less regular. An ideal gamut is described by co-ordinates joining 400, 520, 700 mμ points on the spectral locus.

A line from a white point to a spectral hue depicts all the possible saturation values of that hue. If two hue points are joined, any proportional blend will fall upon this line. Standard white luminants A, B, C are shown. (The purple boundary from 400 to 700 mμ represents non-spectral hues. Luminance corresponds to plane erected vertically from the page.)

diagram (Figure 1.23). Here three fictitiously supersaturated primaries are employed, the spectral hues being ranged along the 'horseshoe' boundary within. As any primary we could possibly use must necessarily be less pure, it and its mixtures must lie within these confines.

The C.I.E. primaries are Red 0·700 mμ, Green 0·546 mμ, Blue 0·436 mμ.

2

THE EYE AND THE VISUAL WORLD

The eye and the camera

Often, the human eye is likened to a camera. It does have broad similarities, but the parallel can be misleading. As in the camera, the amount of light admitted is controlled by the iris, and the image of the scene focused by a lens on to a light-sensitive screen. But there the similarity ends, for the eye is, in fact, a remarkably deceptive organ. It has optical shortcomings we could not tolerate in a camera, and yet, because of continual readjustments and the interpretative functions of the brain, we are left with the impression of perfect vision, of overall clarity. Admittedly, we do meet conditions where our surroundings are dazzlingly overbright, or too dim to see properly, but for the most part we are quite unaware of our visual idiosyncracies.

When photographing the world about us in colour, we encounter unexpected anomalies. A subject we 'know' to be one colour, looks another in the colour picture. We find that the relative prominence of reproduced subjects has changed from those we felt when looking at the scene itself. Delighted with a subject, we may find ourselves disappointed with the photograph of it. We may be impressed by a beautiful scene shot by a good photographer, but may feel let down when we visit the location for ourselves.

The bluish shadows in a snow scene may look phoney in a colour picture, but they really were there from the reflected sky light, if we had looked critically. The mind, however, adapts itself to the circumstances and discounts this, though the camera did not. Likewise, the changing quality of daylight, or the coloured light reflected on to faces from nearby surfaces, may go unnoticed by the eye. There are many reasons for this. The disconcerting element can come from differences between the way our eye-plus-brain behaves and the way the camera records.

46

How we use our eyes depends very largely upon what we are looking for. Our attention is highly selective, and remarkably mobile, whether we realise it or not. The camera, too, is selective, but in a different way. The camera sectionalises the scene into rectangular segments, in which subjects are differentially focused. The eye settles momentarily upon a series of isolated spots, and by turning quickly from one to the next, conjoins them spatially. The camera may relate subjects spatially, by panning, tilting, trucking or zooming, but it can join images too, by cutting or mixing from one to the next; or even juxtapose several in the same frame.

In the process of putting a frame round part of a scene, the camera establishes, in a way the eye cannot, relationships that were not present in the original. These selective relationships may be turned to advantage, as when we reveal the attractive colour and pattern of an ancient wall, without disclosing that in reality this comes from decaying plaster and moss-grown neglect. The relationships may be bizarre, as when a vertical seems to be growing through someone's head.

Composition, camera angle, light direction, colour renderings, will all affect the viewer's impressions and attitudes to what he sees in the picture. But what of the picture-maker?

Picture-making is an equivocal process.

1 *Atmospherically*, there may be features present in a scene that we long to transmit through the camera. But where these are physical factors, ranging from overwhelming heat to vertigo, they have to be conveyed by inference, or symbolically.

Certain features that are unavoidably present may be spurious, or alien to our purpose; such as overhead aircraft noise, or dazzling sunlight, and these one strives to suppress.

2 Our *attitude* to a scene can affect the interpretation of it. Many a mountain view looks particularly good to us after the labour we had in getting there. In the resulting picture, perhaps the light had changed, or our original impressions came from an unconfined view, but one mountain can look very like another, and the magic has gone in the flat rectangular-framed image.

3 One's *selection* from a scene can distort, improve or modify the impression a picture conveys. It may be as blatant as the delightful shot of a lakeside view that discreetly omits the garbage dump alongside. It may be the cunningly chosen viewpoint that

transforms this very garbage into something rich and strange as we shoot through blowing grasses at its grotesque, *contre-jour*-lit mysteries.

All such factors as these form a demarcation between the subject, the picture-maker and his audience. And this the professional turns to his advantage, creating glamour, and persuasive picture appeal as he selects and controls his conditions. But above all, it reminds us that the eye at the scene, and the camera at the scene, are different propositions.

The eye

What is 'natural' is what we see—or so we think! Our eyes, apart from a little short- or long-sightedness, seem to show us the natural world. But it can be disturbing to learn that some 8% men and 0·4% women have colour-vision abnormalities. Black-and-white reproduction is an abstraction of reality, and yet we have become accustomed to accepting this as a convincing substitute—as indeed the flat colour image is—for the real thing.

A brief look at the way in which the eye and the brain interpret the visual world will help forestall many of these surprises, and enable us to take advantage of their quirks.

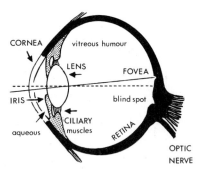

FIGURE 2.1 CONSTRUCTION OF THE EYE The light from the scene enters the eye via the protective cornea, is controlled by a variable iris, and is focused by the lens (in conjunction with the cornea and aqueous). Focusing is achieved through lens-thickness adjustment (by ciliary muscles) changing the focal length of the lens.

This focused, inverted, image falls upon the light-sensitive retina, which comprises numerous receptors. These rods and cones are joined by the optic nerve fibres to the brain. The junction region or 'blind spot' is itself insensitive to light. The fovea or 'yellow spot' comprises a highly sensitive cone-region of greatest visual acuity.

48

The scene's image is focused on to a light sensitive 'screen' coating the inside of the eyeball (Figure 2.1). This *retina* comprises layers of complex nerve cells. Most of the surface receptors (over 120 million) are *rod*-shaped. They are extremely light sensitive, but unable to discriminate fine detail, and are colour blind save to the blue end of the spectrum. The remaining less sensitive receptors ($6\frac{1}{2}$ million) are the *cones*, which are concentrated in a small *fovea*. Here is the centre of our acute vision, enabling us to detect colour, shape and position of objects. These cones, predominantly responsible for our colour vision (Figure 2.2), are of

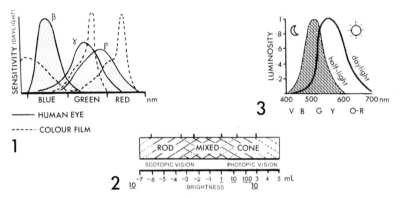

FIGURE 2.2 THE EYE'S COLOUR RESPONSE
1 The eye is thought to possess colour receptors (cones) covering three distinct regions of the spectrum.
2 Its overall response alters for lower ambient light levels, as differing proportions of cones and rods (blue sensitive) are activated.
3 Moonlight appears bluish, although actually a dim version of white sunlight, due to this 'Purkinje shift' as the eye changes from photopic to scotopic (twilight) vision, losing red-orange and gaining blue-green sensitivity.

three sorts, respectively responsive towards violet to blue light, green to yellow and orange to red regions of the visible spectrum. In passing, it is an interesting fact that even this colour vision is not constant over our visual field, so that it is possible for a green or red subject to become modified to yellow and thence grey as it moves slowly from central to side vision.

What we term '*vision*' actually involves a complicated, largely unexplained, involuntary computing process between eye and brain. Our eyes really produce inverted, laterally reversed images. We can only detect sharp detail over about $1\frac{1}{2}°$ (2 cm wide at 2 m), within a detailless wide angle visual field of around 240° (it is

49

due to this peripheral vision that we see in dim light, and readily detect nearby movement). And yet, with rapid eye movements our vision hops from one point of interest to another, refocusing, readjusting our interpretation so rapidly that we are left with the impression of overall clarity. These saccadic jumps are part of our unrealised scanning process, including a tiny local 200-cycle scanning movement. Paradoxically, a completely stationary eye-image fades rapidly. The eye continually adapts—relative to each momentary reference point—and our assessment of the image changes accordingly.

Binocular vision provides two slightly displaced viewpoints, which with mental fusion and experience, enable us to interpret distance and dimension in the external world.

The wonders and the puzzles of vision really derive from one main factor, *adaptability*. Mostly, this adaptability extends our range of perceptivity. Sometimes it is too clever by half, and leaves us with ambiguous or incorrect judgments, as with optical illusions. Even when the camera selects part of a scene, the effect may differ from our impression of the whole.

Brightness adaptation

General brightness adaptation

The eye is capable of operating under an extremely wide range of brightness levels. And with variations from the 10,000 f.c. (foot-candles) of strong sunlight to the 0·01 f.c. or less of artificial lighting, this is just as well! Two of its features enable us to do this. Firstly, the *iris* contrasts and dilates from around $f.$ 2 to $f.$ 10, giving us about 20 : 1 control of light reaching the retina. Secondly, the *retinal sensitivity* changes. Photo-sensitive pigments become reduced in bright light, increased in dim surroundings.

TABLE 2-I
TYPICAL ILLUMINATION LEVELS

Sunlight	10,000–2,500	foot-candles
Daylight	2,500–	200
Sunset	10–	0·1
Moonlight	0·01–	0·001
Starlight	0·0001–	0·00001
Store lighting	500–	100
Office lighting	50–	20
Domestic lighting	20–	5
Street lighting	2–	0·01

These combined phenomena explain why it is impossible for us to judge brightness accurately by eye, and why only a correctly used exposure meter can provide precise measurement.

Light levels of unobscured natural light remain comparatively constant for distance, whereas artificial light falls relatively rapidly with source-distance. And this, together with variations arising from source brightness and shadowing, becomes automatically compensated for by the eye—but not the camera.

Local brightness adaptation

As the eye scans a scene, stopping at fixation points, each fixation time, although very brief, is long enough to adapt to that point's brightness (*local brightness adaptation*). This, especially when combined with *brightness constancy* phenomena (in which we interpret object brightness relative to its background illumination), assists us in perceiving shadow detail, so that we generally underestimate shadow density when assessing by eye.

As we ourselves move around within the scene, adaptation disguises the varying light levels and contrast that the camera itself will record, and the light-meter measure. The eye does not notice these variations so much, and 'reads into the shadows'. Shadows appear to us more luminous, i.e. less dense and impenetrable. The more we concentrate, the more we perceive through adaptation. Furthermore, where we actually know that a subject is situated within shadow (even in a photograph), we are more ready and able to adjust our assessment than if we do not.

Lateral brightness adaptation

The retinal sensitivity of the eye is not entirely local, so that when in scrutinising a scene it adjusts to one area, its sensitivity to neighbouring regions can alter, too. This gives rise to simultaneous contrast illusions.

Brightness assessment is influenced, moreover, by lighting contrast. So, although the ambient light level of dull daylight may, in fact, well exceed that of studio lighting, the latter, being more contrasty, will subjectively appear much brighter.

The *contrast range* within which the eye can perceive tonal gradation alters with light intensity. This is partly due to its internal flare (about 10%) reducing the effective contrast at higher

extremes. The range of luminances that we can interpret at one time varies from 1000 : 1 brightness ratio at fairly high ambient light levels, down to 10 : 1 under dim conditions, and even around only 2 : 1 for very low levels.

Colour adaptation

General colour adaptation

Provided that the colour quality of the incident light covers most of the spectrum to some degree, the eye will accept astonishingly wide variations as white. Because of our rapid process of general colour adaptation, we habitually interpret objects as being of reasonably similar colour to their day-lit versions. Consequently, in everyday life the apparent variations we perceive in a coloured object under various light conditions may be far less pronounced to the eye than we would expect; we are making these compensations continually.

There is less visual compensation, however, when either the light or the reflected colour of the object has sharp peaks or dips, or is of limited spectral range (e.g. 'pure' colour).

Where two light qualities, i.e. cool and warm, are present, the eye tends to adapt to some intermediate, non-present colour quality. This arises whether we are considering two lighting colours on the same subject, or two adjacent colour transparency or television pictures.

Multi-colour light mixtures can produce spurious colour effects, and whenever the light from one source is obscured, distractingly coloured shadows result.

Local colour adaptation

After staring at a strongly coloured subject, the eye retains for a while a positive or negative after-image, after sensation, of it, in more or less complementary hues. Examples of this are listed in Table 2-II (Plate IIIa).

Similarly, prolonged exposure to a large strongly coloured area can result in our entire colour interpretation of following colour quality becoming modified, until the effect has diminished. Typical examples for warm colours (red) and cool colours (green) are included in Table 2-III and Plate IIIb. We could use this

TABLE 2-II

AFTER IMAGES

After a red image a blue/green after-image is seen
After a orange image a peacock blue after-image is seen
After a yellow image a blue after-image is seen
After a green image a purple after-image is seen
After a blue image a yellow/orange after-image is seen

particular phenomenon advantageously to emphasise a warm interior scene after a cold, bleak exterior. But again, it is an effect that can arise accidentally, after watching predominant colours.

TABLE 2-III

MODIFICATION OF HUE AFTER COLOUR EXPOSURE

	After exposure to red	After exposure to green
Red	appears magenta, lighter, greyer	appears bluer, darker, intense, less orange
Scarlet	orange	redder
Orange	yellowish or greenish, desaturated	reddish
Yellow	very light green	slightly orange
Purple	violet	redder
Green	greener, bluer, more vivid, lighter	darker
Cobalt blue	bluer, green/blue	more vivid
Violet	Ultramarine	more purple
Magenta	pinkish	redder
Tanned flesh	yellow/brown	redder, darker
Pink flesh	bluish, paler	redder
White	blue/green	warmer

Lateral colour adaptation

Akin to lateral brightness adaptation, are *lateral colour adaptation* (or *simultaneous colour contrast*) effects between a coloured area and its surroundings. A coloured subject will appear to induce a complementary hue in its neutral background, or a coloured background modify a foreground subject's colour. Colours appear lighter against black, darker against white.

Let us look at some examples that illustrate this common phenomenon.

An orange area against black, yellow or red will appear paler, less intense; while against a white, blue or green background it

53

appears more strongly coloured. Next to green, not only will the orange appear more reddish but the green will look more greenish than when seen separately.

A red subject against blue makes the red look orange by comparison, and the blue greener. Even *white*, when placed in proximity to a pure hue, can become modified, appearing reddish, bluish or yellowish in sympathy with its background.

Against a blue background, a blue area will seem somewhat darker than normal. Dark red or blue against large white areas may look nearly black, while the white itself becomes more vivid.

Both in colour and monochromatic pictures, the effect of simultaneous contrast is most marked at the edges of the areas concerned. But it will depend considerably upon the relative sizes of areas, their brightness and hues.

Constancy phenomena

In interpreting the external world, the brain often ignores the precise information the senses are conveying. Instead, perceived objects seem to retain certain characteristic appearances, irrespective of whether these features are really evident to the observer. These *approximate visual constancy* phenomena can take several forms:

Approximate size constancy

The faculty that prevents our seeing more distant objects as being proportionally smaller. We interpret them as just being more remote.

Approximate brightness constancy

Enables us to see a piece of paper we recognise to be white as that, even although the light intensity falling upon it may be less than a fully illuminated grey surface. Our previous experience continually conditions our interpretation of the picture before us.

Approximate colour constancy

This is an allied effect. When we 'know' what the colour of an object should be, we tend to assess surrounding colours in relation

54

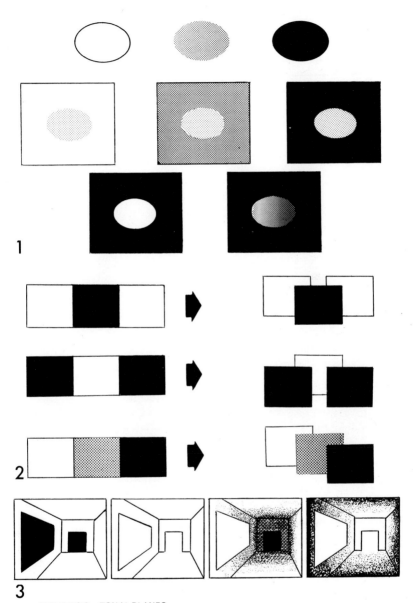

FIGURE 2.3 TONAL PLANES
1 A light-toned object or plane generally appears larger and more distant than an identical area of dark tone. This tonal interaction is called simultaneous contrast (spatial induction). The sharper the contrast, the greater the effect.
2 A series of tonal planes can produce the illusion of advancing or receding areas.
3 Tonal gradation can produce an illusion of solidity and depth.

to it. Familiar objects such as a white shirt, a mail box, soldiers in uniform, national flags—these remembered colours usually derive from our memory of them lit by daylight.

Shadow areas, which the untrained observer assumes to be black, frequently reveal reflected light colour if we study them carefully. And this the camera records.

Approximate shape constancy

Enables us to interpret recognised geometric shapes despite the distortions introduced by the perspective from our viewpoint. Thus, what is presented to us as an ellipse may be interpreted as a circle, and acutely angled planes are construed as possessing right angles. Disregarding the evidence of our eyes, we see the subjects as the normally shaped plates, table tops, coins, cubes, etc., with which we are familiar.

Colour assessment

Where we cannot actually see a coloured light source, our eyes tend to assume the visibly modified colour as actual; i.e. a grey box lit with green light becomes a green box. The exception is when we are certain that this is untrue, as with a blue face. In such cases we interpret the incident lighting as blue—paradoxically even when the effect is caused by coloured make-up and white light—unless further visual clues are interpreted otherwise. Wherever possible, the eye adapts. Hence the dubious value of slightly coloured key lights. The eye may adapt to the key, regard it as white, and then misinterpret other colour values as abnormal.

Whenever the red and green receptors are equally stimulated, we experience a sensation of yellow, regardless of the actual wavelengths of the light responsible (Figure 2.4). The effect may be indistinguishable from the pure yellow line spectrum of sodium light. In fact, we encounter two forms of colour match: that where two colours contain light of the various wavelengths in similar proportions (i.e. similar spectral responses), and that where the component energies are different, but their effect on the eye causes the two colours to appear the same.

Texture can modify our impression of surface colour. Smooth

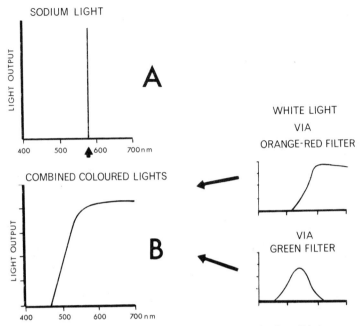

SODIUM LIGHT

A

COMBINED COLOURED LIGHTS

B

WHITE LIGHT
VIA
ORANGE-RED FILTER

VIA
GREEN FILTER

FIGURE 2.4 YELLOW LIGHT The eye sees as identical yellow, (A) the pure yellow light from a sodium source, (B) the yellow light derived from two superimposed coloured light beams.

surfaces appear more saturated, the specular light having the hue of the luminant.

Light quality, too, affects the apparent colour saturation, hard light creating a more saturated, contrasty effect, with brighter, more vivid, hues.

The direction of the light relative to our viewpoint influences the effective brightness and saturation, these being greater for frontal lighting than for oblique and side light.

Our judgment of colour and contrast is affected by the size of a picture, its surrounds and our viewing conditions (ambient light level and light colour, the colour of nearby subjects, etc.). The appearance of a colour depends very considerably upon the surrounding or background colours (Plates IV and V).

Colour and depth

For centuries artists have been aware of the strange way in which 'warm' colours appear to advance, while 'cool' hues

57

recede from the observer. All colours appear to have their relative distances, according to the background against which they appear.

This 'chromatic stereoscopy' can assist in creating an illusion of solidity and distance. Warm-coloured settings tend to look smaller, while cool colours appear further away and larger.

Colour detail and distance

The ability of the eye to detect fine colour detail is limited (see Plate II*a*). Its visual acuity varies with hue, being greater in the orange and cyan hues than in the green and magenta. Furthermore, the eye has chromatic aberrations which prevent it focusing on blue and red details simultaneously.

The illusory impression of distance can be influenced by the background tone against which a coloured area is seen. By careful choice of colour relationships, it even becomes possible to create the effect that some planes are closer, some more remote, although no actual visual clues to perspective are present.

A series of colours against a white background present a spatial illusion in the order: blue/green (apparently nearest)—blue—purple—red—yellow—yellow-green (apparently furthest).

Where colours are presented instead, against a black background, the impression of relative distances changes, so that now red appears nearest, while other colours recede in the order: orange—yellow—green—blue-green—blue—violet.

Owing to this restricted colour acuity, colour television is actually able to introduce technical economies by limiting the resolution, or frequency range, of colour channels. Thus, while large to medium areas are represented relatively accurately, all fine detail is produced by variations in *luminance* only, superimposed, as it were, upon a fuzzy coloured background.

The area of a colour in a picture can have a pronounced effect upon our interpretation. As mentioned earlier, this is an underlying principle of *pointillism*, in which artists juxtapose tiny dots of paint which blend 'in the eye' by additive mixing into a new and, they consider, more vibrant colour than conventional methods provide.

As the real or effective size of detail diminishes, we can less readily detect colours. They seem to pale, some losing their identity before others. Blues can become indistinguishable from dark

58

grey, and yellow from light grey. Green, blue-green and blue of similar luminance can merge. And, eventually, even the wide differences in hue between reds and blue-green are lost. Only brightness variations can be detected. And all this will be affected by size, distance and light intensities. The atmospheric effects of haze, mist or smoke may cause distant colours to become desaturated, add blue to them or give them a warmer appearance.

TABLE 2-IV

CLARITY OF DETAIL

Clarity of detail is influenced by the relative colours involved. In order of legibility these are:

Black	on	yellow	White	on	red, orange, black
Green	on	white	Red	on	yellow
Blue	on	white	Green	on	red
White	on	blue	Red	on	green
Black	on	white	Blue	on	red
Yellow	on	black			

Our assessment of fine colour detail may be influenced, too, by 'spreading effects'. A fine blue pattern tends to have a darker, more saturated appearance against black than against white; contrary to what we would expect of normal simultaneous colour contrast effects. By assimilation the colour of both the background and the pattern upon it become modified when small areas roughly equate.

Further complications arise in colour harmonies. Colours may appear harmonious and co-ordinated when seen close by, but less unified at a distance. Saturation and contrast may be low at short range, but increase with smallness or distance. But here we reach the borderline of the predictable for, given other conditions, the reverse effects pertain!

Colour attraction

Some colours have greater powers of attraction than others. Saturated colours draw the eye more readily than pastel or desaturated versions. A scarlet dress, for example, forces our attention on it, even when completely defocused and in that case

it becomes a distraction, all the more frustrating for our not being able to discern any detail. Bright yellows and greens are, likewise, more able to hold our eye than subdued browns and purples. An excess of prominent hues can create diverse focii of attention, vying with each other, and destroying compositional unity.

Colour harmony

People have long sought to produce colour arrangements that harmonise and give predictably attractive results (Figure 2.5). Certain broad principles have emerged:

FIGURE 2.5 COLOUR HARMONY Several attempts have been made to systematise colour harmonies, including Rood's Hue Circle, in which complementary colours are opposite, and triads are separated by 120° (e.g. G, O, Pb). However, relative saturation, area, form and finish have a strong influence on the effectiveness of such aids.

Near complementaries, *triads* (i.e. hues equidistant around the colour cycle, Figure 2.5) are harmonious. But, as colour harmony is so dependent upon shape, form, texture, proportions, relative saturation, application, social criteria, etc., only the simplest relationships are reliably tabulated.

Certainly the most pleasing pictures contain only a restricted range of hues. Harmonious colour relationships can derive from similar, or from contrasting treatments. Where less saturated colours are prevalent, results can be more natural-looking or drably uninteresting, as the case may be.

Saturated colours, particularly when pure, are more liable to

60

provide problems, for they attract direct attention more readily than 'impure' colours. In abundance, they can appear gay, vibrant, forceful, gaudy, strident, obtrusive, depending upon their application. Conspicuous pattern, particularly when in pure colours, will distract attention.

Colour memory

Although the ability to remember particular colours can be improved with practice, human colour memory is unsure. And where we do not know the original colour of the subject, colour reproduction can be wildly wrong, yet be acceptable. It might even be preferred to an accurate version.

We think we know when the colour of skin, foliage and flowers, for instance, are correct. But close inspection shows that these vary considerably between examples, and with season and light. Probably our most critical areas of assessment are flesh, food and familiar packaging.

We tend to recall colours as they would appear in daylight, although more saturated and rather warmer than they actually were. Usually we remember a light scene as rather lighter than it was; a dark scene as darker.

We tend to associate highly saturated colours with sunny lighting and so assess brightness to some degree according to the colour content of a picture. Pastels and greyed colours less readily suggest bright surroundings.

Colour associations

Colour and emotion are inextricably interlinked, and colour associations are endlessly varied. Some have universal impact, some have significances restricted to groups or nations. A few are listed here:

Red	Warmth, anger, crudity, excitement, power, strength.
Green	Spring, the macabre, freshness, mystery, envy.
Yellow	Sunlight, the Orient, treachery, brilliance, joy.
Blue	Coolness, ethereality, the infinite, significance.
Black	Death, gloom, sorrow, hidden action.

White Snow, delicacy, purity, cold, peace, cleanliness, elegance, frailty, mourning.

Black relieved with white Sophistication, vigour, newness.

Although of a very general nature, such a list is a reminder of the associative ideas that colour can evoke, deliberately or accidentally, and their value in staging, wardrobe and lighting treatments.

3

BASIC PRINCIPLES OF LIGHTING

Perception and selection

Most of us put only half an eye to the visual world around us. We respond to its influences, but seldom scrutinise its effects all that closely. We tend to assess rather over-casually. The concept of 'soft candlelight' for instance, is generally accepted, and yet if we look more carefully, we see that the small flame from a candle throws texture and contour into quite sharp relief. There is nothing softly diffused about candlelight. Any flattering properties it possesses arise entirely from its low angle as we shall discuss later.

The visual artist, on the other hand, has to take very patient stock of his surroundings, for he is a manipulator—of light and shade, form, proportion, texture, colour, mass and unity. His persuasive cunning stems from recognising these influences and using or re-creating them in a controlled arrangement to express ideas. He omits or emphasises as he chooses. The painter selects, distorts or modifies to suit his particular purpose. Canaletto did not hesitate to reposition buildings to improve the composition in seemingly accurate architectural views. Similarly, the stills photographer retouches, processes and dodges his prints to suit his purpose. Motion pictures and television provide less latitude for change—but they too have their deceits.

Light is a phenomenon that one accepts naturally and unquestioningly. But, as we begin to study the nature and effect of light, we become familiar with its exciting properties. How it can reveal, conceal, exaggerate, confuse our interpretation, lure our attention, distract our interest, conjure a mood, infer a time . . . Whether picture-making with natural daylight, or with the flexibility of studio lamps, these same principles apply.

Our impressions and interpretations of the visual world depend upon the information we perceive. If a surface appears to us to be

63

a smooth, plain area, then we assess it accordingly. But, supposing it is in reality quite rough and vari-toned, this will not be of any account to us as observers, for we see what we think we see, and are unconcerned with what exists in reality. Unconcerned, that is, unless this smoothness and plainness is an incorrect or unfamiliar rendering of the subject. Conversely, we may find that the area looks more textured or modelled than we expect or prefer it to be, and react accordingly.

This line of thought leads us to the concept that we might falsify the appearance of a subject, according to how we light it. We can exaggerate or suppress its characteristics, imply the presence of features that do not exist. We can confuse the observer so that he cannot interpret accurately what he thinks he sees before him.

And so we reach what are really the fundamental philosophies of lighting. In applying techniques, our first aim is to decide exactly *which* aspects of our subject we wish to emphasise, which to suppress. By selective interpretation, we can choose features that most characterise the subject, that flatter it, or are least attractive, according to our purpose.

We can compare, or isolate, a subject relative to its surroundings. We may want to draw attention to (or from) its shininess, sparkle, smoothness, toughness, transparency, delicacy, symmetry, uneven form, outline, bulk, weight and so on. Controlled light enables us to do these things in many subtle ways.

Principal characteristics of lighting

As we study light, we shall find it most convenient to examine separately its quality, direction, effective intensity, coverage and colour.

Light quality

The quality of light depends initially upon the nature of its source. Between hard shadow-producing light and diffused, shadowless soft light, lie infinite blends.

HARD LIGHT
Clear-cut and vigorous, hard light creates strongly defined shadows. It reveals surface contours and texture. It is highly

64

directional, and can therefore be localised. Whether originating from the unobscured sun or a studio spotlight, this hard light has similar basic properties when lighting the scene (Figure 3.1, part 1).

FIGURE 3.1 LIGHT QUALITY
1 Hard light comes from many natural and artificial sources. The smaller the effective light-emitting area, the harder the source. (Hence a distant localised soft light can produce distinct shadows.)
2 Soft light, too, comes from natural and artificial sources, and from scattered hard light. For well-diffused, shadowless light, large-area sources are necessary. Light diffusion reduces source efficiency.

The unobscured sun, being a distant point source, throws the most clearly defined shadows, but given a small enough light source, one can derive a convincing, if weaker, substitute. The more concentrated a light source, and the greater its distance, the harder will its light appear to be. If the light is close, or of larger size relative to the subject, diffraction effects soften off the shadow edges, making them less clear-cut. Hard light is by its nature readily restricted from inadvertently illuminating adjacent areas.

Whether the subject lit by hard light appears harsh and crudely illuminated, or bold and well-defined, will vary with the appropriateness of this lighting treatment.

SOFT LIGHT
At the other extreme we have soft light (Figure 3.1, part 2). This may be scattered, shadowless illumination emanating from a cloudy overcast sky, from a canopy of fluorescent tubes, bounced from a ceiling or produced by harder light sources covered with diffusing material. Light from a broad light source suppresses

65

texture and reveals information in shaded areas without creating further shadows or sharp highlights. Modelling, or any tonal gradations due to surface undulations are considerably reduced. It is difficult to prevent such soft light from spilling in unwanted directions.

Flat light of this kind may seem initially to be the ideal, for surely it 'shows us everything'. But, in fact, it has decided limitations, especially in a two-dimensional picture. If the soft light is directly behind us, or illuminating the subject over a wide angle, shaded regions or cast shadows are unseen. Where the soft light is angled, parts of the subject are shaded from the light, but these shadows will be subtle, with graded half-tones at the edges of the shadows. The result may be a delicately plastic rendering, or an all too vague, indecisive effect, depending upon the occasion.

Light direction

The direction of light falling on a subject is best considered in relation to the viewpoint, rather than the direction in which the subject itself is pointing (Figure 3.2). If the subject is taken as being at the centre of a horizontal clock-dial, the camera viewpoint is at 6 o'clock, or 6H.

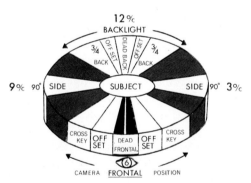

FIGURE 3.2 LIGHT DESIGNATION Light direction is classified as related to our viewpoint irrespective of the subject direction.

FRONTAL LIGHTING

Lit from 6H, shadows of the subject are cast directly behind it and obscured—though visible from other viewpoints. The more frontal the light relative to the camera lens-axis, the flatter is the

66

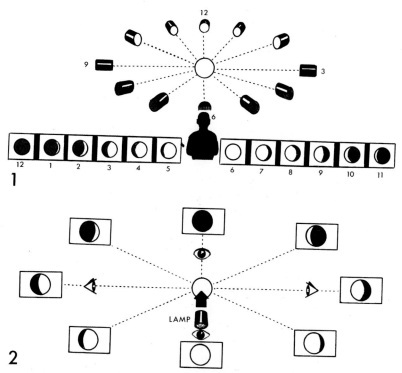

FIGURE 3.3 LIGHT DIRECTION AND VIEWPOINT
1 From a fixed viewpoint subject appearance alters with changes in light direction.
2 The effect of any given light depends upon our viewpoint.
Thus if we alter either the source direction or our position (e.g. switch to another camera) the appearance of the subject will change.

appearance of the subject from that viewpoint. Both surface modelling and textural effect are suppressed by dead frontal lighting. What we call *texture* is actually the pattern of tiny individual shadows cast by small surface irregularities.

Frontal lighting can prevent disturbing or superfluous shadows, or reduce unwanted modelling. This enables us to make faces look younger, disguise wrinkles and bulges, and ensure that spurious surface irregularities are not noticeable, for example in a photo caption, or a sky-cloth. For this the principal lamp may be placed as near to the lens as possible, probably using soft light to suppress or preclude shadow formation.

For most purposes, sufficient flatness can be achieved by placing the main light alongside the camera. But where even this still

67

EDGE LIGHTING *Top:* Under soft light, texture and form are unclear. *Centre top:* Edge lighting emphasises, almost caricatures, such detail. Sand, rock surface and ammonites are now prominent. The half-embedded specimen (top left rock) is barely discernible under soft light. *Centre bottom:* Oblique lighting here also produces shadow patterns. Whether these are attractive or distracting will rest with the application. Those falling across the basket actually prevent our seeing its detail. *Bottom:* A more frontal light position reveals texture and form, but without creating spread shadows.

produces distracting shadows, as on closely spaced planes or intricately sculpted detail, and where surface contouring or multi-plane shadows, must be further suppressed it is possible to light virtually along the lens-axis by using the somewhat cumbersome Pepper's ghost device (Figure 11.12).

In general, surfaces face-on to the light beam are brightest. If the surface is highly reflective, dead-frontal light will bounce straight back into the camera lens. This effect is less pronounced with fairly rough surfaces, but a hotspot is still visible though this depends upon the size and distance of the light source. Where surface contours are very irregular (broken up) any hotspot becomes less evident, or is dispersed.

As a frontal light moves from the lens-axis, the appearance of the subject changes progressively. Light decreases on the side of the subject furthest from the lamp. Exactly how depends upon the subject's shape. As the lamp is angled, and contour shadows obscure surface detail, the shadow of the entire subject grows over nearby planes. The virtual intensity of the lamp lessens, too, as it moves towards a side position.

As we saw in Chapter 1, when planes are angled to the light their effective brightness from the camera viewpoint will fall. Where a surface is curved, each point on it is at a slightly different angle relative to the light, and this gives the tonal gradation or shading we interpret as subject contour in the eventual picture. *Soft light* produces a more gradual fall-off in brightness, while under *hard light* the transition is more abrupt.

So far, then, we have seen that the prominence of surface undulations can be controlled both by the quality and the direction of light falling upon them. The complete effect naturally depends upon how strongly contoured the subject was in the first place. The greater its actual modelling, the more pronounced are the changes with different lighting treatment. A flat matte plane may show little alteration in appearance with quite wide lighting variations.

When one recalls these various influencing factors, it is not unexpected to discover that the entire appearance of many subjects can change very considerably as the hardness or diffusion of the incident light is adjusted, and as the position of the main luminant is altered. For, in the process, the apparent brightness of individual surface planes will have become modified, so giving them different emphasis, and altering their relative prominence.

SIDE OR EDGE LIGHT

If the lamp is moved round the subject, to side positions 3H or 9H, it forms a very shallow angle to the surfaces facing us at our 6H viewpoint. If perfectly flat, such a plane would theoretically be entirely unlit, although anything protruding at right angles to it would be brightly lit.

However, most surfaces are not completely flat. Where the light is fractionally forward of the side position, part or all of these frontal planes are skimmed with light.

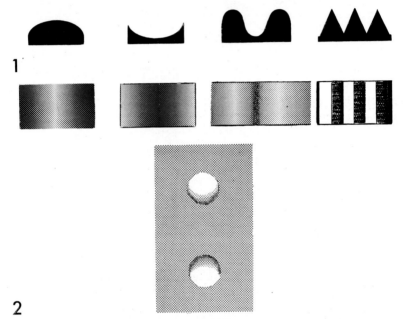

FIGURE 3.4 SURFACE TONAL GRADATION
1 In a flat picture tonal gradation is usually interpreted as surface contour.
2 Direction of shading, too, can influence interpretation. This shading implies that the surface has a bump and a depression; but invert the page, and the illusion is reversed.

The slightest undulations or projections cast long, exaggerated shadows. Though most pronounced with hard light, even soft light in an edge position will emphasise general contour. This is akin to the terrain lit by the setting sun.

The shallowest texture becomes strongly modelled under edge lighting, revealing the characteristic surface of stonework, fabric, embossing, grain in wood, leather and similar low-relief materials.

The actual direction from which this 'textural lighting' shines

TEXTURAL DAYLIGHT *Top:* Edge lighting from a steep sun throws into sharp contrast the rough stonework of this ruined mine. *Centre:* At sunset, even a lonely fledgling sparrow casts long shadows. Stone texture is emphasised; but reveals the shallow depth of field. *Bottom: Contre-jour* shots can transform even the most mundane subject. The pathway's cobbled surface, the steps, the foliage, are all emphasised.

upon the subject is immaterial, save for any wish we may have to emphasise particular features. The light can skim along the surface at a shallow angle from above, below, or the sides of a vertical—or from any near-horizontal angle in the case of a horizontal plane.

With a simple subject such as an orange or ball, the basic appearance remains similar whichever direction the edge lighting comes from. With a more complicated subject, such as the human head, its entire appearance may be transformed, according to which aspects become emphasised or suppressed.

FIGURE 3.5 FALSE DRAWING Tonal gradation can create accidental impressions as to the shape of subjects. In this example, the arch casts a graded show onto the background. In a restricted shot (A) this gradation actually created an inaccurate illusion of background shape (B).

BACK LIGHT

If the light is moved to a position at 12H, directly behind the subject, the lamp itself is hidden and mostly ineffectual, although any translucent, furry, feathery edgings catch the light and stand illuminated—as when sunlight shines towards us through leafy trees.

If we move the light from this dead back position, towards 1H or towards 11H, provided the lamp does not shine straight into the lens, it begins to illuminate the side edges of the subject, progressively emphasising its outline there. Within an angular range of 10–11H and 1–2H, we have *three-quarter back light*.

We have seen in this section the three basic directions from which any subject can be lit. As a single lamp is moved round the subject, the lighting effect of one basic position gradually alters, until subsequently it becomes transformed into the next. Between two types, the light will have something of the features of each. Whether we move the light or our viewpoint, the illusion of change will be similar.

Shadows

All shadows come from an absence of light, but they originate in several ways. Initially, there is the shadow formation on a half-lit object, where part of it has been left unilluminated—a side-lit globe, for example. This may, rather ambiguously, be termed shade.

Cast shadows are formed wherever incident light has been interrupted by a solid object. These are fundamentally of three kinds:

PRIMARY SHADOWS Shadows on the subject itself, arising from its own surface contours (e.g. a nose shadow).

SECONDARY SHADOWS A subject's shadow falling upon adjacent planes (walls, floor, etc.).

TERTIARY SHADOWS Shadows of other nearby subjects cast upon the main subject—usually distorting as they fall over its contours.

One also encounters what may be designated 'false shadows', which are in reality unlit regions between two lit areas, or where illumination ceases, at the edge of a light beam. These can appear from a distance as shadowy areas.

Paradoxically, imaginative lighting is as much a matter of skilful creation and distribution of shade and shadow as of selective illumination. To be effective, shadows should be well defined and unambiguous. This may prove difficult to achieve, but where they are vague or distorted, their entire purpose can become defeated. The exception is when very defocused dappling from cookies creates barely detectable undulations of light to break up a surface.

Better to create drawn shadows artificially with paintbrush and air-brush than to use misshapen real versions, or light to omit them altogether. Also, it is best to avoid distracting multi-shadows from spuriously overlapping sources or 'dirty light' wherever lighting is used persuasively.

Functions of lighting

Having examined how light behaves, let us turn to the functions that light offers us:

1 To direct attention to specific areas, giving prominence to particular features, subduing others.

FIGURE 3.6 SHADOW FORMATION Shadow density. (*a*) Shadow density is greatest on matte, light-toned, flat, undecorated areas placed at right angles to the light, and undiluted by spill light from other sources. The density depends, too, upon the hardness, size, power and distance of the light source. (*b*) Personal assessment of shadow strength is influenced by its edge-gradient. Hard-edged shadows look darker.

2 To reveal shape and form, giving an illusion of volume, contour, size and proportion.

3 To establish environment, displaying subjects' surroundings, spatial relationships, scale, perspective.

4 To characterise the subject and its surroundings, establishing mood, atmosphere, time.

5 To develop compositional relationships, developing and unifying tonal proportions.

6 To maintain visual continuity of the above factors.

7 To satisfy the technical requirements of the system, its brightness and contrast limits.

1 *Directing attention.* One can direct attention through lighting, in a number of ways. The most obvious method is the isolating spotlight. Artless perhaps, but an effective unambiguous way of concentrating attention upon a particular subject, or a selected part of the subject. Suitable for displays and decorative presenta-

tion, one can restrict the light coverage so that only this item is illuminated, while its surroundings remain in darkness. More subtly, the light intensity upon the subject could be considerably higher than that falling on nearby areas.

There are several variations on this principle. While having the main subject itself frontally lit, we might present adjacent subjects silhouetted against a light-toned background. Thus the viewer's eye would be directed towards the intended region while the rest of the picture became a supporting environment for it. In such a way attention could be concentrated on a singer with a chorus or surrounding scenery playing a secondary role.

Occasionally one can do exactly the opposite for a brief effect. One might, for example, have the surroundings lit to a low light

FIGURE 3.7 Shadow sharpness. Initially, shadow sharpness is influenced by the opacity of the subject and firmness of outline. Shadow sharpness decreases: (a) with a larger-area source; (b) as the subject moves further from the background; (c) as the subject/lamp distance decreases; and as light diffusion is increased. (d) Where the subject is small relative to the light source, and where the lamp is near the subject, the shadow cast by one part of the source becomes lit by another part. This illuminated shadow (half-shadow or penumbra) forms a graded border to the main shadow (umbra). Sharpest shadows arise from point sources, and parallel-ray light beams.

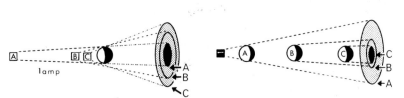

FIGURE 3.8 Shadow size. (a) The size of the shadow is always larger than the subject. Shadow size increases as the lamp/subject distance is reduced. Close lamp positions give greater size changes, and exaggerate shadow perspective. (b) Shadow size increases with the subject/background distance:

$$\frac{\text{Shadow size}}{\text{Subject size}} = \frac{\text{Lamp/shadow distance}}{\text{Lamp/subject distance}}$$

level, but nevertheless visible, while the main subject is seen strongly silhouetted against a bright background. Obviously, a presentation of this kind has to be handled carefully, or what is intended as an intriguing, tantalising arrangement can turn to viewer frustration and rejection. Furthermore, when eventually all is revealed by adding frontal illumination, the whole affair can become something of an anti-climax or disillusionment!

2 *Revealing shape and form.* Ideally, the revelation of shape and form should be a calculatedly arranged process. Light needs to be controlled so that it *selectively* shows particular features of the subject. As we shall see later, when discussing portraiture, aspects of the subject that should be diplomatically suppressed, can all too readily be revealed.

Perversely enough, if these characteristics are hidden or

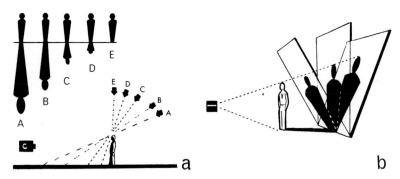

FIGURE 3.9 Shadow length. (a) Shadow length increases at shallow light angles, and (b) with obliqueness of the lamp to the background.

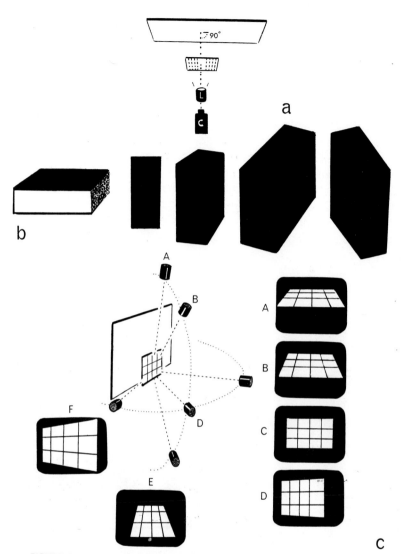

FIGURE 3.10 Shadow distortion. (a) The shadow is least distorted when the camera, lamp and shadow are in line, and the background at right angles to this axis. (b) Even then, the shadow profile can appear misshapen or is unrecognisable, due to the aspect presented. If the subject is large, parts of the shadow may be less sharp, or distorted by perspective. (c) As the light (or camera) moves from the central axis, the shadow image becomes increasingly distorted. Such distortion may be natural and appropriate.

By projecting a shadow 'pre-distorted' in the reverse shape (e.g. pattern (A) projected from position (E)) counter-distortion can present an undistorted image on the background. A solid shadow-frame (e.g. a window) can similarly be built with counter-distortion.

reduced too extensively, the subject ceases to look right. Too often, perhaps, studio portraits are presented in which lines and wrinkles have been obliterated with such success that only a wraith of the original person remains.

3 *Establishing surroundings.* As light reveals a subject's surroundings, it inevitably adjusts interpretations of size, distance and volume. One has only to recall how much larger a light-toned room seems to be than its dark-walled counterpart, to realise how light intensities can falsify physical parameters.

4 *Characterising the surroundings.* Later we shall consider how the effects of atmospheric lighting derive fundamentally from basic associations of light and shade; from our most rudimentary reactions to environment. By selecting carefully the lighting coverage and angle, we can impart something of these responses

a

b

FIGURE 3.11 Multiple shadows. (*a*) Two or more lamps casting shadows on the same background give deep shadow (umbra) where their respective shadows coincide, half-tone shadows (penumbra) where the shadow from one lamp is diluted by the light of another, and a background lit by their combined light.

Coloured lamp filters can supply multi-colour shadows and subtle colour mixing. By fading between lamps with individual cut-outs, background shadows can be changed at will. Multi-shadows can suggest multiplicity of objects (e.g. numerous tree shadows on to a sky-cloth).

(*b*) The *penumbrascope* consists of several open lamps on a rotating fitment. This casts multiple shadows which weave from side to side, continuously changing in tone.

78

FIGURE 3.12 Shadow control. Where background shadows are obtrusive, their prominence may be reduced in several ways. Perhaps a lower camera position will hide the shadow, or the pictures may be recomposed to omit it. Shadow-free lighting may be the solution. (*a*) The lamp may be raised or moved round the subject, to throw the shadow off the background. But this can degrade subject lighting. (*b*) Subject to background distance can be increased. (*c*) The offending shadow may be diluted, but the extra light may cast spurious shadows or overlight the surface. (*d*) Disguise the shadow with background break-up, or hide it in a foreground object (e.g. foliage). (*e*) For small objects, background shadows may be eliminated by displaying them on a glass plate displaced from the background. (*f*) Items may be arranged on an illuminated panel.

in a picture. Long shadows may suggest evening light, but they may be used associatively to convey peacefulness, sadness, rest. Hard lighting may stimulate hot sunshine, but can introduce a dynamic, vital, or a cruelly revealing character to the picture.

5 *Compositional influence.* Light enables us to co-relate objects, to emphasise compositional line, to unify groups, simply by limiting its coverage and arranging its spread-pattern.

Place three objects before a plain background and arrange a light-blob behind each. The result is three isolated items. Instead, illuminate their background with one all-embracing area, and they are immediately conjoined compositionally by their communal light pattern.

FIGURE 3.13 Revelatory shadows. (a) Shadows can reveal hidden subjects, and the detail, shape and depth of planes. (b) Falling across a surface, they can reveal subjects outside the frame, and contours of surfaces onto which they fall.

Where light or shadow patterns fall across surfaces, they influence the compositional effect (e.g. venetian-blind shadows on a wall). Similarly, wall-shading, light-streaks, and projected patterns can engender compositional forms.

Scenic line and tone can be emphasised or suppressed by lighting, as can perspective, and so control the reproduced picture.

6 *Visual continuity.* Where the tonal balance or background values seen on one camera differ substantially from those from another viewpoint, pictorial continuity can be disrupted. At worst, a scene can look daylit in one shot and nocturnal in the next! Lighting may need to be arranged to alleviate such distractions or ambiguities.

FIGURE 3.14 Silhouettes. Silhouettes can be obtained with the unlit subject before a lit background (a); or by casting a shadow, behind a rear-lit translucent screen (b).

7 *Technical limitations.* Controlled lighting enables one to encompass an optimum proportion of scenic tones within the exposure limits of a reproduction system. Where scenic contrast is excessive, suitable lighting can assist to some degree, in accommodating the problem. Similarly, lighting can improve or emphasise the clarity of detail, to allow it to be reproduced more effectively.

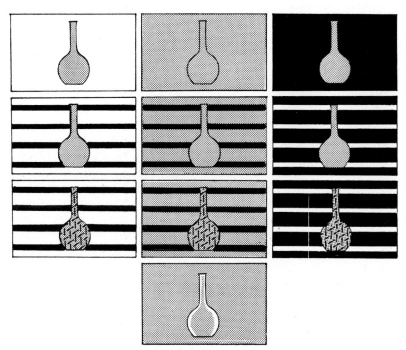

FIGURE 3.15 SUBJECT TO BACKGROUND CONTRAST How strongly a subject stands out from its surroundings depends upon its relative brightness (tone), colours and clarity. Where subject and background might merge, back light can provide isolation by rimming the subject and emphasising its outline.

The fundamental lighting process

Key light

The initial step is to establish the principal lamp lighting the subject—the *key light*. This main light should usually predominate, whatever its direction, or conflicting effects can develop. One lamp can too easily nullify another, by reducing its modelling, or creating a confusion of shadows.

81

The choice of position and angle of this main light is determined by the appearance we seek in the subject and by where we want to place emphasis. Usually the key light will be in a cross-frontal position relative to the camera. It creates the principal shadows and reveals form, surface formation and texture, and largely determines exposure.

This main light may actually or apparently emanate from a locational source (e.g. daylight through a window, sun, lamplight, etc.), or simply be an unspecified but acceptable luminant. With experience, however, one can 'cheat' a great deal, so that although establishing main source direction in the spectator's mind, one insinuates key lights wherever they are needed for continuity of effect.

Fill-light

The fill-light or fill-in is a shadowless soft light introduced both to reduce the harshness of shadows cast by key light (lowering the contrast ratio of highlight to shadow) and to reveal shadow detail. Ideally, this fill-light should not modify exposure, create its own spurious shadows or defeat the effect of the key light. Moreover, it should be able, as should all lights, to be switched on alone, and create no undesirable shadow formations or modelling.

It is worth stressing this ideal concept, because strong fill-light is all too often used to iron out mistakes, to disguise the ugly or inept modelling of badly placed keylights (to illuminate the deep eye shadows produced by oversteep key lights, for example). There will always be occasions when one has to resort to such first-aid to improve unavoidable results, but that is another matter.

Back light

As we saw earlier, back light is simply light that falls upon a subject from behind—a light shining towards the camera. And yet quite a lot of confused thought has built up about its use. The amateur tends not to use it at all, except accidentally. Certain 'pictorialists' use it abundantly as an 'atmospheric necessity'. Some 'realists' decry it as false and unnatural. The

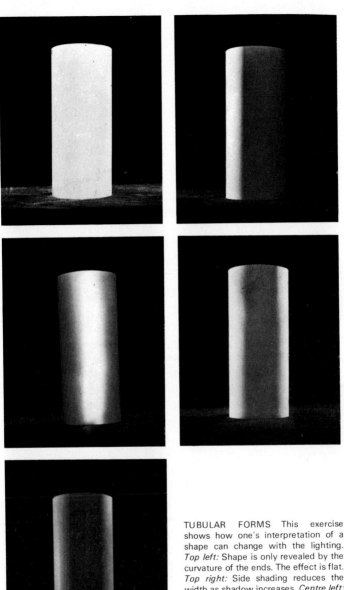

TUBULAR FORMS This exercise shows how one's interpretation of a shape can change with the lighting. *Top left:* Shape is only revealed by the curvature of the ends. The effect is flat. *Top right:* Side shading reduces the width as shadow increases. *Centre left:* Double side-shading reduces width further, and tends to suggest metallic surfaces. *Centre right:* Double-rim lighting has a broadening effect; although at lower intensities. *Bottom left:* this may be less evident. Instead, it may result in a bisected effect.

tyro makes it an essential routine for all his lighting treatment. In practice, of course, back light is a persuasive tool that, when appropriate, has a valuable part to play in pictorial effect.

Back light has four fundamental purposes:
1 It outlines part or all of the subject, forming a rim that tonally separates it from its background. Where dark clothing, for example, would merge into similarly dark background tones, such back light is invaluable.
2 It models the periphery of subjects, revealing edge contours. Thus, although there may be sufficient tonal isolation so that a dark suit stands out from a light background (as a silhouette), only when back light catches its folds and reveals its shape will the material appear to have solidity.
3 It can illuminate areas that fall in the key light's shadow, and would be insufficiently revealed by fill-light.
4 Back light enables the detail of translucent objects and tracery to be revealed.

To the charge that back light is an artificial concept, one has only to recall the *contre-jour* effects that arise in nature. Any time we face into light, we encounter back light on intervening subjects. This all occurs quite naturally. Aversion to back light is usually a reaction against misapplied techniques.

But we do not always need back light, especially where side light is used. Back light that is too steep, excessive, or inappropriate, is worse than none, the result being artificial, phoney or just downright ugly.

The sparkling haloes or rimming given by back light can indeed be beautiful. But such beautification must not be misapplied. A weather-beaten tough with excess back light can look incongruous.

Also, one must guard against lens flare (bright patches from inter-lens reflections) or overall fogging. A lens hood (lens shade, sky shade), or a teaser (gobo) may shield the lens sufficiently, if the light cannot be barn-doored off the camera.

In certain applications, soft light can be used for back light. This is particularly applicable when a softened-off light is used to backlight a person leaning over a demonstration table, so preventing any spurious shadows on the subject. In general, however,

SPATIAL ILLUSION *Top:* Lit by soft light, there is no sense of depth or form. *Centre top:* Adding a side key (9H 3V) both become enhanced. *Centre bottom:* An additional key at 2H 2V, increases the illusion further. *Bottom:* Extinguishing the soft light, the keys create a harsher, dramatic and more pronounced impression.

TABLE 3-I

COMPARISON OF HARD AND SOFT LIGHT

		Advantages	Disadvantages	Advantages	Disadvantages
		As a key light		*As a fill-light*	
HARD LIGHT *Shadow-creating, directional light*	Readily restricted and controlled	Gives well-defined, clear-cut modelling	Modelling can be harsh	Coverage can be controlled	Casts additional shadows
	Beam focusing and localisation readily achieved	Shadow-formation reveals texture and form	Shadow-formations may be unattractive or distracting	Effective over long distances	Destroys subtleties of modelling
	Compact light sources possible		Local hot-spots likely	Does not fall off rapidly	
SOFT LIGHT *Diffused, non-directional light*	Not readily restricted	Can provide many half-tones, and delicate tonal gradation	May suppress modelling with excess use	Provides subtle half-tones	Not readily localised
	Relatively large bulky light sources	Does not cause distracting shadows	May cause lack of clarity and crispness, making subject flat overall	Does not cast spurious shadows	Spreads over adjacent areas
		Does not emphasise modelling and texture	An inefficient light source for high lighting levels	Reduces harshness of shadows, making shadow detail visible	Brightness falls off rapidly with distance

such soft light is not readily localised, and is not always easy to control for intensity if the lamp/subject distance changes rapidly.

Balance

Balance is the adjustment of the relative brightnesses of lamps. It is an elusive process, for even by demonstration we could only illustrate isolated examples. The visual impact of a particular balance changes subtly with the subject and the situation. Delicate changes of nuance become possible by even slight alterations in the relative intensities of the lamps being used. This we can gain only from perceptive experience.

One can take the same lighting set-up and, by readjusting the brightnesses alone, change it from tropical sunshine to overcast day, mysterious night or romantic moonlight. Intensities are always relative, and as the viewpoint changes, the effective balance will change too. This is an intrinsic problem of continuity in multi-camera productions.

Productional use of lights

A single lamp may satisfy our requirements so completely that additional light would simply be superfluous, muddling or out of character. More often, a series of lamps is needed, combining to build the effect we are seeking. In displaying still-life, for example, the lighting that demonstrates the quality or form of the article may be quite different from the light needed to explore its decorative shapes or texture. Further lamps bring out the characteristics of the setting in which it is placed.

It is not surprising to find, therefore, that the range of lamps and lighting accessories that have evolved over the years has grown considerably. Many improvised devices eventually become orthodox equipment. So too, specific lamp functions have acquired widely accepted names. Some are parochial, others have ambiguously diverse usage. Part of the problem of classification lies in the way the function of a light can change with our viewpoint, and in the multi-purpose nature of some applications.

Strictly speaking, a lamp has no intrinsic position. The same lamp can become frontal, side-light, back-light, top-light, as the

TABLE 3-II

USE OF LIGHTS IN PRODUCTION

Key light, key:	principal lamp illuminating the subject, casting main shadows, and the most noticeable highlights
Fill-light, filler, fill-in:	soft light illuminating shadows cast by the key light
Back light:	light from behind the subject, usually illuminating its edges
Base light, foundation light:	diffuse light flooding the entire setting uniformly to prevent local under exposure
Rim-light, rimming:	illumination of subject edges; usually from back light
Modelling light, accent light:	loose term for any hard light revealing texture and form
Cross light, (counter key, balance light):	frontal light at any height, about 4-5H, 7-8H
Kicker, cross-back light, $\frac{3}{4}$-back light:	back light at any height from positions 1-2H, or 10-11H
Edge light:	texture-revealing light from around 8-9H, or 3-4H, 12-1V, or 6-5V
Effects light:	light producing specific highlight areas (e.g. around a practical)
Bounce light:	light obtained by random reflection from a strongly-lit surface
Set light, background light:	light illuminating the background alone
Eye light, catch light:	eye reflections of a light source; often a low-power camera-lamp specifically for that purpose
Hair light:	lamp localised to reveal hair detail
Top light:	vertical light (12V position); undesirable for portraiture
Clothes light:	spotlight specifically revealing form and texture in clothing
Underlighting:	lamp below the lens axis (4-6V) for effects purposes or to relieve downward shadows and modelling
Three-point lighting:	term for rudimentary three-light set-up with key—filler—back light
Contrast-control light:	soft fill-light from camera position; illuminating shadows seen by camera, hence reducing highlight/shadow contrast

camera's location is altered. Consequently, although we can designate lamps clearly enough for a single static camera position, any *directional* classification for lamps in multi-camera production must always be related to a given camera's viewpoint.

However, *functional* terms for lamps, such as key-light, clothes-light, effects-light, can continue to be used irrespective of the camera's position; although even this nomenclature can appear strange at times, when a key-light (usually associated with relatively frontal positions) is located behind the subject, e.g. to rim-light a profile shot.

4

TOOLS OF LIGHTING

Luminants

Tungsten lamps

The traditional tungsten lamp and its high-power professional derivatives offer an extremely wide choice of power-ratings ranging from a few watts to some 20 kw. Although reasonably long-lived, reliable and adaptable, unfortunately, tungsten filament lamps waste considerable electrical energy as heat, while their light normally tends to be deficient at the blue end of the spectrum. Their proportionally large filaments do not lend themselves to the high optical efficiency possible with point light sources such as arcs and discharge lamps.

The normal tungsten lamp has one further drawback. At high working temperatures, the filament metal slowly evaporates despite an argon or nitrogen gas filling, condensing on cooler parts of the bulb as a progressively obscuring black deposit. Standard studio tungsten lamps actually contain loose abrasive tungsten granules which can be scoured round the inverted bulb to clean off this blackening. The gradually thinning filament leads to a reduction in lamp life. For colour film, balanced at 3200 K, most studios have for some time used C.T. (colour temperature) tungsten lamps, notwithstanding their 100-hour life. When their colour quality as key lights deteriorates over some 150–200 K, they are used for less critical purposes.

Overrun lamps

As the supply voltage to a tungsten filament lamp is varied, we find several things happening. Its prospective life is modified, its colour temperature changes and its efficiency and light output alter (see Figure 4.1). We can use this principle to increase lamp life, by *underrunning* them at lower supply voltages. Conversely,

90

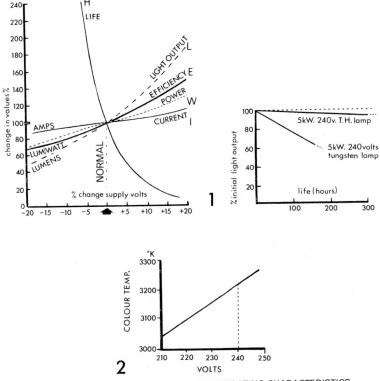

FIGURE 4.1 TUNGSTEN FILAMENT LAMP OPERATING CHARACTERISTICS
1 As the supply voltage of a lamp deviates from the designed value, changes take place in light output (L), life in hours (H), efficiency (E), current (I), consumption in watts (W).
2 Colour temperature variations for a 240-volt tungsten lamp (3200 K rating) are shown.

we can obtain a greatly increased light output and higher colour temperature by *overrunning* them at a voltage higher than is normal for that filament construction. But the price paid is a correspondingly shorter life. Both colour quality and light output fall off during use.

It has long been the practice to employ overrun lamps where high light output is required from compact lightweight equipment. Both the amateur and the professional filming on location, with confined space, or with limited power supplies available, have found overrun lamps able to make the near-impossible a practical proposition.

As all users know, the effective life of overrun lamps is an uncertain prospect. It can be considerably prolonged by using a

91

TABLE 4-I

TABLE 4-I
TYPICAL LAMP PERFORMANCES

Type	Watts	Light O/P (lumens)	O/P equivalent	Efficiency lumens (per watt)	Average life (hrs)	Typical colour (Kelvins)
Gas-filled tungsten fil. lamp	Up to 150	2,000		13	1,000	2,600– 2,900
Photoflood lamps						
No. 1	275	8,000– 8,500	800 w	36	2	3,400
No. 2	500	15,000– 17,000	1,600 w	36	6	3,400
No. 4	1,000	28,500– 30,000	3,000 w	36	10	3,400
Nitraphot	500		1,000 w	17	100	3,200
Studio tungsten lamps	10,000	328,000		33	75	3,400
	5,000	165,000		33	75	3,400
	2,000	57,000		25	100	3,280
	1,000	25,500		25	100	3,200
Internal reflector lamps	275	3,300 centre beam candles			3	3,400
	375	13,000 max. centre beam candles			4	
	500	8,000 max. centre beam candles			6	
Tungsten-halogen lamps	250	6,500			150	3,200
	650	20,000		32	15	3,400
	650	16,000– 18,500			50– 70	3,200
	800	22,400		33	50	3,200
	1,000	33,000		30	15	3,400
	1,000	25,000			200	3,200
	1,250	31,500		25	200	3,200
	2,000	52,000– 58,000		25	100– 200	3,200
	5,000	130,000		25	150	3,200
T.H. floodlight	1,000	22,000– 25,000			200	3,200
	1,500	33,000		22	200	
	2,000	44,000– 58,000			200	
Fluorescent lamp	125	5,750		46	1,000	3,600– 4,800 equiv.
Arc (high intensity)	14,000	42,000		30	$1\frac{1}{2}$	5,400– 6,400
Linear metal halide discharge lamps	200, 1200, 2500, 4000			80– 102	200– 1000	5400–6000

tapped-transformer, or series-parallel switching arrangements to underrun the lamps while making preliminary adjustments to the light positions. This way, lamp life is prolonged and it allows time to judge the effectiveness of lighting treatment. It also largely overcomes the shock of initial high-current surges when the lamp is first switched on. For the actual take it is only necessary to switch to full power.

With such equipment, a small assembly of fittings using around 3 kw can provide the effective output of a normal 10 kw rig.

Overrun lamps are essential too, where the so-called 'practical' fittings under strong studio lights may not look sufficiently bright. The usual applications are in table-lamps and standard lamps, but for all such purposes normal lamps with a voltage rating 5–10% below the supply may be used as a short-life substitute.

Internal-reflector lamps

Internal reflector, or sealed beam lamps are of the normal or overrun tungsten type with their own reflectors built in. They produce hard or softened-off light, according to their constructional design. Invaluable where space is restricted, they require no housing, are extremely lightweight, adaptable and readily concealed. On location they can be clamped or clipped to any handy furniture, hung on a wall or mounted on a stand with ease.

However, the internal-reflector lamp is not robust, and is only available in lower power ratings, up to 1000 w. With clip-on accessories the light spread can be controlled or restricted (see Figure 4.11).

Tungsten-halogen lamps

One of the most important advances in lamp design has undoubtedly been the development of the tungsten-halogen lamp. Such lamps are also often called T.H., or quartz-iodine (Q.I.) lamps.

The halogen family of elements includes iodine, bromine, chlorine and fluorine, and has the property of combining with tungsten in a reversible temperature-controlled reaction. By adding a halogen vapour, such as iodine or bromine, a regenerative cycling process is introduced, so that the evaporated tungsten now becomes redeposited on to the filament, avoiding both blackening and undue thinning of the filament. As the redepositing process is uneven (being greater on the cooler parts), the brittle filament

93

does eventually break—usually due to mechanical shock while operating, or heat-up expansion at switch-on.

Because of the halogen additive there is a choice of longer-life lamps of high power, as Table 4-I shows, or proportionally shorter-life versions with greatly increased output. The actual halogen used influences the colour quality of the lamp.

Briefly, the tungsten-halogen cycle operates as follows. The evaporating tungsten leaving the filament reacts with the halogen vapour to form a tungsten-halide, at between 250° and 800°C. This is streamed back by convection currents to the hot filament, where at around 1250°C it is broken down again into tungsten and halogen, the tungsten being deposited on the filament, while the halogen is released to recycle. One should avoid handling these lamps, as natural skin secretions can stain and weaken the quartz or silica envelope.

Twin-filament lamps

The twin-filament studio lamp is available in tungsten-halogen form. By local switching, one or both filaments can be selected at choice. The main merit of such lamp flexibility is that it helps to preserve a high colour temperature light quality over a greater intensity range. In a large studio a 'saturation rig' (Chapter 10) may now be provided, using many identical lamp fittings or luminaires, each source having its high- and low-power operating range. Where the output from a 5-kw dual source proves to be too bright, extensive dimming could reduce its colour temperature beyond acceptable limits. Instead, one can switch to the lower output ($2\frac{1}{2}$ kw) from one filament, working with little or no dimming, and obtain a more satisfactory colour quality.

Carbon arcs

Carbon arcs are low-voltage, high-current sources developed in motion picture studios to provide high intensity light of excellent colour quality. The arc being a very concentrated point source, produces very sharp, crisp illumination with enhanced modelling, textural and shadow formation. With the advent of other powerful, more compact, and less demanding light sources, the use of carbon arcs has lapsed in both film and television studios.

Although the shortcomings of arcs make them less convenient

for many studio applications, they remain invaluable where extremely high light levels, as from 24-in. lens, 225 amp. 'Brutes' for example, are needed to cope with large acting areas. They are also valuable to balance natural sunlight intensities in the open air, or for night shooting, where other sources are inadequate.

Arc lamps require a D.C. supply voltage (usually 115 v) and are necessarily heavy and bulky, particularly with their sizeable 'ballast resistances' which preclude their being hung in isolated positions.

The gaseous arc itself is drawn between two cerium-cored white-flame carbon rods or 'trims'. These continually burn away, the motor-driven feed rotating the positive pole to sustain a symmetrical crater. The lamp requires skilled individual adjustment and surveillance to preserve the flame shape. Burning life is limited to about 90 minutes, plus the need for cool-down time before retrimming.

As the colour temperature of a carbon arc is higher than that of incandescent lamps, or that prescribed for most colour film materials, a corrective colour filter can become necessary in these circumstances, to reduce the 6000 to 3200 K. Low-colour temperature (LCT) trims burn at around 3350 K, but still need corrective light yellow filters for colour work. With mixed sources (e.g. incandescent and arc lighting) such correction of colour quality is imperative because camera-lens filters are not practicable.

Gas discharge lamps

Increasingly used for location lighting, gas discharge lamps rely on a mercury arc within an argon atmosphere. They provide compact, very efficient units with high light output and relatively low heat dissipation. Spectral peaks and deficiencies are improved by rare-earth iodide additives, to produce a colour temperature approximating to daylight (5400–6000 K). This value requires some $1\frac{1}{2}$–3 mins. to build up from switch-on (striking).

Disadvantages of gas discharge lamps lie in their need for auxiliary equipment (ignitors and ballast units), the inherent delay in re-striking after switch-off, and the fact that conventional dimming methods cannot be used. Flicker (beat, dark-frame) during filming has posed problems although shutter adjustment, waveform control, and multiphase lighting can help here.

Metal halide discharge lamps are finding various applications in 'bare-bulb', linear, and sealed beam forms. As well as large-

area usage of the HMI (hydrargyum/medium arc-length/iodide) and CSI (compact source iodide), the latter is found in follow-spots, and pattern (effects) projectors. The Xenon lamp, of lower efficiency, is mainly used in film projectors.

Light sources

The most rudimentary and robust lightweight lamp fitting is the circular-spun aluminium reflector. Conical or dish-shaped, the reflector is provided with a hook-frame, spring-clamp or mounted

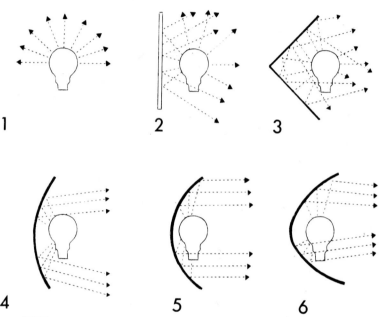

FIGURE 4.2 TYPES OF LAMP REFLECTOR DESIGN
1 An open lamp radiates light in all directions. A reflector can collect and control the light, and increase efficiency. The size and shape of a reflector determines how efficiently light is collected, and distributed towards the subject.
2 A flat mirror simply creates a virtual equidistant lamp image, combined beams radiating forwards in all directions.
3 The *conical* reflector offers basic light restriction only.
4 Spherical reflector shapes create a spreading, broad beam to flood an area with light.
5 Parabolic reflectors produce a parallel-ray beam for localised illumination, distant illumination and pre-lens light control.
6 Elliptical reflectors give a converging beam, concentrating on a small area (e.g. for projectors or enlargers) beyond which it diverges. In each case, the lamp is situated at the focal point of the reflector. A lamp position is often movable, to obtain accurate alignment, or to provide variable beam-spread. Matted, rifled (grooved) or dimpled reflectors may be used to soften the beam.

on a light telescopic stand. With an overrun or tungsten-halogen bulb, it offers a well-spread, hard-light source. A clip-on concave reflector cap cuts off direct illumination and converts the fitting to a slightly softer broader source. Although useful for less exacting lighting, particularly for improvised set-ups in broad-area location interiors, this type of fitting offers little directional control, save by clip-on flaps, or supplementary light shields.

The first steps in light control lie in the introduction of carefully shaped polished-mirror reflectors. The evolution of typical forms is seen in Figure 4.2. To assist further in controlling the emergent light, *spill rings* or louvres may be attached. By cutting off divergent rays, they prevent 'fresh' light from spilling on to nearby surfaces.

Soft-light fittings

As we see in Figure 4.3, the soft-light fittings used in practice are quite compact units, although this is strictly a contradiction in terms when we remember that really soft light can be derived only from large area sources. Compactness inevitably results in only softened-off light quality from high intensity sources, however much diffusing medium or beam dispersal is used. Nevertheless, for most purposes their illumination is sufficiently diffuse, particularly when several such lights are grouped.

Small soft-light sources of up to 4 sq. ft in area have the advantage that they can be directed more readily to specific areas. Large soft sources of perhaps 12 sq. ft in area tend to spread in an uncontrolled way over wide areas.

On location, bounce light reflected from lamps pointed ceiling-wards can be used to cast random soft light over the scene.

FLUORESCENT LIGHTING

All soft-light sources are notoriously inefficient. Most utilise frosted lamps, internal reflection or a diffusing sheet in order to achieve optimum light dispersal, and yet the resultant illumination is still only comparatively shadowless. The concept of using large banks of fluorescent lamps would appear to be an attractive solution. The fluorescent tube has a long life, a colour quality dependent on its coating—nominally about 3700–4800 K—and a high light-efficiency relative to standard tungsten lamps.

But their light is not very readily directed or kept from spreading, and as fluorescent tubes are only available in lower power

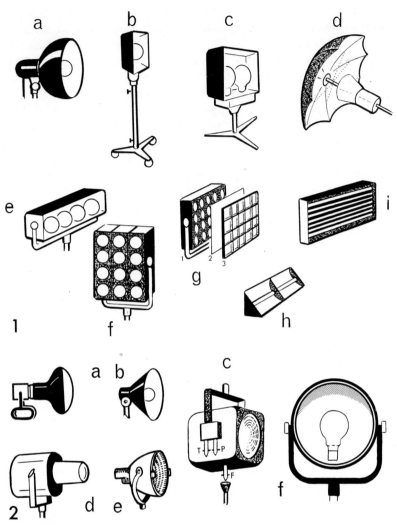

FIGURE 4.3 TYPICAL LIGHT SOURCES Studio lighting units (luminaires).
1 Soft light sources. (a) Single scoop 500 w–1$\frac{1}{2}$ kw. (b) Broad $\frac{1}{2}$–1$\frac{1}{2}$ kw, on telescopic, dismountable castored stand. (c) Double broad 1–3 kw, on turtle (low-level fixed stand). (d) Umbrella head (central lamp shooting into collapsible white umbrella reflector). (e) Strip light, border light, 5-lite, quad. 250-w–1-kw lamps. (f) Cluster, nest, mini-brute. (g) Bank, 10-lite ((1) internal-reflector lamps, (2) diffuser medium, (3) restrictive grille or slats). (h) Ground row, trough (for illumination of backings, behind coves, restricted space). (i) Fluorescent bank.
2 Hard light sources. (a) Internal reflector lamp (in clamp). (b) Overrun tungsten lamp, in reflector. (c) Fresnel spotlight showing pole-operated tilt, pan and focus controls. (d) Profile spotlight (soft or hard edged; including pattern projection). (e) Parabolic scoop (rifled reflector; adjustable 60° spread). (f) Sky pan (3 ft dia 5 kw, 10 kw. Very wide angle, for lighting backdrops, cyc., etc.).

98

ratings, multi-tube fittings of higher output are necessarily bulky and fragile. Nor is the colour spectrum of fluorescent lighting continuous, for it possesses pronounced peaks, as can be seen in Figure 1.3. Colour inaccuracies are, therefore, inevitable. The colour rendering of subjects illuminated by fluorescent lighting is unpredictable for colour film, and although it is possible to employ compensating filters in a fluorescent-lit location, many lighting cameramen prefer to switch off existing luminants and utilise their own tungsten lamps—or at worst aim to overpower the fluorescent light.

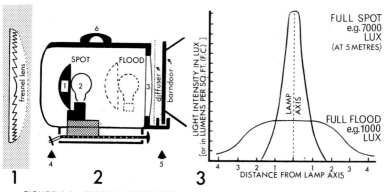

FIGURE 4.4 FRESNEL SPOTLIGHT
1 The fresnel (stepped) lens is derived from the thicker, heavier, solid plano-convex lens. It overcomes filament-image, colour aberration, and overheating problems, and achieves a more even, sharply defined beam. The rear glass face may be dimpled to improve light uniformity and beam edge-softening.
 Removal of the lens converts the lamp to a lower-intensity, harder light source with greater spread.
2 The fresnel spotlight is available in ratings including 100 w, 500 w, 2 kw, 5 kw, 10 kw, 20 kw. The figure shows operating range from fully flood (60°) to fully spot (10° at the lens focal length). (1) Parabolic mirror (2) Lamp (3) Fresnel lens (4) Focusing control (5) Frontal bracket for lamp accessories (6) Hoisting loop.
3 Polar diagram showing typical variation of coverage and light output for fully flooded and fully spotted extremes.

Hard-light fittings

After the first developments in lamp fittings, in which the lamp was mounted in front of a mirrored reflector, the next step was to add a lens to focus the emergent light. This is the basic design of the spotlight—the standard source of hard light and the maid-of-all-work in the studio.

In present-day spotlights the mirror with lamp affixed at its focal point is moved to and from the lens to give a light beam of adjustable spread (Figure 4.4). With this arrangement the light

intensity is not constant, but increases as the fully flooded wide-angle beam is spotted to its narrowest (fully spotted) spread.

The spotlight has three main operational adjustments. It can be tilted up and down, panned from side to side and, as just said, set

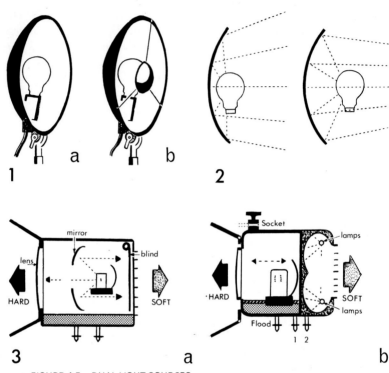

FIGURE 4.5 DUAL LIGHT SOURCES
1 Dish reflector. The basic dual-purpose source is the dish with removable back-reflector. Without the clip-on central light-shield (a) the hard light of the lamp shines directly forward, accompanied by the reflector's softened light. With the central attachment (b) direct illumination is cut off, and only softened light from the reflector emerges. Light from the reflector is not readily restricted.
2 Long-range scoop. The focusing long-range scoop adjusts the bulb-to-reflector distance, to change from wide-beam softened light (a) to a narrow-beam soft-edged spot (b).
3 Dual source luminaire (twister). This arrangement provides a fitting that emits alternatively hard or soft light. It takes two basic forms: (a) a single lamp in a fresnel spotlight (with rear blind closed) or internally reflected soft light when the blind is opened and barn doors obscuring the lens (low efficiency in soft light position), and, (b) two back-to-back units comprise a normal spotlight, and a soft source derived from an aluminised reflective surface. (For single purpose use, separate soft or hard half units are derived.)
Controls permit (1) mode switching: hard or soft light. (2) power selection: *hard* by switching filaments to $2\frac{1}{2}$ kw single, 5-kw ratings; *soft*, multi-lamp switching. A flag-holder socket and colour frame (diffuser frame) attachment are to be found on the lamp casing. The luminaire is pole operated.

at any degree of flood or spot to meet the need. This may be done by a knob or handle on the fitting, or from several feet away by means of a special aluminium pole control. The flexible end of the extendible pole has a housing that turns the 'loop' or 'T' controls on the lamp, to enable the slung lamp to be precisely positioned from the ground. It is feasible to have such operations controlled remotely by servo mechanisms, but such complication is rarely worth while in normal studio conditions—particularly as lamp accessories would still require local manual control, anyway.

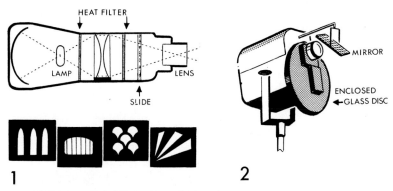

FIGURE 4.6 PROJECTION SPOTLIGHTS
1 Profile spot (Ellipsoidal spot). These provide precisely shaped hard-edged beams, controlled by shutters, iris diaphragm, or metal plates. Shadow patterns can be projected, using metal stencils (masks), wire mesh, etc.
 Where heat-absorbing glass filters are incorporated, glass slides can be projected (window shapes, clouds, decorative patterns, etc.). An iris control may provide intensity adjustment.
2 Moving pattern projector. Moving pattern projection derives from designs painted or printed onto a large disc of heat-resisting glass—a segment passing the lens at an adjustable speed. (Other patterns utilise decorative glass to provide image break-up.) The beam-deflector mirror permits vertical or steeply angled projection.

Most spotlights are designed so that the edge of the light beam falls off in brightness. This achieves two things. A hard-edged light beam creates distracting arcs of light as its periphery falls upon a surface. Secondly, by softening-off the beam edge, the light of one lamp can be merged imperceptibly with adjacent light beams and so achieve even illumination over a large area. Within limits, one can adjust lamp coverage by controlling the degree of lamp flooding, but this method affects lamp brightness also, and is insufficiently decisive for most applications.

101

Beam-shape control

Barn doors

Various ingenious devices have been created to assist the lighting director in restricting the light coverage of a spotlight. The most universal is certainly the barn door. This comprises from one to four hinged flaps, attached to a frame that slips in front of the spotlight housing. Many studio lamps have this device permanently attached in a rotatable frame that enables a flap to be turned to the cut-off angle needed.

Because of its universal application to creative lighting techniques, it is well worth examining more closely the usage and problems encountered with the barn door, for this is a basic tool. We can apply the barn door in many ways:

> To restrict light to specific acting areas.
>
> To light specific positions (actors, furniture or scenery).
>
> To light people while leaving nearby walls unlit or shaded.
>
> To light walls (scenery) while leaving nearby people unlit.
>
> To shade-off light casting unwanted or ugly shadows from scenery, people, sound booms, practicals, etc.
>
> To provide isolated light patches (e.g. around practicals).
>
> To create atmospheric light-streaks (e.g. shafts of sunlight on walls).
>
> To create shadowy areas.
>
> To avoid duplication of light (overlapping of adjacent lamp beams).
>
> To restrict illumination on light-toned surfaces (preventing their being overlit).
>
> To prevent a light beam spuriously streaking along a parallel wall.
>
> To prevent back light from creating lens flares.

Although remarkably versatile, barn doors necessarily have their limitations. Only rectangular shapes or slits of light are possible. How sharp the shadow edge cast by the barn-door beam cut-off proves to be, depends upon the area of the door-flaps. Large doors are cumbersome, space-consuming where several lamps are closely grouped, and do not lend themselves to small area light restriction. Smaller area doors, on the other hand, are less effective in localising light, provide softer-edged shadows, but enable one to achieve small isolated pools of light.

As the barn doors are closed, the effective output of the lamp is

FIGURE 4.7 BEAM-SHAPE CONTROL
1 The barn door. (a) The barn door comprises up to four independently hinged adjustable metal flaps on a rotatable frame. These allow selective beam cut-off. (1) Long doors. (2) Short doors. Used individually or in combination, various straight or rectangular restrictions can be formed, (b) progressively boxed-in for very localised use, and (c) rotated for angular restriction.
2 Typical examples of barn door use are shown. (a) Horizontal shading; long doors only. Note the 'end-leak'. (b) Subject isolation. Tightly boxed-in. (c) Localised shading. Boxed-in. (d) Lighting into an angle, beam shape becomes distorted.
3 (a) Spill ring. A series of shallow concentric cylinders restricting edge-spread of light. (b) Snoot and funnel. Restricting a spotlight's beam-spread to a localised round soft-edged area.

103

FIGURE 4.8 LAMP MOUNTINGS *In the studio.* (*a*) (1) Hydraulic extensible stand. (2) Spot rail (light tower) of tubular scaffolding. (3) Camera light. (4) Underlighting flood on turtle stand. (5) Telescopic floor stand with offset arm (A) and side arm (B) (low-level bracket). (6) Small boom light. (7) Scenic flat with lamps attached. (A) wall clamp, (B) hanger (C) faceplate. (8) Lighting catwalk. (9) Lighting rail. (10) Telescopic pipe (skyhook, monopole); slides along power rail supplying lamps. (11) Suspended tubular barrels (bars, pipes), counterweighted, or on electrical hoists. (12) Pantograph (lazyboy). (13) Cookie on flag arm. (14) Cradle (tubular construction) supporting lamps, heavy apparatus, arcs, etc. (15) Roof or fly suspension area; girders, ceiling hooks, slotted or tubular pipe-grid, ladder-beam, or suspension bars.

(*b*) Motorised barrel: showing—(1) Suspension and power cables. (2) Power outlets wired to permanent or pluggable numbered supplies (patching system). (3) Sliding sleeve to permit cross-bars. (4) Adjustable drop arm attachment. (5) Lamp on sliding carriage.

reduced, particularly as the light-slit narrows and edge-diffraction effects arise. The edge-shadow too becomes much softer. A lamp with the four flaps of the barn doors nearly closed wastes most of its light, and produces a small soft-edged blob, suitable perhaps to simulate the wall-illumination pattern of certain practical lamps.

Barn doors of the two-flap variety have excellent shading-off properties, but end-spill, or end-leak, may prove troublesome as uncontrolled light emerges from the corners of the doors.

FIGURE 4.9 LAMP MOUNTINGS *On location.* (1) Multi-flood stand. (2) Spot rail (light tower) of tubular scaffolding. (3) Lightweight telescopic floor stand. (4) Heavy duty castored stand. (5) Flood in collapsible telescopic stand with flexible neck. (6) Hidden internal reflector lamp. (7) Boomlight (counterbalanced arm). (8) Ground lamp providing bounce light. (9) Support bar (telescopic, screwed or sprung) with clamped-on lamp. (10) Overrun bulb in existing illumination system. (11) Lamp lashed to existing structure. (12) Tubular scaffolding frames. (13) Spring-jaw clamp on to existing structure.

Snoots (*high hat, funnel*)

These are metal cylinders or cones clipped to the front of lamps to restrict the light beam to a fixed circular patch, the area of which depends on the lamp distance and the relative snoot size. Leaden malleable snoots are less used, but enable the vari-shaped light patch to be tailor-made for any application.

Light restriction

For more sophisticated light restriction a family of localised light shields has been devised:

FIGURE 4.10 LIGHT RESTRICTION
(a) *Gobo* Jet black wooden screen to hide lamps or cameras. (b) *Overhead teaser* Solid horizontal plane to prevent back light reaching camera lens (lens flares). (c) *Flag* Small gobo to prevent unwanted spill from 'fresh light' (e.g. 1 sq ft area). (d) *Target, blades, dots* Small rectangular, square, round or semicircular opaque or translucent shields. (e) *Scrim* Translucent, vari-density flag to reduce or soften local illumination. Very large area scrims (butterflies) are used for location exteriors. (f) *Cookies* Opaque or translucent profile or stencil sheet, to create dappling, shadows or general light break-up.

Gobos

Although these consist of nothing more than large black boards, gobos have a variety of applications.

One may be set before a lamp to prevent fresh light from spilling over selected areas.

A gobo may be hung to keep a beam from reaching the camera lens and causing flare. Occasionally scenery or another lamp can

be deliberately positioned as an obstruction to gobo-off light in this way.

The gobo can even be used as a lamp-hide—a particularly valuable subterfuge for location exteriors, where the camera can shoot straight at the dark gobo and overlook it, while a lamp hidden behind it lights the scene.

Flags

These are small gobos, of about 1–2 sq. ft, affixed by adjustable angle arms to the lamp fitting or a floor stand. They provide hard- or soft-edged shadows of any shape, by adjusting the lamp-to-flag distance, and enable highly controlled light restriction to be achieved.

Targets, blades, dots

These are tiny, rectangular or round flags, normally of about 6 sq. in. area.

Scrim

A flag of gauze or net, used to soften light locally, to cast thin shadows, or to give a local reduction in light intensity. The

FIGURE 4.11 THE INTERNAL REFLECTOR LAMP
1 A mirror-silvered internal wall coating provides an inbuilt reflector. The face glass may be clear, frosted, dimpled or ribbed, to produce hard or semi-diffused light, according to its application. Power ratings up to 1 kw are available.
2 Small accessories such as barn doors, spill rings or snoots can be clipped over the lamp-face for limited control.
3 Mountings include spot bars, wall plates and spring-jaw clamps.

density of a scrim, which may be uniform or graded, can be arranged to suit particular needs.

Cookies, cucoloris, cukes

Constructed of solid or translucent material, stencil or profile cookies provide shadow patterns of various forms. The strength of these shadows may be controlled by construction, from barely perceptible dappling to pronounced hard patterning.

One of the chief applications for cookies is to break up plain surfaces and so prevent them from taking on a glaring, overall evenness.

A still more ingenious use is to place a cookie in front of a strong key light, to produce almost imperceptible irregularities in the light beam. These will not register as shadow formation, but reduce the overall harshness of the hard source. By this means, one can key light from a frontal direction in the kind of situation that is nominally 'lightless', or takes place under subdued lighting, without the audience becoming conscious of the deceit!

Controlling light intensity

Successful lighting requires careful intensity control. We can achieve this initially by using suitable lamps. The type and power of each lamp, its light quality, and its distance from the subject, will set the relative light intensities. For spotlights, variation of the beam-concentration also provide some measure of brightness adjustment.

Diffusers

One of the simplest and most effective methods of control is by placing diffusers over selected lamps. These slightly soften the light by diffusion, and by increasing the virtual source size, but intensity reduction is generally the most pronounced effect. In a static lighting set-up, the balance achieved this way may be complete. Electrical control systems may be quite unnecessary. Furthermore, unlike power dimmers, diffusers can reduce light output without affecting the colour temperature of a lamp.

Diffusers have the merit that they can be placed over part of a light beam, to adjust the light levels falling upon selected areas.

108

So, instead of covering the entire lens with a diffuser, one can have vertical, diagonal, or horizontal half-diffusers, segments, or diffusers of graded thicknesses, i.e. sections of single, double and treble thickness.

In this fashion, exceedingly selective lighting is feasible. A spotlight can be arranged so that a distant actor is fully lit, but passes into proportionally lower intensity light as he moves closer to the lamp, thereby preventing overlighting. It becomes possible to restrain light on a person's face, while allowing the full light to fall upon his dark clothing.

By such methods, one lamp can be made to do the work that would otherwise necessitate several individually balanced lamps. For some subjects, such as scenic models and miniatures, the multi-diffuser approach has the particular advantage that we need use only one dominant key light, so preserving a single shadow-former, and avoiding confusing multi-shadows that would be difficult to eliminate on such a small-scale subject.

FIGURE 4.12 BEAM INTENSITY CONTROL (mechanical)
1 Diffuser. The simplest mechanical method of controlling the intensity of the light beam is by placing diffusing material over the lens. (a) A full diffuser reduces overall light intensity (with some softening). (b) Reduces light locally to prevent over-illuminating specific areas, or intensity doubling from overlapping adjacent light beams. (c) A graded diffuser provides progressive light fall-off.
2 Iris diaphragm. On a spotlight, an adjustable iris can be used to control beam spread (as in a following effects spotlight) or adjust the intensity of the lamp, according to its positioning in the optical system.
3 Shutters. Louvres or venetian shutters can be hand or motor controlled to adjust the light flow of any type of lamp, including arcs and discharge lamps.

Typical diffusing materials include: spun-glass sheeting, wire mesh (wires), gelatined wire mesh (jellies), frosted and opal glass, cello glass, oiled silk (silks) and frosted plastic sheeting. Each causes its own characteristic diffusion.

Electrical control

Increasingly sophisticated electronic methods of light control have been developed in recent times. The simplest requirements can be satisfied with portable dimmer-trucks or dimmer-boards, enabling a small studio or a location unit to control a limited number of circuits, handling a total loading of perhaps 10–25 kw.

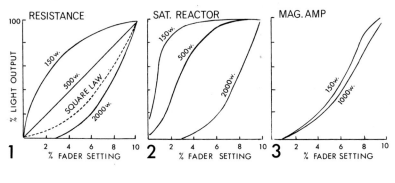

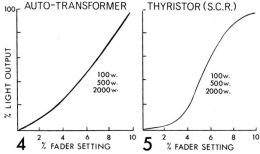

FIGURE 4.13 TYPICAL DIMMER CHARACTERISTICS Ideally, there should be a square-law relationship between dimmer (fader) setting and light output, to provide apparently uniform light increases to the eye (with its log. law). Dimmer performance should not change with varying attached loads.
 Illustrated are typical performance curves for various types of dimmer.
1 Resistance dimmer.
2 Saturable reactor (choke control).
3 Magnetic amplifier (low current saturable reactor).
4 Autotransformer.
5 Thyristor (silicon controlled rectifier (SCR)).

The consoles of larger electronic installations not only switch and adjust intensity for any chosen lamp or selected groups but they can store such patterns of information, including the relative intensities of each lamp, and recall them at the touch of a button. Automatically timed fades become possible. Whole sequences

110

TABLE 4-II

TYPES OF ELECTRICAL DIMMERS

Method of dimming	Principle	Advantages	Disadvantages
Resistance dimmer	Lamp current varied by adjusting amount of resistance wire in series with lamp	Simple. Medium cost. Reliable. Suitable for A.C. and D.C.	Power dissipated as heat in resistance wire. Fairly bulky. For even dimming, small load must not be fed from high load dimmer
Auto-transformer dimmer	Iron-cored coil across the power supply; variable voltage can be tapped off to feed lamp	Cool working; compact; reliable; smooth control with varying load. Excellent power economy	Suitable only for A.C. Relatively expensive. Bulky
Saturable reactor (reactance dimmer) (choke control)	An iron-cored coil in series with an A.C.-fed lamp will cut down its current; and hence lamp brightness. By adjusting a D.C. control-current flowing through an overwound control-coil, the impedance can be varied	A small D.C. control supply can be used remotely to adjust large loads. Fairly low cost. Occupies small space	Suitable only for A.C. Heavy. Dimming action can vary considerably with loading
Magnetic amplifier (low-current system)	A derivation of the saturable reactor. An auxiliary D.C. amplifier adjusts control-coil current, using feedback developed from the load circuit	Smooth control for various loads	Suitable only for A.C. Small dependence on load
Silicon-controlled rectifier (thyristor)	A semi-conductor device which controls lamp current according to the timing of a stream of electrical 'gating' pulses applied to it	Lightweight; smooth control with varying load; compact; high efficiency. Medium to low cost	Can generate interference: (a) acoustical, as lamp filaments vibrate at audio frequencies; (b) electrical noise induced into nearby mic. cables. Filter circuits and special mic. cables reduce

of operations can be stored, too, on cards or tape, enabling transitions to be repeated precisely, even when handling several hundred kilowatts.

At first glance, this would seem to offer the ultimate for continuous television production. It would be possible to have the console memorise all variations of light control that the lighting director introduced during rehearsal, and carry them out automatically for the actual take. One could go over them until they were precisely as required. As an actor entered a doorway, a distant key light could be bright, reducing its intensity somewhat as he walked towards it. For the close shot in which the background brightness had to be reduced to improve the tonal balance of the shot, this could be automatically anticipated as the camera cut to that picture. Or so one might think.

But there is always the human element—the actors themselves. It only requires an actor to move a little more quickly or slowly, to perform at a different pace from that rehearsed, to alter the timing from the preset version, or upset a series of lighting rebalances. Moreover, the idealised concept of modifying the balance shot by shot to suit the precise requirements of each, is usually frustrated in television by sheer lack of time. Shot-by-shot organisation takes planning time, and a great deal of anticipatory accuracy based on experience.

Reflector boards

In sunny locations, reflector boards offer power-free methods of filling dark shadows, reducing tonal contrast, and providing *contre-jour* key lights. Usually these are firmly constructed flat wooden assemblies with gold or silver coating. Very lightweight, collapsible devices all too easily flap in the slightest breeze, and nothing draws attention to a reflected light patch more than juddering position shifts. The character and colour of reflected light depends on the surface of the reflector. From mirrors, metal sheet, foil-faced boards and silvered roller screens there is a hard light quality. With surface treatment (pebbling, ridging) one can soften-off the reflected light quality. A white matte finish, or cloth reflectors, can provide quite softly diffused light.

The reflector's main application on location is when the sun is to the side or facing the camera. Reflectors have to be rela-

tively large (over 4 × 3 ft) to be effective over a scenic area of any size and this necessitates quite careful positioning and support.

The efficiency of the reflector varies considerably with its design, and softness of the light produced. Soft light falls off quite rapidly with distance, and is less controllable. All are very dependent upon the caprices of the natural light.

Within the studio, or interior location, reflectors can augment the light from orthodox lamps, and may be particularly useful on small area set-ups, when economics or circumstances prevent a more comprehensive rig. For large-scale studio use, their value is arguable, for similar or improved effects can be obtained more readily and economically from orthodox light sources.

A rather less familiar use for the matte reflector is to establish a

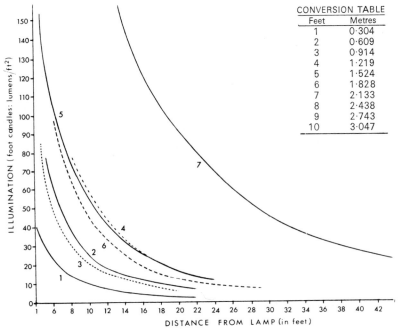

FIGURE 4.14 TYPICAL VARIATIONS OF LIGHT INTENSITY WITH DISTANCE The rate of light intensity fall-off relative to distance varies with the type and design of lamp used. These curves for normal tungsten lamps illustrate typical performance for:
1, 500-w Single broad; 2, 1,000-w Single broad; 3, 500-w Scoop; 4, 1,000-w Scoop; 5, 10 × 150-w Bank (tenlite); 6, 500-w Spotlight (pup) fully flooded; 7, 2-kw Spotlight.

113

soft highlight positioned exactly where we choose, when photographing silver, glass or shiny plastic. These reflected 'highlights' and 'shadows' (from reflected black gobos) do not contribute to the lighting as such but assist in controlling the pictorial effect.

Hand-held lamps

Hand-held light units are used mostly on location rather than in the studio. They are used:

> Where the lighting set-up is impromptu.
> Where space is restricted.
> Where highly mobile action has to be illuminated with very limited facilities.
> Where all the available light has to be concentrated on just the areas seen in shot and moved as the camera pans. In this way off-the-cuff interviews, or remarkable feats of architectural lighting are achieved on a shoestring.

The size of units that can be hand-held is necessarily limited, as is their available power range. Spot-bars carrying overrun internal reflector lamps are probably the commonest example of lightweight fittings suitable for this purpose.

Stable light positions are essential for well-nigh all kinds of treatment. Except for news shots, or for swinging key-light effects, light movement is a distraction. Even lightweight stands, although vulnerable, do offer stability. But for many location applications even this simple fitting can be restrictive.

As an expedient, telescopic lighting poles or support bars (polecats, barricudas) can be braced between floor and ceiling, or between two walls. Lamps are then attached to these using clamps, or hook-on profiled plates. Such plates (which incorporate spigots into which lamps fix) may also be utilised, by sticking them with adhesive 'gaffer tape' onto convenient surfaces. Similarly, large spring-jaw clamps (gaffer grips) with in-built lamp supports can often be attached to nearby structures or furniture, for temporary lighting.

In the studio there is little reason to use hand-held lamps if the setting and operations are suitably designed. Where orthodox, precisely positioned and balanced lighting is possible, there is no doubt that it is preferable.

114

5

PORTRAITURE—STATIC

Emotional reactions to portraiture

Portraiture forms a high proportion of all photography, and deserves our particular attention in any study of lighting—more, perhaps, than any other subject. Portraiture tends to arouse emotional attitudes in our audience. We can modify the appearance of most objects and locations very considerably without audience comment, but pictures of people are another matter. Most of us have distinct opinions as to what people should look like; and when it is one's own portrait, assessment can be critical indeed.

Certain characteristics have become quite widely accepted by each society as attractive, strange, ugly, bizarre. These aspects can be exaggerated or suppressed by the skilled application of lighting, make-up, coiffure, costume and camera treatment.

There is no right or wrong treatment for portraiture in the ultimate. It is a question of appropriateness to an occasion. Even *accuracy* cannot be used as a parameter of choice. For instance, people generally prefer colour reproductions in which faces are rather warmer and somewhat yellower than in life; and they will assess this distortion as a faithful rendition.

The human head has a basic shape, and although certain individual characteristics, such as deep eyes or large ears, are more or less pronounced between one person and the next, the same fundamental considerations remain. And the basic effects of lighting are still true.

When the head is lit from certain directions, unattractive shadow formations arise. These may be less obvious with some individuals—a person with a small nose has a less distracting nose-shadow, however misshapen—but such modelling is still inherently undesirable. For example, save for special effects, a head should never be lit from directly above. The result is skull-like distortion for most faces.

We can take as an ideal when lighting, that each lamp whatever

115

its purpose, should when, adjusted for intensity, be able to be switched on alone without creating undesirable effects, such as ugly shadows or excessive hot-spots. In practice this may be unattainable perfection, nevertheless, such a goal reminds us of the importance of each lamp's contribution to the total effect.

Sometimes disturbing or distorting modelling is unavoidable, and one may be obliged to try to nullify it, probably by increasing fill-light, or introducing some sort of supplementary key light. Combined with skilled rebalancing, the defects may no longer show, but they are certainly still there, unless the modified lighting has swamped them completely.

Given the appropriate conditions, the viewer will accept the most extreme portraiture lighting—even finding it 'different'. But we have to distinguish between occasions where environmental motivation makes a half-lit face dramatically apposite, and a situation such as a formal interview, where only attractive character portraiture could be justifiably expected, and any unconventional distortions would be out of place.

Conventional portraiture should not however, be a rubber-stamp treatment, a predictable approach irrespective of surroundings. Like the screen fight in which the hero somehow never gets dishevelled or dirty, the result would lack conviction. This is not to argue that lighting should fluctuate from burned-out faces to detailess murk, on the grounds that under true-life conditions this sort of thing happens. Veracity is one thing, the creation of a persuasive image another.

Certainly, unorthodox lighting treatment may occasionally come off brilliantly, and produce arresting, attractive pictures. Given a suitable subject, experience and an element of luck, the basic rules of all practices can be circumvented.

In motion pictures it has long been the practice, when large attractive close shots are required, to light these separately for optimum effect, even if this treatment differs considerably from the facial lighting seen in long shots, where defects are less blatant in the smaller subject image.

Lighting treatment can modify one's impressions of health, age, beauty, considerably. Under contrasty, steep, or edge lighting most people appear tired, older, haggard. And although make-up may have successfully enhanced or glamorised, such illumination invariably coarsens and destroys the effect entirely, perhaps producing a pathetic, disillusioning, even grotesque result.

116

Specifying lamp position

In lighting, we are essentially dealing with a three-dimensional situation. Fortunately, every position in space can be pegged by locating its respective horizontal and vertical aspects. It is simplest, if we discuss the light's horizontal and vertical attributes separately, for the combined result will possess the characteristics of each.

For most subjects, the changes in appearance as we alter the lighting angle are subtly progressive (although greater as the light beam becomes oblique to any surface). So to see an appreciable variation in the changing light, we usually need to compare well-defined alterations in light direction.

Using the clock-face as a reference (see page 66) when designating the angles, Figure 5.1 shows the camera at 6 o'clock horizontally, and 3 o'clock vertically, i.e. 6H/3V. The clock-face involves angular differences of 30° per 'hour', or 6° per 'minute', and this everyday standard is a simple, unambiguous one for any lamp designation.

As the effects of lamps will always be discussed here as *relative to the camera's position*, a lamp near the camera lens will always be termed 'frontal', irrespective of the direction the subject itself is facing. Particularly in a multi-camera production, or when we choose new viewpoints, this reminds us how the effect of the light changes with its direction. Whether the light is moved, or our new viewpoint puts it in a different position, is immaterial.

Here are probably the most important lighting fundamentals. It is the *effective* light direction that matters. Light must always be assessed relative to our (the camera's) particular viewpoint. If the light is shining from behind us, straight onto the subject, it is 'frontal'. If we move round the subject so that light now shines directly at us, and hence is behind the subject, it becomes 'backlight'. Changing the lamp position instead, would have provided similar results. We specify a lamp's function therefore for a particular camera/lamp relationship. Although light may reveal different aspects as a subject moves about and various facets become visible, the characteristic results of this lighting direction remain constant.

Remember, the effect of a lamp's *vertical* lighting angle is equally important as its *horizontal* direction. This is easily overlooked in plan sketches of set-ups.

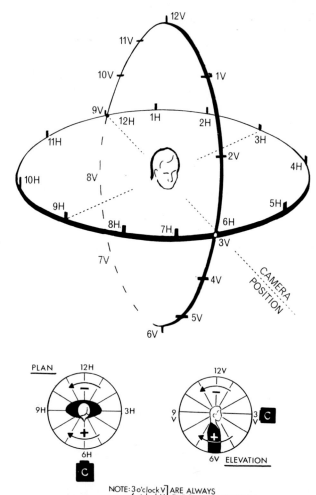

1

2

NOTE: 3 o'clock V⎤ ARE ALWAYS
6 o'clock H⎦ THE CAMERA POSITION

FIGURE 5.1 SPECIFYING LAMP POSITIONS
1 The position of any lamp can be located relative to an imaginary horizontal clock-face with the subject at its centre, and a similarly centred vertical clock.
2 The camera position is at 6H/3V. Intermediate positions between 'hours' are denoted by + (clockwise) or − (anticlockwise) signs. 'Hours' represent 30° steps; 'minutes' are 6° each.

The basic effect of lamp positions

Let us start from rudiments. Light from the camera lens position flattens modelling. As it is raised in height, shadows appear under the eyes, nose, chin and, of course, lips and ears. A certain

118

amount of shadow is desirable, but as the light steepens we become progressively disturbed by these encroaching shadows and the more distinct modelling in forehead and cheeks. The lower parts of the head shade off. For a thin, gaunt face the effect will become unattractive more quickly (i.e. at a lower angle) than for podgy, less-defined features, which may actually be improved by rather steeper angles.

A slight tilt or turn of a head can alter the shadow lengths (Figure 5.2). Light which is a perfectly well-angled key when a

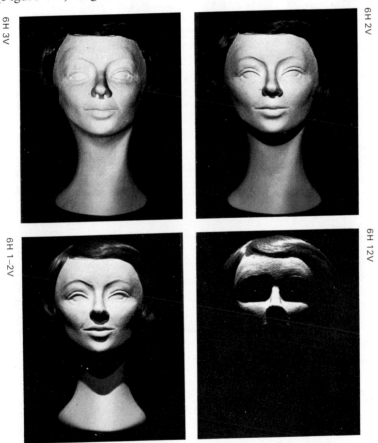

6H 3V

6H 2V

6H 1-2V

6H 12V

THE HEAD—VERTICAL LIGHTING ANGLES As the vertical light angle steepens, modelling becomes more pronounced. Downward shadows grow, progressively 'ageing' the subject. For less defined features, steep angles may still remain acceptable; while for strongly contoured faces, modelling may increase disproportionately. Nose and chin shadows lengthen, as do eyebrow, cheek and lip shadows. *Bottom left* shows as a double-exposure, the relative shadow displacement rates for the nose and chin.

119

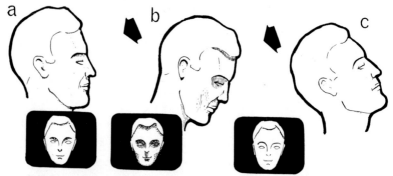

FIGURE 5.2 CHANGES IN EFFECTIVE LIGHT ANGLE The fundamental effect of light direction remains, but the degree of specific modelling alters with changes in subject position. (*a*) A key light is correctly angled for good facial modelling. (*b*) When the head tilts down the facial modelling steepens. (*c*) Tilting the head upwards, it looks more directly into the light and modelling is reduced.

person is looking ahead to talk to another adult, becomes effectively of a much steeper angle if the person looks down to a small child, and the facial modelling changes accordingly. A cut to a low-camera angle would emphasise this. Similarly, as a person looks upwards, his key becomes effectively of a lower angle and more flattening. But more of the quandaries of subject movement in the next chapter.

Moving the lamp

Returning again to the frontal lamp beside the lens. As we move it sideways in a circle round the subject, we find the nose shadow, short at first, spreads sideways across the opposite cheek. The far side of the face becomes progressively shadowed. At around 45° off-axis (i.e. around 4–5H and 7–8H), nose and cheek shadows join, until eventually that side of the face is completely shaded. We shall look in greater detail shortly, but so far it is clear that the combined effect of moving a lamp sideways *and* upwards will produce a result with the characteristics of both directions.

 To start with, as a broad practical guide it becomes easier to consider *zones* within which effective lighting can be obtained (Figure 5.3). Inside these zones slight readjustments can be made to suit an individual's requirements. There is nothing mechanical about this concept for, as we shall find, our exact choice and the lighting balance adjustment (especially with moving subjects), is challenge enough! But we do in this way develop a sense of light location,

120

with a realisation of characteristic effects. If we obtain harsh, dramatic or unflattering treatment, it will not then, be accidental.

When first lighting faces, we soon become aware of problem shadows, particularly from the nose and chin. To be unobtrusive, nose and chin shadows normally have to be kept relatively short —but short shadows are associated with flattening light. Good

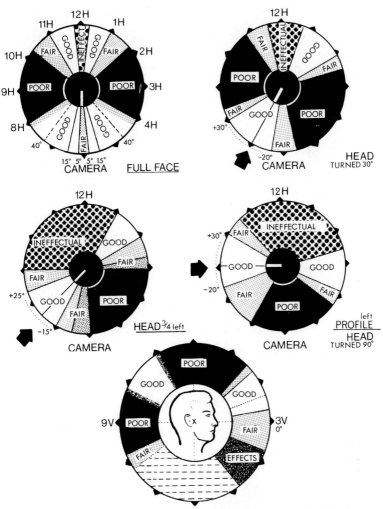

FIGURE 5.3 OPTIMUM PORTRAITURE ZONES Each basic head position has a range of optimum key and back light directions for normal portraiture. The desirability of angles for conventional portraiture is rated as: white (good), grey (fair), black (poor).

121

7H 3V

3 and 9H 3V

8H 3V

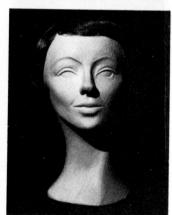

7H 2V

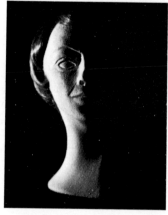

9H 3V

THE HEAD—HORIZONTAL LIGHTING
ANGLES *Left column:* Moving the
light round the head causes one side to
become progressively shadowed, while
the other is increasingly lit. The nose
shadow moves across the face. *Top
right:* Lighting from both sides pro-
duces the centrally shadowed 'badger'
effect. *Bottom right:* Vertical and hori-
zontal angles combine to create dia-
gonal shadows and shading.

122

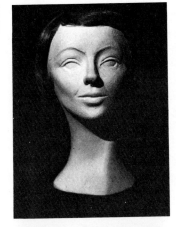

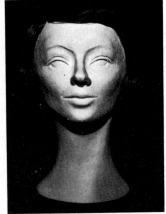

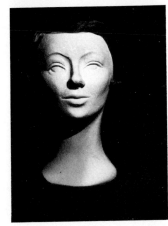

THE HEAD—FRONTAL KEY LIGHT
The head has been lit here. *Top left:* from the left at 7H 2V. *Top right:* Frontally, 6H 2V. *Bottom left:* From the right at 5H — 2V. As most faces are asymmetrical, appearance and expression can change considerably with the key light position.

modelling produces well-defined shadows. So there is the dilemma that the very lighting that creates attractive modelling and shadow formation for some aspects of the subject, also gives an undesirable appearance to other features.

Portraiture lighting derives in fact from three co-related factors: the inherent influence of a particular light direction (this will be similar whatever the item we are lighting); the characteristic effects encountered as light falls upon specific parts of any human head (we all have nose and chin shadows, etc.); and the ways in which the proportions of certain individuals' features can modify the modelling (i.e. deep-set eyes, nose formation, balding).

123

Portrait-lighting defects

Studying the effects of various lighting positions, we can discover a number of regularly unattractive factors.

NOSE

Shadow, making the nose look longer, bent or broken; long nose shadow, fluctuating in length or shape when speaking; the nose shadow forming a triangle of light on the cheek, making and breaking with head movement; pseudo moustache effects on upper lip; twin nose shadows ('wings') from two key lights.

Highlights on nose tip, causing bulbous or tip-up effect; at the side of the nose, highlights causing broken or misshapen effect.

EYES

Eyes partially or totally shaded, by nose or brow; black inner corner to eye, from nose shadow; steep key creating 'black eyes', eye recession, or skull-like look; one black eye formed as brow illuminated by back or side light; eyelashes creating shadow patterns on cheek.

Eyes without reflected highlights look dead, expressionless, wan; very large eyelights, or a multiplicity of reflections, look strange, perhaps giving a shifty look; lamp reflections in spectacles, frame shadows from spectacles.

HAIR

Dark hair without reflected highlights appearing an untextured, sculpted mass.

Excess hairlight creating fuzzy, over-glamorous or over-brilliantined effect; hot crown or 'flat top' to the head, due to oversteep back lights, or to top light; fair and thin hair appearing 'bald' through steep or excess back light.

EARS

Ear interiors becoming black or formless when insufficiently lit; ears sticking out, or appearing translucent, or hot-tipped, through excess or oversteep back light; forward ear shadows on to the cheek, distracting in profile shots.

CHIN

Chin shadow reaching as a dark bib down the neck with steep back light; particularly disturbing (especially on bare shoulders)

124

when diagonal, giving a lop-sided effect, or profile shadow on shoulder.

FOREHEAD
Hot bulbous top; over-widened face due to highlights on temples.

FACIAL MODELLING
Insufficient modelling (key too frontal or too soft); gaunt appearance (key too high on thin face); lop-sided (key too far sideways or on the wrong side); over-broad face (lighting angle too shallow); broadness exaggerated by back light (key on the wrong side); facial modelling exaggerated, i.e. baggy eyes emphasised, wrinkles, flabby skin texture (light too oblique or too hard for subject).

Any lighting set-up giving rise to such defects as these is generally undesirable, apart, that is, from special 'location' or 'character' applications. It is always possible that the defects may be overlooked. Or we may just have to accept them as unavoidable, particularly where the correction of one defect results in another becoming more pronounced.

Quite often lighting shortcomings are disguised by other considerations. Subject movement may reduce our awareness of defects. Shadow patterns on the face may be accepted as 'environmental'. And then again, one lamp may overpower the ill-effects of another.

Developing portrait lighting

Let us now take a closer look at the characteristic effects of lighting upon typical head positions. Again we shall use the clock-face method of lamp location, and study in turn the full face, three-quarter frontal and profile angles.

Full face, frontal light: central

Let us move the light from below the camera, up to a level position, then above the camera at an increasing angle.

6H/5V UP TO 6H/4V: UNDERLIGHTING
All shadows are cast upwards, forming unfamiliar patterns of modelling. Normally shadowed areas under brows nose and chin, are now fully lit. Strange shadows are seen (over the bridge of

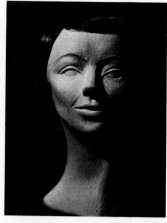

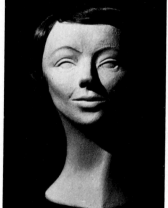

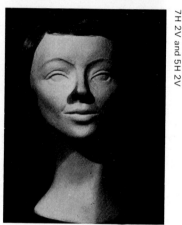

NOSE SHADOWS An obtrusive nose shadow. *Top left:* may be reduced by a more frontal lamp position, but at the expense of reducing modelling. *Top right:* By extending the shadow until it joins with facial modelling, a cheek triangle is obtained instead. (At a 45° horizontal, 45° vertical position.) *Bottom left:* However, if the head is turned from the key, or the lamp moved horizontally, the triangle breaks, and a long nose shadow appears. *Bottom right:* Cross frontal keys produce dual shadow formations, and introduce two nose and chin shadows. These not only distract, but can broaden the nose tip, and sharpen the chin.

the nose, above the top lip, above the brow). The eyes become strongly lit, the overall effect being bizarre, uncanny, horrific.

Underlighting can be used with discretion, to compensate for undue modelling from downward key light, for glamorising and giving the effect of youth. If diffused and set at around 4H, as a main key, the light can pleasingly suggest warm fire glow.

126

6H/3V: LEVEL, DEAD FRONTAL

Flat, unmodelled lighting, with a general lack of solidity and roundness, this light may help where it is diplomatic to make the subject look younger, or where a face is very strongly wrinkled. But such a lamp position can be dazzling for the subject and a performer could have difficulty in reading cue-sheets with a low-angle key near the lens.

6H/3V TO −2V: FROM LEVEL 0° UP TO, e.g. 45°

Modelling improves, shadows become progressively more notice-able from brows, nose, lips, cheeks, jaw at this angle. As lamp height increases, the face generally narrows and the nose appears to lengthen. One can become too aware of lighting symmetry with this central steeper lighting.

6H/2V TO 1V: e.g. 45−60°

Modelling generally becomes progressively harsher here, until eventually it is only suitable for occasional dramatic effects (60−75°). Typical results include black eyes, long nose and neck shadows, an emaciated look, the forehead becomes over-pronounced, and a long bib-type chin shadow covers the chest. Eye-lash shadows sweep down over the cheeks, and eyebrows bristle.

6H/1V: TOP LIGHT

This light angle creates a crude, flattening hot top to the subject's head and shoulders or, at best, a long, crude nose shadow—an ugly light direction of little pictorial value.

6H/12V TO 11V: TOP LIGHT

Hair, shoulders and ears are lit from this position and the nose is strongly illuminated in a dark face. Sometimes top light of this kind is used as hairlight. But unless localised and dim, such lighting is liable to produce crude effects.

Full face, frontal light: offset (+4H to −6H; +6H to −8H)

Offsetting the key creates a progressively lop-sided effect to the face, as the side opposite the light becomes increasingly shadowed. If the lamp is both raised and offset, the jaw shadow is diagonally displaced towards the bottom right or left of the features.

Generally speaking, an elevation of between −3V to −2V (10−45° from the horizontal) is the optimum height range for normal

127

portraiture, with a degree of offset between $-6H$ and $4H$, or $+6$ and $8H$ (about 5–60° from centre). The extremes are best avoided though (the results are usually too flat at 6H or too harsh at 4H or 8H), and 15–40° is a typical offset range, and 20–40° elevation.

As the lamp moves round horizontally, the nose shadow spreads across the face—diagonally if the lamp is also elevated. Stronger modelling develops on the side away from the light, the lit side tending to lose subtle contouring. A shadow grows in the corner of the far eye as the nose shadow cuts across it. The lit side of the face appears to widen, the features becoming more unbalanced in the process.

An oft-quoted *cross-light* position is 45°H/45°V, where the nose/brow shadow joins with the cheek shadow to form a triangle of light on the far side. Admittedly this settles the ever-present dilemma of the size of the nose shadow, but somewhat severe lighting can result, including a nose shadow shading over most of the far eye. Moreover, the triangular motif does become rather a mannered visual cliché.

As we have seen, light cannot be greatly offset for most faces without modifying the facial balance, and creating prominent shadows. How marked these are, will be influenced by the hardness of the key light, and the degree of filler used.

Full face: side light

Moving the key light further round the subject to a 3H or 9H position, i.e. 90° to the lens axis, we have *side light*. This edge-lights the face, bisecting it. If this is done from both 3H and 9H at the same time, we get a curious 'badger' effect with a dark band down the centre of the face.

With side light, the inner corner of the near eye-socket becomes shaded, and the overall result is quite unsatisfactory for normal portraiture. At elevations above 30° (position 2H or 10H) the results become even more grotesque.

Back light

With the lamp directly behind the subject at 12H/9V, looking towards the camera (situated at 6H/3V), the lamp is hidden by the subject, the light only rimming peripheral hair and ears. Raised, the lamp shines over the subject straight into the camera lens. Raised further, to 10V–11V position (30–60°), the shoulders, the top of

THE HEAD—BACKLIGHT (1) As dead backlight is raised, the top surface rimming increases in area.

the head and hair become progressively lit. Gradually the border contours and texture of shoulders and arms become clearer.

Oversteep back light (11V–12V) results in a dark bib shadow on the chest, and a white nose (a hazard that arises all too easily when people look upwards or lean back). Low back light (e.g. 7V–8V) has only the occasional value of lighting filmy costumes and the underside of large coiffures and hats.

With offset back light (11H/10V or 1H/10V) the light becomes more asymmetrical, a rim of light appearing on one side of the head, ear and neck. One shoulder becomes brighter than the other.

129

THE HEAD—BACKLIGHT (2) As backlight is moved round the subject, its sides become increasingly lit. *Top right:* The nose-tip becomes illuminated and subsequently, *Bottom left:* 'black eyes' develop.

If offset too far (e.g. at 10H or 2H), one grows conscious of the one-sided nature of the rim. More of the side of the face is lit, with a large forward shadow from the emphasised ear. The eye on that side becomes progressively rimmed around brow and temple, so that the socket looks black.

From the side opposite the key, the offset back light rims the face effectively. From the key side of the face, back light would reinforce the brightness of surfaces already lit by the key, perhaps creating overexposure, and counteracting the modelling of the key in that area. Again, where both key and back light are on the same side of the head, the facial lighting may appear lop-sided, although ironically it can help us at the same time to enhance the illusion

that all the light is coming from the same general region of the setting, and this can assist in adding conviction to the atmosphere of a scene.

A standard variation on the use of back light is double-rim lighting, in which positions 11H and 1H are used simultaneously, creating a rim on each side of the subject. The result can be glamourising for women, but is liable to broaden the face too much and make the forehead look higher. One should also be careful in introducing it in masculine portraiture. Some adherents use double-rim lighting simply to achieve symmetrical shoulder brightness, and avoid the unlit shoulder produced by a single offset back light. But this sets up two forward pointing head shadows and gives an irrational emphasis.

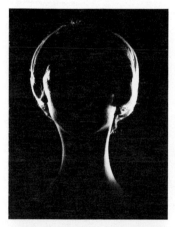
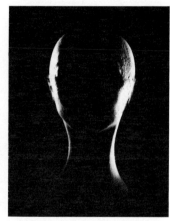
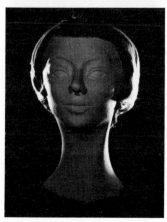

THE HEAD—BACKLIGHT (3) *Top left:* Double rim lighting may augment other lighting when it is appropriate, although *Top right:* its effect is largely influenced by the subject's hair formation and facial structure. *Bottom left:* It may be used with soft frontal lighting only for certain glamorous effects.

131

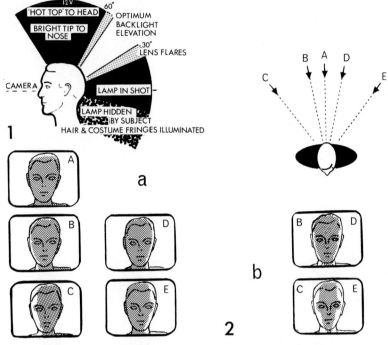

FIGURE 5.4 BACK LIGHT
1 The effectiveness of back light changes with its vertical angle.
2 (a) Back light rims the subject's sides, to an extent depending upon its horizontal angle.

The width of the illuminated rim broadens as the light moves from behind the subject towards a side position. Any subject contouring or protuberances (e.g. ears, hair) will cast long shadows forward over the side of the face when slightly offset backlight is used, these shadows shortening as this backlight moves towards $\frac{3}{4}$-back position.

(b) Combined back lights produce double-rim lighting, which exaggerated, becomes a 'badger' effect.

Slight double-rim lighting at the subject's edges can produce a glamorous, attractive visual effect. If inappropriately applied, however, it can over-emphasise head outlines (i.e. ears, coiffure) and apparently exaggerate head-width, neck thickness.

The shaded centre-stripe effect that results from broadly-angled double-rim or from side-lighting, is seldom appealing. It often arises in horsehoe-grouped shots where cross-light for facing speakers bisects a centrally-positioned person.

Three-quarter frontal face

As a head moves from full-face round 45° to a three-quarter position, the effect of normal frontal lighting changes. What provided good modelling for full-face may no longer suit the repositioned features.

132

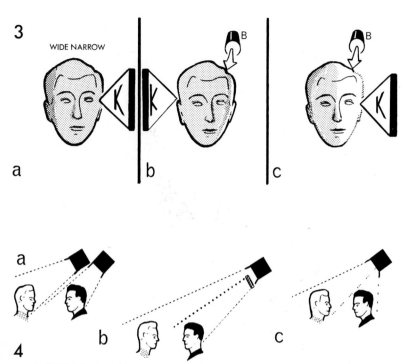

FIGURE 5.4 (contd.)
3 The direction of back light may modify the apparent balance and width of the face. (a) When the key is directed on to the narrow side of the face, the wider side may be visually narrowed by shading. (b) When the key lights the wider side of the face, a back light on the narrow side rims it, effectively widening it. (c) A back light on the same side as the key will tend to nullify the key's modelling and overlight one side of the face. Increased compensatory fill-light would encourage flat results.
4 The amount of back light required by one subject may be less than the key-light intensity for another nearby subject. To obtain a suitable balance one may: (a) Use separate lamps where space permits; (b) use a localised diffuser; (c) arrange a single lamp so that the key is fully positioned on one subject, while its beam-edge fall-off serves to back light the other subject.

One now begins to think in terms of the 'near side' and the 'far side' of the head, naturally divided at the nose and mouth. With the three-quarter-face head pointing to a camera-left position (7H–8H), a key from that direction will result in a small nose shadow (particularly using low to medium lamp elevation) and a shaded front-side to the face. The effect is three-dimensional as the shading reveals the shape of the head and surface contours.

If we take the key further round towards the back of the subject, to −9H, the frontal shading increases, and the nose

133

THE HEAD—OFF PROFILE *Top left:* Moved slightly forward from a profile-lit position, nose shadow and facial modelling increase. *Top right:* Lighting improves when the key light is repositioned along the nose axis. *Bottom left:* A side light from around 9H 3V provides hair and facial edge lighting, to supplement the 3H 3V key.

shadow grows. This dark wing becomes more prominent as it spreads across the near side of the face, until eventually it joins with the cheek shadow to form the traditional triangle.

The price one pays for the excellent three-dimensional properties of 'far-side' lighting is the presence of the near-side nose shadow. Consequently, some exponents of the art consider it preferable to light a three-quarter head from the near side (6H in this case) to thrust the nose shadow to the less prominent far side. This, however, is at the cost of solidity and modelling. A key light pointing straight to the nose of a three-quarter head may prove to be the best compromise.

Low and steeper lighting elevations for a three-quarter face

134

create similar modelling variations to those we have already met in full face—the steeper elevations emphasising facial structure.

As the key is moved further round the three-quarter head (still facing three-quarter camera-left) until it is at 9H on the far side, we see bolder effects of side lighting, and modelling emphasised on the near side of the head. At + 10H, although in a side position relative to the head, the lamp is becoming back light relative to our viewpoint and we detect typical back-light effects forming. Further round still, the light at 11H just rims the face.

We have now covered the most rewarding angular range of lighting for the three-quarter-face position. If the key light is shifted to a frontal position beside the camera at 6H, the resultant portrait is uninterestingly flat as one would expect.

If the lamp moves towards 5H (so that the face looks away from the key) the results become less acceptable, ugly modelling forming round the eye, with the nose partly shadowed, until the front features become fully shaded at around −4H.

A little further round, to 3H, the lamp edge-lights relative to the camera viewpoint, modelling the front of the face and neck strongly, and casting across it pronounced shadows from the ear and hair.

From 1H to 2H, the back light becomes a kicker, catching the near side of the face and attractively delineating the edge of the head.

In these examples, we have examined the changing effect of light direction with a head facing three-quarter left. For a three-quarter-right-looking head, the results are identical, but mirrored, of course, so that directions 7, 8, 9, 10, 11, become respectively 5, 4, 3, 2, 1, and vice versa.

Profile

In profile, emphasis is upon the facial outline. With the head facing 9H, its most attractive key positions are within some 10° of that direction. Lit from the far side at level to medium elevations (9V–10V), we see the edge light skimming along the near face, together with a short nose shadow and jaw and cheek shaded towards the ear.

Raising the key towards 11V will, as we have come to expect, increase gauntness as the shadows under brows, cheek-bones, nose, lips and chin, grow.

Lit from the *near* side (e.g. at 8H), the profiled features are

135

7H 2V

5H 3V

3H 2V

2H 2V

1H 2V

THE HEAD—THE PROFILE *Top left:* Keyed away from the face, emphasis is upon hair. A brow shadow defaces the nose. *Top right:* Frontal light produces flat, unmodelled features. *Centre left, centre right, bottom left:* Moving the key round behind the profiled subject contouring increases but the nose shadow grows. Shadow length and texture increase considerably at more oblique lighting angles.

more fully illuminated, but rather flatly modelled and the nose shadows placed out of sight on the far side of the face. Some lighting directors feel so strongly about avoiding the nose shadow that they are happier to accept the reduced modelling of this lamp position.

In general, the nearer lamp position is most suitable for high-key subjects, or where natural facial modelling is excessive.

Key positions from 7H to 4H are frankly not worth considering artistically for a left-facing profile (9H) as the effect is generally unsatisfactory.

Angles 4H–3H (3V–2V) represent a useful rimming side light outlining the profile keyed from around 9H. Slightly forward of 4H the cheek and ear are skimmed with strong hair and ear shadows. Further back, towards 2H, the efficacy of the light falls as the right-hand rim narrows. Further back still, from 1H to 12H, only the top hair is tipped with light.

Filler (fill-light)

Character of the filler

As we know, the purpose of filler light is to give overall illumination to the shadows cast by the key, and so reduce excessive tonal contrast, without casting new visible shadows. So, invariably, soft light is used.

The intensity of the filler has a considerable effect upon pictorial impact. The filler intensity should never exceed that of the key, and most would agree that it should rarely equal it, for the purpose of the filler is essentially to augment. Where the filler is roughly as bright as the key light, results are undynamic and lacking in modelling. Shadows appear very weak, and most of the viewer's visual information must therefore be derived from colour and tonal differentiation, perspective, and similar clues to three-dimensionality, such as parallactic movement.

The importance of filler depends initially upon the relative area of the subject being illuminated by the filler, and upon the function of that area. If the region left in shadow by the angle of the key light is quite small, that is, if the key light is almost frontal, the filler intensity required for the shade-off region is uncritical. However, if the key is positioned so that it leaves much of the subject unlit—as with a far side key on a profile face—then the

137

area to be illuminated by the filler is much larger, and the filler intensity becomes correspondingly more important.

Figures are often quoted for the proportion of fill-light that one should advisedly use relative to the key-light intensity. This may be given as a 'key-to-fill' ratio, or as a 'key-plus-fill, to fill' ratio. Provided we realise which is being used, either approach is equally useful—although the preference in colour photography is towards the latter.

We shall see later (Chapter 12) that the illumination of shadow and the consequent reduction of the contrast range in the scene is important if a wide-range subject is to be accommodated within the restricted tonal limits of film and television systems. But in addition to these technical restrictions, there are artistic considerations in choosing fill-light intensity.

To arrange fill-light so that all shadow detail is always visible is to diminish the artistic potential of pictures. Shadow is important. It not only reveals form but it creates areas of lower tonal mass that assist in compositional unity. Pictures without a sufficient proportion of lower tones lack a sense of solidity and three-dimensionality, in a similar way that an absence of highest tones results in a picture lacking sparkle and vigour. Unless well-defined shadows exist, we are completely reliant upon subject tones alone for pictorial variation.

It is often overlooked that the filler intensity must depend very considerably upon the *significance* of the area it is to light. As simple examples, we might take a decorated Greek vase, a proclamation poster, and a wayside notice-board. These might be lit in such a way as to appear bold and clear. Every detail can be read.

We can equally imagine circumstances in which shadow falls upon them, to convey an idea of form or environment, but in a luminous manner so that we are aware of detail, even if it is not clearly discernible.

Lastly, the shadow may be deliberately unfilled, for decorative reasons perhaps, for dramatic purposes, or to intrigue. Perhaps the obscuring leaf-shadows on the wayside notice are moved by the wind, and we suddenly discover a warning of a cliff edge! In even these simple illustrations, the strength of the fill-light is very dependent upon the artistic purpose.

How much filler we use will be affected too by the time of day, the location (an interior may require less filler, particularly if it is shaded or shadowy) and the *mood* of the scene we are seeking to convey.

138

For portraiture, the ratio of filler to key light is influenced by the subject. Where strong, vital modelling is required, fill intensity should be relatively low, although somewhat higher for a woman. For glamorous applications and for children, the high key effect that results from a lower ratio is decidedly more pleasing to the eye.

So statistics are only a guide. Fill-light may be one-half to one-third as bright as the key light. There may be none at all! This is part of the challenge of sensitive lighting balance.

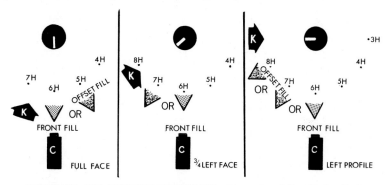

FIGURE 5.5 FILL-LIGHT (FILLER) POSITION The preferred direction for offset fill-light will change for different head positions.

Where light spread is undesirable, in low-key scenes for instance, or considerable distances involved, one may have to use hard light as a filler, notwithstanding spurious shadow formations and nullified key light modelling. If the light is kept to a low enough intensity, one hopes that the key can override these defects.

Filler position

Various opinions are held as to the correct filler position (Figure 5.5). These include:

1 Frontal fill, a camera position fill, placed there irrespective of the subject direction, filling to some degree all areas seen by the camera as shadow.
2 Offset fill away from the key light in full- and three-quarter-face shots, for the shaded area of the face.
3 A similar, but wider angle filler.

The first method is probably the most obvious, for one may argue that there is little point in filling shadow areas that are not

139

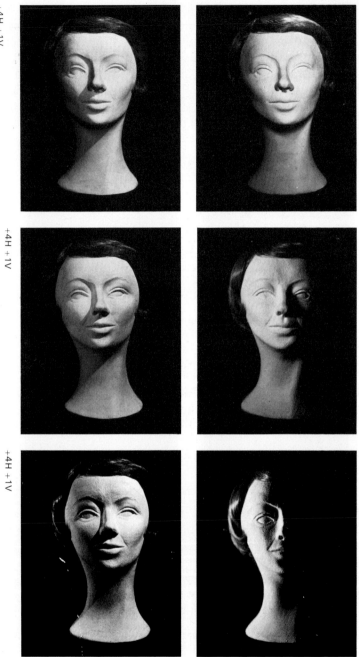

+4H +1V

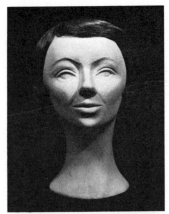

1H 2V

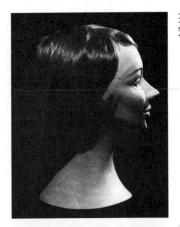

+3H 3V

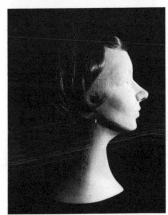

+4H +3V

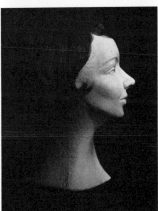

THE HEAD—FILLER POSITION (page 140) Different filler positions for a full face, with the same key light. *Left column*, combined effect; *Right column*, filler alone. *Top pair*, frontal filler; *Centre pair*, 45° left filler; *Bottom pair*, Side filler (left).

(page 141) *Top left:* Frontal filler does not compensate for harsh modelling from a steep key light. *Top right:* A high frontal filler creates ugly modelling on profile keyed from 1H 2V. *Centre left:* A filler at 4H 3V destroys modelling from the 3H 3V key. *Centre right:* Keyed at +4H 3V, the frontal filler controls contrast. *Bottom right:* It does not correct the modelling from an oversteep profile key at 4H 1V, however.

+4H +3V

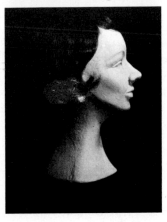

141

seen by the camera. Moreover, there is no chance of accidentally creating erroneous or conflicting secondary modelling such as can arise with more off-axis filler positions (e.g. 4H), particularly when combined with widely angled cross keys (e.g. 8H) on a full face.

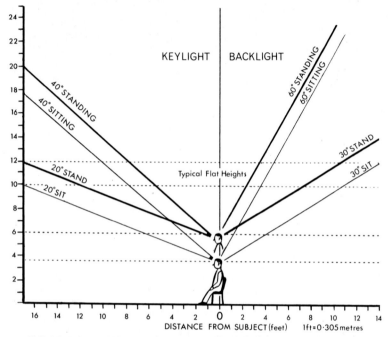

FIGURE 5.6 PREFERRED LAMP HEIGHTS Actual angular measurement is seldom convenient in the studio. Instead, by measuring the lamp distance from the subject, and the lamp height, one can check optimum elevation angles.

It may be fairly contended, on the other hand, that only by offset or even wide angles for the fill can we avoid with fill flooding on to the key-lit area of the face, so degrading the subtle half-tones there. Any fill added to the key-lit side of the face is normally not only superfluous but flattens the key modelling.

For a profile looking camera-left, keyed at 9H, we might use fill-light at 7H to 8H, for this does not destroy the shading towards the back of the head.

Supplementary lighting

This term is sometimes used for the high intensity soft luminant used as a frontal light, while back light (often double-rim or side

142

TABLE 5-I

LAMP POSITIONS AND PORTRAIT LIGHTING

Position	Back Light	Frontal Light
Lamp's vertical angle too steep	Nose becomes lit while face in shadow ('white nose')	Harsh modelling
	Effect most marked when head tilted back	Haggard appearance
	'Hot top' to forehead and shoulders	Black eyes; black neck. Long vertical nose shadow. *Emphasises:* forehead size, baldness, deep eyes. Figure appears busty. Forehead shadows from hair. Hat brims and spectacles shadow badly
Lamp's vertical angle too shallow	Lens flares, or lamp actually in shot	Picture flat; subject lacks modelling
		Shadows on background, behind subject
Under-lighting	Largely ineffectual	Inverted facial modelling
	In women, under back hair lit	Shadows of movement beneath head level (e.g. of hands) appear on faces
	Shadows from ears and shoulders cast on face	Shadows cast up over background
		'Mysterious' atmosphere when under-lighting used alone
		Useful to soften harsh modelling from steep lighting
		Reduces age-lines in face and neck
Light too far off camera axis	Ear and hair shadows on cheek	In full face, long nose shadow across opposite cheek
	One side of nose 'hot'	An asymmetrical face can be further unbalanced if lit on wider side
	Eye on same side as back-light appears black—being left in shadow while temple is lit	One ear lighter than the other

Note: All lamp positions shown relative to camera viewpoint.

143

light) strongly defines the contours of the head. This supplementary is seldom truly diffused, but more often derived from a softened-off hard source. Consequently, its shadow formations, although quite discernible, are subtly gradated.

The sharp modelling of a hard key light can be far too harshly defining for many subjects, particularly where we seek to convey softness, delicacy and subtle contours. So, rather than use such a hard-contrast lamp, which then needs to be alleviated with abundant soft fill-light, a key light of a less strident, softened-off character might be preferred. Such a technique can produce extremely attractive results, and is quite widely used for figure studies, babies, children and elderly faces.

TABLE 5-II

LIGHTING BALANCE

A rough guide to suitable lighting proportions

	Too bright	Too dim
Frontal Light	Backlight less effective	Backlight predominates, often becomes excessive
	Skin-tones high	
	Facial modelling lost	
	Lightest tones tend to be overexposed	Darker tones underexposed. Can lead
	Harsh pictorial effect	to muddy, lifeless pictorial effect
Backlight	Excessive rim-light	Two-dimensional picture; lacks solidity
	Hot shoulders and tops of heads	
		Subject and background tend to
	Exposing for areas lit by excess	merge
	backlight causes frontal light to	Picture appears undynamic
	appear inadequate	
Filler	Modelling from key-light reduced and flattened	Excessive contrast
		Subject harshly modelled

An extension of this approach is the 'soft frontal and modelling back light' treatment, in which the frontal light is highly diffused. This arises naturally in *contre-jour* shooting, where sky light alone illuminates the face, and is capable of producing seductive half-tone or unimaginative flatness, according to the skill with which it is used, and the subsequent processing.

The realities of portraiture

We have examined in some detail how light can create effective portraiture, and how one should avoid disturbing or unattractive shadow formations. And yet we have all seen lively portraits in which the light patch on the nose and burned-out hair highlights suggested dynamic sunlight, or the black eyes and craggy look, epitomised an outdoor scene. Here the lighting process has conveyed an environmental effect that a 'studio portrait' would have missed.

For some subjects there is an intangible transformation process between the person we see and the camera's translation of him. It can be in proportion ('I didn't realise he was such a short man'), age ('She looks much older in the flesh'), or simply an indefinable change that somehow makes the subject look a different person when photographed. Many people appear intriguingly different in left and right profiles.

FIGURE 5.7 SHADOW AND NOSE-SHAPE
1 Nose structure is revealed by shadow formation: (a) by the shadow-edge along the bridge of the nose; (b) by the tip-shadow on the upper lip and cheek; (c) by shading on the nose-tip.
2 Shadow reveals the nose's bridge-structure, and can (a) emphasise the thinness and length of the nose; or (b) the unevenness of a broken or irregular bridge structure.
3 The tip shadow can (a) lengthen the nose, emphasising long or large noses; (b) twist the nose; (c) bend it down.
4 Tip shading (a) shortens the nose length; (b) emphasises retroussé noses; or (c) turns down the nose end.
5 Where light falls upon part of a nose, it may (a) appear bulbous (from steep back light); or (b) broader or bent sideways (from side light).
6 Double nose-shadows are not only distracting but can broaden the nose at its tip.

145

TABLE 5-III

STATIC PORTRAITURE—CORRECTIVE APPROACHES

		Lighting	Camera	Subject
Hair	Light	(11), 15, (18), (20)	B	
	Dark	(10), 21		
	Thinning	11, 15, 16, (18), 20	B	
	Bald	2, 13, 15, 16, 18, 19, 20	B	
Forehead	Prominent	2, 13, 14, 16, 18	B, D	d
	Wide	(3), 5, 8, 10, 13, 14, 18	B, D	d
	Narrow	2, 4, 6, 7, (9), 11, 12	(A)	
Eyes	Deep-set	2, 7, 22	B	d
	Protruding	16, 18	D	e
Nose	Large	2, 4, 6, (7), 9, (11), 14, 16	D	a, d
	Small	1, 3, 5, (8), 10		e
	Broken	2, 4, 7, 9	D	a
	Long	2, 4, 7, 9	B, D	a, d
	Bent	2, 4, 7, 9	D	
Mouth	Large	2, 4, 7, 9, 16, 20	D	b, (c), d/e
	Small	1, 3, 8, 10		
Chin	Large	2, 4, 7, (11), 13, 14, 16, (17), 18, 20	D	a
	Small	1, 8, (10), (22)		
	Narrow	(12)		b, (c), d
Neck	Thick	4, 13, 14, 16, 17, 18, 20	(A)	e
	Wrinkled	2, 7, 11, 16, 17, 18, 20, (22)	(A), C, D	e
	Double chin	1, 7, (11), 16, 17, 18, 20, (22)	A	d
Ears	Large	3, 13, 14, 15, 16, 17, 18, 19, 20	D	b, (c)
	Prominent	3, 13, 14, 15, 16, 17, 18, 19, 20	D	c
Features	Wrinkled	2, 4, 7, 11, 14, 22	C	b
	Unmodelled	1, 3, 5, 8, 10, (12), 18, 20	D	b, (c)
	Broad	5, 8, 10, 13, 14, 18, 20	A, D	b, (c)
	Narrow	2, 6, (9), 11, 12		(c)
Spectacles		1, 3, (9), (11), 16	D	d, e
Figure	Heavy set	2, (3), 5, 8, (10), 13, 14, 16, 19	D	b, (c)
	Slight	(11), 12		a
Disfigurement		14, 16, 17, 18, 19		b, (c)

KEY

Lighting: 1, Raise key light; 2, Lower key light; 3, Offset key light; 4, Key more frontally; 5, Key far side of ¾ face; 6, Key near side of ¾ face; 7, Avoid hard key; 8, Avoid soft key; 9, Watch nose shadow emphasis; 10, Increase lighting contrast; 11, Decrease lighting contrast; 12, Double rim light; 13, Avoid double rim lighting; 14, Avoid offset back light giving emphasis; 15, Reduce back light; 16, Draw emphasis to other characteristics; 17, Hide in shadow; 18, Shade off area; 19, Merge area with background; 20, Use localised scrim; 21, Increase hair light; 22, Include some soft underlighting

Camera: A, Use higher camera angle; B, Use lower camera angle; C, Perhaps use lens diffuser; D, Particularly avoid close wide lens angles

Subject: a, Use full-face position; b, Use ¾ face position; c, Use profile position; d, Tilt head upwards; e, Tilt head downwards *N.B.:* Items in brackets may apply in certain cases.

FIGURE 5.8 CORRECTIVE LIGHTING The human face is rarely symmetrical. Most faces have characteristic unbalance (*left*) or disproportion (*right*).

On camera, such irregularities may be emphasised, but can be disguised with varying success by make-up and, where the subject is stationary, by lighting.

Where the subject is mobile, corrective lighting is impracticable, and irregularities may even be exaggerated if incorrectly lit. For example, by the key light on the wrong side (*left*), by top light, combined top light and backlight, and double-rim lighting (*right*).

Portraiture is an enigmatic process, and we may have to play down or emphasise a feature that characterises the subject in order to make him look right. Even comparing as simple a change as keying a full face from the left, then from the right side, can produce startlingly different interpretations. Most faces are not symmetrical. Move the key to a central spot, and it will change again. Which version best represents an idea of a suitable portrait of that person is a matter for individual interpretation.

Types of portraiture

We can usefully categorise different types of portraiture:

NATURAL Producing an apparently normal, unsophisticated, humanised, everyday representation.

147

FORMAL The 'studio portrait' approach, in which a posed, rather self-conscious air prevails.

CHARACTER A vocational or 'type' image (outdoor, strong, soldierly, etc.).

GLAMOROUS Deliberately enhancing ('beautiful', 'handsome', fashionable).

ACTION 'Activity' portraits, actual or posed, e.g. glass-blowing, dancing or other genre subjects.

BIZARRE Uncanny, ugly, grotesque, exotic, experimental effects.

Such categories remind us how extensively our lighting approach needs to be adjusted to suit the occasion. Something of the harshness of steep lighting, or grotesque edge lighting, may exactly convey the atmospheric conditions of a foundry, or the horror of a hunted man. So too, his pose, demeanour, costume, make-up, etc., will influence our interpretation.

Within limits, lighting can be used correctively to reduce emphasis on facial defects (Figure 5.8). Unfortunately, we may improve one feature at the expense of another, so that double-rim light intended to broaden the face now makes the ears stick out. Or in giving a bulbous face more character with a steeper key, the eyes become small and 'piggy'. Filling in the eyes would then nullify the previous modelling and cause the neck to thicken!

We soon learn to avoid emphasising a broken or generous nose with coarse or strong highlight shading, to prevent the long nose being lengthened with a shadow beneath, or twisting the tip of a pointed nose with a diagonal side-wing.

Although a person may nominally be static, natural animation causes a certain amount of head movement; nose shadows slither to and fro, and modelling changes subtly. The nose-tip catches a back light momentarily. One notices eyelash shadows on the side of the nose. The face is in motion—and all that that signifies.

It is as well that we should consider this point for a while. It is the moment of truth in all portraiture for motion pictures and television. As faces tilt and turn, our carefully positioned shadows sweep across the features. We begin to appreciate that lighting must be set with head movement in mind. A delicately poised cheek triangle that only exists at one head angle but disintegrates into a long nose shadow or a half-lit face at others, provides indifferent portraiture. The solution is to avoid very critically

148

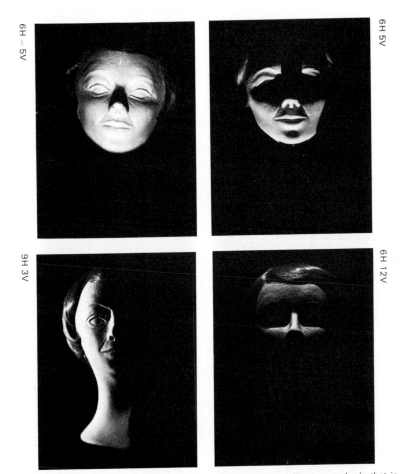

EFFECTS LIGHTING Sometimes one deliberately creates modelling or emphasis that is not normally acceptable. These extreme examples show typical dramatic applications. *Top left:* Underlighting, used to create an uncanny, horrific effect. *Top right:* If the lamp is too steeply angled, though, the eyes may become shadowed. *Bottom left:* Side light bisects the face, giving strong, coarse modelling. *Bottom right:* Top lighting renders the head skull-like, and is used to convey ageing, sordid surroundings, crudity, harshness.

positioned lamps and to anticipate movement. For one cannot fall back upon the skills of the retoucher nor, as with the painter, leave out what we do not like!

If, for a full-face shot, our key is well offset (e.g. at 8H), when the head turns into the key, the light may become centrally aligned to the nose, and the modelling satisfactory. But where the head turns away from the key (towards 4H), the features are virtually flattened on the key side, with unattractive cheek and eye-

149

socket shadows appearing on the nose. The significant frontal region of the face is shaded (lit by filler alone) and the cheek/ear/neck area over-emphasised.

This is the beginning of the quandary of multi-camera shooting, to provide lighting that is equally successful from several viewpoints.

Group portraiture

Static, or relatively static, groupings of people are regularly encountered in TV and motion pictures. We find them in interviews, panel games, production numbers, in drama, demonstrations, and so on. They consist of recognisably repetitive arrangements of two or more people. In lighting a single portrait we had every opportunity to tailor-make the lighting to suit the characteristics of that individual. Now let us see how far we can apply these principles to more complex set-ups. .

The two-group

Strictly, one would want to treat the subjects (Figure 5.9, part 1) as two separate portraits (*b*), but space restrictions or facilities may be too limited, and certain lights may have to be communal (*c*). This is necessarily a compromise, for a light of suitable intensity as a key for one person may be excessive as a back light for the other. Fortunately, partial diffusers can often correct this imbalance (e.g. by reducing the lower portion of a beam).

Variations on this theme (*d*) and (*e*) are sometimes applied: (*d*) to achieve the key on the far side of each face; (*e*) to ensure that the nose shadows are hidden in both profiles.

The three-group

In television, the 3-group is a common discussion arrangement, and yet it poses a surprisingly knotty problem. The difficulty lies in maintaining good portraiture for the middle person on cross-shots. A typical breakdown is shown in Figure 5.9, part 2.

There are several possible lighting approaches. Drawing (*a*) shows each individual lit separately, with communal fill-light. Each can be balanced for optimum effect, but the frontal filler is at too wide an angle for the side speakers. Although good for a forward-facing middle-man, cross shots on cameras 1 or 3 reveal poor bisection when he looks left or right.

150

Drawing (*b*): slightly improved, the fill-light has been split, to serve more suitable angles, while for convenience or economy, the side speakers share key/back lights. The central speaker is individually lit as before.

In drawing (*c*) the group is communally lit with key/back lights and now, balance apart, the middle-man is quite well lit on cross shots. If, however, he faces forward, he is bisected by two side lights. A localised frontal key might be faded up to override this effect, but the result is not always acceptable. Any attempt to fill out the 'badger' shading leads to unduly flat treatment.

The quandary of providing good portraiture for a person who looks to either side as well as to the front has no foolproof solution. We shall examine the problem of portraiture for the moving head more closely in the next chapter (Figure 6.2).

The panel group

An arrangement (Figure 5.9, part 3) that many would consider television's own, is the panel-game grouping. A line of people (usually desk-bound) faces a chairman, or a further team of contestants.

Approaches here range from communal key, back and fill-lights, to subdivisions, providing individual key and back lighting, but a communal fill-light. Apart from the problem of isolating each person's lighting from that of his neighbour, this last clearly provides a more satisfactory control of each person's requirements, particularly where hair, flesh tone and costume differ considerably.

Large groups

With audiences, orchestras and crowds, we have a further increase in scale. Communal portraiture. Large groups (Figure 5.9, part 4) again, may be lit *en masse* with a community key light, back light, and fill-light (as if lighting one rather spread-out person), or, more visually, we may subdivide the mass into areas or blocks and give each suitably directed group treatment.

Portraiture of surprisingly good quality can often be obtained under these less promising conditions. But, due to the narrow lens-angle required of the camera for closer shots, rather stronger modelling than normal (i.e. less fill-light) may be needed to model

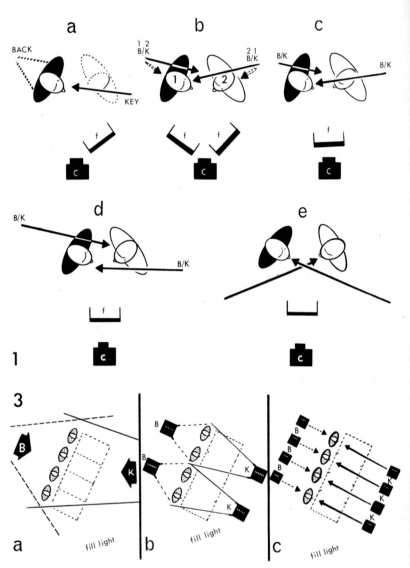

FIGURE 5.9 GROUP LIGHTING
1 The two-group. From the basic portraiture lighting set-up (*a*) the two-group treatment is derived (*b*). This may require simplification (*c*) in the form of communal lamps (due to close subjects, or lamp economy); but then relative angles and intensities become a compromise. The illusion of subject solidity is good. (*d*) This approach maintains the key light on the same side of the faces when cross-cutting, providing greater modelling for the right-hand subject. (*e*) This method projects both nose shadows away from the camera, making them less obtrusive; but solidity is reduced in both portraits.
3 The panel-group. (*a*) Lit *en masse*, (*b*) sectionalised, (*c*) localised.

152

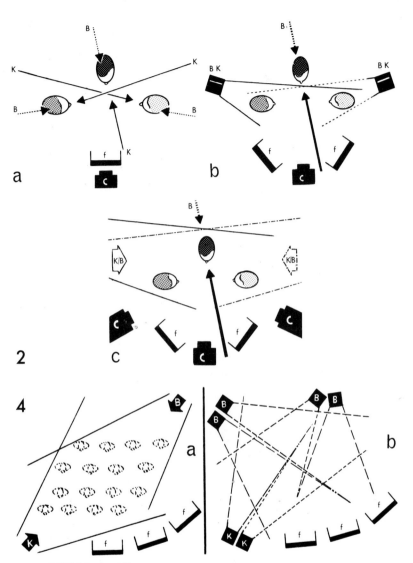

FIGURE 5.9 (contd.)
2 The three-group. (a) Lit individually, with communal filler. (b) As a wide two-group plus a central individual. (c) As an overall group with supplementary lighting.

When lighting such group shots there are several regular considerations:
(i) Potential sound-boom shadows on end speakers when using in-line or horse-shoe layouts. (ii) Where speakers are closely-positioned, isolated individual lighting may be impracticable (spurious adjacent spill-light). (iii) The cross-frontal keys used for in-line seating, tend to move progressively upstage for more horseshoe-shaped formations.
4 Large groups. (a) Lit *en masse*, (b) sectionalised.

153

faces and compensate for the unavoidably compressed features that the lens introduces by perspective distortions.

'Natural' lighting

Perversely, our assessment of portraiture rests largely upon the environment in which the subject is seen. Standing beside a window, a person may appear more convincingly lit with a bisected

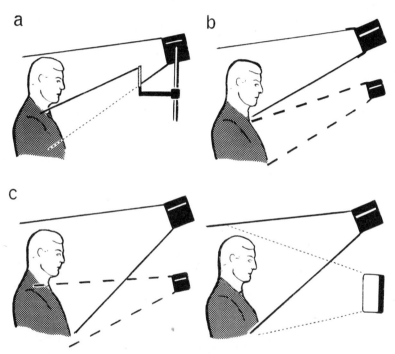

FIGURE 5.10 CLOTHES LIGHT The amount of light required by clothing may differ from that needed for portraiture. Differentiation may be achieved by: (a) a scrim or half diffuser to shade off the overlit area; (b) separate lighting; (c) augmented lighting.

half-light, half-dark face than if we introduced more attractive treatment. If we look at this face in an isolated close-up, the 'poor lighting' can be unforgivable. In an external shot, dark eyes and long chin shadows will go further to convey an open-air atmosphere than orthodox methods.

Against-the-light shots may produce glamourised portraiture. But when we intercut such a viewpoint with a reverse-angle shot

154

showing a companion facing into strong frontal lighting, the juxta-position is disturbing. In this instance one may need to rationalise the lighting and make it more compatible for both viewpoints by reducing the contrast.

When the subject is positioned near a visible light source, distorted or crude modelling may not only be acceptable, it may be the only way of creating a wholly realistic illusion. But we should be wary of deducing from this that it does not matter how one lights a subject and that it is all a matter of taste and opinion. Nor should one stick slavishly to a rubber-stamp concept of precise key/back/fill positions. Those who suggest that certain 'filmic' lighting techniques can outwear their use, are as right in their way as those who condemn the empiricists and available light 'happenings' that have also had their vogue. All art forms have fine works born of accident: But such accidents seem to happen more reliably and more frequently for the initiated.

6

PORTRAITURE—DYNAMIC TREATMENT

The nature of dynamic treatment

Up to now we have been considering techniques for lighting the *static* person. With a stationary subject, we usually have time to examine the features carefully and decide from their proportions how best to enhance or emphasise particular aspects and playing down others. We may find that by moving the key light slightly higher, the cheek-bones become much better modelled; the back light is just catching the tip of one ear; that slight facial blemish would be less apparent if the filler were moved to one side.

But these refinements are for a static subject, under our control. What happens when we have to light subjects that move about? After all, we have seen how the appearance of a subject changes with the direction of the lighting, and with variations in the camera viewpoint.

In television and motion picture photography, lighting must be arranged so that one achieves continuity of effect, despite subject and camera movement. The audience should sense no changes in the characteristic appearance of the subjects—in their shape, size, age, attractiveness, construction, nor in the time or condition of the environment (night in one shot, day in another; a change from sinister to gay, etc.).

How great a problem this is, depends upon several factors, including what the viewer is looking at, and how well he can see defects. Indifferent facial modelling may pass unnoticed as he is preoccupied with events, or may simply be accepted as an environmental effect. In longer shots, with full-length figures and more distant views, facial modelling is less critical. But for waist-shots and closer it becomes important. Where movement is fast or extensive, poor modelling can pass unnoticed, but once the subject comes to rest, we can begin to apply the principles of static portraiture.

156

Lighting action areas

There are several ways of going about lighting for movement. As one would expect, they all derive in principle from the 'three-point lighting' concept (key/filler/back light) discussed earlier in regular portraiture.

Basically the technique is a methodical illumination of area. This is necessarily the way in which you begin to tackle dance routines, full-stage activities, or start to light when details are unknown, action widespread, or time and facilities restricted. The individual procedures may be defined as:

1 Overall three-point lighting (Figure 6.1, part 1).
2 Dual-key area lighting, providing key, filler and back light of some sort for most camera positions (Figure 6.1, part 2).
3 Soft frontal light with modelling three-quarter back light (Figure 6.1, part 3).
4 Side keys: hard light along the sides of the setting providing key and back lights, with soft filler from the front of the setting (Figure 6.1, part 4).
5 Localised areas of three-point lighting (Figure 6.1, part 5).

Part 1 This is the first of the so-called 'general lighting' methods. Here we have a mechanical solution that may, with luck, provide surprisingly good results, if cameras do not cross-shoot too obliquely. The back-light position is arbitrary, varying from one dead back (2), to one or two three-quarter back lights (3, or 1 + 3). The hard key-light position may be related to mechanical rather than artistic considerations (i.e. to location structure, or to suit the sound boom).

Part 2 An improved approach divides the area into two sections with single or dual back lights.

Part 3 By providing a strong overall base, or foundation light to flood the whole scene, we can prevent any areas being under-exposed, and restrict tonal contrast.

The subject is usually seen clearly enough, but the result is relatively flat and uninteresting—even with colour to assist in the differentiation of planes. If the soft light is given emphasis from one side, rather than distributed as even, overall illumination, basic modelling is improved. Adding three-quarter back spot-lights can increase modelling—particularly from oblique camera angles.

157

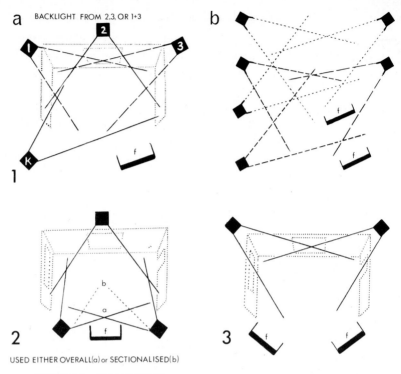

USED EITHER OVERALL(a) or SECTIONALISED(b)

FIGURE 6.1 AREA LIGHTING
1 Overall three-point lighting. (a) Total treatment for smaller areas. (b) Sectionalised treatment for large areas.
2 Dual-key area lighting.
3 Soft-frontal area lighting.

With care, the results can be attractive, with *contre-jour* quality, but, at worst, haphazard and mediocre, with indifferent modelling.

Part 4 A more sophisticated treatment, which is capable of very high quality results, employs a strategically angled base of soft lights frontal to the setting. Along the side walls of the setting are spotlights carefully positioned to suit the requirements of local action areas.

For many camera positions these lamps become well-angled keys and back lights. They will be frontal to obliquely angled cameras and suitably side-angled for frontal cameras shooting profiles.

Although this technique may produce high-grade lighting (and assist in avoiding boom-shadow problems—Figure 10.4) it does

158

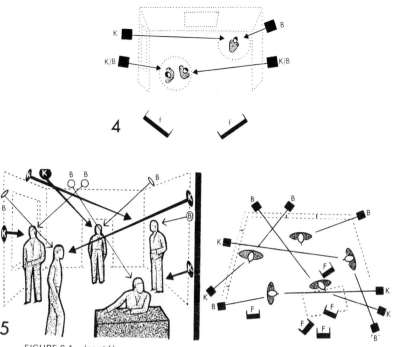

FIGURE 6.1 (contd.)
4 Side-keys area lighting.
5 Localised areas of three-point lighting.

suffer from the arbitrary filler angle, and a likelihood that abundant soft light may over-illuminate walls of flatten modelling.

Part 5 Here we have the most developed, discriminating method. Each position is individually lit with, as far as possible, its own key/filler/back light. Easiest when positions are dispersed and head-movement limited, this tailored approach offers lighting of the highest quality.

The dilemma of lighting movement

Of course one would like to be able to light each individual camera shot for optimum effect. In motion pictures this is axiomatic. It can be feasible in television, in a tightly directed production for limited-angle shooting. But where action is continuous or cameras widespread, one is usually obliged to compromise. If skilfully handled, this compromise need not be obvious.

159

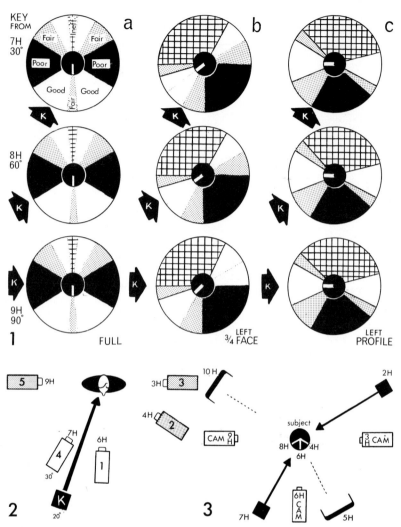

FIGURE 6.2 THE EFFECT OF MOVEMENT By relating separate zonal plots (Figure 5.3), the effect of moving the head or the camera viewpoint can be ascertained. Where results deteriorate, corrective adjustments become necessary.
1 The moving head. Comparison reveals how far one key light will maintain satisfactory portraiture for wide head turns.

Examples show the effect of head movement when the subject is lit for (a) full face, (b) three-quarter face, (c) profile.
2 The moving camera. Moving the camera between viewpoints 1–5, we see in this example, that the key light (K) becomes:
Camera 1 Good (see Figure 5.3(a)); *Camera 2* Fair (see Figure 5.3(c)); *Camera 3* Fair (see Figure 5.3(d)); *Camera 4* Good (see Figure 5.3(b) mirrored); *Camera 5* Fair (see Figure 5.3(d) mirrored).
3 A set-up may sufficiently suit all directions for isolated subjects.

160

Even with quite long continuous takes, it is possible to provide ideal lighting, given suitable subject movement and camera treatment. Paradoxically, certain quite complex action may readily be lit to perfection, while other seemingly simple moves precipitate mediocre portraiture. Let us take an example of the latter.

Imagine that a seated person must adopt a series of head positions, e.g., with the camera at 6H, he faces variously 3, 4, 6, 8, 9H. We may find that a frontal key is rather too flattening for certain facial angles, while modelling is just right for others. A black-eye or crawling nose shadow may develop for some positions, and become aggravated if he also tilts his head downwards.

HEAD DIRECTION *Top left:* For a three-quarter right face, the optimum key direction is from the region in which the head is facing (+4H +1V). *Top right:* However, when the head turns towards the front, a prominent nose shadow forms. *Bottom left:* When the head looks camera left, away from the key, modelling is decidedly unattractive.

161

And yet here we have just one seated person whom we cannot light to our satisfaction.

Ironically, we can find ourselves with what appears to be quite complex action, and yet be able to treat it exactly as we wish. If, for instance, several people go to a number of localised spots but when there, look in specific directions only, surprisingly simple solutions can be supplied. There is such a situation in Figure 6.1, part 5. Each 'action point' is individually lit to suit the action there. In many settings there are chairs, tables, doorways, windows, fireplaces, where such localised lighting set-ups are feasible.

If the action there becomes too variable, we may have to accept the shortcomings, introduce first-aid improvements for certain shots, or convert the lighting to a more suitable treatment. We can, perhaps, light 'key shots' and leave others with less than optimum quality.

Methods of lighting for movement

How does one accommodate movement in individual people? There are several approaches, any or all of which are to be found in television and motion picture production lighting.

Figure 6.3 shows typical examples of these techniques. The principles are easily understood, but their practice is part of a highly complex series of judgments.

1 We may not find the lighting difference distracting; although it is better for one position, the other is adequate (Figure 6.3, part 1).
2 Positions may be sufficiently displaced to permit separate lighting treatments (Figure 6.3, part 2).
3 An anticipatory dual set-up may serve both equally well (Figure 6.3, part 3).
4 Lamps may have dual functions, e.g., a back light becomes a key, and the key a back light (Figure 6.3, part 4).
5 An additional, supplementary lamp could be brought in to augment the new position (usually a soft light), perhaps with rebalance (Figure 6.3, part 5).
6 The main lighting might be augmented to improve a particular position, e.g. extra key for an intermediate position (Figure 6.3, part 6).

162

7 Strong auxiliary fill-light may be introduced to 'key' or over-ride poor modelling from additional camera positions, perhaps with rebalance (Figure 6.3, part 7).

8 Existing lamps can often be rebalanced to give them a different relative importance (Figure 6.3, part 8).

9 It might be better to switch or cross-fade to a new set of lamps. As one set of lamps is faded out, another set is faded up, so that they change smoothly from one treatment to the next (Figure 6.3, part 9).

10 The subject might be followed with its own specific lighting (e.g. a follow-spotlight; Figure 11.11).

Optimised portraiture

For most productions our prime aim is to show participants at their best. Whether emphasis is on personality or glamour, our intention is to present an image that the audience will interpret as 'attractive'. Now although attractiveness itself is very much 'in the eye of the beholder' and therefore not easily assessed, it is possible, as we saw in Chapter 5, to outline various aspects of portraiture that are generally regarded as displeasing.

Some of these effects are very evident, such as 'black eyes', haggardness arising from top light, over-bright hair. Others are somewhat less disturbing, or less obvious, but nevertheless detract from the subject's appearance. Among regular examples of these, there is the de-characterisation arising from flat lighting, emphasis on facial unbalance, and lighting that draws attention to physiological shortcomings.

It can be argued, therefore, that as human heads follow a reasonably consistent form, and parameters for unattractiveness are distinguishable, portrait lighting must inevitably settle around certain systematic techniques; these methods being adapted to suit the particular configurations of individual subjects. Conversely, we can provide calculatedly unattractive effects too, when occasion demands.

Possibly one of the greatest hazards in lighting for movement, lies in inconsistency; in failing to maintain continuity of effect with changes in camera and subject positions. If lighting has been devised to convey glamour or age, it should continue to portray this in successive shots. As we have seen, various subterfuges are

163

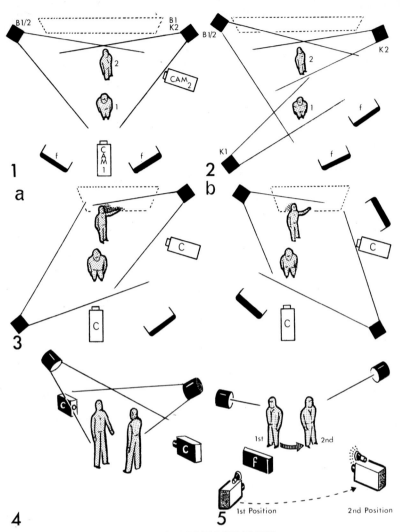

FIGURE 6.3 METHODS OF LIGHTING FOR MOVEMENT
1 Preferred position. Preference is given to one head position while another remains only adequately lit. For Camera 1 adequate; Camera 2 good portraiture.
2 Separate isolated set-up. The subject moves from one lighting set-up to another (perhaps including dual-function lamps).
3 Dual set-up. Lamps are arranged to serve both head positions equally well.
(a) Portraits good, but defacing shadow on map. A non-anticipatory solution.
(b) Anticipatory dual solution avoids map shadows.
4 Dual-function lamps. Lamps serve as key lights for one shot, and back light for another. (See Figure 5.4, part 4.)
5 Supplementary light. A supplementary lamp augments the second position; e.g. as the subject moves away from the filler, a camera lamp is faded up to provide fill-light.

feasible to control lighting direction and balance as conditions and viewpoints change.

Experience suggests that our assessment of pictorial continuity usually derives initially from tonal contrast, and only subsequently from light direction. (Key directions can often be cheated considerably without interrupting pictorial flow.) If one shot presents a contrasty effect (e.g. *contre-jour*), the picture will seldom intercut readily with another of low contrast (e.g. frontally lit) unless there are obvious environmental explanations for the

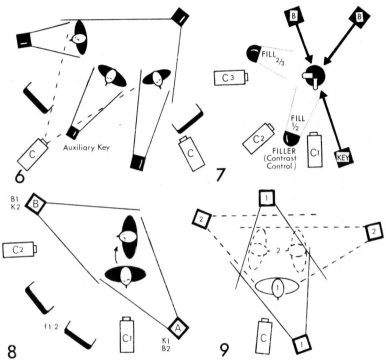

FIGURE 6.3 *(contd.)*

6 Auxiliary key. A localised auxiliary key may be added to meet an intermediate position between two main areas.

7 Auxiliary fill-light. A strong auxiliary fill-light serves as a 'key' for other subject or camera positions (but is liable to give poor key and back light angles, and picture quality variations).

8 Rebalance. The intensities of existing lamps are readjusted for the second head position (e.g. for Camera 1, Lamp A is strong, Lamp B is weak; rebalanced for Camera 2, so that Lamp A is weak and Lamp B is strong).

9 New lighting set-up. Switching or cross-fading to a different set of lamps lighting the same area (e.g. from Group 1 to Group 2).

dissimilarity. (Where, for example, interior/exterior viewpoints are intercut of a person beside a window.) In realistic drama, light intensity, balance, and direction must usually be consistent with the environment. There are anomalies. If an actor passes an incidental practical lamp, any increased illumination as he moves past would be a valueless disruption of continuity. But if this light represents an important environmental source, the total illusion would appear quite false if we maintained an even light intensity throughout. In more stylised productions, such niceties seldom arise.

7

STILL-LIFE

The varying nature of still-life

The broad classification of *still-life* encompasses a vast range of subjects—all artefacts and inanimate substances, from simple flat planes, to the most intricate and elaborate object arrangements. For any study of still-life is primarily concerned with the persuasive presentation of *materials*, whether they form part of a mighty edifice or a tiny machine-tool. An article may be presented in an advertising display, or just form an incidental part of the furnishings of a setting, but if it is not appropriately lit, its purpose is that much diminished. As with portraiture, the precision and complexity of the lighting treatment will be influenced by the closeness and clarity with which we see the subject.

In lighting such materials, our methods depend largely upon our purpose. We may be trying to recapture the sensual pleasures of food in the way we light some luscious fruit. Or we may be wanting to reveal exactly how its surface texture betrays a parasitic fungus. Again, perhaps we are simply intrigued by its decorative value. Our aims determine our approach.

Scrutinise the familiar

Let us begin by reminding ourselves of the obvious—we overlook it daily. We rarely scrutinise the familiar. Particularly in lighting familiar subjects and materials, we have to coach ourselves to see what is actually there, not what we assume to be present. We must not overlook detail that habitual glances have taught us to ignore. As we have seen, in revealing a subject, light influences our impressions of size, distance and planar relationships. We must take care to examine the subject for what it really is, and use light to selectively portray the appropriate characteristics.

Distorting reality

If all planes are lit equally, any illusion of modelling and depth is destroyed. But we must not forget that directly we cause specific planes to be gradated or to fall into total shadow, we may begin to modify or obscure some other detail. In creating strong visual clues about contouring, for instance, the shaded surface may now make surface printing hard to read. A bottle that looks solid

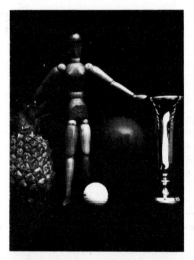

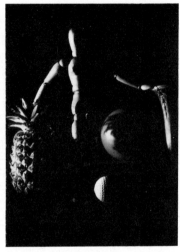

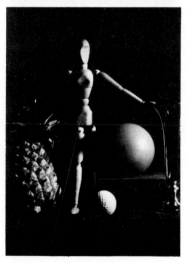

TEXTURE AND FORM This group was lit *Top left:* frontally, *Top right:* edge-lit from 9H, 3V and *Bottom left:* edge-lit from 3H 3V. Try comparing the extent to which each version conveys the shape, texture, contours, materials of each object. Although the first displays the silver vase best, the ball is least effectively shown. In it the woodgrain is clear, but the pineapple's surface is less pronounced. In the second its shadow obscures the ball's shape.

enough to jump from the screen, but with a label that is hard to read, or alternatively a crystal-clear label on a vaguely defined bottle, may be our difficulty.

How thwarting all this is in practice, varies with the subject, and our intentions. A human face can be grotesquely lit but still decipherable as such—although we may no longer be able to recognise the person. But with less familiar subjects slightly wrong emphasis or obscured detail may make them incomprehensible.

APPEARANCE CHANGE WITH LIGHT DIRECTION (1) *Top left:* Illuminated by dead frontal lighting, equal emphasis is given to all front planes. *Top right:* Predominantly backlit, the outline is emphasised. *Bottom right:* Side light from 3H 3V emphasises certain features, while obscuring others.

169

This is one of the principles of camouflage disguise techniques, in fact!

Unsuitable treatment renders materials ambiguously, or wrongly, e.g. making skin appear waxen, or velvet look bristly. One could light a textured surface so ineptly that it would reproduce as if smooth. Again, if its characteristics are over-emphasised, a subject becomes transformed in a strange, coarsened or simply distracting fashion. Better to imply, to subtly suggest, rather than underline

APPEARANCE CHANGE WITH LIGHT DIRECTION (2) *Top left:* Lit from 9H 3V, the emphasis is now moved. Unimportant aspects are highlighted and required details lost. *Top right:* By turning the subject through 45° required details are now visible with this same key at 9H 3V. But subject shape has become distorted from this new viewpoint. *Bottom left:* Instead, two side keys at 3H 3V and 9H 3V create effective modelling from the optimum viewpoint.

SURFACE INTERPRETATION *Top left:* Flock wallpaper has here been arranged horizontally and vertically. Shining down on to the horizontal surface light shows only slight detail. But edge-lighting the vertical plane details are thrown into sharp relief. Hence our interpretation of the surface varies with light angle. *Top right:* Under a spotlight, the jug appears dark, glossy, but smaller than the identical version *Bottom left:* lit by soft bounce-light. Now the surface appears more shiny as light surroundings are reflected. Its tone seems lighter, its surface more strongly marked. But when highlights are dulled (*d*) *Bottom right:* or dark surroundings reflected, the finish appears quite matte.

Our camera position, its lens angle, and the subject aspects we see, must influence our interpretation of the picture before us. Foreshortening due to a narrow lens angle, exaggerated perspective from a wide-angle lens, or an unusual viewpoint, can influence our impressions of scale and clarity.

Of considerable importance in lighting still-life is the effect of textural lighting—its oblique rays skimming the surface, throwing irregularities into sharp relief. As we saw earlier, we can control this by the angle and hardness of the source, and the amount and direction of the fill-light.

Shadowless lighting techniques enable one to concentrate upon tonal and colour relationships, but at the risk of suppressing texture, modelling and form entirely. Perhaps that is exactly what we are seeking.

Strongly cast shadows create decorative patterns over subjects and backgrounds alike, but with the danger that the subject itself will lose its identity or characteristic form, and become reduced to just another pattern.

Concentrating attention

A sympathetic background supports the main subject without diverting attention from it. So we may use plain, shaded, textured or embossed surfaces, while avoiding those that are heavily patterned or of dominant colour.

It is essential to relate the subject to its surroundings and to other adjacent subjects. All too often the viewer's attention is drawn to intriguing nearby items rather than those upon which he should be concentrating. Or again, lighting and composition may not direct attention appropriately. Subjects may become unobtrusive and be lost amongst a welter of bric-à-brac that is intended to be supporting and enhancing them.

Lighting common materials

The practices involved in lighting still-life would merit a study in their own right. Here, in Table 7-I, we can only discuss principles and outline pointers to methods suitable for particular materials.

When lighting small displays, our main difficulties lie in localising light for specific items; preventing unwanted shadowing, and ensuring that the fill-light illuminating shadows and con-

TABLE 7-I

TYPICAL LIGHTING TREATMENT FOR COMMON MATERIALS

Fabric	Cotton	S, mF, sa/sl, (z)	9
	Wool	H, wF, sa/sl/la, (z)	
	Tweed	sH, wF, laK	
	Silk	S, msl	3, 5, 8, 9
	Damask	sS	2, 5, 9
	Velvet	sH, sF, saK	
	Filmy	wK, sB	7, (9), (11)
Fur		sH, sF, saK/laK	
Feathers		H, sF, wK, sB	(7), 10, (11), 12
Canvas		sH, mF/nF, vlaK	
Leather	Smooth	mS, sl(m)	2, 4, 5, 6, 8
	Grained	S, sl(s)	
	Rough	H, wF, vla	5, 6
Wood	Natural	H, wF, sa	(14)
	Polished	S	1, 2, 3, 4, 5, 6, 8, (14)
Paper	Matte	S, sa	(z, 7), 13
	Shiny	S, sa	3, 4, 5, 13
Metal	Cast	H, mF, sa	(14)
	Machined	S	2, 3, 4, (14)
	Polished	S	1, 2, 3, 4, 5, 6, 8, (14)
Stone	Natural	sH, wF/mF	9, (14)
	Tooled	sH, wF/mF	(14)
Plaster		sH, mF	(14)
Plastics		S	1, 2, 3, 4, 5, 6, 7, 8, (z, 11), 12, (14)
Glass	Sheet	S	1, 2, 3, 4, 5, 6
	Formed	S	1, 2, 3, 4, 5, 6, 7, 8, 10, (z, 11), 12
	Solid	S	1, 2, 3, 4, 5, 6, 7, 8, 10, (z, 11), 12
Pottery	Unglazed	H, wF/mF	(14)
	Glazed	S	2, 3, 4, 5, 6, (7), 8, (14)
Liquid		S/H	1, 2, 3, 4, 7, 8, 12
Flowers		sS, sl, sB	(7), 10, 12, (14)
Foliage		sH, mF/sF	3, 6, 7, 10, 12, (14)

KEY

Light character relative to camera position

K, Key (hard light); F, Filler (soft light); B, Back light; s, Strong; m, Medium; w, Weak; H, Mainly hard light; S, Mainly soft light; /, Alternative choice; sa, Slightly angled to surface; sl, Side light; la, Low angle to surface; vla, Very low angle to surface; nF, No filler

1, Surface is revealed by reflections (lights, nearby objects)
2, Avoid excessively large areas of reflection
3, Avoid too many reflected highlights
4, Avoid spurious flares reflected from surface
5, Avoid reflections concealing surface pattern
6, Dulling surface by spraying, waxing, etc., masks character
7, Back light reveals structure and translucency
8, Overall sheen or gloss best revealed by large broad sources
9, Avoid hard sculptural effect
10, Avoid confusing shadows
11, Silhouette subject relative to background
12, Defocus background to isolate subject
13, Preferably use symmetrical lighting
14, Pronounced background lighting on shadow side of subject
z, Depends on material's purpose
(Entries in brackets are not always applicable.)

TEXTILES This group of materials has been lit (a) *Top:* frontally, (b) *Bottom:* by backlight at 12H 11V. The textiles used are, left to right, velours, slub rayon, satin, pure silk, cotton, linen, crêpe de Chine. Note how the appearance of some of these materials changes. For some, the backlight creates hot spots as horizontal planes bloom-out.

trolling contrast does not reduce texture or create disturbing highlights. For larger areas—and this includes total environment and settings—principal problems are in the number and power of lamps required to suit the various textures and forms; in finding suitable lamp locations that are both effective and yet unseen; in preventing light over-shoot onto adjacent areas, while maintaining a unified effect.

8

PERSUASIVE LIGHTING

The art of conjuring up a feeling of atmosphere and environment, and presenting it persuasively on the screen, is derived from no formulae but from accumulated perceptive observations. Although we cannot hope to devise rules-of-thumb for atmospheric lighting, there are certainly many contributory factors well worth studying here.

The intangibility of lighting

Atmosphere is a deceptive concept. We may achieve it with the utmost simplicity, as when a powerful, arresting, low-key shot derives from a single judiciously placed side light. Conversely, we may need to patiently build up lamp by lamp, until a total, convincing illusion has been created; until our studio setting has taken on the firm reality of an actual modern interior. To the viewer, it is simply that—a room inside a *real* home and he may even be left with the conviction that the place actually exists. But what makes it look that real? What causes one treatment to look contrived and theatrical, while another even surpasses reality? Here is the self-effacing character of pictorial illusion.

The lighting director, like the rest of the production team, follows an ephemeral art of make-believe. The greater their success, the less will their ingenious stratagems be apparent. For lighting this is probably truest of all. The scenic arts are impressive and tangible. We can watch them grow. We can go up and examine them. We can enjoy the very novelty of reconstruction, as from basic scenic units a village square springs up within the studio walls.

What of the studio lighting for such a scene? On the screen a pattern of light and shade evokes an atmospheric impression, guiding our attention, inducing emotions. But none of this is evident in the studio. A wide gulf lies between the influential

screen image, and the mechanics to be seen on the studio floor. Looking around the lit settings we see nothing of the picture's appeal, the interplay of form and colour and the mysterious shadows. Only when we take a person and position him in exactly the right place, we see, from the camera viewpoint, how the lighting has been arranged to capture the character and form of the face. In an empty setting, it is just so much bright, hot light from innumerable lamps stabbing the darkness.

Once analysed, the lighting techniques become 'obvious', but synthesis—the build-up of this treatment—is a very different matter. Part of the lighting director's art is to make allowances for the disparity between what is before the camera, and the version that becomes transformed on the screen—a calculated transmutation that needs the imaginative anticipation of experience to achieve. But even when one seeks to strip bare the mechanics, the mystery of this alchemy, the fascination of the lighting process, remains.

First impressions

Without doubt, the creative artist in motion picture and television production has one outstanding difficulty. He cannot recapture the very essence of his work that is of supreme importance to his audience: the innocent eye or, in other words, first impressions.

For the audience, both sound and picture have an instant significance. But for those involved with a production, familiarity inevitably colours their estimation of this impact. This is easily demonstrated. When a film is watched through several times the relative actions take on subtly different values. At each showing details become apparent that were previously overlooked.

Such familiarity can so easily separate the creator from his audience. We should ponder on the issues that lie between the mental concept, or intention, and the screened effect. Many a wondrous idea, by the time it has been interpreted and interpolated, comes out looking disappointingly like 'the mixture as before'! A great atmospheric sketch can too easily lose its magic between the drawing board and the studio floor. Settings become familiar friends as we work within them so that we grow accustomed to items that may have obtruded initially, whereas something that was at first insignificant may develop a growing value or attraction.

176

A scenic designer may derive a satisfying inner glow from those little touches of authenticity—the bunch of real garlic in the kitchen, the true-period bric-à-brac. But does the camera see them? Do they register upon the audience? In lighting, too, a cunningly devised window shadow that captures the mood exactly, may be just a defocused smudge on the screen. And yet it is the authentic touch that brings conviction. We have only to light inappropriately the backing beyond those imposing windows, for

LIGHT RESTRICTION *Top left, top right:* Localised areas of lighting can convey a sense of subject confinement. Hard-edged light patches give this impression most strongly; according to the position of the subject. *Bottom:* Soft-edged areas of light do this to a lesser degree.

177

the entire room to take on an unconvincing falseness. It is so easy to admire and appreciate factors that are not decisive and contributory to the shot the audience sees and reacts to.

Familiarity with the studio scene can give us an understanding of location that the audience cannot have. Strange shadows may come from an overhead tree-branch that is unexplained to the audience, but we may accept this part of the studio setting because it is so familiar.

On the screen, the camera is our eye. We rely upon it and the accompanying sound to build up our concepts. In the studio, walking around a setting, private impressions are gradually amassed. But from the restricted viewpoints of a camera, especially for closer shots, various facets of this studio scene may not be apparent. Again, the editing process (itself subject to this pre-knowledge problem) may eliminate in the finished version certain valuable influences that were originally recorded by the camera.

Such phenomena are something more than philosophical precepts. They are a reminder of a few hazards of the creative process. And in lighting, as with all the other contributions to the production, success comes not from what we know is there but how it will appear in the screened image.

Lighting style

There are three broad approaches to the problem of depicting the three-dimensional world in the flat picture.

Silhouette

Relies entirely upon subject outline, completely obliterating the colour, tone, texture and surface modelling of the subject. We meet silhouettes in decorative applications (e.g. ornamental shadows), dramatic effects and when shooting against the sun (*contre-jour*). Fundamentally, the subject is in each case unlit but placed against a bright background.

Notan

Directs attention to outline, surface colour and detail, but is not concerned with the solid form of the subject. Its emphasis is upon presenting a flat, two-dimensional effect in which pattern and

178

PICTORIAL STYLES Various pictorial styles are shown here, including *Top left:* Notan *Top right:* Silhouette *Bottom:* Chiaroscuro.

surface detail and colour predominate. We achieve notan effects with flat, low-contrast lighting and negligible back light. Shadows are eliminated as far as possible. A technique mostly used for fashion shows and large-area dance routines.

Chiaroscuro

The most familiar pictorial style. So familiar that we are apt to overlook that it is a deliberately applied concept. Emphasis here is

179

upon conveying an impression of solidarity and depth, which is achieved by carefully controlled tonal gradation, planar brightnesses, tonal separation and shadow formations.

When skilfully handled, this style possesses an arresting, persuasive vitality. Many painters, such as Rembrandt, Caravaggio and Dali, have achieved remarkable three-dimensional illusions in this way.

Pictorial effect

Pictorial mood has tended to become associated with the predominating tones in a scene, as well as with prevailing hue:

Low-key Where mid-grey to black tones predominate, which suggests the sombre or the sober, evening, cosiness, heaviness or tragedy.

Very low-key Where black areas predominate, relieved with smaller areas of lighter values, and night, mystery, the sinister, mysterious and the highly dramatic are suggested.

High-key Where white to mid-grey areas predominate, and there is a suggestion of cheerfulness, comedy.

Very high-key Where white to light-grey tones predominate, implying delicacy, simplicity, gaiety, openness, triviality and the ethereal.

Large, well-marked areas of tone give a picture strength, vigour and significance. A dark tone, relieved by smaller distinct light areas has grave, solemn, mysterious qualities. A light tone relieved by smaller, distinct dark areas suggests brightness, liveliness, cheerfulness, delicacy; whereas unrelieved dark tone containing few contrasting areas tends to be dull or depressing, conveying the notion of sleep or dark.

Pictorial quality is yet another of those subjective impressions which are hard to pin down. 'Quality' derives from both the clarity and the tonal range of the picture. One cannot be dogmatic. The crisply contrasting sharply defined areas so appropriate to one situation, may be entirely wrong for another in which delicately graded diffusion alone will convey the atmospheric impression we seek. Each could be a picture of the highest quality.

Nor can we use as a guide to pictorial attractiveness the tonal range encompassed by the picture. A shot without dark tonal areas may appear thin, and lacking in body but it may equally

well look delicate and refined. Without lighter tones, a picture may appear sadly lacking in vigour and sparkle, or, conversely, convey exactly the wan light of fading dusk or a foggy locale. A picture with few half-tones can seem harsh or coarse, or to have vitality and dramatic force.

Approaches to pictorial treatment

Our approach to lighting treatment can take many interestingly different forms. Some are direct and obvious, others deceptively oblique, and far from what they appear. We can classify them roughly as:

Illumination Overall; solid.
Realism Direct imitation; indirect imitation; stimulated realism.
Atmospheric 'Natural'; decorative; abstract.

Overall illumination

Here the area is flooded with light (mainly frontal), visibility being the main concern. The result tends to *notan*. At best, one can distinguish subjects from their surroundings; at worst, the result has low pictorial appeal, as flat lighting creates ambiguously merging planes. Colour and tonal variations, and surface detail are relied upon entirely to convey information.

Solid illumination

Similar in basic precepts to the overall approach, back and side light are carefully located and balanced to frontal light, to achieve solidity and clarity. Again, the effect is to non-representational neutrality.

Direct imitation realism

Probably the most controversial topic in the field of lighting, is that of the 'natural' approach. Tiring of the predictably stylised sameness of certain lighting methods, the ever-perfect portrait and the ever-present back light, some critics argue their wish for more *realism* in lighting.

They have a point. Consistency can pall. Artificiality can detract. 'Let's have no make-up, we want natural faces. Use

181

natural lighting and locations. Hand-hold the camera. Invent dialogue and action as we go!'

So why not imitate natural lighting? We could do just that, and arrange appropriately proportioned studio lamps where the natural sources would be. But these are revolts against mannerisms, mechanics and methods—usually where they have outlived their value, become clichés, or been obtrusively handled. Sometimes it is a search for novelty rather than a fresh eye, or an ineptitude with the more traditional mechanics.

The results of direct imitation can be extremely satisfactory. But we have only to look critically at 'available light' photographs and home movies to see what can happen. Portraiture suffers first. It is erratic and can be discouragingly ugly. Hot tops to heads, black eyes, half-illuminated faces, overbright patches, barely discernible areas. One person squints into blazing light, while his facing partner, with overbright illumination behind him, has glowing ears and nose, and frizzy hair.

In life, as we discussed earlier, our eyes 'see through' shadows and our brain continually interprets and normalises what we see. But when we photograph people in such an environment, we become conscious of factors that would go unnoticed by the human mechanism.

Unaided, natural lighting can produce uncertain effects. Occasionally, only by deliberately simulating the real thing can an overwhelmingly convincing environment be created. But for the most part selective disciplines are needed, rather than random happenings. For, as we have seen, deliberately devised approaches give us the opportunity to optimise audience persuasion, and to achieve more dynamic, more convincing presentations; particularly in multi-camera shooting. At worst, such techniques can become tiresomely contrived stereotypes.

Frequently one must employ subterfuges, as the true environmental lighting would be ineffectual, or undramatic. 'Complete darkness' is a case in point. One must insinuate light into the scene, justified or not, if the audience is to see anything at all. A completely blank screen has very rare application.

Realism—indirect imitation

With this approach one imitates a natural effect, but by a *contrived* method. We might project 'sunlight patterns' on to a wall, that supposedly come from a nearby window. A series of merging

light blobs around a practical lamp seem to be coming from the lamp itself.

Realism—simulated

Here we see apparently natural effects, although there are no direct sources visible within the scene. Outside a bedroom door, a balustrade suggests light from the hall below; people sit, lit by a non-existent fire; window shadows come from unseen windows. Exactly how such shadows are created is immaterial. They could be from a projected slide, a cut-out stencil or off-stage window. The effect needs to be convincingly realistic.

Atmospheric—natural

Here we are reaching the most subtle approaches to pictorial treatment. Now the illusion is seemingly natural, but the actual effects and light patterns used can seldom be directly related to the environment. One might, for instance, simulate a more attractive window shadow than actual mechanics of the location allow. A piece of furniture or statuary is discreetly lit by localised light to reveal its form and texture, whereas in reality it would fall unnoticed into dull shadow. The lamp itself may be on the ground, hidden by a 'casually' coat-draped chair. Pictorial detail of this kind is highlighted or suppressed to create pictorial appeal or to conjure a mood. Only careful analysis of the picture will show that the specific light and shade are not what they would or could be in real life. This is a typical motion picture approach, which is followed too in progressive television lighting.

Atmospheric—decorative

Associative patterns of light and shade can imply a particular environment, as, for example, leafy patterns, prison bars and firelight. Over-emphasised, such decorative treatment can become mannered, as shadowy areas and profuse pattern take the eye.

Over-use of decorative lighting can lead to a form of photographic 'pictorialism', a self-conscious approach less concerned with aptness than with effect. Even the characters in such surroundings undergo subtle changes, appearing as cardboard caricatures or perhaps as a larger-than-life send-up. In overstressing atmospheric allusion, mood and pattern, such a technique may verge on cliché.

1 2

FIGURE 8.1 PICTORIAL EFFECT
1 The pictorial result of light and shade can arise as a natural, environmental effect.
2 Over-fussy manipulation of lighting, can develop into a mannered, self-conscious pictorialism that draws undue attention to itself.

Atmospheric—abstract

Here light patterns are used with no directly imitative associations, but for visual effect alone. They may be decorative (e.g. random metallic reflections), representing fantasy (e.g. a whirling colour-wheel cast over an exciting dance sequence), or the bizarre (a face lit only with a slit of light across the eyes). Exciting, fun, arresting, horrifying—but above all, let them be appropriate!

Inducive lighting

Man's reactions to the lighting of his surroundings are of a very fundamental nature. The suspense of a forest at night, the exhilarating sparkle of sunshine on water, the restful tranquillity of dusk, are all familiar instances where mood and lighting are interlinked. Darkness can be mysterious, deceiving, treacherous, concealing. Sunlight can be powerfully oppressive, searching, invigorating, exhausting. Part of the directive opportunities of lighting lie in recreating such conditions, to recapture such associated moods.

Lighting offers flexibility, too. Flexibility in changing the mood, appearance, attention, pace and significance of events. Let us look at these persuasive opportunities in greater detail.

Directing attention

Lighting helps us to guide the eye; to induce it to look in particular directions, to concentrate upon certain detail (Figure 8.2).

184

LIGHTING CONCENTRATION Photographed from a home receiver screen, these examples of television lighting illustrate how light can be used ; *Top:* To suggest scenic depth. *Middle:* To concentrate attention downstage, while establishing an environment. *Bottom:* To concentrate attention upon an upstage character's reactions to semi-silhouetted action downstage.

FIGURE 8.2 DIRECTING ATTENTION Tonal relationships and clarity of detail
enable one to direct attention to particular parts of the picture.
1 Isolated tone.
2 Graded tone.
3 Compositional line.
4 Clarity of detail (depth of field adjustment).

The eye is attracted by isolated tone, by high adjacent tonal
contrast, by saturated colours and those of lighter hue, by areas of
clarity within an unsharp field. It is led towards areas by converg-
ing compositional lines, and by graded tones (usually from darker
to lighter regions).

Revealing facts

Selective lighting enables us to reveal facts that we have chosen to
reveal. It can also be devised to lead the audience to infer facts
that are not true, or not wholly true. This we do when we exaggerate
texture or form, or create false or ambiguous tonal relationships.

Light can be used to reveal facts instantly for dramatic effect.
The prowler lights a cigarette and we see his face in the match
flame; lightning flashes or car headlamps suddenly illuminate the
scene.

186

Concealing facts

Conversely, lighting can be arranged to prevent our receiving information about a subject or a scene. Imagination is stimulated much more when the eye has only tantalisingly restricted knowledge; provided that sufficient clues have been laid to guide the train of thought.

This principle has many applications; from the half-lit face in

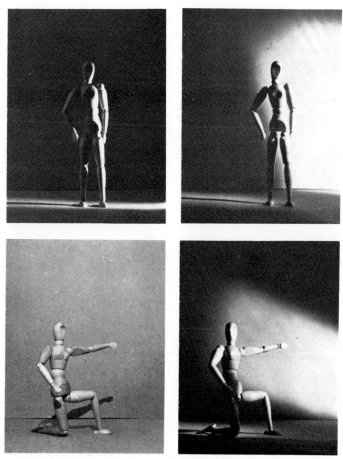

SENSE OF LIGHT DIRECTION *Top left:* A sense of light direction is derived initially from its distribution over the subject. *Top right:* The impression of direction comes, too, from the location of light on the background. The extent to which light direction guides our impression of direction is evident in, *Bottom left:* while in *Bottom right:* the combination of subject and background lighting coupled with gesture strengthens the illusion.

187

which shadow conceals identifying scars, to extinguished room lights preventing our seeing the villain departing. Corrective lighting in portraiture offers less dramatic but equally valuable opportunities.

Creating associations of light

By the way in which we arrange the direction, intensity and distribution of light, we can recall or simulate certain prevailing light conditions, and the typical environmental moods associated with them. Among the rather too familiar examples are: romantic moonlight, cosy firelight, sunsets, street lamps, passing lights on the occupants of cars and the fluctuating light falling on to the faces of a movie audience.

Creating associations of shade

When we examine how tonal areas influence our response to the picture, we find the following conditions:

SHARPLY EMPHASISED TONAL CONTRAST
This tends to isolate and define areas. Subjects present a harsher, perhaps more angular, appearance. There is a suggestion of crispness, hardness, definiteness, vitality and dynamism.

TONAL GRADATION
Graded tones, on the other hand, blend areas with soft-edged shadows, producing a more rounded, subtle effect. They suggest softness, beauty, restfulness, vagueness, mystery and lack of vigour.

Shadow

In the persuasive power of shadow lies one of the most intriguing aspects of lighting. Total shadow is darkness. Darkness tells us nothing pictorially. Total half-shadow in the form of a dark-grey overall gloom is somewhat trying to watch, and seldom satisfies the eye for any length of time. Invariably, we need selectively revealed information to show us appropriate visual clues among the unclear surroundings. Persuasion lies in judiciously arranged *local* shadow.

It is only on analysing the potential types of local shadow, that one begins to realise the value and extent of their applications:

STRUCTURAL SHADOWS
Shadows revealing contour, texture and form, including the structure of obscured planes (Figure 3.13).

188

Shadows conveying the concept of time, weather and environment.

ATMOSPHERIC SHADOWS
These may be symbolic in form (e.g. shadows of a crucifix, or a swastika). They may be dramatically or comically grotesque. They may reveal action or impending action, as with shadows of a window-blind. They may conceal, so that we tensely await the intruder.

ABSTRACT SHADOWS
These are the decorative patterns of light and shade; traced by grilles, and lattice work, the vague 'broken-up' dappling cast by cookies.

Atmospheric treatment

However emotively we may describe 'atmosphere', the artist-craftsman has to be able to analyse and synthesise if he hopes to create it with certainty. Any setting, however ornate, can be reduced to artificiality, or meaninglessness by wrongly devised lighting. Remembering how people can be made young, aged, uglified, beautified or rendered unrecognisable by various lighting treatments, this is hardly unexpected.

As an example of atmospheric development, let us imagine a richly dressed set of a living-room at night. The walls are mostly dark. A large table lamp throws a pool of light down on to the gleaming wooden table, revealing the texture of the fur rug beneath. A glow of light on the nearby wall is just sufficient for us to see part of a tapestry. On a side table, a carved figure is silhouetted. In terms of sheer hardware, one achieves this by localised lighting, by heavily diffused spotlights, softened to avoid hard shadows, by texture-revealing shafts that pick out surfaces one associates with good living. Fur, silk, gleaming sheen on wood, attractively shaped forms (the carving, lamp base, silver candlesticks), half revealing, half concealing the fabrics of drapes and a bowl of flowers semi-silhouetted against wood panelling beyond. A streak of back light from a projector-lantern brings beauty to a sparkling crystal beaker. Emphasis is upon luminous shadow, where we can barely see forms within shaded areas and upon soft pools of light that enable us to see just enough, and no more, of the rich surroundings.

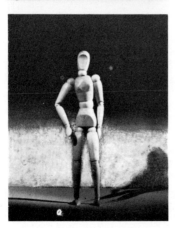

BACKGROUND SHADING (1)

Background tones influence the prominence of the subject, and create an environmental 'attitude' towards it. Lighter tones convey openness, space, subject prominence. *Top left:* Mid tones have neutrality; mid grey subjects merge with their surroundings. *Top right:* Black backgrounds throw subjects of mid or lighter tones into relief. *Centre left:* Background shading can suggest restriction. Where the tonal demarcation is sharp the effect is coarse, firm, crude, definite, or sordid. *Centre right:* Gradual tonal gradations have more subtle, vague, delicate, or rich connotations. The lower the shading, the greater the restriction. *Bottom left:* But when the subject is positioned to 'break through' the shaded region its strength may become proportionally greater as a result.

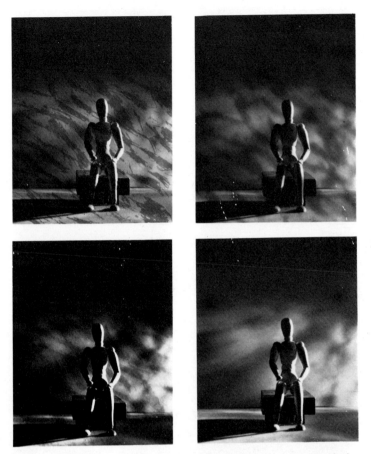

BACKGROUND SHADING (2) *Top left:* Sharply focused dappling appears crude, incongruous, unconvincing. *Top right:* Defocused, the overall effect is improved. *Bottom left:* For serious application, as in this low-key scene, the effect should be localised. Slight sharpening increases the dramatic impact. *Bottom right:* Most attractive, even beautiful effects become possible by applying indistinct light break-up.

Suppose this same scene was the setting for *romance*? A soft firelight glow might fall upon the lovers, subtle back light limning them, separating their background. The character of their surroundings would be evident, but light would concentrate upon the action.

Perhaps the scene is one depicting *tragic death*. Now shadows would be opaque—perhaps concealing the assailant. The light pools form islands of information in the unknown darkness. The corpse is edged with a hard, but restricted key. Its outline is silhouetted. In a patch of light we see a hand. The more we tell, the

191

DAPPLED KEY LIGHT (1) *Top left:* Whereas an unobstructed frontal key light would have provided a bald, bright, even effect, subtle dappling can transform the hard light into an unobtrusively attractive illuminant. *Top right:* If shadows are unfilled, the dappling may become too strong for normal daylight applications; although very suitable for nocturnal, mysterious, or dramatic applications. *Bottom left:* Restricted, unrelieved dappling may be used to create local emphasis or to direct attention specifically.

less we leave for the audience's imagination to work upon. Too little will have them baffled rather than intrigued. With too much, the sense of mystery evaporates.

And what of *sordid* surroundings? Well, if we light for a sordid effect a setting that is dressed to look rich and luxurious, the result is liable to become cheapened and brash. Otherwise, assuming appropriate surroundings, the illusion of squalor is increased through such devices as oblique lighting on walls, revealing all wrinkles and irregularities. Wall shading begins high up. Long, ugly downward shadows are cast by wall furnishings such as lamp brackets, pictures and ornaments. Lighting is hard and angular. Ugliness is highlighted and emphasised. Texture is revealed where

192

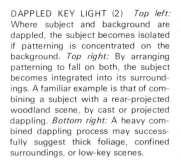

DAPPLED KEY LIGHT (2) *Top left:* Where subject and background are dappled, the subject becomes isolated if patterning is concentrated on the background. *Top right:* By arranging patterning to fall on both, the subject becomes integrated into its surroundings. A familiar example is that of combining a subject with a rear-projected woodland scene, by cast or projected dappling. *Bottom right:* A heavy combined dappling process may successfully suggest thick foliage, confined surroundings, or low-key scenes.

coarse, flattened where delicate. There are probably no sunlight patterns from windows. Corners are dingy. Light may be meagre or stark, cruelly edge-lighting and harshly 'toppy'. There is no sparkling back light. Here is the essence of persuasive illusion— selective enhancement, selective coarsening, inducive shadows.

Darkness

It is too easy to dismiss darkness simply as 'night', and to overlook the unique atmospheric variants. We shall find that the categories here are not mere classifications, but reminders of the dramatic opportunities that darkness affords:

193

OBSCURING NIGHT
Blind night. Barely seen surroundings. Undetailed masses. Darkness hides information.

INTRIGUING NIGHT
Awakening our curiosity as we catch brief restricted glimpses of recognisable subjects among totally dark surroundings.

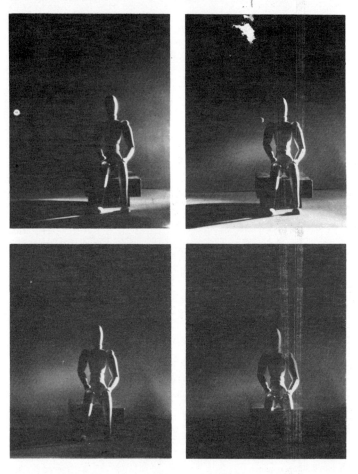

LOW KEY SCENES *Top left:* Tonally unbalanced arrangement, in which illumination suggests the presence of a nearby light source (e.g. house, camp-fire, shops). Frequently used for vehicle interiors at night. *Top right:* Typical effect when using hung lamps for low key scenes. The floor is over-lit, and destroys the illusion of night, or dark surroundings. *Bottom left:* The same situation, with a darkened floor. Most floor materials reflect considerable amounts of light, even when dark toned. *Bottom right:* Light has been shaded from the lower part of the scene, so that an impression of enclosure develops.

194

MYSTERIOUS NIGHT
This has a magical quality. Natural subjects are strangely trans-
formed to have a new charm (as when trees are lit from below by
hidden sources). Light glistens and reflects from the surroundings.

THREATENING NIGHT
In dark, half-seen bushes, danger may lurk. Distorted shadows jag
into pools of light. Emphasis is upon harsh modelling and stark
contrast.

ROMANTIC NIGHT
A clear, free, moonlit night, in which translucent shadows
enwrap, rather than threaten. A luminous sky forms a background

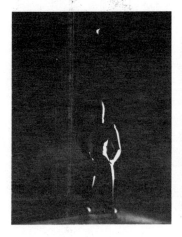

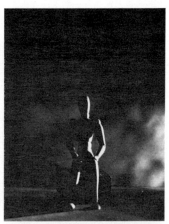

VERY LOW KEY SCENES The extent
and the regularity of the light on the
surroundings will influence the mood
the picture conveys. Too little light,
and it will be hard to see. Too much,
and the illusion is lost. *Top left:*
Fragmentary lighting barely reveals
the surroundings, conveying mystery,
suspense, the unknown. *Top right:*
More extensive, the dappled lighting is
almost expectant, decorative. *Bottom
right:* The lowest practicable treatment
for sustained scenes, both background
and subject are broken up with frag-
mentary light. It may be difficult
(deliberately) to discern and identify.

195

DAPPLED INTERIOR LIGHTING *Top:* Evenly lit, the setting is clearly seen, but unatmospheric. *Bottom:* General dappling renders the wall more convincing, less artificial looking.

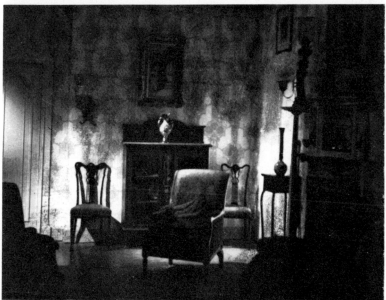

Top: More heavily dappled, the result is suitable for more dramatic occasions. *Bottom:* Low-key situations may employ localised dappled areas.

to action. Tall grasses are rimmed in light, and the leaves of trees hang sparkling on their branches.

Absolute darkness is generally valueless. It reproduces indifferently, showing the defects of the particular system being used which in the case of film are grain, processing variations and print defects, and in television, scintillating noise, streaks and spurious colour, perhaps. Nor will the murk of barely distinguishable images be much better. Detailless, muddy greys seldom carry atmospheric conviction.

To convey a convincing illusion of a dark scene, a series of subterfuges must be introduced. Locational excuses for light are needed wherever possible. It may creep into a dark room from outside sources such as street lamps or moonlight, or one may introduce luminants, firelight, or practical lamps, for instance. If darkness is essential to most of the action, it may still be possible to have someone light a lamp in the course of events.

But, where pitch darkness is inescapable, one has to insinuate light that is accepted by the audience without a moment's thought. Where dialogue emphasises how dark their surroundings are, any over-generosity of light simply makes the characters seem stupid! Fortunately, given half a chance, an audience will help with suspended disbelief. A light would have to be pretty over-emphatic for people in the audience to begin asking themselves where it was supposed to be coming from.

The solution to very low-key lighting lies in rimming with light strategic properties and pieces of furniture that typify the environment. These should be placed wherever possible so as to leave an impression of scale, size and distance. It is best to avoid large areas of frontal light, which should be dim and well broken-up with cookies or indistinct shadows. Odd random light blobs do not convey anything in themselves. Nor do patches of illumination that show us something is there, but leave us distracted, trying to decipher what it is. There are, as always, exceptions. In a Victorian nursery, the hoof of a piebald rocking-horse may look like a groping hand in the half-light; its tail becomes the long hair of someone crouching in the dark.

Low back light puts a slight edge of light around the outline of each subject. Where the subject has a feathery or furry edging, the crispening over-emphasis may become disturbing. Side light shows more of the selected subject—too much if one is not cautious, for it can lose its anonymity this way, and the audience

would become too conscious of the direction of the light. Where light is disrupted by a cookie into irregular dappling, its direction is usually undetectable unless revealed by shadow formations.

Moonlight

Moonlight is one thing to the eye, another to the camera. In reality, moonlight is a low-intensity hard light of similar general colour quality to sunlight so that given long time exposures or an ultra-sensitive emulsion, a colour-film shooting in moonlight would theoretically produce pictures of as vivid colour quality as in daylight. In practice, reciprocity failures in photographic materials modify colour balance with long exposures.

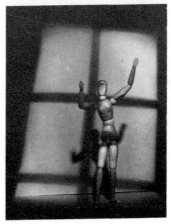

BACKGROUND PATTERNS (1)
Top left: Pattern can be used decoratively, or to concentrate attention. Note, the key and the pattern are from different lamps. *Top right:* Where patterns are projected on to decorated backgrounds, the effects of both are nullified. *Bottom right:* Plain backgrounds display shadow effects most successfully.

199

The colour response of the eye changes in dim light. In daylight, its sensitivity peak is in the yellow-green region. But in dim surroundings, the eye undergoes a spectral shift towards blue. Visual sensitivity in the yellow-orange-red regions of the spectrum gradually diminishes. Hence the apparent blueness of moonlight and the illusion that there is no colour in a night scene.

Blue light is frequently used for moonlight exteriors, presumably to imitate this subjective blueness, and to 'kill' scenic colour (recalling how coloured light reduces variations in hue). The success of such a treatment is highly questionable.

Excessive blue illumination is phoney, especially on faces, but has become a widespread cliché for 'moonlight'. Discreetly

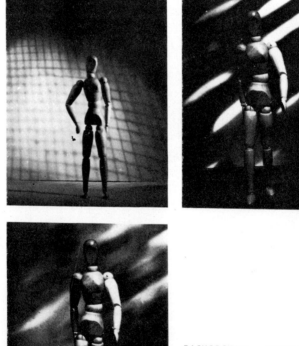

BACKGROUND PATTERNS (2)
Top left: Overall sharpness is difficult with oblique projection angles. Notice how attention is drawn to sharper regions. *Top right:* Sharp contrasty patterns create a dynamic, vigorous impact. *Bottom left:* The same pattern defocused, results in a vague, nebulous, or delicate effect.

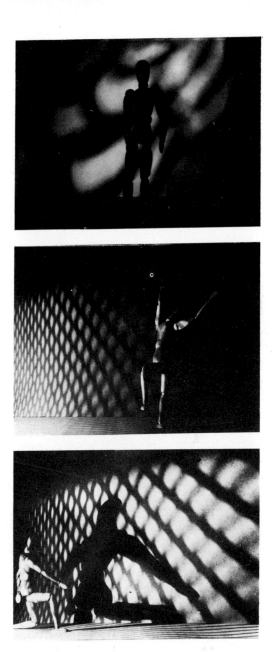

BACKGROUND PATTERNS (3) *Top:* Here the projected pattern dominates the scene. Its shapes are arresting, strong, powerful. *Centre:* This pattern cast on wall and floor provides a decorative background for action. *Bottom:* The same cast pattern in a different application becomes a menacing, forceful, effect when coupled with the figure's shadow.

positioned white light can be less distracting, but it lacks the monochromatic colour-killing properties of blue. In reverse-angle shooting one is liable to encounter incongruous intercutting between *contre-jour* and frontal key-light effects (Figure 9.20).

In the studio, 'exterior moonlight' involves predominant back light, rimming and kicking the edges of subjects, with low-intensity soft filler from a front or side position. Backgrounds are selectively lit, large masses being left dark as far as possible. Skies are dark or dimly illuminated. Where possible, light is broken up into shafts and patches. Where warm-coloured light, such as orange-yellow, can appear to stream from nearby buildings, the coldness of the moonlight is emphasised.

Dawn and sunset

At first sight, 'dawn' and 'sunset' would appear to offer great atmospheric opportunities. However, they have their problems. Firstly, they are easily confused pictorially, unless supported by other temporal clues, such as a dawn chorus or nocturnal owls. Both dawn and sunset too easily become crudely blatant in the reproduced picture. A simulated dawn may develop convincingly with darkened clouds above and a pale yellow glow forming at the horizon. It seems that sunsets are somewhat more tenable, if the horizon is hidden from view, and light is partly to one side, enabling a darkening area of the sky to be seen prominently. Complete fidelity to nature is certainly no reliable solution to reconstituting an effect. Buildings in strong orange-red light with a ball of fire in window after window may be what we occasionally see in a real city scene, but woe betide the lighting director who is tempted to imitate it. The audience would never be convinced!

Changing light

The first step towards creating any atmospheric illusion is to build up a firm mental image of the scene and check over the particular features we would expect to find. Let us imagine ourselves within a room, watching how approaching day modifies the appearance of our surroundings.

It is night. Outside, trees and skyline are vaguely silhouetted against a velvet sky. At first, as the sun rises, light penetrates little

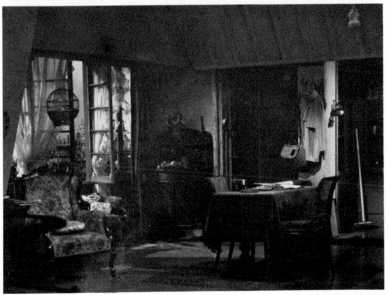

THE STUDIO SETTING (1) *Top:* Under overall soft light the scenery has a very fundamental appearance. Its construction and basic dressing are visible, but non-atmospheric. *Bottom:* Lit to simulate early day, main light enters from imagined windows on the right. Strategic furniture is partially lit.

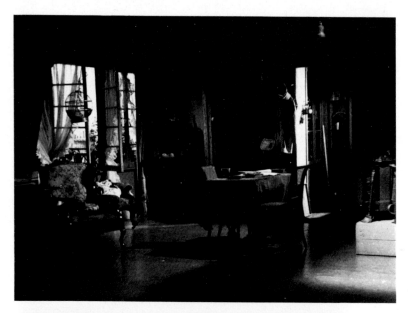

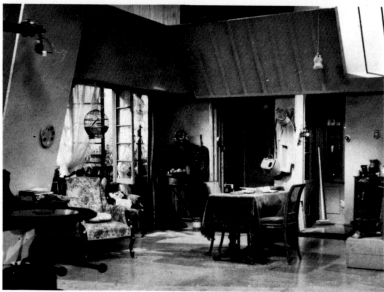

THE STUDIO SETTING (2) *Top:* Early afternoon. Sunlight picks out furniture details by the window. The abundant shadows give a closed-in, claustrophobic feel to the room. *Bottom:* Late afternoon. The fully lit room; less sense of restriction; details are more visible; the skylight implies the sky beyond, and lightness.

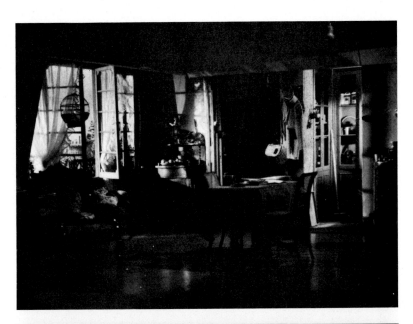

THE STUDIO SETTING (3) *Top:* Evening light is suggested by the low-elevation window light. What would have been an extensive window shadow on the back wall is interrupted by the shape of the room. *Bottom:* Night Moonlight, pools of light from the hung practicals. Small details are visible to convey the character of the room. Deep shadows hide information from us. Furniture merges into uncertain shapes. The effect is comfortable, cosy.

205

THE STUDIO SETTING (4) *Top:* Room lighting is more extensive now, but harsh and sordid
It is dark outside. Light and shade are harsh. *Bottom:* Night. The room is unlit; deserted;
mysterious.

beyond the window. The walls are darkest there. The general outlines of objects within the room are barely distinguishable. General masses merge into soft-edged shadows.

Dawn begins to brighten the horizon. Outside, trees become firm silhouettes. Gradually light seeps into the room; the ceiling lightens. One begins to detect the form of lighter-toned objects.

As the sun rises, walls opposite the window lighten. Darker objects now become clearer. Detail in shadows becomes discernible.

Daylight becomes established. By now, the sun has a steeper elevation. The room is brighter overall. Light scatters and reflects within the room. The window-wall has now become well lit. Well-defined shadows are cast by objects within the room. Light patches form on walls. Sunlight reflects, and we see specular reflections from polished furniture and glass.

As the day develops, the sun gradually moves round and its vertical angle grows steeper, so that it will no longer penetrate the room. Now the walls furthest from a window can be quite shaded. Light levels fall considerably as we move away from the window.

Sunlight

By imitating the characteristic appearance of a particular form of lighting, we can recapture much of its associated atmosphere. But the very aspects that recall this atmosphere, may introduce unattractive portrait lighting. Tropical sunlight, for example, with its steep, hard-cut unrelieved masses of shadow, is strongly evocative, but it creates coarse, harsh, facial modelling, and deep, unrelieved shadows. If we improve upon the portraiture, we begin to lose the characteristic appearance of this kind of sunlight.

Imitating sunlight with lamps presents a further problem in creative lighting; the controversial topic of multiple shadows. Realism decrees that we have a single sun and so a single shadow.

Multiple suns would seem incongruous. And yet, to have hard modelling light from a single direction over an entire setting, is to restrict pictorial opportunities in multi-camera shooting. It may be a physical impossibility in the studio to achieve such light coverage anyway. One-way lighting can result in gross mismatching between shots, and pronounced quality changes on cuts from one view to another. But fortunately, only very rarely does an audience lose a sense of orientation due to changing sun directions, although this is possible in isolated circumstances.

207

The answer to the single-sun quandary lies as usual in expediency and subterfuge. Exterior shots may well appear unconvincing if we make the audience over-conscious of multi-shadows. But it is quite likely that they are overlooking shadows of any kind. The action may be more arresting, or the shadows may fall upon dark or broken-up surfaces. Or, we may have only one shadow in shot at a time.

Overlapping, adjacent multi-shadows, however, usually look bizarre on nearby backgrounds at any time, even when the effect is quite justifiably from a number of obvious sources. But wherever a person appears to be standing in daylight outside a house door accompanied by such an array of shadows, even the least perceptive observer is normally incredulous.

Shadows can be over-evident, too, on the plain unbroken surface of the studio floor, although any floor-patterning or scatter tends to make them less prominent. At times, even one shadow may be untenable; on a pictorial scenic backing or a piece constructed with forced-perspective, it could entirely destroy the spatial illusion.

For most interiors, it is arguable whether specifically unidirectional light is ever necessary. If more striking results may be achieved by multi-suns through windows, supported by pictorially telling 'sunlight patches' on walls, it is the effect that counts. Again, indiscriminate abundance defeats the object.

Lighting transformations

One of the most fascinating aspects of productional lighting is the flexible ease with which it can be transformed. Lighting transformations can range from a sensitively unobtrusive process that we feel rather than observe, to the breath-taking 'firework display' of swift multiple lighting changes accompanying dance-spectacle, for example. The vigorously pointed variations of the latter are part of the panache of such presentations. Compared with these, the stealthy changes in lighting mood that may be developed in a dramatic play, to heighten mood as tension builds up, may go unapplauded. But such subtleties remain a powerfully persuasive function of the art of lighting.

It becomes possible through lighting, to rearrange pictorial emphasis and redistribute tonal masses, and so alter the entire compositional balance of a picture. One can progressively change

208

the tonal impact to create implied subject-restriction (Figure 8.3), or alter the strength, stability or the focus of attention. One can change the prevailing mood, alter the subject's appearance, even modify the pace of a scene.

To be effective, lighting alterations must be unambiguous and pronounced. There is usually little point in introducing painstaking but unseen atmospheric transformations while production treatment is concentrated on close shots. They only jar when they are eventually discovered in long shots. Imagine that while we are watching a big close-up shot of one person, another closes the window shutters and switches on some practical lamps. The effect does not show in the close viewpoint, but it becomes a bewildering surprise on cutting to a longer shot of the transformed room. Incongruous, but it has happened!

Paradoxically, closer shots do give the opportunity during continuous production to make quite broad preparatory alterations and improvements unobtrusively in one part of a setting, while the camera emphasises closer action in another. Thus we can for example, rebalance lighting to accommodate subsequent action.

Lighting transformations can be considered under several broad headings:

Atmospheric change Rapid change (total or partial transformation). Gradual change (total or partial transformation).
Decorative effect Rapid change. Gradual change.
Discrete effect
Animated effects

Atmospheric change

RAPID CHANGE: TOTAL

This can be the sudden act of *revelation*. It may reveal nothing more than the fact that it is morning, as bedroom window drapes are thrown open. More dramatically, as clouds part and moonlight shows the moorland traveller his surroundings, it may reveal notices informing him that he is in a minefield!

So, too, rapid total change can bring *concealment*, preventing further knowledge. The gunfighter shooting out lights and plunging all into darkness is a familiar example. Instantaneous *mood changes* become possible; the soft dream-like atmosphere of a candle-lit scene is cruelly shattered as harsh, contrasty room

209

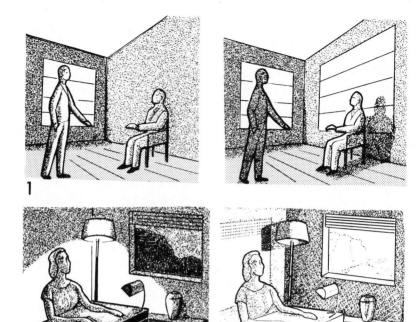

FIGURE 8.3 LIGHTING TRANSFORMATIONS
1 Lighting transformations enable you to redirect attention.
2 Transformations also allow you to modify tonal balance and change the mood.

lights are switched on. Or a person who had been gently lit by the diffused light from a table lamp steps forward and becomes instantly illuminated with stark menacing underlighting as he stands over it.

The commonest form of rapid lighting change arises when someone enters a darkened room and switches the lights on. Fundamentally, this is a simple switching process between low-key 'black-out' and 'room-lighting' conditions. One could have the change remotely actuated by the actor operating a normal wall-switch near the room door. This has been done. But there have been embarrassing moments in a live television show, when the actor forgot to operate the switch and the scene ground on 'in the dark', lamps being surreptitiously faded up to correct the error! Better to get the actor to cover the wall-switch on entry until the

210

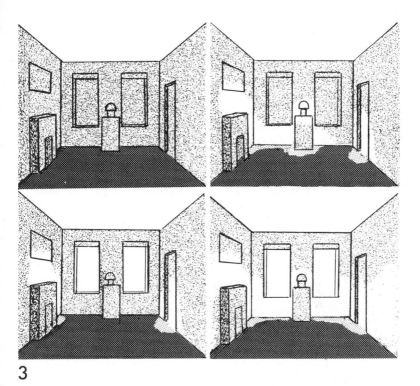

3

FIGURE 8.3 (contd.)
3 Localised light patches can be used in various combinations and achieve a series of transformations. Similarly, one can alter relative prominence, influence spatial relationships, perspective, solidity, modelling, texture, etc.

lights are switched from the lighting-control panel to help synchronism. This avoids the incongruity of having the switch click, or the hand move away, before the light change has been made.

To create such an atmospheric change, one can either light for low-key and switch on an additional lamp group, or change over from one entire group to another. Many lighting directors favour the complete change method, assuming there are the lamps, power and switching facilities. Unfortunately, switching rates differ for high- and lower-power lamps, so creating a somewhat ragged transition. It is disconcerting to see the patch of moonlight suddenly appearing on the wall as the bedside light is switched out.

Attention to detail can be rewarding, where a light-cue has foreground prominence. It can, for example, be worth remembering that oil lamps tends to have separate stages of brightness: the

match is lit; it is applied to the wick; the wick begins to burn; the glass funnel is fitted. The whole can be treated as a gradual light increase, or better still, as distinct brightness levels. We imitate candle lighting similarly. But, wherever possible, try to have candles extinguished by a wet finger pinch or by snuffing. It is exceedingly difficult to synchronise lamp-switching with blown-out lights!

Another frequently encountered gambit is the darkened room where curtains, shutters or blinds are suddenly thrown open to let daylight stream in. Usually one can have a strong key light (hard or soft) outside the window, and arrange for light from this direction to predominate. But where action continues away from the window, one must, however illogically, cheat light from other, more suitable directions also, not confining it to the window direction alone. It may be introduced either masked by the act of opening, or be crept in in time for the subsequent shots.

Rapidly changing light within a car interior suggesting its passage through lit streets or shady countryside is produced by interfading or switching, between a pattern of lamps around the static car body, or by projected moving shadows.

RAPID CHANGE: PARTIAL

In this, we find a localised lighting area added to or removed from an already lit setting. Perhaps an auxiliary table lamp is switched on in a scene, or a character moves about, switching off various lights before departing. The challenge of this effect is in keeping the light change sufficiently restricted and proportionate.

When, for instance, we have a series of candles lit, the audience should be left with the feeling that each light build-up is realistic. Each stage normally comprises two steps: forming a suitable light pattern on nearby areas, and creating the impression that light is falling upon the person from the new luminant, with convincing direction and intensity.

We meet situations where the surroundings are only momentarily illuminated locally, as when someone walks in 'darkness' with a lantern, light falling progressively on nearby surfaces. Parts of the environment grow brighter and dimmer as he moves. (See Chapter 11, follow shots.)

Sometimes the cued effect is extremely transitory. Lightning is a case in point. The main hazard with lightning is in the flash revealing too much! It may throw a shadow on to a sky-

212

backcloth. Positioned as a 'sun' key light through a window, it may throw a flash of patterned light on to the wall of a room. But in doing so, it may also reflect from the outside of the window flat, on to an exterior backing, and illuminate it overall.

Gradual transitions may be 'naturally' motivated, as when we have changing temporal or weather conditions. Evening has come, or a storm is brewing. The effect will probably have to be accelerated, of course, to fit within the duration of a scene, but it should develop almost imperceptibly.

When day breaks or night falls, the sky becomes transmuted; the light patterns on walls change. We can approach this situation by attempting a replica of true dawn or dusk conditions (a transition from one light arrangement to another), or we can cheat by progressively changing light intensity and contrast alone (a rebalance of existing lamps). Which is preferable, is largely determined by production treatment.

It is usually unwise to permit failing light to degenerate into a hard-to-see gloom unless dialogue emphasises the point. The sooner some appropriate illumination is established, the better. Sometimes we might strengthen one established luminant as another fails, so that firelight now brightly fills the darkening room.

Another variety of 'gradual change' effects is the unobtrusively introduced contrivance for achieving mood development. A gay (high-key) atmosphere can become systematically altered to emphasise the changing tension. A romantic idyll is destroyed as accusations lead to rising anger; the lighting coarsens, the beautiful girl's face is seen more crudely drawn—she is not as attractive as we had thought. The hero's features have lost that finely chiselled look, and have a rather aged, raddled air. The scene takes on a sinister aspect, finally becoming horrific. In practical terms, this means reducing fill-light, fading from lower keys to steep lighting, omitting the eye-sparkle of camera headlamps, increasing general contrast in facial and room-lighting treatment, until eventually grotesque underlighting predominates.

We might employ gradual change in the lighting to shift the audience's attention from one area of interest to another, more subtly than by camera or editing techniques.

Another example of gradual change development is to be seen

where a fire, small at first, grows fiercer, until there is a total conflagration. Whether an exterior glow beyond the window—'The barn's ablaze!'—or the yule log brightening Christmas festivities, fire scenes have to be handled with a sense of proportion if . they are not to become theatrical.

GRADUAL CHANGE: PARTIAL

This is another localised effect; one that may need a particularly carefully cheated approach.

Imagine that the scene is a darkened room. The door opens slowly; light streams through on to a seated figure.

Do we do the obvious, and simply let the doorway light illuminate the chair? We might. Perhaps mechanics prevent this, and we rig a second lamp (one through the door, one on the chair). This is faded up slowly as the door opens.

But, more craftily, we might deliberately confine this additional lamp for dramatic effect. Now when the door opens, the seated person is seen within a small rectangle of light not illuminating the irrelevancies of the rest of the room, as the straightforward method would. Attention is fully concentrated on him, and tension increased. Here is a reminder of the surreptitious potential of persuasive lighting.

Decorative changes

These are the transformations of light entertainment, vaudeville, band shows and song-and-dance routines. The dilemma here is to achieve effects looking fresh and original. The permutations of set design, lighting and presentation have become so familiar and jaded over the years that something new is hard to find.

RAPID DECORATIVE TRANSITIONS

Included here are instant pools, blobs, spots or patterns appearing on floor or background (frequently a cyclorama) as a decorative concept. We have had fleurs-de-lis, sun-rays, chequer-boards, flowers and similar motifs.

Flashing lamps have their vogue, in strings, festoons, clusters or strung out along rostra tops, trellis or skeletal scenery. Flashing multi-colour lights, rotating, swirling, jittering, seem appropriate to certain presentations, actuated manually, by automatic flashers, or by sound-controlled relays.

214

These cover many traditional lighting techniques, to accommodate mood changes. The cyclorama changes in tone, providing light, medium, dark values, lit upwards from behind a ground row, from the side or from above. Colour changes are popular, in which we can fade between group colours, or mix a series of hues to taste. A spotlight may light the solo singer.

Silhouette effects can be attractively introduced, by gradually fading out frontal keys and strengthening ground-row lighting—but they have the disadvantage of being an easily recognised formula.

Discrete effect

Extremely localised, or discrete effects range from theatrical follow-spots to uncanny illumination of the soothsayer's crystal ball. More mundane examples include searchlights sweeping the prison yard, a searching flashlight beam, a passing vehicle's headlamps. These 'discrete effects' illuminate a very restricted area, and do not affect the total environmental feel. In many cases they derive simply from a hand-operated lamp.

Animated effects

Animated light or fluctuating illumination provides opportunities for many stylised or decorative lighting variations.

It can be introduced naturalistically too. Light can sweep across surfaces, imparting an exciting pace. It may be the fleeting spots of a mirror-ball; the rhythmical flashing of a street sign; the passing window lights from an unseen train; the ceiling-light set swinging in the course of a fight; even flickering flames from the hearth. Again, this is a lighting approach in which the cause for light-movement should be quite apparent—unless the aim is to mystify.

9

LIGHTING THE SCENE

Natural light

'Natural light' is a deceptively variable commodity. The sun's direction and elevation continually change with the hour, the time of year, and the latitude (see Figure 9.1).

Its quality varies considerably. In the open sky, full clear sunlight creates harsh modelling and dense shadows, only relieved by light reflected from nearby surfaces. But light reaches us, too, scattered from the total sky. As the sun becomes veiled by such atmospheric changes as cloud, mist, haze, rain or fog, lighting contrast falls, and modelling is reduced. Even thin clouds soften sunlight considerably. An overcast sky diffuses the light even further.

The *colour* of natural light changes quite markedly. At sunrise and sunset, a combination of the yellowish-red sunlight, with bluish sky-light illuminating shadows, can falsify colour rendition noticeably.

During the day, a bright sun in a cloudless sky, can produce shadows having remarkably strong coloration from sky-light or neighbouring surfaces. Directly lit subjects appear relatively strongly saturated. As clouds obscure direct sunlight, these effects lessen. Diffused daylight modifies colour too, causing a generally desaturated quality.

As to *intensity* variations, one has only to watch from a hilltop the passing cloud shadows on the terrain below, to see how rapidly light levels change throughout the varying diurnal light.

The problems that natural lighting create are various:

1 The direction of sunlight changes (Figure 9.2). Its directional variation is restricted, i.e. E to S to W.
2 The light quality is inconstant; creating lighting conditions varying from flat to highly contrasted.
3 The colour temperature alters with time, direction and with weather.

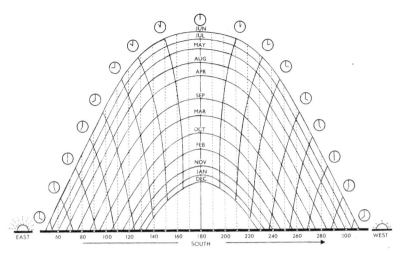

FIGURE 9.1 APPARENT MOVEMENT OF THE SUN (based on Burnett diagrams). A calculation of the direction and altitude (vertical angle) of the sun can be obtained with the use of sunlight diagrams. This version is for 52°N latitude (approx.); times being G.M.T.; compass bearings relative to true North.

4 We regularly encounter too much or too little light for our purpose, or light of fluctuating intensity.

5 The distribution of light is random; one subject may be in shadow while others are brilliantly illuminated.

6 Natural shadow areas may be distracting or inappropriate.

7 Spurious light (flare, glare) may obscure our vision.

8 Scenic contrast is frequently too high.

Within limits such variations can be accommodated, e.g. when encountering high contrast, one might as a palliative, expose for good shadow detail and reduce the film developing time to lower the contrast of the negative. Or, conversely, under low-contrast conditions one could reduce exposure and increase development to exaggerate pictorial contrast.

Where prevailing daylight does not meet our needs, we must choose between waiting for more suitable lighting or weather conditions, selecting a more appropriate time of day perhaps, adjusting to a new viewpoint or providing supplementary lighting.

The kinds of problems we encounter when relying on natural lighting for our luminant depend largely upon the circumstances and purpose of the camera-shots. It is always conceivable that Nature has actually provided the conditions we need. There are even times when one seeks the high contrast and lost shadow

217

detail of harsh sunlight, gladdens at the sight of wreathing mists, dull leaden skies, or welcomes fog, snow and the rest of Nature's repertoire.

But natural lighting, however economic, is essentially un-reliable. We have to adapt ourselves to *its* characteristics. We shall quite often encounter external architectural structures where the features we want to display are never illuminated by natural light with the particular emphasis we are seeking. Possible sun-light directions are limited (from east via south, to west), and the sun may be obscured anyway. Light may never strike the struc-ture at a suitable vertical angle (sunlight being higher and steeper at midday, and of lower elevation earlier and later in the day).

NATURAL LIGHTING (1) The photographs above and opposite were taken within a few minutes of each other, at noon on a summer's day. With the steep sun behind the camera, all the features of the landscape are crisp and well modelled. In the distant view *Top:* outlines are distinct, while in the closer view *Bottom:* surface texture and decay are easily seen.

NATURAL LIGHTING (2) From the reverse side of the bridge, the distant view *Top:* provides merged shadows, indistinctly modelled features, and contrastingly backlit foliage. Slightly closer *Centre:* certain details appear, but emphasis is upon silhouette. The closest view *Bottom:* is still disappointingly featureless, and texture minimal. Although colour could have differentiated planes more readily, a generally flat, dull effect would still have resulted.

219

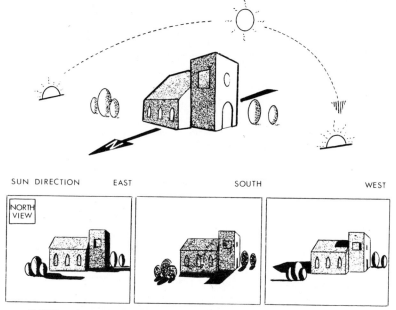

FIGURE 9.2 NATURAL LIGHTING AND LOCATION The effect of sunlight changes throughout the day, altering the appearance of the location subject. Features on north-facing walls are never effectively illuminated by natural light (absence of modelling).

If the area involved is relatively small, it may be possible to introduce our own 'sunlight' to pick out certain detail, and create patterns of light and shade. But for many exterior scenes there is nothing for it but to accept the situation, change our viewpoint, or seek another location that offers more suitable lighting angles.

Within buildings, natural lighting through windows may sometimes prove sufficient, but more often, supplementary artificial light is desirable to illuminate shadows, reduce contrast, and generally model the interior.

Lighting on location

Day exteriors

Unless daylight is waning, any supplementary lighting we use in the open air is likely to prove disappointingly ineffectual for large-area continuous lighting. Even large arcs such as 225 amp. 'brutes'

220

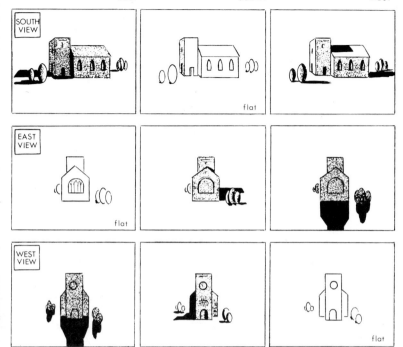

are swallowed up as daytime *booster* lights for shadow areas in brightly sun-lit scenes, although their uncorrected colour temperature often conveniently matches daylight. For closer shots, tungsten-halogen lamps may serve as booster keys or shadow fillers. The main drawback of high-power light sources is in obtaining or routing sufficient power to supply them. Supplies may have to be provided or supplemented by large mobile generators.

General reflection from such adjacent light-toned surfaces as snow, sand, whitewashed walls may fortuitously help to reduce excessive scenic contrast; but more controllable, although still very reliant on the sun's strength and direction, is the light we can introduce with large portable reflector panels. These white, gold or silver-foil surfaces reflect hard or 'softened' light to provide keys or filler, and illuminate shadows. Silver reflectors are most valuable for dark walls and foliage, while the warmer light from white or gold surfaces may be more suitable for portraiture.

If there is a choice, it is as well to select the camera position relative to the sun. The sun should preferably be pointing roughly

221

FIGURE 9.3 SUNLIGHT AND REFLECTORS The efficacy of reflectors depends on their position relative to the sun. (a) Ineffective—at right angles to the sun. (b) Sun directly reflected onto subject. Modelling flattened; subject dazzled.

towards the camera from between 10H and 2H or, failing that, as side light (Figure 9.3). Frontal sunlight (i.e. behind the camera) has a generally flat, harsh, unbeautiful effect that is best avoided unless such an effect is deliberately sought. Coloured subjects may appear rather too coarsely saturated.

Where sunlight is excessive for localised shots, large gauze scrim canopies help to soften or reduce light, and prevent it dazzling the actors.

Night exteriors

There are two possible approaches to filming night scenes involving locations away from the studio: by using high-power illumination following normal lighting principles, or by carefully controlled daylight shooting. Where relatively restricted areas are involved, a portable lighting set-up is feasible, but for most exteriors a discouraging amount of light becomes necessary.

Where the location would naturally have luminants (camp-fire, moonlight, street lamps) lighting treatment is built up from these directions.

Each type of exterior location poses its own typical problems. A forest scene after nightfall has the particular hazard that by the time sufficient detail is revealed in foliage, we may become too aware of specular reflections from glossy leaves. Low directional light is seldom convincing in such scenes. Nocturnal water scenes are especially troublesome, as they all too easily present black, detailless water surfaces, with overbright speculars.

222

SKY FILTERS *Top:* Overbright skies appear blank and without detail. Colour filters are only possible when shooting in black and white; they would give a cast to colour systems. *Centre:* A neutral density graded sky filter can help to reduce sky brightness while maintaining correct exposure for the scene below. *Bottom:* If we reduce overall exposure, sky detail becomes visible at the expense of the underexposed landscape.

Brick buildings can take on a floodlit appearance unless the extensive light required is well localised and broken up. Deserted street scenes tend to appear dully uninteresting or unconvincingly illuminated. Freshly hosed, they gain dramatic value, but the effect may tend to become a cliché.

A more convenient and economical approach to night exterior shooting is, paradoxically, to imitate the nocturnal effect while shooting in daylight. Then, any sunlight becomes pseudo-moonlight. This is done by a combination of underexposure, filtering and processing adjustment. Its success relies largely upon the relative scenic tones involved, the general principle being to keep important subjects in the mid- to upper-tonal range, while darker values are crushed together. Sometimes this degree of control is impracticable.

'Day for night' filming is the only reasonable recourse for most large location exteriors in open country, for one cannot illuminate such areas with conviction. Lens-filtering includes *night filters*, giving a blue cast to the entire scene, *graded sky filters* which darken the upper part of the shot, leaving the lower section unaffected (but the demarcation is arbitrary, so the sky is best avoided altogether) and lastly, the *polarising filter* may be introduced. This selectively darkens the blue sky, although it may result in increased colour saturation for some subjects, rather than the low-luminance effect that is sought.

Processing treatment can assist the night illusion, by printing-down—particularly with *contre-jour* sun positions—and by providing a blue cast.

Pictures shot in any of these ways become that much more convincing when we see night-associated luminants in shot, such as car headlights, street lamps and illuminated windows in buildings.

Interiors

For photographic stills, one may be able to use 'available light', augmented, perhaps, with flash, overrun lamps or small reflector boards. The motion picture strategy of shooting static action at low shutter speeds (e.g. 6 f.p.s. = 4 × light) is of only rare value. But for motion pictures or television, lighting invariably needs augmenting, even where daylight illuminates an interior, for contrast may be excessive, or shadow detail insufficient. It may even prove more practicable to take still photographs initially, and

explore these with the moving camera, instead of attempting costly location shooting.

Where daylight is mixed with incandescent lighting, one finds when shooting in colour, that the differing colour temperatures of the two luminants are incompatible. Either the daylight appears blue relative to the incandescent light, or the latter reproduces too yellow-red, depending upon colour balance of the camera stock. Where the light through windows is not sunlight, but *sky light*, its colour temperature can be high—e.g. 7500 K, north sky. Up-rating the effective colour temperature of the lamps by placing suitable bluish colour media over them may be a solution, despite light loss. Or fixing orange filter-sheets over the windows can modify the daylight to a lower colour temperature (e.g. 3200 K).

Lighting for location interiors varies from an improvised set-up to full-scale studio-type rigs. Most interior locations fall into recognisable forms:

Architectural	Churches, show houses.
Public events	Theatres, displays, sport, circus.
Crafts	Manufacture (factories, works).
Domestic	Visits to private homes, fireside chats, etc.

In *architectural* locations, whether emphasis is upon the buildings or upon activities within them, lighting treatment usually seeks to simulate natural daylight, normal interior night illumination, or unobtrusive atmospheric effects. Excessive or evenly distributed lighting produces an indefinable 'cheapness' and artificiality. Architectural features can be carefully modelled, each lamp blending with its neighbour. By projecting spotlights at unseen ceiling and walls, we can obtain sufficient bounced soft light of indeterminate direction for most general purposes.

The approach to interior location lighting is necessarily influenced by where the camera is going to look. If the camera is to shoot all round the walls and ceiling in one continuous take, the positioning of lamps is likely to be limited indeed, and pictorial quality must suffer.

Discontinuous takes or restricted shot coverage allow a more selective lighting treatment. Tall lamp stands, clamp poles, clip-on fittings or even transportable spot-towers then help to place lamps exactly where they are needed. It is best to avoid where possible, the anathema of good lighting, the all-too-tempting frontal flood

(the camera spot-bar, or soft light on floor stands), but even this rudimentary means has had its successes.

Public events very often include their own integral lighting. Where this is insufficient or of unsuitable quality or direction for the camera, it may need to be supplemented or uprated.

Stage lighting is invariably of too low brightness and high contrast for good photographic quality, and needs to be scaled up and augmented for the camera. Nor need the direction or colour, which is acceptable to the eye, prove attractive under the scrutiny of the camera. The traditional theatre proscenium arch and audience layout generally involves frontal lighting from the circle or balcony using follow spots, key, localised projector spots, etc. Lighting over the stage area can be carried by slung barrels interposed between the hung cloths, drapes and flown scenery. Unfortunately, such lighting barrels are necessarily high, or they will be disconcertingly visible to the audience, and may cast shadows. Additional lamps on perches (vertical rails alongside the proscenium arch) and floor stands provide further lighting positions, albeit predominantly for side lighting.

Even this brief outline reminds us how local restrictions can inhibit lighting treatment. In most cases in fact, the mechanics of the locale have an overriding influence on where the lights can be placed. We might say that the art of such lighting is that of creating the required atmospheric illusion despite the restrictions.

For many public events, such as indoor sports (boxing, table-tennis, swimming, skating) lighting installations often follow patterns agreed as standard with the respective associations, for experience has shown how certain arrangements are liable to dazzle, or confuse competitors' judgment. Similarly, in locations where performers can be frustrated by lighting, as in circuses, the lamps may need to be made steeper, or moved to one side for safety's sake.

Lighting in the studio

When we recall that the term 'studio' embraces establishments from the portraitist's salon, to the mammoth arenas of motion picture and television networks, the range of lighting effort encompassed is clearly considerable. Yet the same groundwork of techniques is common to them all. For more restricted applications, limited or specialised equipment will suffice for all daily needs. For a large television studio with a soap opera today and a

grand opera tomorrow, staging and lighting flexibility must be correspondingly greater.

Studio layout

The motion picture and network television studios have much intrinsically in common (their separate characteristics we shall consider in greater detail in the next chapter). In television, however, time and space limitations necessitated by economical studio turnover, give rise to more condensed studio floor usage. Instead of production being concentrated upon one setting until its sequences are complete, the settings of an entire programme are distributed around the studio. Sometimes further settings will be included (or areas struck) in the course of rehearsal, but this is usually minimal.

How far the disposition of settings around the studio floor facilitates or frustrates creative lighting, must be affected by the systems of lamp rigging and control in use, and the lighting density and power loading that can be handled.

In a television studio containing perhaps ten substantial settings, there may be neither space nor equipment to achieve the precision we would wish for. There is no use in employing several spots to simulate an exciting effect here, if we run out of lamps and time to light the set next door. Nevertheless, with experience, filmic standards are attainable, even under such conditions.

Crowded studios have their particular problems. If settings are too closely positioned, the lamps rigged for one area may crowd out those needed for another. A backcloth close to a window may economise in floor space, but prevent its being lit evenly, and sacrifice simulated sunlight into the room.

Operational fundamentals

Several basic truths soon strike one when lighting a setting. To list them is to state the obvious, but it is surprising how often the obvious takes us unawares:

1 The coverage of a spotlight beam increases with its distance, so that for short 'throws' (i.e. short lamp-to-subject distance) its spread is limited. It covers a proportionally smaller area.
2 If a single lamp beam is used to cover a series of subjects, there is much less opportunity to control the intensity and lighting angle for each. When, however, this is overcome by using several

227

individual lamps, there is then the problem of limiting each to its allotted task, without the confusion of overlapping.

3 The efficiency of certain types of lamp—particularly soft-light sources—falls off with distance, so that it may be overstrong for a nearby subject, and inadequate for one further away.

4 We may wish to light a subject from a certain angle, only to find that the light beam, having accomplished this, passes on to overlight the background, or other subjects, behind it. The light angle must be changed to avoid this, the background tones darkened, or the overbright area must just be accepted.

5 Sometimes, when lighting a surface from a selected angle, other subjects become inadvertently illuminated *en route*. A spotlight that brings a vase of flowers to life, may hit the hero fair and square as he opens the door. Or the opening door itself may become brilliantly overlit at the top (Figure 9.16). Attempts to correct such spurious lighting by shuttering it off with a barn-door flap, are liable to cut light off in the very area we are aiming to illuminate.

6 Similarly, the only angle at which it is practicable to get light on to a particular area may unavoidably provide spurious shadows—from a nearby chandelier for instance, or another lamp. Sometimes a restricted lighting angle permits us to illuminate the subject well enough, but results in modelling or constructional shadows of an unattractive shape or size.

7 Add to this the problems of lighting portraiture for multi-angle shooting, and multi-positioned performers, and we have something of the combined problems of continuous production.

The setting

The exact role played by scenery in motion picture and television production, must be influenced largely by the director's production techniques. Settings may at one extreme have an exact, shot-integrated function or, at worst, degenerate into 'what happens to be behind people'.

Except for occasional distant viewpoints, the audience's impression of a setting is normally built up from the series of localised viewpoints presented by the camera. As the camera frames action into closer and closer shots, the background behind the actors becomes less well-defined as depth of field limits distant clarity when focusing on closer subjects, and the surroundings become more fragmented.

The segmented dissection that each camera shot inevitably introduces, brings with it many persuasive opportunities. We can arrange each frame so that it presents a calculated compositional influence upon our audience. If too self-consciously done though, the result can appear mannered. We can arrange scenery so that it meets only the needs of these restricted viewpoints, and by building *partial settings* of a fully dressed but localised nature, achieve considerable economies.

Although settings may be extensive architectural masterpieces, they are usually only seen completely, if at all, from certain viewpoints for a brief time. The high walls, impressive ceilings and overhanging dressings that serve to complete the authenticity of these few shots simply become hazards complicating and frustrating lighting treatment for all the other shots in that setting. A

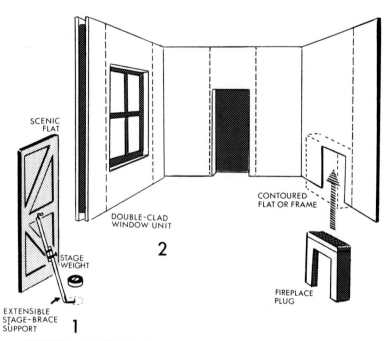

FIGURE 9.4 SET CONSTRUCTION Sets are constructed from individual scenic units clamped or lashed together.
1 The basic unit is the flat. Its plywood, hardboard or hessian-covered surface is painted, papered, etc., as required. It is supported by weighted extensible stage-braces, hinged struts, etc.
2 Joined with more elaborate architectural units (doors, fireplaces, windows) various environments can be assembled. Additional features can be supplied as built pieces (pillars, staircases, rostra).

229

magnificent colonnade can become just a pole growing through the heroine's head in closer shots. Fortunately, the longer viewpoints can be introduced by less costly subterfuges, such as camera mattes, electronic insertion, foreground pieces, etc.

The term '*setting*' encompasses all subject backgrounds, from the simplest to the most complex scenic arrangements. We can summarise their artistic functions briefly as:

Neutrality. Non-associative, non-representational backgrounds.

Realism. *Replica*, convincing copy of an *actual* real place. *Atmospheric realism*, resembling a typical environment. *Symbolic realism*, associative details alone combining to simulate a type of environment.

Fantasy. *Abstraction*, arrangement of shape, form, texture and colour, to express mood, character, thought, etc., without direct relationship to the real world. *Silhouette*, concentration on subject outline. *Bizarre*, distorted reality.

So, as can be seen, scenic treatments—and hence the opportunities for creative lighting—range wide in the course of studio programmes. Dramatic presentations are for the most part realistic. For talks, dance, variety, spectacle and similar programmes, one encounters vogues in taste, each of which provides visual delights until its overfamiliarity palls. Skeletal sets, cut-outs, metal foil, flexible screens, rostra, suspended motifs, stencil screens, large plastic forms, translucent sheeting, designs in light-bulbs, streamers and fringes, pole-clusters, draped matting, painted floors, projected patterns, have all been explored. Each provides its own peculiar lighting problems in the form of spurious shadows, flares, unwanted reflections and so on. The ubiquitous *cyclorama* (cyc.) serves as a universal background.

Surface treatment

Surface tones

Fundamentally, surface tones need to be restricted to a range within the handling capacity of the system. Typically, tonal extremes of 3% (black) and 60% (peak white) in the main illuminated subjects are good reflectance limits for areas in which we wish to detect detail. As light falls upon them, surface values are modified. A dark tone in shadow becomes darker; a light tone

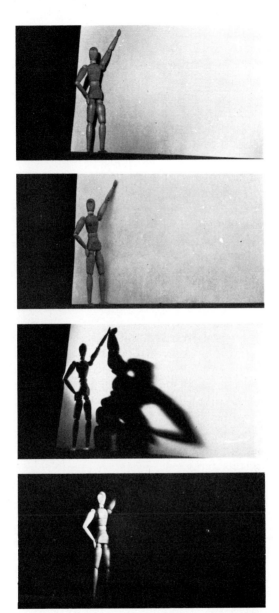

SCENIC TONES *Top:* The light-toned wall easily becomes over-lit under a modelling key. *Centre top:* Overall soft lighting reduces the wall brightness, but at the expense of subject modelling. *Centre bottom:* Lit by an upstage key (e.g. 10H 2V) the background appears even brighter, and a distorted subject shadow spreads across it. (*d*) *Bottom:* Very closely shuttered lighting may succeed in lighting most of the subject alone, and allowing the wall to be illuminated at a lower level.

under strong illumination looks lighter still. And so their relative values (contrast ratio), presented to the camera will be high, higher perhaps than the contrast range the system can accept. Where this happens, these extreme tones will show no detail and no tonal gradation (see Chapter 12).

Thus the lightest tonal values reproduce as blank, white detail-less masses. Similarly, the darkest greys lack modelling, and merge to black. If one attempts to accommodate one end of the tonal scale (shadow detail) it is frequently only at the expense of the other extreme (highlight detail), or intermediate tones will be inaccurately reproduced.

When one recalls that, for example, a 30% reflectance material can be taken up by lighting to the equivalent of a 90% surface, or down to the brightness of a 10% reflectance surface, the flexibility that lighting control provides over apparent surface tone becomes very evident. This often enables us to rectify or improve short-comings in staging and presentation.

Extra localised lighting may be necessary to bring a very dark surface within the system's tonal range, or to correct the reproduced values of overdark subjects. This in turn can pose problems in providing additional power, lamps, rigging and positioning, particularly as there is every prospect that these booster-lamps may spill on to adjacent areas and overlight them, or over-illuminate nearby people.

Similarly, one may try to accommodate a surface that is unduly light-toned, by keeping illumination off it. Frequently, lighting cannot be correctively restricted in this way. On balance, it is far better to control subject tones wherever possible, by selection, or by surface treatment.

An over-abundance of light or dark tones can pall visually. A reasonable variety of tonal range and form provides a more arresting pictorial effect.

Surface contrast

As the human face is our main preoccupation, scenic tones are best related to the 30–40% reflectance of flesh. Under normal conditions, faces are preferably arranged to be $1\frac{1}{2}$ to 2 times as bright as their backgrounds and 3 times as bright or more, for highly dramatic or special effects.

Backgrounds that are substantially lighter than the face not only make the skin appear darker than normal, but prove tiring to watch.

BACKGROUND CONTRAST (1) This exercise demonstrates how impressions of tonal values, contrast, and modelling, are influenced by adjacent tones. The subject in each case is similarly lit. Against a light plane, the subject appears semi-silhouetted, and of lower contrast. Against a black background, subject-contrast appears higher.

In a colour medium, a contrasting background hue can provide marked subject differentiation, even when face and background have identical grey-scale values. But again, we must not overlook any compatible monochromatic version.

Surface finish

A matte surface is technically 'safe' and relatively problem-free, but it does lack the more dynamic feel of a surface with a sheen. In a glossy surface, the reflections, the sparkling highlights, create an illusion of liveliness. We may sense the shape more readily than with a dead, dull finish.

The trouble with shiny surfaces is that they reflect unwanted light too easily. In a static monochrome picture a large bright area on a polished panel may be acceptable—even attractive. In a moving picture, it is distracting to watch the reflection changing its position with camera angle, or to see the shifting reflections of camera headlamps.

In colour, the white glare of such a reflection defaces a coloured surface, and draws attention to the light source. At worst, the overbright highlights can in TV cause smearing, trailing ectoplasms. Dimming the light until it is innocuous only makes it an ineffective light source.

233

BACKGROUND CONTRAST (2) These off-the-tube pictures show how one can concentrate attention by wall shading, by selective light and dark toned backgrounds. So too, we see how a sense of confinement arises from dark overhead tonal areas.

Light bounces off shiny surfaces, so that they invariably look darker than their matte equivalents. A mirror appears dark—until we see something reflected in it. The gold pattern on a wallpaper looks black until it reflects light. Directly it does reflect light, it is liable to be too bright!

One can treat problem surfaces, by dulling them with wax spray, paste, latex spray, water-based dye, flock powder, adhesive nylon gauze or by puttying down. But to do this is often to deface or change the characteristic appearance of the surface. Even then, the treatment may not be effective from different camera directions. One may be able to obscure the offending hot-spot with a suitably positioned object, or by covering the areas with a piece of low-reflectance matte material.

Sometimes, too, specular reflections can provide embarrassment as they bounce from shiny surfaces on to nearby subjects. Cutlery, tableware, silver and chromium, glassware and shiny piano-tops, are regular offenders here. Jewellery often reflects glittering 'pock marks' on to the wearer's neck and chin.

Fabrics and textiles have their associated problems, whether we encounter these materials in scenic or costume applications. In each case, it is important to distinguish between surface *tone* and surface *finish*. Where a material has a smooth, glossy or shiny finish, even the darkest-toned articles may prove troublesome due to excessive blooming.

Where materials are very light-absorbent, as with velvet and deep velours, draping and detail tend to be difficult to reveal without overlighting surrounding areas. A juxtaposition of deep red velours and white lace nets, for instance, can be a time-consuming poser. Such materials inevitably appear darker, and less saturated in colour, than smoother surfaces of identical hue.

Smooth materials such as satins, plastics and glazed finishes are liable to develop blotchy detailless highlights (blooming) as specular reflections of incident light reach exposure limits. We shall find too that such materials used in costuming readily reflect light of their own colour on to the face and neck of the wearer. Overlight materials can look pale and lose modelling unless heavily textured.

Certain weaves will cause the fabric to change colour with light direction, so that a green material may appear grey or blue from different viewpoints. Moiré taffeta and shot-silk are well-known extreme examples of this phenomenon.

Horizontal surfaces

Overbright horizontal surfaces provide regular headaches. Workbenches, table-tops, table-cloths, script paper, are all liable to excessive light bounce. Re-angling the offending surface may help. Sometimes an answer can be provided by surface darkening, dulling down or a colour dip. But again, the problem is primarily one of surface *texture*. A less reflective covering material may help, or perhaps black net draping. At worst, lamp repositioning may be necessary, even at the expense of portraiture.

Surface colour

However 'natural' the colour of the original, it is not necessarily natural in its reproduced form, as, during the unavoidable processes involved in translating colour on to the screen or the printed page, certain colours are bound to translate inaccurately. This, therefore, should be anticipated in the choice and matching of colour in staging and costume. As we saw in an earlier chapter, various physical and psychological factors cause us to interpret colour differently in the original, and in the reproduced forms.

The very act of placing a border around a segment of the scene correlates the subjects within it. This is the foundation of compositional arrangement. People often overlook the fact that colour relationships arise, whether we arrange them or not. The attraction, perspective, harmony, associations, etc., of colour are for ever with us, especially when they are emphasised in isolation on the screen.

In colour, choice of background hues is all-important. Desaturated colours can emphasise foreground subjects. Consequently, flesh, for example, appears more prominent against a pale blue or green background, whereas it merges all too easily against beige, yellow or a desaturated orange.

There need be no direct relationship between the appearance and impact of a surface in colour, and its monochromatic equivalent. In a monochrome medium we are concerned solely with grey-scale values and relationships. Areas that are differentiated in colour, may have the same luminance, and translate into identical grey-scale values in monochrome, so that there is no separation of planes. Form and space may be ambiguously presented. For example, daffodils in colour may be strongly contrasted

236

against a blue-grey sky, only to reproduce as identical values in black and white.

Conversely, one meets colour pictures in which adjacent hues are very similar, or are inharmonious, and yet they may have quite a satisfactory grey-scale appeal.

There are important differences, too, between the ways in which colour and monochrome pictures depict surface characteristics. In a monochrome picture, our total information stems from grey-scale variations, while in colour we have hue also, to increase our understanding of the scene. In the monochrome picture, alterations of light level simply result in changes of grey value; but in colour the light intensity falling upon a surface can modify our interpretation of saturation, and to some degree, its hue.

As monochrome values rise they progressively pale out until they reach white limits. In colour, increased light results in desaturation, until on reaching the system's brightness limits, surfaces lose colour and crush to white, irrespective of their actual hue. On glossy materials this blooming appears as white patches on the surface colour.

In monochrome systems one may deliberately crush tonal extremes. This helps to ensure even tonality in black or white areas—black captions, or white cycloramas, for instance. In colour systems, however, such practices can introduce colour distortion in the process.

Defocused areas in monochrome tend to merge. In colour, an attractive hue will still arrest attention, even when it is indistinct. It might even become all the more distracting because we cannot discern detail in the defocused distance.

Set features

Walls

One seldom lights walls evenly, save in exterior settings. Usually we find them shaded, blobbed, dappled, or lit with an appropriate pattern. This has a practical, as well as a decorative purpose. Top-shaded walls help to throw faces into greater prominence, to create an illusion of depth and solidity, to suggest a sense of enclosure—a ceiling to the room.

Most studio settings are three-walled, the fourth being imagined or partly simulated. Four-walled sets are occasionally met with, individual 'wild' walls being flown, slid aside or hinged

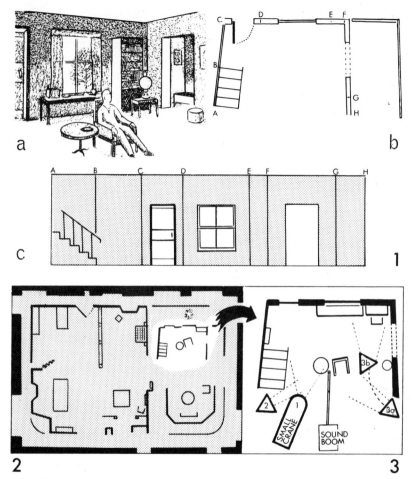

FIGURE 9.5 THE DEVELOPMENT OF THE TELEVISION LIGHTING PLOT
1 The construction of the studio setting (a) is revealed in a scale plan (b)
showing a bird's-eye view, and side elevations (c) A $\frac{1}{4}$-in. to 1-ft or 1:50 scale used.
By mounting the elevations upon the plan, a scale model is obtained.
2 On a squared scale studio plan (showing facilities such as lighting and scenic
hoists and supplies), the individual settings are drawn in their relative positions.
This setting plan (floor plan) is used to direct scenery erection, and for production
planning.
3 Upon this plan the disposition of cameras and sound booms can be drawn,
together with agreed furniture positions, to form a camera plan.

open, to allow entry for cameras and sound pick-up. Lighting
under these conditions becomes very much a compromise for con-
tinuous action, particularly when floor lamps are impracticable,
for steep keys and filler above the walls are largely unavoidable.

238

4 **5**

FLOOR
STAND
LAMP

LAMP ON
CROSS
BAR

6

FIGURE 9.5 *(contd.)*

4 At pre-studio rehearsals, the lighting director draws on a copy of this plan, the positions and movements, together perhaps, with anticipated key light directions. This forms an action plot.

5 A transparency (tracing, overlay sheet) showing the disposition of lamp-rigging facilities (hoist-points, barrels, grid, etc.) and power points, is laid over the action plot. Sets are outlined, and lamp symbols are drawn to indicate the exact type, position and usage of the total lamp requirements. Lamp patching (dimmer channels and supply routing) is included, for lamp identification.

6 Copies of the lighting plot are used to instruct lighting rigging, to assist lamp setting (blocking). The plot serves as a layout and lighting treatment display, to help the lighting director and his assistants in adjusting and controlling his entire lighting concept.

Flat heights

The heights of the wall-flats from which a setting is constructed can have a direct bearing upon lighting opportunities. Many of the principal lamps are arranged directly over the walls of the set.

239

FIGURE 9.6 DESIGNATING POSITIONS IN THE SETTING General references to positions in the setting areas are as shown. More detailed positioning is generally quoted relative to the viewpoint of a particular camera (e.g. 'move to camera left, upstage in Camera 3's shot').

Consequently the vertical angles of these lamps must become steeper wherever the flats are high.

Lamps may, of course, be hung lower within the setting area, providing they do not appear in shot, cast unwanted shadows, or create lens flares. For the most part, however, scenic flats influence both the height and direction of many lamps illuminating the action. For smaller box-settings (e.g. 9′ × 15′) this is particularly true.

The height of flats is usually determined initially by the camera's shots. Wherever the camera uses a wide-angle lens (and hence a large vertical angle of coverage), it is placed some distance from the flats, or wherever the camera tilts upwards (particularly from low viewpoints) the distant flattage must necessarily be built higher to prevent shoot-off. There are other approaches to avoiding cameras shooting past the scenery and seeing sets, equipment, and studio beyond. The most familiar devices to obviate higher and higher flattage include borders, cutting pieces, architectural features such as arches, ceilings, or some other obscuring scenic feature. These in turn can present their own intrinsic hazards.

Scenic flat heights range from 8 to 9 feet at lowest, to typical 10 to 12 foot flats. These suit most general applications, but for bigger settings in large studios, flats upwards of 15 feet in height are needed.

Set layouts

The general layout of a setting can determine possible lighting treatment. At one end of the scenic scale we encounter *open sets*; these usually present various design features (free standing or suspended) arranged before a cyclorama background. Columns,

240

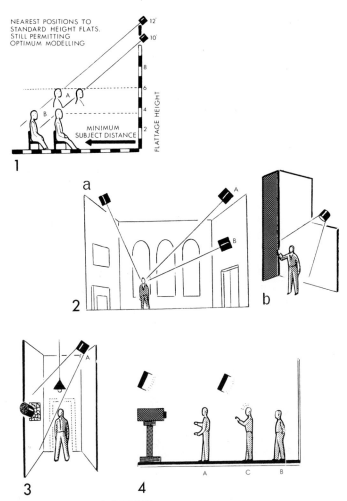

FIGURE 9.7 SET PROPORTIONS

1 Optimum lamp height. If the maximum vertical lighting angle for good por-
traiture is around 40° (allowing for typical 10–20° head tilting), to prevent over-
steep lighting, a lamp should not be closer than line (A) for a standing position,
(B) for a seated person.

2 High sets. (a) Tall settings precipitate steep lighting (A), unless lamps can be
hung low within the setting area (B), and raised for up-angled shots. (b) High flats
may be confined to essential regions, and reduced elsewhere to permit lower
elevation lighting.

3 Narrow sets. In lighting narrow settings (hallways) steep lighting on walls (and
people) may be unavoidable (A). Frontal key lights may produce flat unatmo-
spheric results, and create camera and microphone shadows. Maximum light
break-up may improve lighting treatment.

4 Deep sets. Balanced downstage soft light (A) usually proves of inadequate
brightness to provide filler for upstage areas (B). Mid-stage take-over filler may be
unavoidable, despite its height, and potentiality to excess top lighting at (C).

241

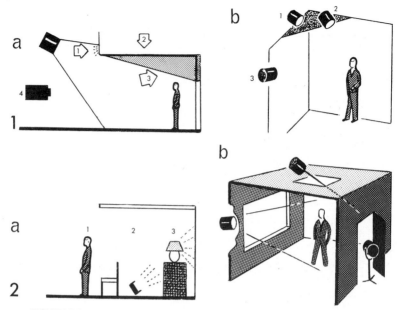

FIGURE 9.8 CEILINGS Ceilings are introduced into settings to prevent shooting over the setting at low camera angles, for atmospheric effect, and/or because they are architecturally essential. Ceilings restrict possible lighting treatment; light directions and elevation are limited, which can increase shadowing problems. The limitations may prove acceptable nevertheless, for setting, atmospheric, and action requirements. They may, however, force the lighting director to adopt solutions that are mechanically practical, but artistically inappropriate.

1 Various pictorial defects can arise. (a) (1) Spill-light on vertical planes. (2) Dark, unlit ceiling. (3) Spurious shadowing on wall, due to ceiling cut-off. Unlit areas of setting. (4) Portraiture treatment limited to frontal and cross-lighting. (b) (1) Preferred lamp position for good portraiture but the ceiling obscures the light. (2) Closer lamp avoids the ceiling, but the light angle is now too steep. (3) Provides suitable low-angle, unshadowed light but from the wrong direction.

2 The basic problems introduced by ceilings may be improved by various stratagem: Lighting approaches. (a) (1) Bring action out from ceiling. (2) Use hidden lamps to light ceiling and walls. (3) Occasionally, practical lamps may assist scenic illumination. (b) Light through openings in the setting (windows, doors).

3 Scenic modifications. (a) Restricting the ceiling to the area seen. (b) Sloping the ceiling. (c) Localising the ceiling. (d) Introducing false-returns in walls so that a seemingly solid wall has a gap for concealed lamps. (e) Using cutting pieces (false soffits, beams) to conceal lights. (f) Vertical planes (e.g. scenic cloth) hung in position of camera shoot-off. (g) Translucent ceilings are sometimes provided; but little light penetrates, and the supporting structure is revealed. Camera mattes optical printing, or electronic insertion provide the ceiling without lighting impairment.

flats, cut-out motifs, provide decorative structural units around which action takes place. Programmes using this type of setting include talks, song, dance, instrumentalists, displays, spectaculars.

The main lighting problems here include those of appropriately lighting these isolated scenic units without casting unwanted

242

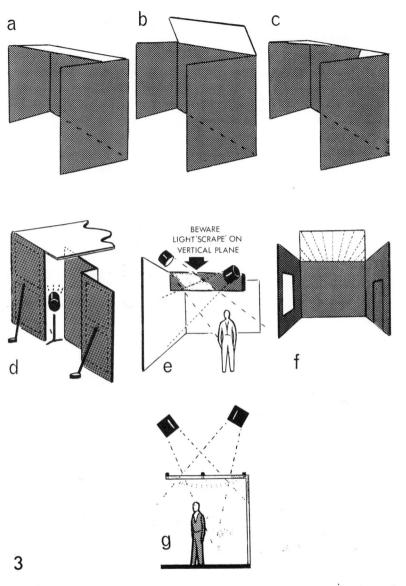

a b c

d e f

BEWARE
LIGHT 'SCRAPE' ON
VERTICAL PLANE

g

3

shadows or light onto adjacent planes; and the mechanics of lighting people from suitable directions while avoiding accidental shadowing or spill-light. (Where a spotlight follows movement among such units, this can indeed pose difficulties.)

At the other extreme of scenic presentation, we meet the *closed*

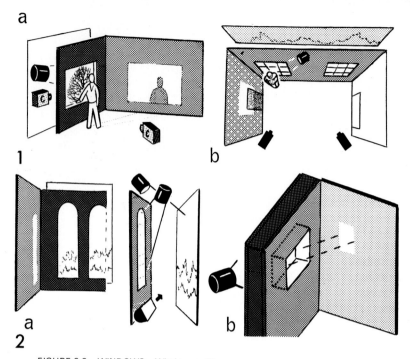

FIGURE 9.9 WINDOWS Window positions.
1 (a) Side-wall windows have the advantage of action opportunity (e.g. people
look out; cameras can look in), and temporal opportunity (i.e. sun, moon, etc.,
projection on to action and setting). The exterior location is less in evidence in
frontal and left-cross shots, in this example. (b) Upstage walls offer continual
locational opportunity (exterior is visible in most shots), but less temporal oppor-
tunity (one sees external scene brightness, but little of its light falls on people or
setting walls). Little action opportunity, except on upstage cross-shots. Upstage
windows only permit oblique cross-lighting, thus much of the lighting effect is lost.
2 Window size. (a) Large windows introduce certain difficulties: in lighting the
entire visible backing evenly if close to the setting; in achieving similar sunlight
distribution through all windows; in causing the possibility of interior lighting
falling on darkened backings. (b) Small windows and deep windows (e.g. castles,
prisons) restrict light entry to a limited, valueless area.

set. This is generally constructed from a series of conjoined scenic
flats arranged to form a three-fold assembly. In most instances
decorated and furnished to resemble architectural interiors (as
stylised or naturalistic reproductions of rooms), layouts of this
type form the basis of most dramatic productions. By slightly
splaying the downstage side walls of the set, easier access is
provided for cameras, sound boom, and for lighting. This in turn
facilitates more flexible production treatment (camera movement,
cross-shooting) and improved lighting for action along side walls
and downstage areas of the setting.

244

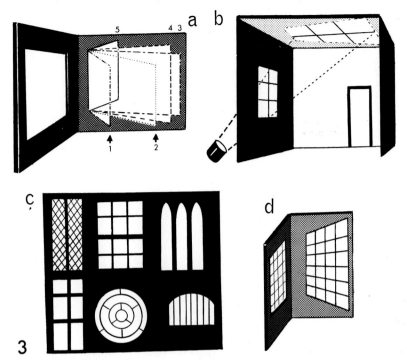

FIGURE 9.9 (contd.)
3 Window patterns. (a) Window pattern shapes can influence impressions of time, location, atmosphere. The following examples show their potential when suitably applied. (1) Ineffectual, mean, restriction (e.g. for confined or sordid interiors). (2) Sunlight, strong daylight. (3) Broad, bright, delicate, airy. (4) Expansive, intrusive exterior scene (lamp close to window). (5) Street lamp below (lamp on floor). (b) Decorative ceiling patterns may suggest street lighting below, but often prove obtrusive. (c) Typical projected window patterns. (d) Lamp too close to window, produces diverging pattern.

Where space restrictions enforce a short lamp-throw, such geometric distortion is inevitable. Only remote lamps (e.g. 20 feet away) emitting reasonably parallel light-rays provide non-divergent shadows. Particularly where large extended shadow formations are required, it is essential to use a distant high-intensity point source, and avoid diluting spill-light.

Windows

Window shape can influence the effectiveness of both interior and exterior lighting.

Small windows, particularly in a deep embrasure, can prevent the projection of sufficient well-shaped light into a room. Conversely, large-area windows may prove hard to light evenly in the space available.

At the oblique angles from which one must often light through windows, their effective width is narrowed, so that especially with

245

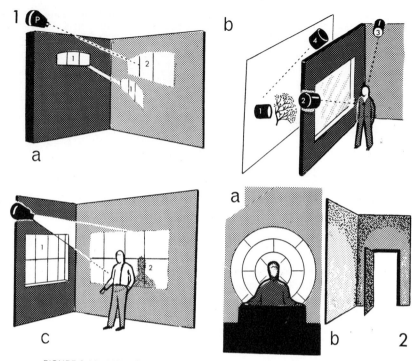

FIGURE 9.10 WINDOW EFFECTS
1 Cheated window effects. Where a meaningful, attractive shadow cannot be achieved directly, it may be preferable to project an effective imitation. (*a*) Restricted window access. (1) Unsuccessful effect obtained from through-window lighting. (2) Cheated projected effect. (*b*) The obscured window. Where nets prevent direct sunlight a convincing subterfuge is to light the nets separately perhaps (1) with leaf-dapple, and to introduce an interior key (2) cheating the sunlight. (Rear kicker at (3).) In general, where translucent materials cover the windows light is best intensified on the backing (4), and through-light, (1) kept to a minimum to prevent a 'blind window' effect. (*c*) Projected window pattern. A person standing in the projector beam can reveal the phoney origin. (1) No shadows (or light) on subject from true window direction. (2) Wrong subject-shadow angle. (The projector must be stable, or swaying pattern reveals the device.)
2 Artificial shadows. (*a*) Where space or mechanics prevent effective window patterns, a painted imitation may appear more realistic. External light illuminates the window frame. (*b*) Careful air-brush spraying (blowing down) of tops and corners of walls can supplement shading by lighting. Such shading must not conflict with lighting treatment.

narrow windows, little useful light can be got through. Full drapes on either side of a window similarly restrict light spread.

Where lace curtains, net curtains, voiles and other fine-mesh drape materials are stretched across the window opening, they readily become overlit by 'sunlight', which is impeded, so that wall-patches are virtually ineffectual. In such circumstances, it

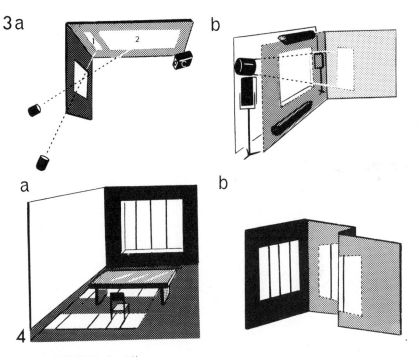

FIGURE 9.10 (contd.)
3 Window pattern restriction. (a) The more oblique the lighting angle (1), the more restricted its pattern. Greater angles (2) may provide effective treatment, but reveal the lamp in cross-shots. (b) Restricted background/window distance prevents even backing lighting, and frustrates sunlight.
4 Disrupted window patterns. Window patterns may be nullified when: (a) disrupted by furniture; (b) misshapen by surface contours; or suppressed by surface tone, texture, or decoration.

To be completely effective, window patterns should be cast upon flat plain undecorated surfaces. Wall dressings (mirrors, pictures, brackets, etc.) or architectural features such as doors, arches, buttresses, must interrupt and nullify the effect. Similarly, where there are wall-drapes, or strongly-decorated or darker-toned surfaces, these will reduce the effect of any window pattern falling upon them.

Whereas the outlines of any bordering drapes, venetian blinds, or surface lettering upon the window may project successfully providing a distant point light-source has been used (close lamps create spreading and varying shadow sharpness), any stretched gauze, ninons or nets across the window openings are likely to abort window patterns.

may be preferable to light the backing behind the window more intensely to give the scene beyond greater definition.

Even when drawn back (swagged), such light-toned materials easily become over-illuminated, and pose contrast difficulties.

Night interiors bring their own hazards. Strong interior lighting may throw spurious shadows on to an unlit photo blow-up

247

outside the window. We find too, that strong keys representing moonlight or street lamps can hit the back of window flattage and bounce on to any exterior backing. Where this is light-toned, it now becomes mysteriously overlit!

Backings

Any scenic surface beyond an opening in the setting is, strictly speaking, a *backing*—a scenic cloth, a wall-flat, a cyclorama. The term *background* is a more general one for any kind of surface behind a subject.

Backings have an environmental value that is often overlooked. In establishing the presence of an exterior beyond our studio-constructed room, we do more than just prevent the audience from seeing the studio wall. Closing drapes or obscure glass would achieve that. Backings introduce spatial conviction—an increased three-dimensional illusion. A window, for example, not only lets light in but also reveals the external world. It shows us where the room is located. Sunlight brings the external world into the room, as do the noises of everyday life that complete the sound impression.

A variety of materials is used as backings for windows, including neutrals such as plain cycloramas or flats (perhaps with light variations, patterns or foliage applied), scenic flats, glass-fibre brick walls, pictorial scenes on artist painted cloths, hand-tinted photo blow-ups (murals) or back-projected pictorials (rear projection). All are widely used.

Economy often demands that the same scenic backings should serve for day and night scenes. We cannot simply leave light off a pictorial daytime backing to render it nocturnal, although for economy one frequently attempts to do so. Skies, shadow formations and tonal distribution all reveal the fraud. A photographic backing may be doctored, to have rear-lit window openings for night, or sometimes even frontally lit reflective patches, with some success.

In colour one may, with luck, convert a snowy landscape with leaden skies into grassy green meadows under a summer sun by colour-lighting changes, but this is exceptional. Rear-projected backings are undoubtedly the most highly adaptable.

Scenic 'cut-outs'

These have the merit of providing some parallactic movement between relative planes. Such cut-outs must, as with all pictorial backings, show light direction compatible with the studio lighting,

248

FIGURE 9.11 SCENIC CUT-OUTS Photographic or painted self-supporting scenic cut-outs (profile pieces) can suggest progressive planes, e.g. hills, buildings, skyline. (1) Low profile cut-out forming a ground row. (2) Floor trough (cyc. lights).

and spurious shadowing should be avoided. Ground lamps between them help in controlling their respective brightnesses, and in differentiating planes (Figure 9.11).

The cyclorama

Curved in a shallow 'C', the cyclorama (Figure 9.12) or 'cyc.' can be built as a permanent structure, or more usually, formed from a storable *cyc.-cloth*. Canvas, duck or velours are typical cyclorama materials, and they may be hung and stretched from battens, tubular pipes or a permanent slide-track. White, light blue, mid-grey, dark blue and black cycs. offer extensive staging opportunities.

FIGURE 9.12 THE CYCLORAMA The 'cyc' is a plain, neutral curved general purpose background surface.
1 A concave strip (merging-curve, ground cove) ideally merges the cyc. imperceptibly with the ground, hiding the floor join. Due to their angular differences, floor, cove and cyclorama may need separate lighting to achieve this.
2 A concave ramp, or a ground row can hide ground lamps, lighting the lower part of the cyc.

As a neutral background to scenery, the cyc. facilitates front-projected shadows, light patterns and light shafts—mid- to upper-values being the most adaptable for this purpose.

249

With the cyclorama used as a 'sky', we can run the gamut from dawn to sunset, with clouds, sun, moon, stars at the touch of a button. Although a time-consuming venture, such potential changes demonstrate the effective lighting flexibility the cyc. offers.

Colour media necessarily reduce the effective brightness of a lamp by as much as 20% for deeper blues and greens. Consequently it can be both uneconomical and problematical to light large areas with dense colour media. Light tends to fall off rapidly around the lamp, leaving restricted coverage and localised hot-spots.

Gauzes (scrims)

Thin cotton netting, known variously as gauze or scrim, has a mesh around $\frac{1}{8}$-in. diameter, and is mostly employed in black, grey or white forms (see Figure 11.9).

Gauzes are used scenically in three ways:

1 Over scenic backings to soften outlines, tonal contrast, and colour. The unevenness and the artificiality of painted backgrounds is somewhat disguised by this means.
2 Over windows to suggest aerial-perspective and diffuse detail, and to provide a non-reflective substitute for glass. Lettering can be attached or painted on its surface.
3 As stretched, hung sheets.

Against a cyclorama, a stretched gauze can help to hide storage creases or stretch wrinkles. However, any light or shadow pattern thrown on to this cyclorama may form an image upon the gauze also. Thus we may get a 'double moon' in a night scene—although with care, this gauze problem can be turned to advantage in producing multi-clouds, watery moons and multiple tree-shadows.

One can light through black gauze with acceptable light loss, but white gauze lightens, and reveals light coverage, factors that qualify its use in ceiling and wall applications.

Floors

The smooth, specially levelled surface of the television studio flooring contrasts with the nail-studded wooden flooring of many motion picture studios. Television cameras must be free to move anywhere, rapidly, so scenery normally has to be supported by slings, bracing or weighted struts. This provides the bonus of a clean floor surface which can be readily decorated with water-paint and quickly machine-scrubbed.

In the motion picture studio, scenery is *spiked* to the floor for greater stability. Scenic structures are more extensive and elaborate. They must often be more robust. Cameras run on specially laid tracks, nailed to the floor. Floor coverings of boarding, canvas or prepared surfaces are provided where required. As we shall see later, this differing approach affects camera mobility, and hence lighting problems, but it influences too, the elaboration practicable with two media. Whereas, for example, the film studio can use profiled flooring throughout a 'cobbled highway' (plaster, plastic or rubber sheeting), the television designer, having to allow for camera moves, may have to make use of an ingenious floor-pattern painting machine. This prints cobbles, stones, floor planking, parquet flooring, by the yard with its interchangeable rollers, artist-painted handwork being used for more subtle treatment. However, for the lighting director, this presents a plane that has no real texture to 'bite on', and detail that disappears in white specular reflections. Even when disguised with scattered peat or sawdust, such speculars still shine through this dressing and the materials themselves are all too liable to become spread around the studio. Carpets, turf, matting or any floor irregularities are the bane of the moving camera, and so have to be carefully localised.

Shiny floors in general, e.g. for spectaculars and dance routines, provide kick-back hazards unless lit from side positions. But then, one may be lighting to avoid localised floor reflections, rather than to suit the subject. At times bad patches can be covered, as when correcting furniture speculars. Total soft light is occasionally advocated to ensure that at least such specular reflections are of larger area, but at best this is only a palliative.

Foliage

Incandescent lighting is deficient in the blue-green region of the spectrum, so considerable output may be necessary to create any pictorial impression when illuminating dark foliage, especially with coniferous shrubs or trees. Glossy evergreens such as laurels, rhododendrons and hollies produce this difficulty, and also tend to result in diverting highlights.

The position of foliage is important, too. If there is exterior foliage too close to a window, from within the room it will look dark and ill-defined, even when ground lamps are used to augment illumination.

251

FOLIAGE *Top:* These laurel leaves have been lit in four different ways. *Top left:* lit from behind, a translucent effect. *Top right:* backlight bounces from the leaves, exaggerating their sheen. *Bottom left:* unlit leaves against a light background, silhouetting them. *Bottom right:* frontally spotlit; high light intensity needed. Little shine.

Centre: Pictures of fine blossom do not always benefit from backlight. Here it has caused detail to merge and local highlights to clump together. *Bottom:* Frontally lit, the same blossom is now more sharply defined.

PROPS (PROPERTIES)

Within the architectural shell that forms the setting are the props —the set dressings, furniture, household articles, books, papers and odds and ends that furnish the environment. Pictorially these not only need to be appropriate but also suitable for the system in tonal value, contrast and finish. In reality they are often hired to suit the application, with a prayer that lighting, surface treatment or good fortune will enable them to be used successfully. If action calls for particular articles and these are only made with a tone or finish outside the preferred tonal range, that is just unfortunate. A similar situation arises with certain hired clothing. We could have all items specially made, but this would hardly prove economical.

It is wise practice to avoid glass or plastic sheeting in windows, pictures and furniture as far as possible, in any surfaces facing the camera. Glazed doors that can catch light as they are opened have their revelatory moments. One may hopefully wax-spray such glass to reduce highlights, but this gives an unconvincing dullness.

Although one may sometimes have to devise lighting primarily designed to avoid flares or reflections in varnished woodwork, metalwork, tiles, pictures and the like, it is usually a better proposition to modify the camera position, re-angle the offending surface or tilt it downwards to throw reflections in another direction. Lighting just to accommodate unsuitable properties, drapes, furniture and setting tones can easily be at the expense of its main purpose—creating effective portraiture and environmental illusion.

PRACTICAL LAMPS

All light fittings appearing within the setting are *practicals* (or pracs. Figure 9.13). Chandeliers, candles, oil lamps, torches, wall brackets or what have you should, when lit for a night scene, appear as genuine sources of light from which the scene appears to be illuminated. For that reason the position and nature of all practicals should be an integrated, planned part of the setting and lighting design.

Regrettably, too few practicals can themselves be used as total luminants. Many are puny under strong studio lighting. It may be possible to use an overrun lamp in a large, heavily shaded fitting so that light spills from it at just the right intensity on to the nearby wall. But for colour shooting, many practicals will not support suitably uprated lamps because there is too little room, or

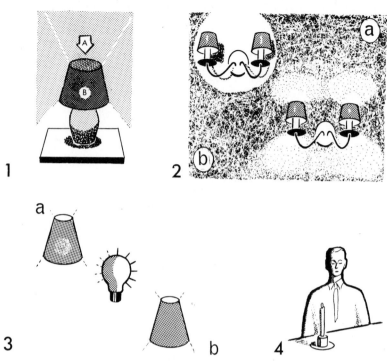

FIGURE 9.13 PRACTICAL LAMPS
1 Unattractive light pattern. (a) Upward streak suppressed by an inserted piece of diffuser. (b) Bulb seen as localised hot spot (see part 3).
2 Ineffectual light output. From small low-power fittings. This requires localised simulated wall-blobs from, e.g., projector spotlights. (a) Incorrect imitation (b) Correct imitation.
3 Overbright bulb, despite satisfactory emergent light pattern. Paint down or shield front half of bulb, leaving full light to illuminate the wall. (a) Before treatment (b) After treatment.
4 Incompatible light direction. Subject lighting direction does not agree with the position of the practical.

dangers of overheating. Consequently, in a colour production their effectiveness is reduced. But lit practicals that do not seem to do anything are as incongruous as showing a person lighting a match to read in blatantly brilliant surroundings.

Practicals can be divided roughly into those in which the light source is visible, those covered with a translucent shade, and those where an opaque shield surrounds the luminant.

In the first, by the time the lamp is bright enough for the fitting to look effective, the visible source is overbright for the camera. A bare gas-mantle or oil-lamp flame when turned up enough can be far too intensely distracting, and in television is liable to engender

254

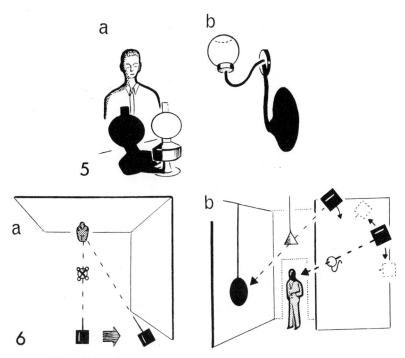

FIGURE 9.13 (contd.)
5 Shadow of practical on nearby surfaces. (a) Unrealistic (b) Unattractive.
6 Hanging practicals. (a) May require that the key light be offset, or (b) steepened or restricted to avoid spurious shadows on distant people or settings.
 Hanging practical lamps are usually positioned in upstage or non-action areas, to prevent entanglement with the mobile sound boom-arm, or spurious shadowing on performers. Lamp suspensions may appear abnormally long when shot by low-angle cameras; and unless brailed, are liable to pendulum-swinging under strong studio ventilation. The distorted, elongated shadows of hanging practicals can sometimes be hidden by throwing them out of shot, or made unobtrusive by casting them onto dark or broken-up surfaces.

spurious trailings as the source or camera moves. Reducing the brightness of such a source to a manageable intensity leaves the fitting strangely dim and unconvincing. Around wall and stand fittings we might arrange light patches imitating the normal emergent light pattern. Cheating may go further, as when we replace the real gas-mantle with a white-coated lamp of comparable size. The ultimate in deceit perhaps, is to use an unlit mantle, or a card replica, and illuminate it with a hidden spotlight.

Translucent shades provide their lighting complications. A practical with a white opal globe all too often looks lit, even when switched off, as studio lighting falls upon it.

TONAL BALANCE (1) The distribution of light on a background can have a pronounced influence upon the compositional effect. *Top:* A balanced, unified, but perhaps rather conventional and dull result, is obtained by this centralised background lighting. *Centre:* This particular subject has a right-hand bias, so that the asymmetrical background lighting may be suitable. The shot would appear more balanced tonally if the camera were panned right. *Bottom:* The background shading is against the subject, and creates unbalance. In certain cases, one might introduce such unbalance deliberately, to create unrest, uneasiness, tension.

256

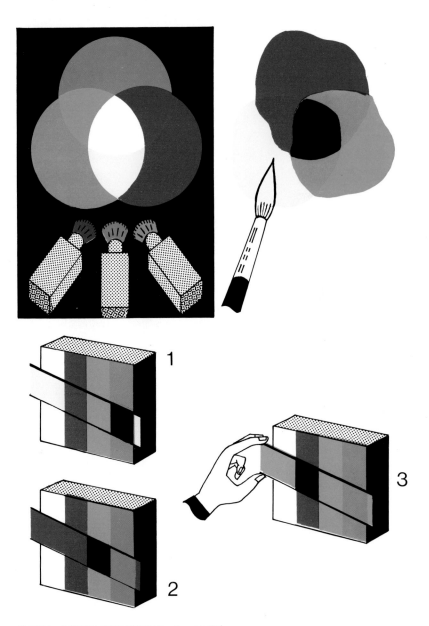

PLATE I COLOUR PRIMARIES (See figure 1.20)
Top left: additive mixing. The primaries for coloured light—red, green, blue.
Top right: subtractive mixing. The primaries for coloured pigments, and for translucent materials (filters)—magenta, cyan, yellow.
Bottom: Examples of subtractive mixing, when using colour filters. (1) Yellow filter. Absorbs blue light, transmits red and green light. (2) Magenta filter. Absorbs green light, transmits red and blue light. (3) Cyan filter. Absorbs red light, transmits blue and green light.

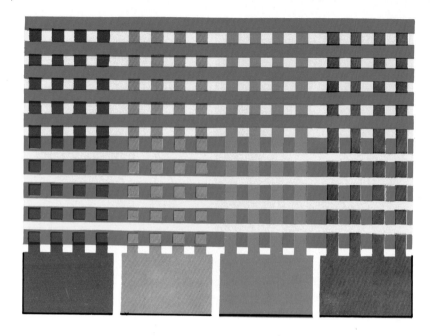

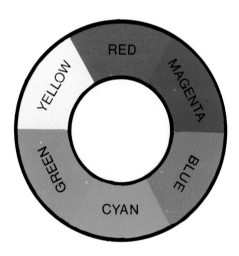

PLATE II
Top FINE COLOUR DETAIL The colour of fine (or distant) pattern can appear to change with its surroundings, and with size. Try viewing the tilted page. Also examine the colour continuity from a distance. Reasons for these changes are complex. They include contrast and adaptation effects, and visual aberrations.

Bottom COLOUR CIRCLE The colour primaries are disposed around a circle, complementary colours appearing opposite.

PLATE III
Top AFTER IMAGE Stare at the left figure, counting twenty slowly. Then stare at the cross on page right. An after-image in the complementary colours will appear.
Bottom COLOUR EXPOSURE After staring fixedly at one of the colour patches, look at the photograph, and note how hues appear altered. Try this using one eye—then compare the left and right eye versions alternately.

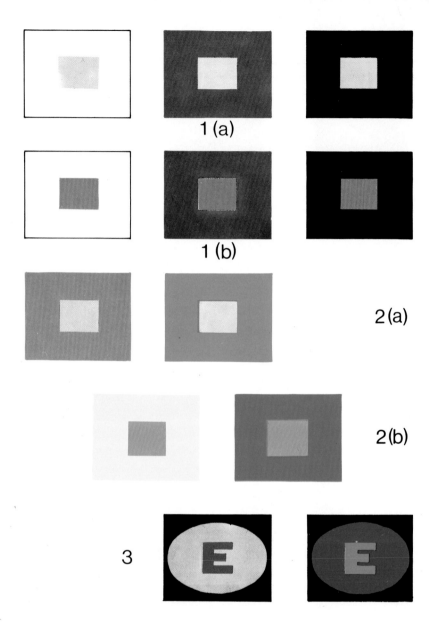

PLATE IV THE EFFECT OF BACKGROUND
1 Adjacent tones can modify our assessment of (a) tonal values; (b) saturation.
2 Adjacent colour affects our assessment of hue: identical colours can look different; dissimilar colours can look identical. (a) A neutral tone tends to take on a hue complementary to its background colour. (b) A hue can undergo a shift towards the complement of its background colour.
3 Certain adjacent colours create strongly vibrant effects.

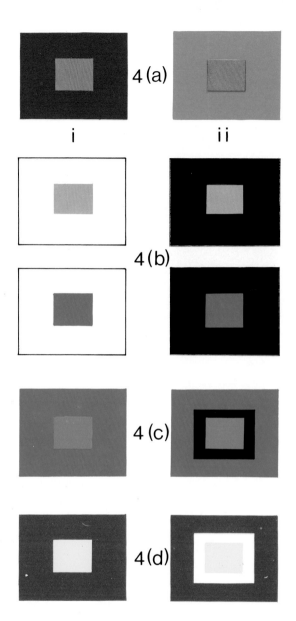

PLATE V THE EFFECT OF BACKGROUND

4 (a) Apparent colour strength (saturation, chroma) can be modified by adjacent hues, appearing weakest (i) against a strong colourant of similar hue, strongest (ii) against a strong colourant of complementary hue. (b) Strong value contrasts modify a colour's saturation. (i) Light colours appear weaker (desaturated) against black than against white. (ii) Dark colours appear weaker (desaturated) against white than against black. (c) Heavy black borders subdue conflicting colour areas of high saturation. (d) White borders help to unify dark, strongly saturated contrasting hues.

PLATE VI GIRL WITH FLOWERS Strong lighting may reflect the hue of adjacent surfaces onto shadow areas. Here the magenta flowers and the yellow dress reflect on to the face. Natural skin tone is present only on the near arm.

PLATE VII
SNOW SCENE Colour reproduction may reveal hues that the observer's eye has ignored. Here in shadowy areas the snow is blue with the reflected sky light.
GALLERY Strong tonal contrasts, together with striking shadows, provide an arresting interior scene. Low key shots are often avoided in colour, but when carefully controlled, and created through contrast, rather than under-exposure, very successful results are possible.

PLATE VIII
OPEN AIR FRONTAL SUN Thanks to colour differentiation, we can readily distinguish between various planes, notwithstanding the strong flattening frontal sun. Our attention is drawn to the red shirt.

In monochrome, all this impact is lost, and planes merge.

EXTERIOR LIGHT AND SHADE Here we achieve the effect through the interplay of light and shade, and not by colour differentiation alone. Consequently the picture will reproduce well in monochrome, and is more significantly arresting.

Opaque shades allow overrun bulbs to provide effective local illumination, although any overlit interior lining must not be obtrusive.

Lighting balance

Balance, as we saw in an earlier chapter, is the process of controlling the relative intensities of lamps after they have been set; that is, their angles adjusted and their coverage restricted. Balance is undoubtedly the most elusive facet of the art of lighting. Quite small changes in the proportions of light have such a pronounced effect upon the feel of a picture, that even a series of 'before and after' demonstrations only begin to convey the nuances that balance adjustment provides.

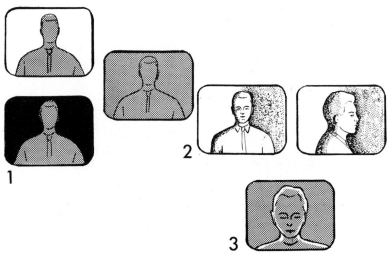

FIGURE 9.14 FACE AND BACKGROUND CONTRAST
1 Face tones should contrast with their background to provide subject isolation.
2 In static portraiture, contrasting edge tones are often used to achieve subject separation.
3 Sometimes outline rimming is effective; but as in part 2, can become mannered with overuse.
 Colour contrast may successfully isolate subjects, although its monochromatic separation may prove negligible.

For attractive and convincing balance, the relative brightnesses of all sources should be considered:

1 The key, the filler and the back light in portraiture.
2 The predominant face and clothing tones, and their background.

257

TONAL BALANCE (2) *Top:* Background shading can direct attention inappropriately, to the lower part of the figure. It could alternatively give the figure strength, as it penetrates the darker background. This approach is frequently used with lighting people to isolate the faces more clearly against a darker background. For darker skin-tones, the treatment may be less successful. *Bottom:* Typical 'ground row' lighting, from a horizontal floor unit. Brightest at the bottom, the background shades progressively towards the top. Widely used for cycloramas. Note how the legs are cut off and merge into the dark floor. This is avoided by placing the figure higher (rostra), or by using a light floor.

3 Relative wall-brightnesses in a room (those containing windows generally being the darkest during daylight).
4 Room ceiling brightness in relation to the walls (can be noticeably darker, particularly light when the exterior is snowy, or where illuminated with pools of light from practical lamps).
5 Judgment of the brightness of an exterior (e.g. seen through room windows), in comparison with that of the interior.
6 The strength of light entering a room (sunlight, moonlight, street lamps) balanced against the impression of the brightness of

an exterior scene (dark areas outside windows can make infiltrating sunlight appear overbright, or incongruous).

7 The brightness of practical lamps at night, their light patterns and apparent effect upon the surroundings.

8 In daylight exteriors: assessment of effective sunlight strength on people, and upon the setting, the density of shadows, sky brightness and the apparent brightness of interiors seen from without.

9 In night exteriors: the moon's apparent intensity relative to people and the setting, shadow density, sky tone, the brightnesses of any visible interiors, exterior practicals (street lamps, signs, cars, shop windows, etc.) and their effectiveness.

Technical problems arise in arranging these correlated balances, for the camera can only handle restricted brightnesses and contrasts for effective pictures. Suppose, for instance, we have a hot Mediterranean sun beating upon whitewashed walls, and a family at siesta, in a room behind tightly shuttered windows. Pictures in the murky half-light of the room would be unacceptable,

FIGURE 9.15 BACKGROUND SHADING 1 As walls are progressively shaded the background is transformed from a blank, open, spacious surface to one implying the presence of a ceiling, and giving a sense of enclosure. Extensive shading conveys intimacy, cosiness, compactness and a confined space, even oppressiveness, where top shading is heavy.
2 (a) A naturally confined space (boat, aircraft, train, tent) is imitated more convincingly with (b) top and base shading.

except for a brief shot at most. We have to uprate the interior illumination somehow, even if we only provide enough to rim features.

But what if we unshutter the windows? There must necessarily be a high contrast between the exterior and the interior. In a true location this could be excessive. It would probably not be possible to expose for detail in both. We could expose for the interior and let the exterior burn out, or expose for the exterior and let the interior be underexposed. The solution could be a compromise, judiciously brightening parts of the interior and avoiding excessive intensities from the exterior—perhaps using a black gauze over the window to hold back the overbright scene.

Brightness and darkness are largely subjective relative effects. A key light may look brighter if we reduce the associated filler, or if we lower background brightness.

Overlighting a background may make foreground objects look darker. If, to remedy this undue background brightness, the camera lens is stopped down, all other picture tones will be correspondingly lowered, and faces become even darker than before. The reverse happens of course, if the aperture is opened to expose the dark faces more correctly.

A balance in which highlights predominate and shadows are unrelieved, produces results that include the stark, dynamic, coarse, ugly, strong, confined, or restrictive. A more or less even filler-to-key ratio where shadows are clearly illuminated to appear as well-lit surfaces can, on the other hand, seem flat, dull, undynamic, open-air, delicate, drab, weak or fresh, according to the occasion.

Lighting quandaries

In lighting, as with all crafts, there are many problems that are encountered regularly. Some have arbitrary solutions. For others, the most profitable answer is to modify the situation itself, so that a more successful lighting treatment is possible. If, however, we were to try and avoid all the circumstances that create lighting problems, production and staging techniques would be unreasonably restricted. The predicament lies in judging whether it is worth degrading the lighting for the productional advantages. Quite frequently, for instance, lower-quality lighting is precipitated throughout an entire scene by structural arrangements that have only brief productional value.

The quandaries outlined in Figures 9.16, 17 and 18 are by no means exhaustive; various additional predicaments are included throughout other chapters. Some would be avoidable in shot-by-shot treatment where scenery and lighting can be rearranged to suit specific action. In the television studio, however, breaks during video-tape recording (e.g. for costume and make-up changes) are seldom sufficient for major relighting. Instead, one must recognise the complications and apply the most practicable alternatives.

Lighting method

Once we begin to light the setting, mechanics and artistic judgment become inextricably interdependent. Individuals set about the process in different ways, but the general procedures outlined here are typical, whether our lighting is aiming to augment natural illumination or to build up the total modelling for a studio set.

Above all, the entire procedure must be systematic, each lamp making its particular contribution to the illusion; the blended lamps gradually combining to devise the mood, atmosphere, environmental effects we are seeking. The type of setting involved, and its purpose, will determine our actual lighting treatment. So must the time and facilities available.

For optimum results, and the greatest flexibility of treatment, there is much to recommend the practice of lighting the setting and the performers with quite separate lamps—as far as this is practicable. Certain action lighting will fall on the set, and vice versa, but 'general purpose' illumination is best avoided.

ANGLED BACKGROUNDS Two problems arise when background planes are angled to the light. Apparent tonal values change with its obliqueness; any light cut-off (barn-dooring) becomes uneven.

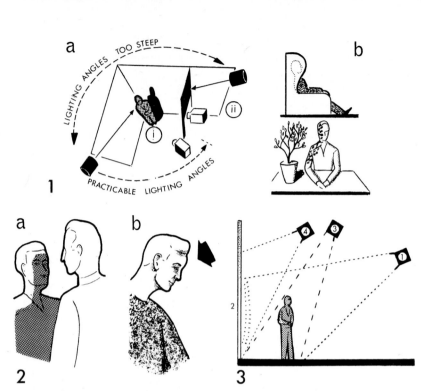

FIGURE 9.16 LIGHTING QUANDARIES (1) Lighting problems frequently arise for which solutions are not immediately obvious, or compromise is unavoidable. This figure collects together the most common difficulties.
1 Restricted lighting treatment. (*a*) (i) Actor positioned near walls, or in corner angle, restricts possible lighting direction; (ii) camera shoots where scenery blocks lighting (camera shadows). (*b*) Surroundings (from furniture to wall fittings) can limit lighting.
2 (*a*) Spurious shadowing occurs where two people become aligned to a lamp beam. Repositioning is usually more practicable than relighting. (*b*) Exaggerated modelling follows when downward-tilting heads effectively steepen the key light.
3 (1) A key light may serve to illuminate both actors and background, (2) but a light-toned background may become overbright unless the key is restricted—which is only possible when actor positions permit. (3) Key restriction for close wall positions introduces steep light angles (poor portraiture). (4) Steep background lighting may result in ugly set-modelling.

However extensive the scene to be lit, we shall find that it can be subdivided into various parts, including:

Large scenic planes, such as cycloramas (neutral or decorative backgrounds), backdrops (pictorial clothes, photo blow-ups).
Wall flattage.
Constructional features, e.g. fireplaces, windows, staircases, columns, trees, etc.
Backings, i.e. beyond windows and doors, etc.

262

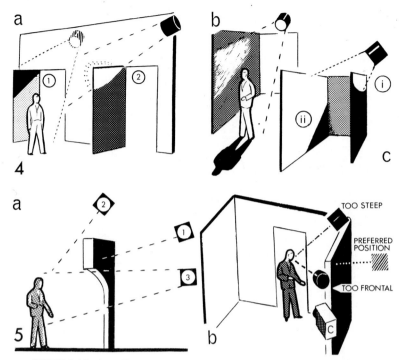

FIGURE 9.16 (*contd.*)

4 Spurious shadows and hot spots. (*a*) Back light through doorway creates crude shadow pattern on door (1). Distant key hits opened door, causing localised overlighting (2). (*b*) A key light can inadvertently be allowed to streak along adjacent walls, casting elongated shadows and emphasising texture. (*c*) Where lamps are positioned behind flats, corner-cutting shadows may arise as they obscure part of the light beam (i). Similarly, shadow areas (ii) are likely.

5 Scenic obstructions. (*a*) Horizontal obstructions (arches, drapes, cutting pieces, overhead beams) can influence lighting elevation. Instead of the desired angle (1), lighting has to be steep (2) or low (3). Between these angles, action is shadowed. (*b*) Vertical obstructions. Cameras tight against side walls may shoot subjects for which suitable lighting is precluded in continuous production.

Sometimes it is possible to circumvent such situations by using concealed lamps (hidden behind scenery or gobos); or through false returns in flats; or by cheating the position of lamps, actors, cameras, or scenery to suit specific shots.

Set dressings, e.g. furniture, wall decorations, statuary, etc.
Action lighting, i.e. for performers, comprising broader action
areas, and specific action points.

Lighting may be built up in several ways: individually, a single lamp being lit at a time; or progressively, the lamps being successively lit, added until the total effect is complete. There is another approach, perhaps, where light control is limited, and here all lamps are lit together, and then separately positioned to suit their allotted

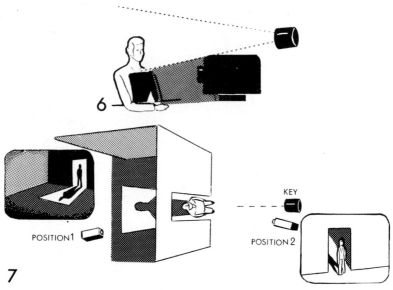

FIGURE 9.17 LIGHTING QUANDARIES (2)

6 Camera shadows. If a camera intercepts a light beam its shadow is cast upon the subject. Raising the lamp causes the shadow to move downwards, but coarsens the lighting. The light may be barn-doored off the shadow region, but then leaves it unilluminated. Moving the camera back (using a narrower lens angle) may be preferable.

7 Reverse-angle shots. The light level required to produce a strongly dramatic effect at viewpoint (1) may be excessive from viewpoint (2). Typical situations include light streaming through door, strong sunlight through windows.

 Best accommodated by shooting the differing viewpoints independently and adjusting lighting balance accordingly. Lens-aperture adjustment alone is seldom sufficient.

purposes. But such unscrambling can become a somewhat confusing and eye-tiring procedure.

Large scenic planes (surfaces ranging from perhaps 250 to 3000 sq. ft. or more) frequently require continuous lighting, without over-bright patches, unlit 'holes', or defacing shadows. Practice, skill, and the right kinds of lamps are necessary to illuminate such surfaces evenly. If there are to be decorative effects (e.g. clouds, patterns, blobs, streaks, shading, colour, etc.) these must be carefully and appropriately distributed. Ground rows should be arranged to provide even coverage, their light merging with that from hung lamps—unless we seek a border illumination effect—intensity and colour being matched along their length. Differences of light intensity or distance can produce apparent colour variations.

Care is usually necessary when lighting near cycloramas,

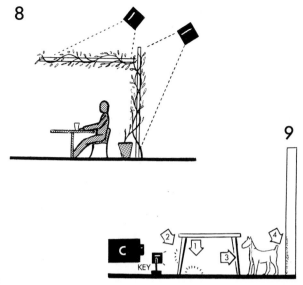

FIGURE 9.17 (*contd.*)

8　Light penetration. When a subject is positioned within translucent or per-forated planes, certain problems arise. Sufficient light may be prevented from reaching the subject; or the surface may become overbright once enough light has penetrated; or shadows may obscure or camouflage the subject. These difficulties can be caused by the presence of leafy branches, lattices, venetian blinds, decorative frames, gauze, net, plastic sheeting, drapes.

9　Ground lamps. Where action is at or near ground level, typical problems include: (1) light streaking along the floor; (2) intermediate objects becoming brightly lit; (3) shadows being cast on to the subject, and (4) upon its surround-ings.

backings, etc., to avoid accidental shadowing, or spill-light being cast onto them.

A wall area can be treated in several different ways. It may be lit overall by a single source. We can then deliberately interrupt this light to form dappled or patterned effects (using cookies, branches, stencil cut-outs, etc.). Alternatively, the light from a series of lamps can be continuously merged; or instead their beams may be separated to leave unilluminated patches. Any wall-shading will be introduced around this time.

The camera-light

Since the early days of motion pictures, some sort of camera-light has proved invaluable to illuminate shadows, reduce contrast and act as a mobile key light. This lamp (known variously as a

265

FIGURE 9.18 LIGHTING QUANDARIES (3)
10 Camera traps. To increase shot flexibility cameras can take sneak-shots through doors, windows, fireplaces and pull-away panels in scenery. But lighting for such shots is necessarily limited to what mechanics are possible. These may not permit suitable portraiture, continuity, etc.
11 Lighting a piano. (a) Shadow problems include: (1) Performer's shadow on keys; (2) shadowed fingers; (3) lid (or stick) shadow on pianist. Illumination problems: (4) Steep lighting, or (5) dazzling low key light, caused by trying to avoid shadow problems (2) and (3). (6) Inside of piano dark. (7) Hot spots on piano body. (b) Typical lighting approach.

'basher', 'headlamp', 'camera fill-light' (Figure 9.19)) has become a familiar luminant for improvised lighting on location and a regular attachment to the studio camera (the detachable camera 'spot-bar' has an allied application).

In television, where camera movement is likely to be impeded by floor lamps, the lighting director must resort to camera-lights:

As low-angle fill-light.

To key close action that cannot be lit correctly by rigged lamps.

12

13

FIGURE 9.18 (contd.)
12 Background pattern position. A centralised background pattern changes in
frame position as the camera viewpoint alters. This frustrates pictorial balance
and continuity whenever cameras move.
13 Camera-lights. (a) While providing low-level filler, camera-lights may over-
illuminate parts of the subject. (b) One person's camera-light may over-illuminate
another person positioned nearer the camera. Its lighting-angle for the nearer
subject may be unsuitable; or may provide a strong kicker, edge-lighting his face.
(c) Camera-lights can produce spurious light reflections in spectacles, and shiny
surfaces.

To reduce unsatisfactory close-up portraiture by rebalancing
misangled keys against more suitably angled camera-lights.

An invaluable expedient, the camera-light also has its weak-
nesses. It reflects in any shiny surfaces facing the camera. As
cameras move away or change their viewpoint, their lights go with
them—an embarrassment if two combine to light a subject and
one then departs. As the camera moves further from a subject, its
light becomes less effective. Camera-lights prove less useful,

267

therefore, with narrow-angle lenses. One camera-light can produce a strong effect on another camera shot, often as a kicker or a side light. At closer range any camera tracking produces marked changes in brightness (due to the inverse square law), so that constancy control becomes difficult. Where multiple camera-lights are used, a profusion of catchlights in the eyes can become displeasing. Spectacle wearers can rarely be lit in this way, owing to strong specular reflections.

FIGURE 9.19 CAMERA-LIGHTS Camera-lights take several forms: (a) single spotlight, (b) spot bar, (c) broad source, (d) twin headlamp, (e) strip light, (f) spot frame (garland) circle of photofloods.

Perhaps the least controllable aspect of the camera-light is its general, unavoidable spill on to all foreground areas. Localised camera-lights are useful only for semi-static cameras; otherwise subjects can be seen entering and leaving its area of illumination. Any camera-light, while lighting one person, is liable to over-illuminate another, closer to the camera, especially if the nearer subject has lighter-toned clothing.

Finally, where camera-lights are used with other luminants, there can be discrepancies in colour temperature—particularly when overrun or high-temperature sources are fitted to the camera.

Analysing lighting treatment

Provided that the lighting treatment is not too complex, or considerable soft light used, it is usually possible to analyse a picture and deduce what basic approaches were employed. We do so by examining shadows and shadow formations, and the relative brightness of surfaces. Where soft light is used, these clues are

268

FIGURE 9.20 LIGHTING CONTINUITY Technical and artistic continuity problems arise in several forms.

1 As a camera moves around a subject what was a rimmed, decorative, or night effect becomes progressively flatter and unattractive.

2 Cross shooting between people facing to and from the light source produces intercut bright and dark pictures. (a) Exterior, (b) interior—exterior shooting. From different intercut viewpoints, any contrasty lighting balance may present varying brightness and atmosphere. More even lighting may produce a poorer pictorial effect.

3 Backed by a light wall (1) a face appears dark. Against a dark wall (2) it appears light. (Intercut viewpoints are disturbing.)

4 From a sunlit window to within a room, light intensity would naturally fall. Interior light levels must be maintained, however, for wide-area portraiture and pictorial quality. But evenly distributed lighting may lessen the illusion of an interior.

less evident, and although shadows may still be hard-edged, surface modelling is restrained, and shadow areas illuminated. Diagnosis from shadows on dark or broken-up surfaces becomes less feasible. Nor should brightness and hardness of subject lighting be confused. A strong soft light may mask a weak hard source.

By joining a shadow to its subject, and continuing to project in a straight line, the direction of the hard source becomes apparent (Figure 9.21). Thus, in portraiture, nose and chin shadows point

FIGURE 9.21 TRACING THE LIGHT SOURCE The line joining the shadow to the subject indicates the light source responsible.

the key light. The person's shadow on the backing may be rather more misleading, for perspective distortion can stretch or compress space (i.e. through using wide or narrow lens angles respectively) and therefore modify the apparent light direction. Elevation is revealed by how far below (or above) the subject the shadow detail appears, and orientation, by how far it is to one side.

Setting lamps

While lighting a scene in which several luminants are on simultaneously, one can identify the coverage of each by 'flashing' sources (switching them on and off), by waving over them, by holding a finger near the surface to be lit and projecting back the shadow, by curling a finger and checking direction similarly from its shadow on the palm of one's hand, or by examining your own floor-shadow. Only look at lamps through suitably dark filters, and then rarely, for adaptation and after-images impair contrast judgments for some time afterwards. It may be unavoidable though to ascertain whether a lamp is accurately centred on its subject (fully spotting can assist, instead) or perhaps to determine how barn doors need to be adjusted for precision cut-off.

270

10

MOTION PICTURE AND TELEVISION TECHNIQUES

Theatre, motion pictures and television

People studying lighting techniques for film and television are sometimes recommended to examine those of the theatre. Personal opinions may vary, of course, but experience suggests that the procedures for stage lighting are only obliquely related to the studio crafts of motion pictures and television.

The theatre is fundamentally a live, three-dimensional enactment, seen directly by the wonderfully adaptable human eye, from a comparatively distant, fixed viewpoint. Facial modelling and subtle tonal gradation are not readily apparent. Light is used to convey stylised mood, temporal and decorative concepts. Aside from occasional localised effects, the stage is customarily lit as a whole, with suitable variations across its width. Colour is employed ornamentally or dramatically, but in an enhanced manner seldom acceptable to the camera. Some stage lighting directors prefer to work primarily in white light.

Much theatrical lighting, like stage make-up, appears generally disproportionate, or even bizarre, when seen under the closer scrutiny of film or television cameras, for it has been specifically and skilfully designed for the broad effect. Consequently, factors that have to be closely considered for the camera, such as exact tonal balance, multiple nose-shadows, black eyes, bisected faces, are of little account in stage lighting. Paradoxically, where coloured lighting is used in the theatre, there is a tendency to frequent, unobtrusive colour variations to which the mobile camera would do little justice. The changing colour shades provided by altering the intensity of a coloured light, can be a subtle tool to stagecraft, but are unperceived by the camera.

Certain dramatic effects are arresting on the stage, seen from a

271

distance, but potentially ugly under closer scrutiny. A person isolated in a vertical spotlight is a case in point.

Both motion picture and television cameras have a series of technically imposed parameters (e.g. an aversion to insufficient or excess light intensity or contrast) that, unless carefully considered, will impair the image and thwart the purpose of the picture. And these need to be taken into account on all occasions if pictures of high, consistent quality are to be obtained.

The techniques of motion picture and television lighting are interestingly related. Their ultimate intent is identical. Their problems and working conditions have marked differences. Although organisations and individual approaches will differ, we can outline reasonably typical conditions under which motion pictures and main network TV studio lighting is created. The lighting specialist is known by many titles, director of photography, lighting cameraman, lighting director. In television, job demarcations may vary, and his title be adjusted accordingly.

Basic motion picture mechanics

Lighting procedures

Where close preliminary planning is possible, key members of the production team can assess and co-ordinate their individual efforts. The film producer, film director, art director (or set designer), lighting cameraman (director of photography) and those responsible for sound, costume, make-up and allied crafts, have the opportunity to prepare their specialist contributions.

PRELIMINARY PLANNING
The lighting cameraman relates the film director's intended production treatment, and the story requirements, to the scenic design, and in evolving a lighting scheme giving life to his interpretations, considers the potential problems of camerawork, time estimates and so on. For upon him rests the entire responsibility for production lighting, the visual image, and usually for selective camera set-ups and movement, as well as pictorial composition; although these last aspects may be detailed by the film director with the camera operator's co-operation. He is customarily supported by a camera crew of five for this single camera mounting, backed by a team of electricians headed by the gaffer.

272

LIGHTING METHODS

Within the film studio, the chief electrician (gaffer) is responsible for lighting the setting to the lighting cameraman's requirements. Anticipating probable needs, he may rough-in the set lighting (i.e. rig suitable lamps for background lighting), ready for the lighting cameraman's final instructions. Rehearsal of the story-action (dialogue, moves, etc.) then takes place within the setting, and with this knowledge the lighting cameraman arranges for any background lighting modifications he deems necessary. Now the main portrait lighting is devised, lamps are positioned, set and balanced for the action the director has rehearsed perhaps with the help of stand-ins, who are lit in the principals' positions. Some preliminary actor-rehearsal may have taken place before studio rehearsals.

DISCONTINUOUS SHOOTING

The production is segmented into a series of *shots*, each lasting from a few seconds to a few minutes. A 90-minute film may have some 600–800 shots. With an editing cut every 3–10 seconds, some 3–15 seconds per shot have been quoted. In Hitchcock's experimental film *Rope* the exceptional shot duration of 6–8 minutes was reached, although this same master of film techniques used 1360 shots in *The Birds*. A good serial unit may achieve 120 shots a day (around 18 minutes' running time) on certain types of production, but this is untypical. A sequence may equally well take days or weeks to complete.

Lighting development

As far as the art of lighting is concerned, we can detail principles and formulate procedures, but creative treatment must ultimately rest upon the individual exponent. Whether we light by building up a rig lamp by lamp as on-the-spot observation suggests, or conceive the overall lighting treatment beforehand as a paper exercise, depends largely upon the people and facilities concerned. Both the 'build-as-you-go' and the 'total-strategic-plot' approaches have their merits and weaknesses. The results can be identical.

Some lighting directors have argued that it is only possible to light one shot at a time. There is a certain truth in this idealism, for the more one has to light in continuity, or with restricted resources, the greater the compromise. However, where experience and facilities permit, extremely high standards are possible.

273

There is the danger, of course, that despite anticipation, imagination and expertise, circumstances can prevent the optimum results —but that is another matter.

Each shot (action sequence) is usually retaken several times, to correct, improve, or give variety of treatment, until those concerned are satisfied. Scenery, actors' positions and camera treatment, can be cheated (Figure 10.1) as much as one needs to avoid spurious shadowing, faulty composition, etc. Normally shooting is concentrated on one camera, although particular situations may require two, or even three, for total coverage. When the shot is completed, the lighting is modified, or the scene relit by the lighting cameraman in the time required. Close-up shots should preferably be lit separately from the longer shots, the make-up, too, being rearranged for the more delicate and less strongly defined treatment that optimum portraiture requires.

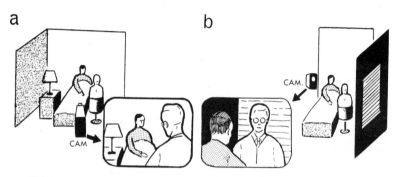

FIGURE 10.1 CHEATING Subject, scenery and properties positioned appropriately for one shot may prove unsuitably placed for the next. In discontinuous shooting they can be rearranged to suit. Judiciously done, even drastic alterations will pass unrealised by the audience. Typical reasons for cheating include: improving composition, enabling more effective lighting and facilitating camera mechanics.

For many years now, the film director has been largely reliant upon his assessment of the scene through his portable optical viewfinder, or that detached from the camera. With such a procedure, he is largely dependent upon the camera crew's interpretation of his instructions, having no accurate check on the picture until he eventually sees the projected image of the processed film.

More recently, the *hybrid* film camera, with its small auxiliary TV camera, demonstrated that it could provide a continuous monochrome check-picture, monitoring what the camera records. But

274

currently this system has yet to establish itself. Such a scheme has also had its trials in television studios.

Following the completion of each shot, the camera floor-tracks (providing smooth, judder-free movement) must be repositioned for a subsequent set-up.

CHECKING RESULTS
The following day, rushes (or dailies) are viewed, and the lighting cameraman estimates the *printer-light* (timing or Cinex) setting at which he wishes the film to be printed to give the appropriate visual effect (Chapter 12). For colour film, this is a black-and-white check print, made on release print stock. As this economy does not permit grey-scale or colour values to be assessed accurately, timed colour rushes are provided for selected key scenes.

LAMP RIGGING
Some lamps may be rigged from perches or grids in the studio ceiling, or permanent cat-walks around the walls, but most are arranged on cradles, suspended on tackles from ceiling joists, on spot-rails, platforms or mobile spot-towers of tubular scaffolding tailored to fit behind the outline of the setting. Other lamps, hung on ropes, attached to scenery, or on movable floor stands, can be placed exactly where the lighting cameraman needs them, because he can ensure that they do not interfere with his camera moves. As film can be *post-synchronized* (i.e. sound recorded afterwards to fit the silent picture), and shots are generally of rather short duration, the sound pick-up problems for the sound mixer and sound room operator do not restrict the lighting treatment.

CONTINUITY PROBLEMS
When lighting for colour film, with its comparatively restricted contrast range, the lighting cameraman must rely heavily upon light-meter checks of the lighting intensity, and experienced scrutiny through a viewing filter, to ensure that he has appropriate balance and contrast. Within limits, the processing laboratories can improve or compensate for accidents or misjudgments, but the parameters for colour film are limiting.

Although individual scenes are filmed over a long period of time, on many separate occasions, often with varying types of location and weather conditions, lighting continuity and quality must be consistent throughout. This ever-present challenge is not to be underestimated and it is a problem, too, for costume,

275

make-up and scenic departments. Moreover, considerable capital costs are at stake over this period, particularly when one recalls that items are shot, not in continuity order, but to accommodate the mechanics of set construction. As all scenes in 'the railway station', for example, are photographed at one time, and the set is then broken up, they must be right when joined months later into their eventual places in the completed motion picture. Such piecemeal techniques however, do enable all facilities and work effort to be concentrated on these scenes alone, so that lighting, costume, make-up and scenic treatments can be the optimum.

RESTRICTIONS AND OPPORTUNITIES

The lighting cameraman has certain inherent handicaps. The studio motion picture camera requires an operator to follow optical-focus by adjusting the lens to measured subject-distances, while a cameraman moves the camera itself, composing the shots and following action.

Light-control facilities in the motion picture studio are normally limited. Portable dimmer-trucks and contactor panels (i.e. mass circuit-breakers for group switching) substitute the more elaborate television lighting consoles (without the latter, complex high-quality TV lighting would be impracticable).

However, there is every opportunity in motion-picture making, to modify the intensity, quality and colour of individual lamps by diffusers and similar devices, to suit the requirements of each take, and one can always improvise. It even becomes feasible to hand-hold or manipulate a lamp for shorter shots. A lamp beam can be gradually covered or uncovered for part of an action, placing a hand to shade the light and prevent local costume burn-up an an actor approaches.

Basic Television Studio mechanics

Television also is a diversified medium. At one end of the spectrum we have the straightforward clarity of approach employed by small educational TV units or local stations, working miracles with a restricted budget and economy of equipment. At the other extreme are the flexible facilities of large TV networks, who regularly achieve the 'impossible', producing near-motion picture results in an unbelievably short time. Standards are indeed variable, but at their best they reveal lighting in its most sensitive forms.

276

Television networks today carry a wide range of productions, each with its own particular demands. Many have now evolved routine patterns, mostly for quizzes, panel-games, interviews, musical presentations and certain comedy shows. Soap operas and situation comedy are to be found staged in settings from near-vaudeville to small-scale dramas with ambitious standards. Talks programmes follow a simpler format, but can introduce the uncertainty of last-minute portraiture where important participants are not seen until air-time. For our present purpose we shall examine aspects of the lighting process for a drama production.

One thing that strikes a visitor to a major TV studio is the speed and accuracy with which lighting must be completed. A time-bracket is allocated, within which a variety of work-functions have to be co-ordinated, and time hangover from any one of these inevitably interferes with the operations that follow.

As much as possible must be planned and co-ordinated before the show enters the studio, if a large amount of effort and money is not to be wasted, with makeshift results. Notwithstanding these principles, the time-pressure factors are high though they vary between the different types of contribution. Certain aspects, such as scenic design, can be largely assessed days, or weeks beforehand. Others, such as those of the camera and sound-boom operators, will not be discovered until the actual studio rehearsal.

Most programme directors do not subscribe to the concept of really specific planning in which they determine precisely beforehand the shot-content, camera operations and sound treatment. Many consider this stultifies artistic direction and spontaneous inspiration. It can. Many effective ideas are only realised when cameras are moving about the studio setting, with real actors. But freedom to leave decisions until the last minute, and to avoid self-commitment, necessarily leads to uneconomic use of time, money and facilities. Over-meticulous, soulless mechanics perhaps, on the one hand, through over-planning, ineffectual improvisation on the other, overstraining the production team. These are the main dangers.

Professional TV directors walk this tightrope with remarkable perspicacity or keep their requirements simple, and avoid problems.

There is no universal organisational approach to television studio operations. Methods vary between companies, and between

277

countries. In most larger studios, lighting has long been recognised as a major function.

In some organisations the lighting director's responsibilities are managerial relative to the operational team (cameras, video, sound). He is concerned with devising the complete lighting treatment, and assessing the technical and artistic suitability of the pictures, as well as advising other members of the production team in this field. In this set-up he will probably be aided by an operational colleague who concentrates upon technical organisation, the availability of facilities and the like.

Another set-up involves a technical director. He may be a technical adviser, direct camera operations, carry out video-switching operations, serve as supervisory engineer. To any or all of these activities, he may add the job of lighting! More frequently, he will liaise with a specialist lighting director who concentrates upon this aspect of the production.

Here, the lighting director's function will be assumed to be in the first organisational category.

Preliminary planning

Initial planning processes for studio operations begin with the production director and the set designer roughing out a series of scale plans that promise to meet the needs of the action and locale of the script. Having analysed the story and formulated their ideas, they pool their concepts, and begin to turn pipe-dreams into plausible mechanics. The lighting director should be present at this early date to assess potential technical and operational problems, and discuss lighting and pictorial opportunities. For less exacting productions he may wait until the staging plans are more fully defined.

(For the smaller productions planning may be quite nominal, off the cuff lighting treatment adapting itself to last-minute changes.)

Subsequently, when the production director has more substantial ideas as to how he intends to interpret the show, he meets the lighting director, sound, costume, make-up specialists, set designer and, perhaps, technical director, to outline his operational treatment. He may be able to provide a detailed account of the actors' positions and moves, and information on camera shots. He probably knows that he needs five pedestal cameras and a camera crane for instance. It may look as if he will have to have two

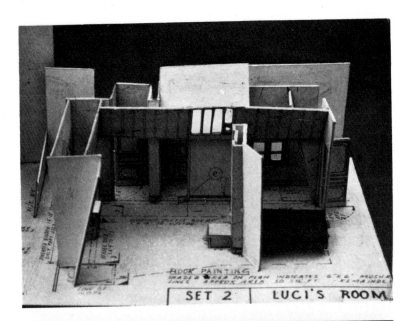

FLOOR PAINTING
SHADED AREA ON PLAN INDICATES 6"x 6" MUSHA
LINES APPROX AREA 50 SQ FT REMAINDE

| SET 2 | LUCI'S ROOM |

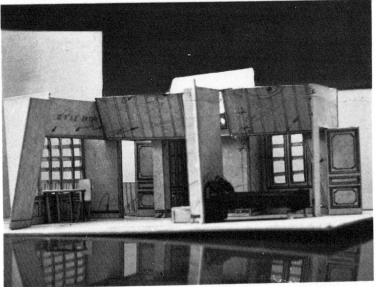

THE STUDIO SETTING A model is constructed by sticking elevations to thin card, and attaching this to a studio plan. The model aids the production team in visualising more exactly the camera set-ups, lighting, action, etc. By examination from different viewpoints, the opportunities and problems that are likely to arise can be anticipated. (See pps. 203–206.)

279

sound-booms per set. They might examine sketches, samples of wall-coverings, materials, photographs, etc. The exchange is likely, however, to be of a much more perfunctory nature.

An accurate scale *floor-plan* of the studio layout is then prepared (at the standard $\frac{1}{4}$ in. to 1 ft or 50:1 ratio), together with sheets of scale *elevations* showing wall heights and architectural features (windows, arches, doors, etc.), constructional details and so on (see Figure 9.5).

Although scale models may be devised by sticking cut-out elevations onto the studio plan outlines, most of the television lighting director's work is done from a practised 'three-dimensional imagination'—and a modicum of clairvoyance.

For more complex staging, models may help eye-line checks on potential light directions.

The outside rehearsal

The next stage of proceedings is in the *outside rehearsal hall*, where set outlines are chalked or taped on to the floor (a full-scale version of the studio plan), with strategic vertical poles denoting doorways, arches, etc., and substitute furniture and mock-up fittings forming location points.

Watching the rehearsal with perhaps, certain guidance from the production director on the shots he anticipates, the lighting director scrutinises the action, as actors go through their lines (dialogue) and moves, noting details on a studio staging plan to form an *action plot* (Figure 9.5, part 4). He may draw in principal directions for key lights, basing them upon the actor/camera positions for each shot sequence. At least he now knows where people are standing, sitting, making entrances and so on—unless the action later becomes modified. At best he has a pretty clear appreciation of the production director's intended treatment.

It may prove necessary, as a result of seeing action, to acquire more detailed information, or to suggest alterations in direction, staging, costume or make-up. Where cordial teamwork prevails, constructive comment is a welcome way of learning mutual problems, and achieving the optimum in a short time.

Let us imagine typical conversations between the lighting director, and the production director, costume designer, and set designer. We see here something of the way in which one needs to anticipate, to estimate problems, even before they begin to happen (Figure 10.2, part 1).

L.D. 'She has her head bent down, looking at the floor (potentially ugly portraiture). How close is your shot?' (It may not distract in long shot)

P.D. 'A big close-up, on a narrow-angle lens, from over there.' (It's a screen-filling portrait)

L.D. 'Will she still have her hat on?'

C.D. 'Yes, it has a wide brim and a veil.' (The brim shadows the face and the veil catches the light!)

L.D. 'I cannot use a camera-light, the camera is too distant (its intensity falls off rapidly with distance). Can I put a floor lamp down there?'

P.D. 'No, Camera 3 moves over to there immediately beforehand.'

L.D. 'Perhaps I can light her through the window (with sunlight).'

S.D. 'There are nets over the windows (light will not penetrate). There is a low ceiling over the bay window.'

L.D. 'Can't we take the net off?'

S.D. 'I don't really like the stock backcloth from that angle, the nets soften off the exterior view.' (Painted cloths can look artificial on angled shots)

L.D. 'Can we move the actress along the seat?'

P.D. 'No, it would affect the other shots. Camera 1 would not be able to follow her over from the door.'

L.D. 'Do we see the hall outside the doorway before she enters the room?'

P.D. 'No, we are watching the hero depart.'

L.D. 'Then if we leave the door ajar, I could get a floor key through from the hall onto the girl's face . . .'

A problem is solved. But it does illustrate fairly, the type of anticipation that is needed. It is not sufficient to wait to see it on camera and then correct matters. There just is not the time!

The lighting plot

THE BACKGROUND TO PLOTTING

Our first thoughts towards the plot begin with script reading. Dialogue, plot, stage instructions, all give firm leads to atmospheric and staging development. One begins to think about pictorial opportunities . . . But it is best to wait. There is nothing more thwarting than dreaming up treatments that turn out to bear no relationship to what the production director intends to do!

Atmospheric treatment is a latent image—memories of

281

personal experience, of films, of environments, of book illustrations. Such fragments accumulate, combining as a subconscious guide.

The study of Sherlock Holmes in Baker Street, London, becomes a real place in the mind's eye. One senses the daylight struggling through thick lace and dark drapes to streak the heavy wallpaper. One can almost smell the leather chairs, touch the antimacassars, the cluttered knick-knacks, feel the claustrophobic Victorian mustiness.

But then comes the cold light of day; the need to think in material terms, to wed these atmospheric conjectures with the practical problems involved. Let us list broadly, the sort of physical aspects to be taken into account:

Scale, dimensions, proportions of settings.

Surface finish Tone, texture, colour, contrast.

Constructional features Architectural features (window details, ceilings, overhangs, gauzes, cycs.). Level changes (stairs, rostra, double-tier arrangements, etc.). Hanging units (decorative, trees, etc.). Scenic erection methods, etc. Space available for lighting fittings (floor lamps, concealed studio lamps, etc.).

Furnishings (position and form) Drapes, furniture, pictures, ornaments, statuary, mirrors, etc. Practical lamps (their nature and function).

Exteriors Backcloths, floor treatment, foliage, ground rows, profiles, etc.

Costume and make-up information Materials, finish, texture, colour (relative to backgrounds, mood, etc.).

Production treatment Actors' moves, positions, actions. Camera treatment (shot lengths, camera positions and movements). Sound treatment (positions and action of sound booms). Temporal effects (day, night, etc.). Atmospheric and cued effects required.

Distribution of settings, and action areas within settings Relative to lamp densities. Relative to power (lighting loads) and power routing. Relative to accessibility of lamps and lighting facilities.

Lighting facilities Lamps available (number, types and performance). Lamp positioning (apparatus and methods of lamp rigging). Lamp supplies (cabling, power and phase problems).

Light control (patching, console mechanics). Lamp cueing (lamp grouping, group switching and fading).
Safety regulations Fire risks, mechanical hazards, etc.
Union agreements Time, manpower considerations, etc.

LIGHTING APPROACH
Fundamentally, there are five ways in which one can go about lighting mechanics:

1 The 'look and light' approach. Examine the setting and action. Have all lamps specially rigged individually to suit lighting treatment (a typical motion picture concept).
2 Similar, except that the studio has a 'saturation rig': a regular pattern of a large number of lamps, from which to select. This can eliminate all rigging, but create congestion.
3 A more modest version, in which a sparser, regularly spaced lamp pattern can be augmented where required with additional or special purpose luminaires.
4 The 'plot and light' approach. A total lighting plot is drawn, prior to the studio rehearsals, and lamps then specially rigged as 1 or selected as 2 for the needs of a particular production.
5 Lamps indicated in a total lighting plot are positioned and prepared for a specific show, using the studio layout of method 3.

The 'look and light' approach is flexible, and does not require one to estimate three-dimensionally. Planning can therefore be less comprehensive, and last-minute changes are easily satisfied, giving considerable freedom to the lighting director.

But such a procedure is time-consuming, for in addition to lamp selection and positioning, various balance and cueing activities have to be devised and checked *ab initio*. Moreover, it is all too easy when assessing lighting treatment in this piecemeal way, to meet the needs of the moment, and overlook problems to come.

The plotting process

A system that has found favour in television studios is akin to method 5 mentioned earlier. A plot is prepared by the lighting director, in which lamp symbols are drawn upon a plan outline of the studio settings. This drawing shows the disposition of lamps, their power-patching and routing, and their operational functions can be interpreted.

FIGURE 10.2 TECHNIQUES OF THE TELEVISION LIGHTING PLOT

1 Physical restrictions. To achieve a particular lighting effect, various physical problems may have to be circumvented. In this example restrictions include (1) ceiling; (2) covered windows; (3) subject position; (4) camera shadow. (The solution proved to be a floor-stand key light (5) through a nearby doorway.)

2 Lamp height. A reasonably distant key (1) would not reach the subject (B) unless lowered into shot at (2). To place it at a more suitable height, it must be taken further from the subject (3). Now however it may light other intermediate subjects at (A).

3 Varying heights of scenery and acting areas. These must be allowed for when plotting lamp positions.

4 Lamp shadows. Lamps lighting Setting A, may obscure those lighting Setting B. Height adjustment, beam localisation, revised lamp positions, may be the solution.

5 Rigging space. The ideal key light positions for adjacent settings may coincide. Then compromises are inevitable, and treatment must be revised.

FIGURE 10.2 (*contd.*)
6 Lamp take-over points. The take-over between the beams of successive lamps must be controlled to prevent obtrusive multi-shadows or doubling intensities. Take-over arises (*a*) vertically, (*b*) horizontally.

Light cut-off provided by barndoors is soft-edged. The sharpness of this shadow edge depends upon the size of individual flaps relative to the lamp area. Adjacent lit areas cannot therefore be joined accurately 'edge to edge' (as is possible with hard-edged effects projectors). Wherever overlap is unacceptable, it becomes necessary to introduce shadow corridors in less critical regions. These regions may be so large that the performers move in and out of lit areas. Appropriately used, the result is effectively attractive. Overdone, the technique can appear mannered.
7 Space restrictions. (*a*) We may anticipate using a particularly dramatic window effect, but, (*b*) in fact, little space is available (plan). (*c*) The elevation shows the actual effect would be valueless. (*d*) If space is provided for a suitable lamp throw, a low-angle camera could shoot into the light.

PLAN VIEW

SIDE VIEW (ELEVATION)

1

HEIGHT

B

A

2

FIGURE 10.3 LAMP DISTANCE AND HEIGHT
1 The direction of the lamp axis having been decided, the lamp distance is next determined, according to the vertical angle and the lamp height required.
2 An identical lamp angle may be obtained from using a close, low lamp (A) or a high, distant lamp (B). Each method has its merits.
(A) A low lamp near by: lower intensity is needed; less power and heat; coverage is readily restricted; the intensities of localised areas are readily controlled; lamps are easily accessible; but it may require more lamps to cover the area; low lamps can pose beam take-over difficulties, obstruct cameras, booms, come into shot or cause lens flares.
(B) A high distant lamp: more even light spread is possible, fewer lamps are needed for a given area, so there are fewer lamps to adjust, and also, less light level change with subject distance from lamp. But considerable distances (throws) may be required, there may be difficulty in controlling and restricting light in localised areas, higher lamp-powers are required, and lamp accessibility may be limited.

As every lamp is drawn on the plot, one must keep in mind a clear, *three-dimensional* concept of its function. Anticipatory interpretation is the whole basis of this method. For instance, there is little point in indicating a key light for someone, only to find that it will be cut off by an obscuring ceiling-piece (Figure 10.2, part 2). One has to take into account the varying heights of settings (Figure 10.2, part 3), and that, where settings are congested,

286

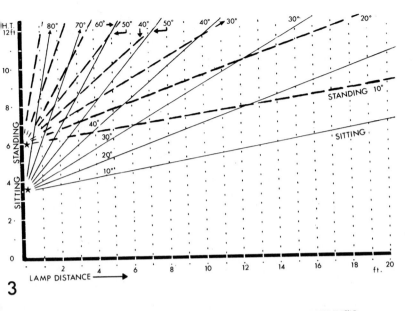

3

4

FIGURE 10.3 *(contd.)*

3 An elevation shows the effect of lamp height and distance relative to the vertical light angle.

Steepness of vertical lighting angle increases as the subject moves closer to the lamp. So where a subject is lit from a lamp 10 ft. above the floor (typical minimum height) it should not usually approach nearer than about 5 feet, if attractive facial modelling is required. For downward-looking subjects, the closest distance to avoid harsh steep lighting is around 10 feet. Nearer positions are better lit along the wall plane, or from a lamp at right angles to the wall.

4 Assuming a normal lamp height of 10 ft the vertical light angles at various distances are shown, for standing and sitting positions. A downward head tilt may increase these angles by up to 20° (see Page 113 for conversion to metres).

lamps lighting one area may obstruct those lighting another (Figure 10.2, part 4).

Tailor lighting treatment to the time and facilities available. The window-pattern of Figure 10.2, part 7, could require a 10-kw. lamp or a 150-amp. arc to do it justice. In such circumstances, there is little point in using an ineffectual, low-power lamp. Better to use a different treatment entirely.

287

CAMERA VIEWPOINTS The same object under constant lighting is seen from opposite directions. From *Top left:* detail within the glass is silhouetted by backlight. From viewpoint *Top right:* the key is frontal, and reveals the surface formation and gold flakes embedded in the glass. Shot from the key light position, *Centre left:* surface detail and finish are evident. The camera moves round 90° *Centre right:* and the key is now a sidelight, edge-lighting contour. *Bottom left:* With the camera positioned 180° to the key, it becomes backlight. Now the subject is silhouetted, translucently, but there is the danger of lens flare, as in this example.

The plot can be built up by treating separately the lighting for the portraiture and for the settings. In general terms, after examining in turn the various actor and camera positions (known or estimated), the light-direction axis is drawn for each sub-area. The lamp is positioned at a sufficient distance from the subject to provide a suitable vertical angle for the light. Figure 10.3 makes this clearer. Where a series of adjacent areas need to be keyed from a similar direction, one lamp may cover them all, and provide the optimum direction, height and intensity. Back light is similarly located. Fill-light is then arranged from a suitable direction and height.

Probably one of the worst digressions regularly found in television lighting is in positioning fill-light. It is invariably slung at too high an angle (to permit cameras and booms to move around underneath), and may prove to be at an inappropriate horizontal angle to the key lights. Where production approaches are uncertain, it is not unknown for over-generous fill-light to be used, in an attempt to nullify indifferent modelling from inappropriately positioned key lights. But here we touch rather upon the circumstances in which lighting finds itself catering for other productional operations, rather than inept lighting treatment as such.

Early television lighting usually commenced by swamping the whole scene in soft light (base light) so that no areas were left unlit to merge into shadows full of picture noise, and the overall contrast was kept down. Key lights, back lights and the rest built up on this foundation light.

Modern practices prefer the motion-picture principle of setting the hard-light sources, and adding the soft filler afterwards to a suitable degree, reducing the harshness of modelling and shadows.

As must have become clear from earlier chapters, this outline is but the tip of the iceberg. In deciding upon a lamp axis, we have to allow for many associated but often conflicting factors. The result is a simple lamp symbol—the reason for its being there, a deal of experience.

The main considerations that influence lamp position in lighting *action* (dynamic portraiture) are:

The power and coverage of the lamps available.
Directions the subject is facing.
Subject appearance (facial modelling, clothing).

289

STREET EXTERIOR *Left above:* Daylight results from a soft base light augmented by a strong key light. *Left below:* The nocturnal street; dimly lit, localised light, dull, sleazy. *Above:* Sinister, with deep shadows; mysterious; treacherous.

Any aspects of the subject to be emphasised (character, age, youth).

Action continuity (how subjects, cameras and booms move around).

Camera viewpoint(s) (anticipating camera shadows, lights in shot, lamps impeding cameras).

Sound boom positions (boom shadows).

Obstructions (hanging practicals, arches, overhangs, scenic suspension, etc.).

Interposed points (Lamp spuriously lighting intervening subjects).

Spurious lighting or shadow (stray or spill light on nearby walls, and reflections).

Visual continuity.

Time of day, location, natural light direction.

Environment, mood, atmospheric effect.

These, then, underlie our choice of position for each lamp. We have to consider concurrently how the functions of a main lamp may change with different viewpoints (e.g. back light for one shot, key light for another).

Lighting the *setting* follows similar lines. Having built up a mental image of the scene from plans, elevations, etc., we systematically light walls, furniture, drapes, to that end. Bearing in mind the 'natural' lighting direction (from windows or practical lamps), light is arranged with suitable direction, shape and intensity. We have to try and anticipate unattractive or detracting shadows, or similarly wayward light patches.

Although key lights for people may reasonably fall upon the setting also (provided the effect is appropriate), the lamps designed to light the environment cannot be relied upon to provide good portraiture, for their angles and intensities are essentially related to the tone and character of the setting. Wherever possible, therefore, it is best to keep the two functions of portraiture and set lighting distinctly separate.

Devising the lighting plot

Bearing the foregoing considerations in mind, let us now try to evolve a step-by-step analysis of the actual plot:

1 Note the actor's positions and moves within a plan of the setting.

2 For each static position (e.g. by doors, in chairs, etc.) note the main directions of heads. Also incidentally consider associated personal characteristics such as deep eyes or a large nose, and problems with costume, such as with hats.

3 Draw in ideal key light directions for these static positions relative to the camera angles used at that moment (see Figures 5.3 and 6.2). Where several head positions are involved, the light may need to come from a compromise intermediate direction, or may be faded or switched between several more suitably angled lamps as necessary.

4 Decide whether transitional actor-movements need specific lighting, or will receive suitable treatment from local spill light. Occasionally intermediate areas may be left unlit.

5 Now consider how far away from the subject we should place the lamps along the axes derived for key light directions, to achieve the elevation-angle required (see Figure 10.3).

292

6 Hazards: will the lamp be in shot? Will it cause lens flares, boom shadows, camera shadows, actors' mutual shadowing? Will spurious lighting fall upon adjacent people, or the setting? Does the scenery permit or obstruct the lamp position? Will spurious shadowing arise from other lamps?

7 What lamp type and power rating is required? How will the lamp be positioned there, and how adjusted?

8 Place the lamp nearest to this ideal position.

9 As the plot evolves, we need to consider whether there is a change in a lamp's function (deliberate or fortuitous) in successive shots when cameras are moved or switched. Certain re-balance or lamp re-selection may be necessary during action.

10 Technical factors must be considered, such as camera sensitivity, available facilities, rigging problems, time available, electrical load distribution, colour temperature and safety factors.

11 We next treat the settings following a similar procedure, and systematically light with suitable intensity, light quality and coverage, the architectural features, furniture, dressings, backings, practical lamps, etc. This is done taking into account time of day, location, atmospheric developments, cues, etc., and the various mechanical and artistic quandaries and opportunities we have discussed in earlier chapters.

This all sounds very complicated. It is. Judgments must be formed, problems foreseen and so on. But the solution lies, as with all mechanico-artistic pursuits, in breaking down the project into its component parts, and taking these systematically until the entire commitment has been analysed and dealt with. Undoubtedly, many such complexities are overcome using the 'look and light' approach, and even more, in single-take methods of production. But where time is short and the work-effort involved is large, detailed planning and operations of the kind we have been outlining, are inevitable. The alternative is a lower artistic standard.

Background of lighting mechanics

Currently, a colour television studio (e.g. 80 × 100 ft) can be filled with as many as ten substantial settings, requiring some 200–250 lamps for total illumination. These lamps comprise key lights, back lights, set modelling lights, fill-lights, effects lights, lighting for backings, lamps simulating sunlight, augmenting practicals, and various additional purposes. The position,

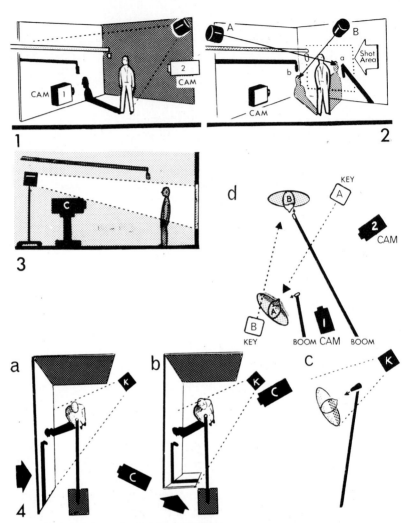

FIGURE 10.4 SOUND BOOM SHADOWS

1 From Camera 1 the microphone shadow is out of shot, and lamp provides three-quarter back light. But from Camera 2, the lamp is now frontal, throwing a boom shadow on the background behind performer.

2 Microphone shadow (a) is caused by the frontal key light being in line with the boom arm at (A). By placing the lamp (B) at a wide horizontal angle to the boom arm (or vice versa) the repositioned shadow (b) is thrown out of shot.

3 Floor lighting avoids microphone shadows unless the boom arm dips into the beam of the lamp. But it may provide obtrusive actor shadows on the background.

4 Further common circumstances in which boom shadows occur: (a) when the boom arm is parallel with a wall; (b) when the boom operator cannot see his boom shadows; (c) where the performer is playing away from the boom; (d) where two booms pick up near (A) and far (B) action. (The latter can shadow the close source, particularly on upstage camera (2).)

294

TABLE 10-I

METHODS OF ELIMINATING BOOM SHADOWS

Principle	Method	Result
By removing the shadow altogether	Switching off the offending light	This interferes with lighting treatment
	Shading off that area with a barndoor or gobo	Normally satisfactory, providing the subject remains lit
		Shading walls above shoulder height is customary, to give better prominence to subject
By throwing the shadow out of shot	By placing the keylight at a large horizontal angle relative to the boom-arm	A good working principle in all set lighting
	By throwing the shadow on to a surface not seen on camera when the microphone is in position	The normal lighting procedure
By hiding the shadow	Arranging for it to coincide with a dark, broken-up, or unseen angle of background	Effective where possible, to augment other methods
	By keeping the shadow still, and hoping that it will be overlooked	Only suitable when inconspicuous, and when sound source is static
By diluting the shadow with more light		Liable to over-light the surface, reduce surface modelling, or create multi-shadows. Inadvisable
By using soft light instead of hard in that area of setting		Occasionally successful, but liable to lead to flat, characterless lighting
By using floor-stand lamps instead of suspended lamps		Light creeps under the boom-arm, avoiding shadows
		But: floor lamps occupy floor space; can impede camera and boom movements; can cast shadows of performers flat-on to walls
By altering the position of the sound boom relative to the lighting treatment		May interfere with continuous sound pick-up or impede camera moves
By changing method of sound pick-up	By using slung, concealed, personal mics., pre-recording, etc.	These solutions may result in less flexible sound pick-up

THE CAVE *Top:* Under overall soft light, the result is flat and artificial. *Bottom:* Lit with a single 10-kW lamp, the set appears as an exterior scene.

Top: Localised lighting transforms the setting into a convincing night interior. *Bottom:* With further lighting restriction, the scene depicts 'unlit' conditions.

intensity, coverage, quality (and colour) of each has to be adjusted, with a view to the selected variations that the action, mood and mechanics of continuous production will require. We may have around 4 hours to set the lot!

Rehearsal time is precious. One could modify lighting during camera rehearsals, but to do so is to miss the very pictures one is creating. To wait for a rehearsal-break to relight is to go for long rehearsal periods with incorrect lighting and pictorial treatment (a hindrance to the whole production group, who are left waiting for the revised version to judge the technical and artistic aspects of their own contributions, such as make-up and costume). The lighting can be wrong for a dozen reasons. The production director may have changed his shots or the actors' positions; the sound man has boom-shadow problems; the lighting continuity is not working out; a lighting effect looks phoney; there are unforeseen staging snags; we may have guessed wrongly . . .

One just has to anticipate these things. Anticipate that the furniture could be shiny, that the dark wall-panelling might need extra light, that the exterior sky cyclorama might have wrinkles, that the sound man could neèd a second boom for this scene, that the cameras are likely to shoot more obliquely and see the lamp outside the window. There is not time for much trial and error. And yet the easy routine or the trite must be avoided.

RIGGING THE LAMPS

To make the fullest use of time, certain major studios have introduced extremely flexible methods for positioning and controlling lamps. Within the studio a network of electricity hoisted tubular bars (barrels) carry pairs of dual-source lamps that can be slid to any position along their lengths. Both bar heights and individual lamp heights can be adjusted (pantographs). Some organisations favour separate telescopic suspensions.

In the method we are discussing, the large lighting plot is rigged overnight. Electricians working in the empty studio lower all lighting barrels and affix or locate the types of lamps exactly as indicated on the plot, together with accessories, colour-media, etc., plugging and patching them correspondingly. All barrels are hoisted to the ceiling.

The studio is now clear for a scenic crew to bring scenery into the studio. Trucks and trailers are unloaded, the stacked and numbered scenic units being positioned relative to the studio

floor-plan. Bit by bit, these units devised and decorated elsewhere are lashed together, strutted, braced, until as we look around, there, as large as life is the 'baronial hall', or the 'sleazy dive', the 'forest' is beginning to take shape, the 'street' complete with rubber cobblestones . . . and so on. But this is only the framework. Large trucks carry the properties, the furniture, drapes and greenery to clothe this skeleton. Soon the 'baronial hall' will have its rich arras, armour, escutcheons and the rest. All too soon it will be morning!

Lighting barrels are lowered, to put the various lamps at heights to suit their purposes. An army of other craftsmen is at work, too, painting floors, hanging pictures and drapes, arranging tree branches, positioning furniture, hammering wayward scenic bracing, refurbishing some damaged plastic-shell masonry, touching up paintwork, and covering joins between flats. Out of piles of timber and board, trailers heaped high with the most improbable odds and ends, convincing locations have been conjured in a matter of hours. The organisation behind this phenomenon is part of the unsung background to these daily events.

SETTING THE LAMPS

Although approximately positioned by the rigging crew, each lamp will need to be turned, tilted and have its coverage and intensity adjusted to match its plotted function. Once this meant electricians climbing portable step-ladders to manipulate (rough trim) each by hand. Nowadays these activities are mostly carried out from the floor, with telescopic poles that latch on to the lamp controls (remote electrical adjustment of pan, tilt and focus is feasible but expensive, and barn doors require manual positioning).

Lamp heights are revised—a little steeper here emphasises the texture, a little shallower there takes the wrinkles out of that backcloth.

Over here we shall have to compromise. If the lamp is steep and gives good modelling on the wall-panelling, the wall-brackets fastened to it will cast ugly shadows. It the lamp angle is lowered to reduce the shadows, a bright flare appears on the glossy panelled surface.

The drapes over here are far too dark, but just the right style. They need extra light. But the light-toned statue in front of them then becomes overbright. Move the statue out a little, and steepen and barn door the lamp to light behind it? No, light still spills on

299

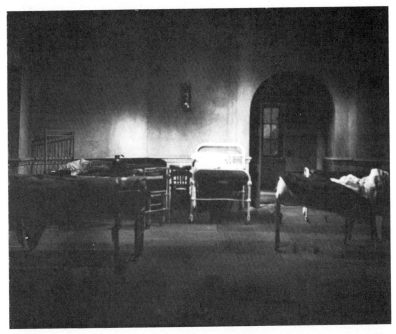

HOSPITAL WARD *Left above:* Under soft light the illusion of an interior is absent. The 'blown-down' walls are clearly visible. *Left below:* Localised hard lighting together with a soft base light, suggests a day interior. *Above:* The hard light alone creates a 'closed-in' atmosphere.

to the statue. The set designer can help by re-positioning or replacing the statue or drapes.

The 'bedroom' is proving a problem. The stand-lamp outside the window was to provide 'moonlight', both as the heroine gazes out, and upon the pillow as she sleeps. Its intensity would be lowered for the window position, increased to get sufficient brightness on to the distant bed. A nearby cupboard has proved larger than expected. It prevents the lamp reaching the bed. One solution is to rig another lamp up there, to project a 'window shadow' pattern on to the bed, while the original lamp outside the window can take over as the girl looks out.

And so the process of setting lamps continues. Now, accurate detailed planning brings its rewards. However, in the limited time available, ambitious treatment is only possible when such aspirations are combined with sureness of touch. To speed up proceedings on a show of this complexity, the lighting director would probably be 'split-working' with his assistant. As they instruct

301

electricians to adjust each lamp to match the lighting plot, their walkie-talkie radios help them to remotely guide others, and to contact the lighting console operator. Problem lamps are investigated and the rig modified where necessary. All around, settings are being dressed, camera and sound equipment assembled and painters and carpenters are finishing off their sundry chores.

Camera rehearsal

This is the first time the director and cast see the settings. It is the first time most of the camera, sound and lighting crews meet the show at all. If it is a 50-minute colour production, they have something like 12 hours' worth of camera rehearsal time spread over two days, to become familiarised, co-ordinated, and to put polish on performances and presentation, before video-taping the result. The video-recording may be a straight run, or it may consist of scenes shot in any order (for time or continuity reasons), to be edited together days later—perhaps having music or effects added at that stage.

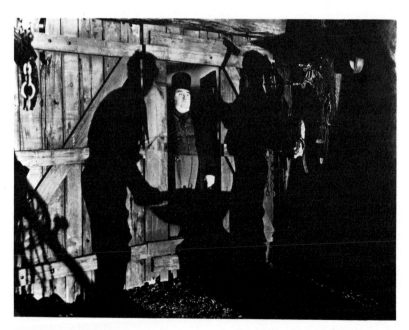

ASSOCIATIVE SHADOWS Shadows here convey dramatically, and with powerful economy, activity in a blacksmith's forge. There might well be only a lamp and a wooden doorway to conjure this effective illusion.

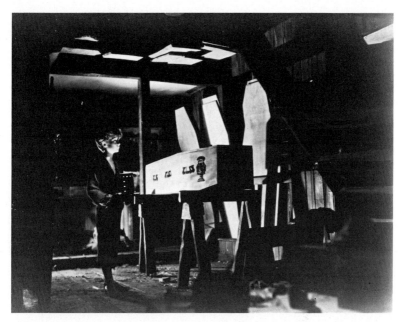

IMPLIED LIGHTING The lamp held by the boy illuminates his face. It provides negligible environmental lighting. Instead, skilfully controlled floor lamps light the scene in such a way that only close scrutiny reveals their application.

Production directors tackle this marathon in several ways. Some begin rehearsal with a *dry-run* or *walk-through*, in which the actors go through lines and action for each scene while camera and sound crews watch, the director explaining treatment and continuity. Because this does not give any opportunity for picture checks on camera treatment, lighting, wardrobe, settings, etc., it is undesirable as a regular practice where time is limited.

The first camera rehearsal is normally a *blocking-out*, or *stopping run-through*. For some production directors this rehearsal is conducted from the studio floor, watching mobile picture monitors. Each scene is 'blocked and run' in turn, first going through the action slowly, and correcting inaccuracies as they arise, then a run-through confirming co-ordination and timing.

In the production control-room, the director watches his preview monitors (one for each camera or other picture source), and the *main channel* (*transmission, studio output*) monitor onto which his selection is switched.

Over his intercommunicating talk-back, the production direc-

303

tor guides and instructs the crew via their headsets. Pausing at times to improve, modify, readjust cameras or actors—or to visit the studio floor to revise the treatment—the rehearsal evolves.

Subsequently there is a *dress rehearsal* or *final run-through*, which is a direct replica of the version to be recorded. Where time permits, there may have been an intermediary run-through (total or partial).

Lighting the rehearsal

Throughout the rehearsals, the lighting director, sitting at a lighting console, watches the sequence of pictures as they appear on his monitor in the video-control area. He can see how successful the teamwork and anticipation have proved to be. As he detects shortcomings in the pictorial or technical quality of the pictures, he notes the defects, passing his observations on to other members of the team, perhaps with suggested remedies. Where the problems essentially involve his lighting mechanics, he may either unravel the snags himself, or instruct an assistant. But time presses, and while he is on the studio floor, the lighting director loses contact with rehearsal developments, and is unable to check on the very pictures he is producing.

Teamwork is essential, as the continual consultation with cameras, sound, costume, make-up, set designer, production director, *et al.*, demonstrates. Discussion takes time. Talks may be necessary with the scene hands, to find whether they can move a wild wall without entangling with lamps, with firemen perhaps because there is some wayward cable hazard, with the studio video engineers about some disturbing colour misregistration on Camera 5, for example, and with electricians—'What if we do the fire flicker this way?'

Guided by the lighting director, the video operator has been examining film inserts and colour-matching them to the studio output and poses questions such as whether to 'settle for this reddish foliage and a reasonable version of the horses, or green foliage and bluish horses'.

During first rehearsal the video operator works 'hands off' until the lighting has been balanced by the man at the lighting console —preferably the lighting director himself, for as we have seen, in creative lighting, balance is an integral part of the entire visual concept. Later he will improve the matching of pictures with subtle readjustments of the separate camera channels.

Once in the video-control room, away from the studio, the preview monitors become the 'eyes' of the lighting director. Only by watching the camera pictures can he ascertain what is going on in the studio, because even if there is an observation window, its viewpoint is limited.

Now he begins to see more completely the shots the production director had in mind.

'We are shooting off over there (the set designer is to add some extra flattage but it may foul the key!). The actor's position by the table has been moved to achieve better composition; now we must "fine-trim" the lamps lighting this new mark, to prevent doubling. We had better let the make-up artist know that we cannot reduce the back light on this period wig. If we drop the barn door on lamp 24, the wall-shading will give us a better sense of enclosure.' So the rehearsal continues.

One soon gets into the habit of relating action and cameras to strategic landmarks among the furniture and settings. So, as a

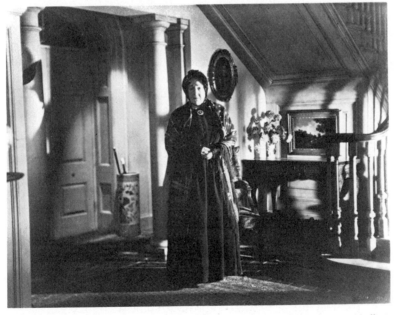

DECORATIVE SHADOW A particularly good example of an attractive environmental effect in which shadows impart a compelling appeal. Try analysing the architectural justification for this lighting. Join the shadows to the objects causing them, and so trace the light directions. The steep door lighting; the banister shadows from floor level; the well-lit painting may not be strictly rational, but the effect is superb.

TEMPORAL LIGHTING (1) Above and opposite show Motion Picture lighting at its best. Attention to detail, controlled depth of field, sensitive balance and the absence of inappropriately steep lighting, convey an environment, a mood and a time of day, with great sensitivity.

Examine the window patterns. Are they projected or cast? Darkened walls emphasize them effectively.

character enters the front door, we see his hair is overlit. Looking at the plot we see that this key light is channel 47; so we flash that lamp to confirm identification, and reduce its intensity by fading it down a little. The balance is now fine.

Life is not really like that, except for static shots. The character walks through a hot-spot which burns his face up ... but he has walked on, and the camera pans with him to another area. We can no longer see the problem patch. We now know that there *is* a hot lamp, but cannot see it to identify and correct. The mystery can only be solved by investigation on the spot. Careful balance checks with a light-meter before rehearsal could have anticipated this type of fault ... but was there time to measure all light intensities?

Instead, the television camera becomes our exposure meter. Having selected the lens aperture and camera sensitivity, relative intensities are adjusted by experience, as we initially set the lamps, and balance them finally from the monitor pictures as the camera

306

TEMPORAL LIGHTING (2) The same scene later. A worried and depressed mood is enhanced by the new lighting treatment. No luminants are visible, but trace the origins of the light areas on the walls. Upward shadows reveal the use of low lamps. Lamps on the floor, or on low stands result in light patterns such as these.

shots emerge during rehearsal. This method of light control creates its own uncertainties, for colour temperature variations can now develop throughout the scene. It may be better to use light-reducing diffusers or 'wires' to cut down light from each lamp and avoid reducing its working colour temperature by dimming. But individual attention is time consuming.

Television is a medium in which the close-up predominates. This is unfortunate. Portraiture for close-ups is very exacting and yet complex production conditions do not, for the most part, allow the ultimate in portrait lighting. Lamps on floor stands can be a nuisance to camera movement; zoom lenses can easily yield very close shots (albeit compressed due to perspective distortion) from distant positions, even where it is impracticable to arrange good lighting; frontal soft light has usually to be slung quite high (10–12 ft), particularly when camera cranes work at full elevation; key lights are often oversteep, being located above the walls of the setting to minimise boom shadows—the walls

307

themselves being kept to 10–12 ft in height, to prevent cameras shooting over the top. These are among the prices one must pay for high productivity. Nevertheless, the final product often achieves remarkably high standards.

Developments in television production approaches

From their inception, most television organisations have made wide use of film in their productions. Some have gone so far as to film all complex studio productions (drama, opera, spectacle), employing the electronic camera for more routine shows. Other networks have used electronic television cameras to the full, recording their products on high quality video-tape systems.

Video-tape recording presents quality indistinguishable from the original television image, and permits the most complicated editing and video effects. It therefore becomes feasible to shoot piecemeal, even on a rehearse-and-record basis, for quite brief programme fragments. Mobile video-tape recorders enable roaming location units, with instant playback checks, to provide extensive material, either for complete or contributory programme purposes.

The hybrid film camera has been used in television studios; with TV viewfinder and monitoring arrangements attached to standard film cameras. At the vision mixing desk, remote stop-start and auto-timing devices, allow camera-switching between a number of mountings, as required. As the end-product is *film*, processing follows normal motion-picture methods, except that time does not permit meticulous reviewing, and the eventual editing is more of a jointing procedure than the measured act of deliberate comparison which takes place in the motion picture cutting-room.

All these are indicative of the various ways in which television studios have sought to satisfy the gargantuan appetite of the medium—ways that have their separate problems and procedures, and must necessarily impinge upon the opportunities and limitations afforded to lighting as an art.

11

EFFECTS

In this chapter are gathered together hints and comments upon the various lighting effects encountered in studio production. Many of these, if skilfully used, do not appear to the audience as effects at all, but just look natural! A few provide attractive or startling illusions that leave them wondering how it was done. But mostly we must encourage their suspended disbelief, so that it is only afterwards, if at all, that they realise all was not as it seemed.

Light effects

Firelight

Simulated firelight can make or mar a night interior scene. When handled imaginatively, the effect is extraordinarily realistic, but occasionally one's credulity is somewhat stretched.

Devices to imitate firelight embrace elaborate rotating discs, smoke or gas-jets set before a point source, projected smoke or flames, and the invaluable fire-flicker stick (Figure 11.1).

A faint orange filter over the lamp may help, especially if augmented with yellow and darker patches, but bold colour easily looks suspect. Fluctuating the light intensity adds to the effect, even when the firelight would in reality have been a constant glow.

FIGURE 11.1 FIRE FLICKER STICK Narrow strips of rag attached to the stick are gently shaken in front of a ground lamp to simulate flickering firelight.

Shafts of light

Shafts of light from heaven, through cell windows or other emotionally charged locations, can only be provided directly, where a smoke or dust laden atmosphere makes the light-beam visible. As ventilation systems in colour studios need to be very effective (each lamp provides the heat of a substantial electric fire), such an atmosphere is quite rapidly dissipated. Instead, light streaking along a stretched gauze panel or a defocused graphic can be superimposed, to create this illusion.

Passing lights

MIRROR BALL

The spot-lit mirror ball (Figure 11.2), familiar in the dance hall, reflects a travelling pattern of tiny light-dots across the scene as it rotates.

FIGURE 11.2 MIRROR BALL A strong spotlight illuminates the multi-mirror-faced ball. Revolved by a motor the resultant pattern of light dots moves across the scene.

MIRROR DRUM

A mirror drum (Figure 11.3), when rotated in front of a lamp, projects a series of bright rectangles that move across the action—usually to imitate the lights of a passing train.

FLICKER-DISC

A rotating flicker-disc set up in front of a lamp will provide pulsating light, passing shadows, or vari-coloured light (Figure 11.4). Sometimes the flicker-disc is used to imitate the stuttering image of early movies—with questionable success.

At slower speeds the horizontal light movement may suggest the illumination from passing vehicles, nearby street or shop lighting, etc.

FIGURE 11.3 PASSING LIGHTS
1 Mirror drum. A polygon of plane mirrors reflects a regular sweeping pattern of rectangular lights across the scene as it rotates (e.g. train windows).
2 Cyclodrum. (a) A rotating circular framework fits over a lamp, holding stencil or shadowing objects (e.g. branches). (b) A drum set with metal foil patches suggests passing lights. Repeating patterns must be avoided.
3 Swinging boomlight. A counter-balanced spotlight provides a swinging key light, to convey movement (e.g. rolling ship).

STROBE LIGHTS

Generating vari-speed flashes (from electronic flash-tubes), these have a relatively low output, and produce stroboscopic speed changes in the resultant picture. They have had their vogue in creating arrested motion or 'momentary blink' illumination in dance routines. Lower speeds can prove dangerous to performers, for this effect is known to give rise to physiological spasms (epileptic fits, headaches, dizziness). Moving machinery too, may appear stationary—an accident hazard.

CAR HEADLAMPS

These are usually simulated with a stand-lamp (restricted by a barn door), turned across the scene. But not too rapidly, or the purpose of the effect will not be evident on the screen.

FIGURE 11.4 FLICKER DISC As its spokes cover and uncover, the beam of the lamp flickers. Multi-colour segments may be used for decorative effect.

311

Practical lamps (see Chapter 9)

Most practical lamps (table lamp, oil lamp, etc.) are too bright on camera once they are powerful enough to illuminate nearby subjects. In very low-key scenes, even a shielded match may provide adequate momentary results, but the majority of situations need to be cheated with imitative studio lighting. Tiny luminants, strategically placed, can often provide a very convincing illusion. They can be used in cupped hands as a match-flare, or concealed within the housing of a practical lamp. A mock-up candlestick has been used before now, with a small bulb in the hollowed-out holder, and a real, lit candle seemingly providing the light. Sometimes simpler methods are possible. One may, for example, remove part of a table lampshade in order to allow its full light from an overrun bulb, to illuminate an actor near by, while the density of the shade masks the light from the camera.

Real candles are largely uncontrollable, even with short wicks. They gutter under strong ventilation, and change in size which gives time-continuity problems. On television cameras they too easily create horizontal streaking and trailing across the picture.

Flashes

LIGHTNING
Forked lightning in the night sky is best conveyed by a filmed insert or superimposition, derived from a library shot, or animation. Flashed projected slides, electronic insertion or captions too often carry little conviction.

Sheet lightning is derived from momentarily struck xenon arcs, rapidly unshuttering a lamp, or simply switching a light on for an instant. If a tungsten-lamp rated above about 2 kw is flashed, the filament heating time may be too long for instantaneous bursts. Whether several rapid flashes or a more prolonged burst proves most effective depends on the application, but it is as well to check against spurious shadows on backcloths, or gross over-exposure during the lightning.

Colour can have an influence upon how convincing the lightning appears to be. For blue-illuminated 'night exteriors' white light (of high colour temperature) provides an effective contrast for the flashes. Where lightning is seen within a room at night, a luminant of light-blue hue (e.g. steel blue) is preferable.

312

EXPLOSIONS

These are lightning-type flashes accompanied by special effects such as smoke, dust, debris—perhaps with flash-powder ignition (Figure 11.5).

Terminals

Asbestos Board

Cable to
Electrical
Supply

FIGURE 11.5 FLASH BOX On applying a voltage the low-current fusewire between the terminals melts, and ignites the magnesium flash powder (perhaps augmented with smoke powder) piled over it.

Projected patterns

Still projectors using metal masks or photographic slides have wide decorative applications, although power limitations may restrict their effectiveness under the lighting intensities required for colour (see Figure 4.6).

Motor-driven attachments enable slide projectors to provide various interesting moving effects, such as clouds, rain, falling snow, fire, smoke and water. Some are more convincing than others, but superimposed projections usually enhance the illusion.

Simple shadow shapes can be produced with large cut-out stencils, expanded metal mesh, foliage, etc., positioned in front of point sources (so-called Linnebach projection).

Projected patterns of venetian blinds, curtains, water running down windows, and the like, are only reliably achieved using a powerful distant point source to cast shadows from real scenic units.

It is possible, at an appreciable light loss, to obtain coloured patterns of changing hue (Birefringence effect). A slide is made with designs in mica, quartz, plastic sheeting or tape. This is sandwiched between two sheets of Polaroid filter. As one of the filters is rotated, colours vary.

RHYTHMICALLY FLASHING LIGHTS

Repeated flashes of light (e.g. simulating an electric sign) can be actuated by electronic timing circuits, bi-metal contact switches

313

and similar automatic units. Sometimes a rotating flicker-disc will suffice to provide the flashing effect.

For 'flashing sign' effects, the sign itself should be synchronised with auxiliary studio lamps lighting appropriate areas of the setting.

Image distortion

Lens flare

Whenever the light from an excessively bright source enters the lens and becomes internally reflected and scattered, we are likely to encounter lens flare.

Specific light flare usually takes the form of multi-edged discs (from the lens diaphragm) or streaks of light. With more general flare, black areas become greyed out, resulting in desaturation and reduced contrast. On colour TV cameras specific lens flares may be bluish in colour and accompanied by colour degradation, despite electronic *flare correction circuits*.

Mostly, such flares are encountered from low-angle back light (cured by barn-dooring the lamp off the camera, suspending a gobo to shield light off the lens, or raising the lamp height), and when shooting into light sources or specular reflections. Deliberate lens flare has been used for decorative purposes, but is a haphazard effect that may not be repeatable.

WAVERING IMAGE

Where a lamp shoots through flames or smoke, its beam can become diffracted into a strangely undulating light—a projected heat-haze shimmer. Most pronounced on flat captions, the surface can appear to writhe in a weirdly dramatic fashion. Burning wax, fire-lighters, oil-soaked rag and incense have all proved successful for this purpose.

GRADUATED FILTER

Graduated filters (or night filters) take two forms: neutral density types in which the dense upper section gradually fades to a clear lower section, and a blue-tinted filter having a darker upper segment fading into a lighter lower region.

They are used occasionally to darken sky tones, but there is always a problem in arranging the filter to suit varying pro-

314

portions of sky areas, and uneven sky-lines. Moreover, the camera cannot be tilted or panned without revealing the filtering.

IMAGE DIFFUSION

Softening of entire picture detail is achieved by placing over the lens a plain glass thinly smeared with oil or grease, a diffusion disc (glass with fine concentric ribbing) gauze, chiffon or surface-treated clear plastic (fog filters).

COLOUR FILTERS

In a colour medium, only a very restricted range of colour filters can be used over the camera lens, unless the aim is to deliberately distort the entire colour quality, perhaps for dream sequences, and similar abstractions. Then lens filters offer more economical, if less flexible colour transformations, than individual lamp filtering.

The corrective and contrast control exercised in black-and-white photography through the use of colour filters is not possible in colour.

Coloured lighting

With any kind of colour photography, there is a temptation to use coloured light wherever possible. Yellow candlelight, blue moon-light, red-orange firelight, orange sunsets, coloured signs, are obvious applications. Opportunities abound in variety and dance spectaculars, for even the most unprepossessing setting can be transformed at the touch of a button. Neutral-toned scenery can be used as a medium for extensive colour changes. Reflective surfaces can glisten with coloured speculars. Amusing or quaint things are possible with coloured light on people, changing their face-tones and their costume.

Beauty is very much in the eye of the beholder where coloured light is concerned. Daringly different or nauseating, providing variety or tasteless exhibitionism, we encounter both appropriate and unsuitable applications. Perhaps all one can say is, be sparing with colour, and check around for other people's reactions!

The effect we achieve by filtering a light source is influenced by several factors: the filter characteristics relative to the colour quality of the light, the intensity and angle of the light, the subject colour, and finish, adjacent surface colours, filter ageing, diluting or modifying spill-light, camera angles and the various subjective

315

effects discussed in Chapter 2. Consequently, it can become quite difficult to provide large, evenly coloured areas, especially on surfaces that are not flat, such as a cyclorama—particularly when this involves colour matching on all cameras, over a wide angle. The problem worsens for deep and for highly saturated colours.

Reflected shapes

Many decorative light opportunities are possible with reflective sheets (Figure 11.6). Metal foil or plastic reflectors can be covered with painted lettering or designs, and when flexed, project a changing image (front or rear projected) on to nearby subjects. The surface can be treated by greasing, dimpling, grooving, varnishing to vary the brightness and texture of parts of the reflection. Patterns at either end of the same reflector can be separately manipulated, or superimposed.

FIGURE 11.6 REFLECTED SHAPES Thin metal-foil or reflective plastic sheeting can be held in a sharply focused light beam, and its image reflected on to near by surfaces. Flexing the sheet distorts the reflected shape.

Among the uses of reflected shapes are animated titling, mobile patterns (for abstractions, dream-sequences, mental turmoil), astronomical effects, and various magical and supernatural applications.

Crinkled metal foil, lit by single or multi-coloured lights, can similarly be used to decorate plain backgrounds with abstract light patterns.

Metal cooking foil or metallic-sputtered plastic sheet may be used to form a circular tube around the camera lens. The central area of the normal scene is reflected in an indistinct peripheral image. Coloured light can be used to produce hue changes in the surrounding decorative reflection. If the tube is given a series of facets, kaleidoscopic images develop.

316

Water

Water ripple

We can imitate the rippling light from nearby water with the apparatus shown in Figure 11.7. The results can be surprisingly convincing if the water is not over-energetically agitated.

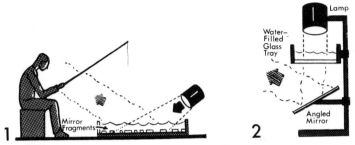

FIGURE 11.7 WATER RIPPLE Rippling light reflected from or through water can be directed on to the scene.
1 A ripple dish: simple, adaptable, and permitting high intensity sources, is space occupying and is immobile.
2 A ripple tray: accurate, compact, mobile, but allows only smaller light sources, and gives less coverage.

There are theatrical devices employing moving patterned glass, or metal stencils, but they appear mechanical under the scrutiny of the camera, and have inadequate light output.

Rain and mist

Whether dripping down window-panes, or being showered from overhead jets, rain is best lit from side or three-quarter-back directions. As excess water will pose runaway and over-soaking embarrassments, an adjustable-spray hose over a restricted area is usually favoured in the studio. Very little light is needed, or the water-drops will appear unrealistically bright.

Mist is generated from a very fine water spray, from smoke machines or heated 'dry ice' (solid carbon dioxide), and requires similar lighting treatment, preferably against a dark background. Sometimes the atmosphere is achieved simply by superimposing a library film-shot of mist, or a small scale tank-contained effect.

Mist tends to set-up the black level of the televised picture and to desaturate colour. For daylight, the lighting must be flat and not appear overbright. Night shots of mist can be troublesome. In

317

closer shots they too easily degenerate into 'poor daylight', while in longer shots one can be very conscious of over-defined light directions. On balance, better illusions are attainable using an image-diffusing method coupled with modest studio mist or fog, than by attempting to generate a real 'pea-souper' in the studio.

Scenic projection and insertion

In this section, we shall be considering two broad families of facilities that enable studio subjects to be combined with separately devised backgrounds (Figure 11.8).

Firstly, there is the '*studio background*' approach, in which the studio subject performs before a photographic picture. This background may be a photographic blow-up, translucent photo-mural or a projected image.

Secondly, there is the '*unseen background*' approach, in which the studio performer can see nothing of the background scene, but works within certain confines and is combined elsewhere with the rest of the scenic effect.

One fundamental lighting problem is common to all systems and that is *matching*—matching the foreground to the background in colour quality, key light direction, lighting contrast, comparable light source areas (i.e. a background with localised lighting will necessitate similar restriction in the foreground lighting). The difficulties increase, of course, where backgrounds change rapidly, for one may not be able to suitably rearrange lighting to suit.

Various staging problems are common to all such combined shots—principally those of matching sizes, proportions, perspective, viewpoints, elevation and definition.

With both photo blow-ups and rear-projection forms of studio background, the background picture presents a flat plane to the studio camera, and so becomes defocused as a whole. With all other systems, the background remains a constantly focused whole.

Large photographic blow-ups are regularly used in studios as backings, and occasionally as complete scenic backgrounds. They can be retouched (dye-treatment converts economical monochrome blow-ups for colour), and lighting can be locally adjusted in brightness and colour. Any surface unevenness, however, is likely to show under oblique background lighting.

318

Rear screen projection (*Back Projection, B.P.*)

The difficulty of preventing shadows or spill-light falling upon the background picture is even greater when rear projection methods are used (Figure 11.8, part 1). Any stray light will dilute shadow areas of the image to a detailless grey, reduce contrast and desaturate colour. To avoid such spurious effects, the light upon the foreground subject (which should be at least 6–9 ft from the screen) needs to be carefully controlled. Frontal light needs to be comparatively steep, and well-barn-doored off the screen. Soft light must be kept to a minimum and bounce-light from horizontal planes must be minimised. Side and three-quarter-back light is used extensively (dead back light would usually be too steep, and less effectual). A black scrim of $\frac{1}{8}$ in. mesh over the face of screen, or a tinted screen, may reduce the effect of spill-light.

An even screen-image intensity is not readily achieved. Not only is there a tendency to a central hot spot in the projected picture, which moves with the camera's position, but screen brightness falls if the camera is angled to the screen axis. Consequently, relative background brightnesses change when intercutting between cameras.

Front projection

Normal front projection (Figure 11.8, part 2) of anything more than simple patterns or abstract shapes, on to cycloramas and similar light-toned surfaces has further disadvantages. Spill-light is more troublesome, tonal contrast more restricted, background surface texture may glare through, and because the projector is inevitably angled to the background, keystone distortion and overall focus snags arise.

Reflex projection (Figure 11.8, part 2) avoids all these limitations on a one-camera set-up, by projecting the background scene along the camera lens axis on to a special screen with narrow-angle reflection properties.

Picture insertion

With picture insertion (by electronic, or travelling matte) the background scene is derived from a separate picture source not seen in the studio. There are no problems with stray light degrading the background image. But, because the background remains

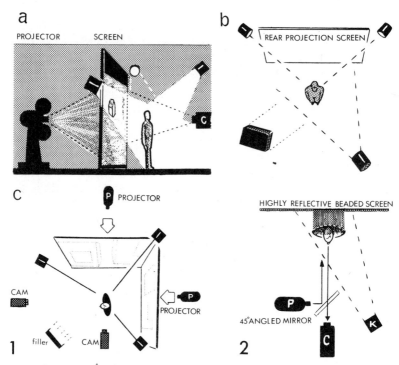

FIGURE 11.8 SCENIC PROJECTION AND INSERTION
1 Rear projection (Back Projection, B.P.). (Background visible in the studio.)
(*a*) A still-slide, moving film, or projected TV picture is focused on to a matte translucent screen (e.g. 4 ft × 3 ft, to 18 ft × 12 ft, and larger); foreground action appears to be within the projected background. (*b*) Lighting problems lie mainly in matching the foreground subject appearance to the background picture, and in preventing spill-light from degrading the projected image. (*c*) Dual screens improve pictorial flexibility, but increase matching and spill-light hazards.
2 Reflex projection—axial front projection. (Background visible in the studio.) Only suitable for a static camera, the background scene is projected along the lens-axis via a half-silvered mirror, on to a highly directional screen. This comprises microscopic glass beads (over 30 million per sq ft) behaving as mirror-backed lenses.
 The camera sees the normally lit subject and the bright reflected scene integrated. The projected background image falls upon the actor, but swamped by his lighting, is indiscernible. His shadow is unseen, being hidden directly behind him. (It is visible from other viewpoints.)
 The camera can zoom in to screen-image detail. Projected backgrounds of even 100 ft × 40 ft are practicable. Foreground scenic planes can be provided with reflective profile screens, or with normal scenery. Holes cut in the screen could permit insertion of built scenic units (e.g. archways).
3 Electronic picture insertion. (Background unseen in the studio.) (*a*) Inlay—keyed insertion—static electronic matte. We select the part of the background picture to be treated (e.g. doorway) and make a paper mask to cover that area of the masking tube. The apparatus then automatically blanks out just this region of the background picture, and inserts the corresponding area of the subject picture. Electronically generated masks permit insertion of simply shaped areas (and inter-scene wipes).

320

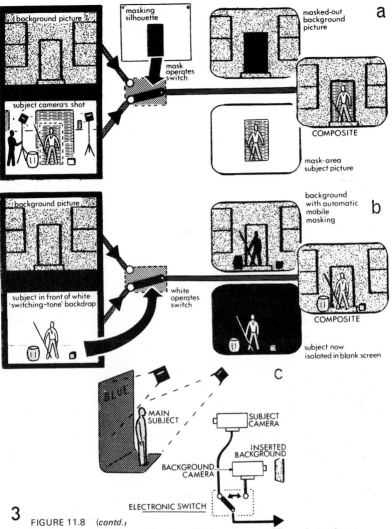

3

FIGURE 11.8 (contd.)

(b) Brightness separation overlay—combined montage amplifier—electronic moving matte. Here the subject picture automatically punches a corresponding mask area into the background scene. Hence the subject camera must see only information that is to be inserted, and nothing else. The subject is therefore positioned before a black (or white) backdrop. The subject and matted background pictures are then combined electronically.

(c) Colour separation overlay—chroma key. Similar to method (B), but using a bright blue backdrop for the subject switching hue. (A 'blue minus luminance' signal is actually used.) The subject must not contain or reflect blue. The subject picture (less its blue component) and matted background pictures are combined electronically. Although blue (cobalt) is universally used, any hue can be utilised for switching. Both hard and soft-edged transitions are possible.

321

constantly in focus, one becomes more aware of its quality and can compare the background lighting treatment with the studio foreground subject.

INLAY OR 'KEYED INSERTION' (Figure 11.8, part 3*a*)
This poses no intrinsic tonal limitations. It is an electronic area-blanking process, in which a selected region is cut from the background picture, and a corresponding section of the foreground picture inserted in its place. Formerly a manually positioned masking process only, electronic switching masks can now be provided semi-automatically for a range of basic geometrical shapes.

BRIGHTNESS SEPARATION OVERLAY
This is a tonally selective method of picture-switching (Figure 11.8, part 3*b*). It demands that all foreground subject tones be very different from those of a selected background switching tone. Either a white or a black switching tone can be chosen for picture insertion, and is set up behind the foreground subject. Wherever this appears in the foreground shot, another source, the background picture, is automatically switched in instead.

COLOUR SEPARATION OVERLAY (CSO) — CHROMA KEY
This is a colour-selective method of picture-switching (Figure 11.8, part 3*c*). The subject is usually set up before a blue background (other specific hues may be used), this switching colour being entirely excluded from the subject. Wherever the system 'sees' blue in the foreground shot, it switches to another picture source providing the background scene. Blue exclusion is essential. Even the blue light reflected from the blue switching-backing (on to hands, clothing, faces, shoe-soles) can give rise to ragging or background breakthrough due to spurious switching. Subject shadows falling upon the blue backing can reduce its local brightness, with similar results. In addition, vague, defocused, or very fine outlines (e.g. feathers, mesh, fluffy hair, smoke), transparent objects and blue speculars, can produce uncertain switching. Later chroma-key systems are more flexible, less liable to spurious switching, and able to handle transparent surfaces, shadows, etc.

FILM TRAVELLING MATTE
There is little opportunity here to discuss the ingenious wonders achieved by motion-picture makers in this field.
For colour shooting, one major system (sodium lamp process)

has the actor lit with a white light which is minus monochromatic-yellow (didymium-coated lamps), while the backing is illuminated with monochromatic yellow from sodium lamps. In a beam-splitting camera a monochrome film records the pure yellow backing for masking purposes, while a colour film provides a record of the foreground subject alone, against black.

Again, an opaque matte mask corresponding to the actor may be derived from his having played against a colour separation backing; this being used to counter-matte a background picture during process printing.

The lighting problem, whatever the method, is that of convincingly matching the light quality, direction, contrast and colour to the synthetic environment.

Transformations

Gauzes, (scrims)

As Figure 11.9 shows, one can modify the appearance of gauze to obtain various scenic effects, selecting and blending light directions at choice. Apart from its application in transformation scenes, scenery has been painted on a gauze (to give a less bold environment than built scenery would provide).

The usual problems when lighting gauze are in illuminating it evenly (nearby scenery and action often force lighting to be steep),

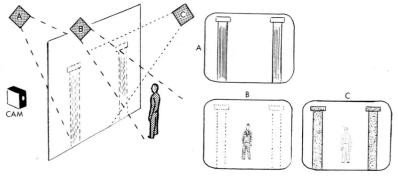

FIGURE 11.9 GAUZES (SCRIMS) Gauzes can be used in three ways: (A) Lit from the front, the gauze appears as a solid plane, supporting surface decoration or painting. Unlit subjects behind the gauze are unseen, unless light passes through and illuminates them.
(B) Leaving the gauze unlit, strongly illuminated subjects behind it are seen with softened detail and contrast. Surface painting on the gauze nearly disappears.
(C) Rear-lit gauze adds an increased mistiness to the lit scene beyond, silhouetting any gauze surface detail.

323

GAUZES *Top:* Frontally lit, the gauze appears solid. Unlit subjects behind are unseen. *Centre:* The subject alone lit, the gauze almost disappears. *Bottom:* With the subject lit, and the gauze illuminated from behind, a haziness spreads across the scene.

and in preventing this illumination from passing through on to adjacent areas.

Samoiloff effect

Essentially a monochromatic device, this relies upon the fact that the appearance of the subject can change completely under differently coloured lights. Red surfaces appear black under green illumination, light-toned under red and vice versa. So, provided we are using a black and white medium, or the actual colour-changes are acceptable in a colour picture (e.g. for maps and graphics, stylised dance, etc.), this form of transformation is simple and effective.

Half-silvered mirrors (transparent mirrors)

When a glass has been very thinly coated with reflective silvering, it can be made to appear either transparent or as a mirror, according to the relative light levels on either face (Figure 11.10). Thus

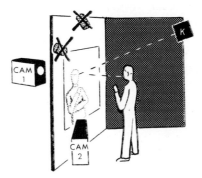

FIGURE 11.10 HALF-SILVERED MIRRORS These permit shoot-through effects. The subject is lit (as in normal mirrors) with a reflected key (K), rather than with side or top light (from Camera 1 position). Unless the mirror is fairly large, and the key suitably shallow, the reflected light will not illuminate the subject evenly. Light loss in the mirror necessitates exposure correction, and higher light levels.

one camera can take 'through the mirror' shots of make-up demonstrations, while another taking reverse shots, sees only the demonstrator and the mirror. However, the silvering reduces light considerably (to one-quarter or less) so that apart from any colour-cast the glass may introduce, light levels can become prohibitively high, necessitating very reduced apertures (or heavy filtering) on the front-side camera.

325

Mirrors used as image deflectors (in projectors, duplexing, caption equipment, etc.) require surface-silvering. Although very vulnerable, this overcomes the degraded image quality introduced by spurious double reflections (from both glass surface and silvering) in normal rear-silvered mirror systems.

Follow shots

Following spotlight

Unashamedly theatrical, this effect places the actor in a pool of light, isolated from his surroundings. But the spotlight has its hazards. Its beam must have an uninterrupted throw (which means that all other lighting near by must be that much higher and steeper). At greater distances, smooth operation needs experienced skill. Other supplementary lighting (back light, filler), however, degrades the spot effect. The spot-circle is ineffectual on patterned or dark surfaces. And, lastly, spot-lit close shots tend to be over-contrasty.

Notwithstanding this, following spotlights have their place, particularly for spectacle subjects, where small, mobile high-intensity beams may be more practicable than fuller lighting treatment, or where localised lighting is required within lower-intensity surroundings.

Travelling key

In dramatic presentations, we may encounter situations where a character moves around, carrying his main source of illumination with him. Walking down a flight of steps, through a doorway, up a corridor, out into the storm-swept garden, into a wood. Here we have a familiar series of problems. If the light source is too bright, it will seem disproportionate (and cause picture defects on the electronic camera). If it is too dim, the effect is incongruous. It is seldom sufficient to be used as a sole luminant.

If we simply follow the actor with a localised lamp (Figure 11.11, part 1), the light direction becomes a very cheated version of the visible source. Its shadow appears on the actor, and the appearance of the surroundings does not alter appropriately as the actor moves about. Moreover, anything coming between the spotlight and the actor is overlit, and throws spurious shadows.

An alternative method (Figure 11.11, part 2) is to provide a

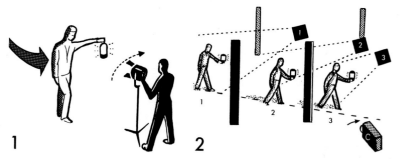

FIGURE 11.11 FOLLOW SHOTS Where a subject moves through a darkened setting, it may be lit by:
1 A travelling (following) key.
2 The follow shot subject may otherwise be lit by a series of interfaded localised areas.

series of lamps along the route, fading them up and down successively. This, however, involves precise timing and may still not be directionally correct.

Model shots

Model-making is a skilled, lengthy, expensive business, so it is not surprising that models are comparatively seldom used. But when they are, they bring their own particular difficulties.

Demonstrational models

These demand clarity. Confusing multiple shadows should be avoided, and shadow detail clearly revealed. In multi-layer models (e.g. showing geological formations), it may be difficult to avoid both inter-layer shadows and specular reflections. The lens axis lamp that achieves shadowless lighting, bounces right back at the camera, even from matte surfaces. Really soft light angled from several directions may help.

Internal lighting in models is invariably unsuccessful under bright studio lighting, unless the ventilation allows high-intensity concealed bulbs to be used.

Miniatures

Taking the form of small environmental replicas, these are used to extend a studio setting, to establish locations, or to simulate

disasters (fire, flood, earthquakes, etc.). Here convincing illusion is the watchword. The general problem is to obtain a sufficient depth of field without simply flooding the miniature with light, and without cooking it to a crisp. The limited depth that a large lens aperture provides may sometimes soften-off detail and add 'aerial perspective', but for architectural models the scale of this de-focusing looks wrong more often than not. For large landscaped models, subtle light variations (e.g. from a translucent cookie in the key light) may suggest cloud shadow, and add conviction. Stark, unbroken sunlight even makes real aerial-shots look artificial.

Models of interiors really require scaled-down lamp units to achieve suitably localised lighting treatment, and except in a process studio, these are unlikely to be available. Improvised work with effects projectors, localised snoots or similar restriction, may meet occasional needs, however.

Camera mattes

These are small, vertical photographic or artist-painted surfaces set up in the foreground of the shot, to obscure and replace part of the real scene. The camera may shoot, for example, through a perspective-painted glass sheet showing a magnificent ceiling, that mates imperceptibly with the three-walled setting in the studio. As always, matching is the difficulty (scale, perspective, tone, light

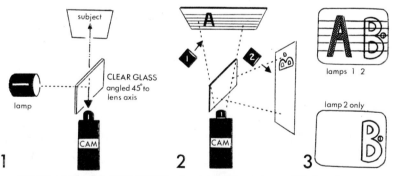

FIGURE 11.12 PEPPER'S GHOST Constructed simply from a 45° clear glass sheet in the lens axis, this can be used:
1 to provide light directly from the lens position (optimum flat lighting, reduces modelling and inter-layer shadowing).
2 to superimpose transparently another subject upon a picture in a static camera. (Fading the ghost scene's lighting up as required.)
3 to mix between two picture sources (fade out one scene's lighting, fade up the other's).

direction, etc.). And again, there is the depth of field dilemma—maintaining both the near by matte and the distant scene in sufficiently sharp focus.

Captions

Caption cards form the original basis of most graphics; for titles, pictorial and diagrammatic inserts.

Captions require flat, even illumination, with an absence of flares and hot spots. This means lighting from both sides of the camera, or from a frame of striplights surrounding the camera. Single lamp lighting is temptingly easy, but for captions measuring more than about 12 × 9 in. leads to uneven illumination.

FIGURE 11.13 LIFT-DOOR SHADOWS
1 As a masking card is raised, lift gate shadows fall across the waiting passengers.
2 A slide projector provides a shadow pattern on the translucent lift doors as it is tilted, or its support hoist raised.
 A sliding sheet, or roller blind, behind translucent windows may substitute these methods.

Multi-layer captions (e.g. where a series of movable layers create animation) are best treated with a Pepper's Ghost set-up (Figure 11.12).

Captions can be animated by lighting, using projected patterns or shadows, colour changes, rear-lit stencils and similar variants.

Three-dimensional caption displays in which solid or cut-out lettering is arranged within a series of associated articles can be extremely effective. The whole can be lit as still-life or a miniature, care being taken to avoid attention being distracted from the lettering by the various surrounding items, and in ensuring that shadows do not destroy the legibility of the message.

12

PICTURE CONTROL

Picture-making is a process that combines several separate considerations:

1 The presentational purpose of the picture: what it is for, what it is about.
2 The subject: its pose or positioning, its juxtaposition to other subjects, and to its environment.
3 Camera viewpoint: its vertical and horizontal angles.
4 Image clarity: focus and plane, depth of field, atmosphere (mist, smoke), image diffusion.
5 Composition: the relative proportions and relationships of shape, line, texture, tone, colour.
6 Lighting: the associative distribution of light and shade.

Various of these factors have been discussed more fully elsewhere.* Here we have been primarily concerned with the last of these—the way in which the visual world is translated according to our choice and arrangement of light.

The effect of light, however, is in its turn influenced by the optical, chemical and/or electronic processes through which the pictorial image passes before it reaches the screen. And these integral aspects of picture control we shall survey in this chapter.

Exposure

Tonal accommodation

As we saw earlier, all photographic and television systems have a limited brightness range within which they can accept light and reproduce a relatively proportional output. If film receives insufficient light, it registers nothing except a fog density. The television camera produces fluctuating noise and colour smearing or trailing. With more light than its maximum limit, each medium

* *The Technique of Television Production*, Gerald Millerson, London: Focal Press.

records only the same maximum density. Typical exposure curves are shown in Figure 12.1.

Shooting a scene with a wide tonal range, where important tones exist from highlights down to shadow detail, the subject extremes may well exceed the exposure range of the film. Tones falling under the toe or above the knee (shoulder) of the curve become progressively compressed. We cannot record subtle tones

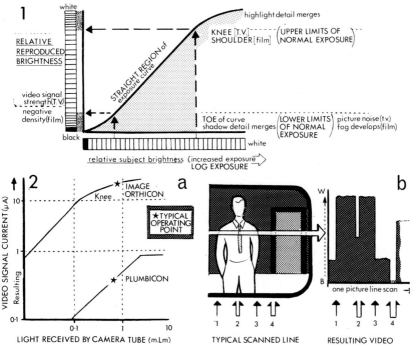

FIGURE 12.1 EXPOSURE CURVES

1 Typical photographic exposure curve. This demonstrates the progressive response of a film or camera-tube to light. At the lower limits (the toe) the darkest tones become less differentiated, finally merging to a common black. At the upper limits (photographically 'the shoulder'; in TV 'the knee') lightest tones similarly become less distinguishable. Between these limits there is a proportional change in the density of the film as the brightness of the subject tones (luminance) increases. The longer this straight region, the greater the medium's latitude. Colour films have little.

2 Typical TV camera-tube exposure curve. (a) The plumbicon TV camera-tube has a linear exposure curve, so within its maximum and minimum electrical limits, the reproduced value is always proportional to the subject tones. At and beyond its clipper levels, all tones are abruptly reproduced as blank white or black. The image orthicon TV camera-tube possesses a knee which creates progressive tonal compression before upper electrical limits are reached.

(b) Systematically scanning an image of the studio scene in a series of lines, a video voltage (video signal) is generated in the camera pick-up tube corresponding to the brightness variations perceived along each line.

331

in extreme highlights and shadows concurrently. Where the subject brightness range is more limited, or the acceptable brightness range of the medium is greater, we can arrange a suitable lens aperture (stop) to encompass the entire tone range of the scene on the straight part of the characteristic curve.

However, if we shoot even an undemanding scene at too small a stop for the prevailing light, the film speed or the subject tones, its lowest values can become compressed beneath the toe. Darker subject tones and shadow detail merge and become lost.

At too large a stop for the situation, the lightest tones and highlights integrate under the knee of the exposure curve (and in television, are subsequently equalised electronically as they 'hit the clipper').

Thus, by under- or over-exposure, even a subject of relatively restricted contrast range may become tonally distorted.

We may be deliberately seeking such inaccuracies, purposefully massing all shadow detail to concentrate attention on lighter-toned areas. We might systematically burn-out light tones to give blank, featureless highlights. The choice is ours. Generally speaking, shadow crushing passes unnoticed, while blankness in large light-toned areas becomes obtrusive.

When the tonal range of the subject is extended and cannot be accommodated by the film or camera-tube, we have to decide whether to lose reproduced gradation in shadows or highlights, or in a little of each, for we cannot retain all.

As lighting contrast inevitably extends the tonal contrast of the scene, the effective range the camera is expected to cope with comes from the combined influences of subject and lighting contrast. A subject contrast of 10 : 1 only requires a lighting contrast of 3 : 1, to reach the 30 : 1 extremes the system can handle.

Flat lighting is often advocated, to ensure that wide subject contrast is not further aggravated, and situations certainly occur where there is no alternative. Where technical clarity is our sole aim, this may meet our purpose. But where we aspire to any sort of persuasive presentation, flat lighting has little to recommend it.

Uniform lighting may be essential, particularly for close, wide-area movement. But uniformity means consistency of level and contrast. It does not mean flatness, with its limited visual appeal.

Generally speaking, a $1\frac{1}{2}$: 1 to 3 : 1 lighting contrast ratio (key plus fill, to fill) satisfies most situations for portraits and close subjects.

332

TABLE 12-I

RELATIVE EXPOSURE VALUES FOR
DIFFERENT LENS APERTURES

f no (standard)	f no (continental)	Relative exposure
1		1
	1·2	$1\frac{1}{2}$
1·4		2
	1·6	3
2		4
	2·2	6
2·8		8
	3·2	10
4		15
	4·5	20
5·6		30
	6·3	40
8		60
	9	90
11		120
	12·5	180
16		240
	18	320
22		510
	25	640
32		1,040

A change of one stop in a series, doubles or halves light passed by the lens.

Thus f. 4 to f. 8 $= \dfrac{f.\ 4^2}{f.\ 8^2} = \dfrac{16}{64} = \dfrac{1}{4}$

∴ From f. 4 to f. 8 requires 4 times the light level (f. 8 to f. 4 requires $\frac{1}{4}$).

From the table, f. 4 = 15, f. 8 = 60. Thus $\dfrac{15}{60} = \dfrac{1}{4}$

For longer shots, where shape, texture and mass are most important, including interiors, architecture and landscape, lighting contrast ratios of 5 : 1 up to even 8 : 1 may prove effective, provided that the centre of attention is clearly visible. But again, so much depends upon the inherent subject contrasts, light angle and distribution, that we cannot be dogmatic.

Despite lens coatings, some inter-element light scatter arises within complex lens systems. This random stray light illuminates shadow areas of the image, giving us no more detail, but instead masks the tonal gradation in the shadows, reducing the overall contrast range. Thus a scene with 130 : 1 contrast may in fact be presented as a contrast of only about 30 : 1 to the film or camera-tube.

These basics of exposure do remind us of the selective choice we have to make in films or television and how we often deliberately forego shadow detail to give lighter tones their 'natural' values

333

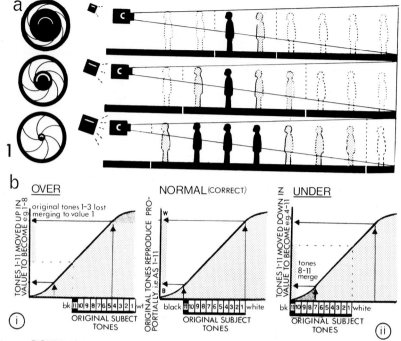

FIGURE 12.2 LENS APERTURE

1 The lens aperture (diaphragm) simultaneously controls the average light level received by film or camera-tube, and the depth of field perceptible in the picture. (*a*) Large apertures (e.g. f. 1·9) result in shallow depth, but less light is required (i.e. shooting is possible under lower light levels). (*b*) (i) Subject tones are moved up the exposure curve as the aperture is increased.

Small apertures (e.g. f. 16) provide a considerably increased depth, but hold back light so that far higher scene brightness is necessary (or can be tolerated), for correct exposure. Very bright conditions (e.g. strong sunlight) can be accommodated by stopping down in this way. (*b*) (ii) Subject tones are moved down the exposure curve as the aperture is reduced.

Lens apertures are calibrated in *F-numbers*, theoretical units based upon the focal length of the lens (F). $f = \dfrac{\text{Focal length}}{\text{Diaphragm diameter}}$. *T-stops* (transmission numbers) are being introduced progressively, and represent actual relative light transmission values of a particular lens (about $\frac{1}{3}$ stop closed on an equivalent f number).

in the tonal scale. Most often exposure is assessed relative to facial tones, deciding that above or below some arbitrary value they look too light or too dark (tests suggest that this is so highly subjective, and so strongly influenced by adjacent background tones, that we cannot really prescribe meaningful figures).

Having pegged face tones, if shadow is undesirably dense, it must be more strongly lit. If the lightest subject tones are too bright, they will have to be darkened by shading, reducing light in

334

c

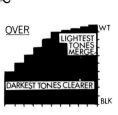

OVER

LIGHTEST TONES MERGE

DARKEST TONES CLEARER

WT

BLK

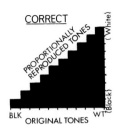

CORRECT

PROPORTIONALLY REPRODUCED TONES

(White)

(Black)

BLK WT
ORIGINAL TONES

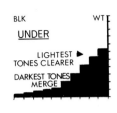

BLK WT

UNDER

LIGHTEST ► TONES CLEARER

DARKEST TONES MERGE

a

b

2

FIGURE 12.2 (contd.)
2 (a) For a given focal length and aperture, depth of field increases with sub-
ject distance; but image size diminishes. (b) For a given aperture and subject dis-
tance depth increases with lens angle (decreased focal length); but image size
diminishes.
 Exposure is controlled in 'still' photographic cameras both by selection of lens
aperture, and the duration of the shutter opening (shutter speeds). Ciné and
television cameras rely primarily upon aperture selection and light-intensity
adjustment to select exposure. Neutral density filters can reduce overall light
transmission and obviate the use of over-small lens apertures. Ciné cameras may
have variable-angle shutter-openings to control exposure times.
 In all cases, as well as modifying exposure, choice of aperture also alters the
effective depth of field; while the choice of exposure time necessarily affects
image-arrest time of the moving subject.

that area or physical treatment. Failing that, we must accept one set
of tonal extremes as determining exposure, and lighten or darken
faces to suitable proportions. Within the studio, required depth of
field or practicable light levels usually influence the starting point.
 Under-exposure generally leads to an increase in colour satura-
tion, while *over-exposure* produces desaturated effects in the pic-
ture. Either may be turned to advantage, as when flatly lit, over-
exposed pictures are deliberately devised to create delicate pastel

335

colours. But one must guard against inadvertent effects too, as in low-key scenes, where reduced light intensities may lead to an unwanted exaggeration of hue. 'Correct' exposure is therefore very relative, depending upon which range of scenic tones one wishes to select and reproduce clearly.

Sensitivity

The light levels required for a particular film or television system depend upon the inherent sensitivity of that system, the lens aperture (hence the depth of field) chosen, and the loss due to any corrective filters. Where light is too excessive for the required aperture, a neutral density filter of an appropriate factor can reduce it. Within the studio, and in many interior locations, however, we are more likely to be embarrassed by a lack than by an excess of light, and to use lenses wide open.

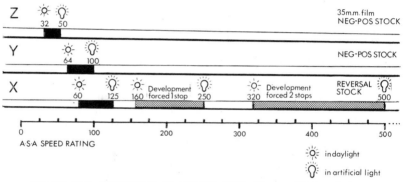

FIGURE 12.3 SENSITIVITY OF COLOUR FILM The sensitivities of three colour-film stocks are compared: under normal development conditions for daylight and artificial light exposure, and with forced development.
Type X: (Reversal) Fast. Good colour, little grain. Tends to be soft. Limited latitude. Printing quality problems. *Type Y:* (Neg/Pos) Fairly slow. Good colour rendering. Quite sharp, but grainy. Good latitude. *Type Z:* (Neg/Pos) Fairly slow. Good colour quality. Sharp. Grain free. Easy to use. Tolerant under poor light conditions.

Colour systems require about twice to three times the light level of black-and-white media. Several modern film emulsions have improved sensitivity, with ratings from about 50 ASA (400 f.c. key) up to some 160 ASA (tungsten) to 200 ASA (daylight). But the price one has to pay for sensitivity is usually a rather more grainy image. As Figure 12.3 shows, forced development by increased time and/or developer temperature, provides higher effective film

speeds where circumstances demand. Even effective ratings of 800 ASA become feasible for less critical applications. But in increasing density, contrast (gamma) and grain are also increased.

The typical latitude of negative colour film stock is of the order of 3 stops for a 30 : 1 subject contrast range, but less for reversal stock.

In television, the advancement of 16-mm film quality, coupled with the definition enhancement of electronic-sharpening processes, increased film mobility and economics considerably.

Whereas motion picture studios found key lights of 800 f.c. (even 1200 f.c.) necessary for feature colour film shooting at f. 1·5, such light levels were not realistic for sustained television applications. The monochrome film levels of around 150 f.c. (1600 lux) at f. 8 were a more sought-after figure!

COLOUR TELEVISION CAMERAS

Most modern colour TV cameras use *Plumbicon* type camera tubes. Operating on the same principles as the earlier *Vidicon* tube, but using a different photo-conductive layer, the Plumbicon offered a more stable, compact, electronic camera, able to operate at around f. 4 at levels in the region of 150–250 f.c., handling a 30:1 contrast range. The Plumbicon's weaknesses lie in its liability to produce coloured trailing (lag) behind fast-moving high-contrast subjects —particularly under low-key conditions. Comet-trailing and localised blooming from bright speculars and light sources can provide further embarrassing staging problems. Technical developments have now generally overcome these problems, however (bias light to reduce lag, and an anti-comet-tail or highlight overload protection gun to prevent highlight overloading).

So too, the Plumbicon tube's original insensitivity at the red end of the spectrum has largely been compensated for in later 'extended-red' tube designs; so remedying the hitherto inaccurate reproduction of certain red-blue colour mixtures. Definition too, has been crispened by horizontal and vertical aperture-correction circuits.

Colour temperature considerations

The electronic camera has advantages over the film medium, in its readiness to adapt to any colour temperature standard, simply by

337

aligning the camera to different red–green–blue proportions. Thus, the camera can easily be matched to suit low or high temperature luminants, and produce a consistent colour balance.

A typical television studio colour temperature standard is 2850 K (Illuminant A). Standards over 3000 K are difficult to maintain, and lead to shorter lamp life. For remote telecasts, where prevailing light variations of 4500 K–12,000 K are possible, this adaptability is an invaluable facility.

As to permissible variations of colour temperature from a given standard, deviations of ± 150 K are generally discernible, while a ± 200 K change becomes very evident in most applications. Discrepancies can to some extent be compensated electronically, and in any case, depend largely upon the subjects involved, and comparative assessments (see Chapter 1).

Film is colour balanced according to its intended application:

Kodak Type A is balanced to 3400 K, for tungsten-halogen or photoflood illumination.
Kodak Type B, 3200 K, for normal studio incandescent lamps.
Kodak Daylight, 6000 K for sunlight on a clear day.

Variations of ± 100 K are generally quoted for film colour temperature range. Beyond this, colour compatibility filters (colour correction; Wratten filters) enable one to change the effective colour temperature of the prevailing light to match film stock standards, and to compensate for light quality variations when shooting in daylight or artificial light. But correction is approximate, and light losses are unavoidable. Such filters are sometimes given a *speed index*, indicating the effective lower film speed that results from filtering.

Tracking

In a colour medium, the light-sensitive surfaces of the film or camera-tube are individually responsive, through filtering, to red green and blue light respectively. Each surface has its own exposure characteristic. Ideally these characteristics should match so perfectly that as the amounts of red, green and blue light are increased in proportion, the reproduced image is taken through a tonal range from black via neutral greys up to white. Any imperfect tracking would result in spurious red, green and blue proportions, and hence a hue change in that part of the luminance range. Thus a grey-scale would show spurious coloration at certain den-

338

sities—magenta in the blacks, cyan in the highlights, perhaps. But ideal *colour tracking* is not generally attainable, whether we are considering camera-tubes, picture tubes or film emulsions. Some colour inconsistency is therefore inevitable as luminance and saturation change, but kept to a minimum, it can be overlooked in most applications. Paradoxically, tracking errors in colour systems become most evident when reproducing multi-tone monochrome pictures, for distracting colouration then develops.

Motion picture processing

Motion picture production is inevitably a drawn-out procedure. Even where a hybrid camera system is used, the monitoring picture serves only as a preliminary guide for picture content, framing and composition. The recorded image quality, colour values, lighting balance and pictorial subtleties must remain unknown factors estimated from experience, until the film itself is screened.

The review of the first prints from the processing laboratories is the moment of truth. Let us examine, then, the broad steps through which the film passes between camera and screen.

The bulk raw film stock is loaded into *magazines*, which are attached to the motion picture camera. After exposure, this now precious commodity, the *camera master* (*camera stock*) is unloaded, and forwarded to the *processing laboratories*.

On receipt of the film, the laboratories process it to the manufacturer's instructions. The actual steps involved depend upon the type of film used. Where a *reversal process* is involved, the camera master becomes transformed into a positive print. More usually, a *neg-pos* process is employed, in which the camera master forms the valuable *original master negative* from which positive *prints* are derived.

As an initial check, *test strips* (*Cinexes*) are prepared by the laboratories, showing in a succession of frames from each scene, the effect of printing exposure. These frames are progressively numbered with their *timing* or *printer lights*, and enable the lighting cameraman to decide how light or dark a print he requires. The density may have been selected for corrective purposes (to compensate for over or under exposure), for matching purposes (to provide continuity of mean picture brightness), or for pictorial effect (e.g. to enhance or create a low-key or high-key atmosphere).

The lighting cameraman, director and others concerned, view

339

the *rushes* or *dailies*. These are mute prints (positive) projected to give a general indication of the suitability of the material shot. Uncorrected, these prints (sometimes called *one-light prints*) are screened exactly as they came from the camera, including clapperboard marking, fluffs, retakes and all. For economy, check prints are usually provided in black and white, although selected sections may be printed in colour as guide prints.

Taking these rushes, the film editor assembles a selection according to their required content and length to provide a *cutting copy* (*rough cut*). This preliminary editing gives an indication of the form of the final film. The various sound tracks (dialogue, effects, music, etc.) are run in synchronism with it (laying sound tracks) to complete the compilation.

Along the border of the original negative were stamped during manufacture a series of *edge numbers*. These indicate film stock type, date and footage (not to be confused with code numbers added during processing, for picture/sound track editing). So, when the cutting copy print is forwarded to the laboratories for *negative cutting*, the operative there can match the edited version exactly to the corresponding negative portions, and introduce the transitions indicated by the editor.

This assembled master is then graded (timed), each sequence being scrutinised to assess the brightness and colour of printer light required for the most satisfactory picture quality. Both visual and automatic methods are used. There is less opportunity for such control where reversal stock was used in the camera.

According to these grading instructions, a *corrected print* (*or answer, approval or grading print*) is produced. This print of the finished film is then examined by the production group, and any further grading changes indicated. In such circumstances, further recorrected versions (second or third answer prints) would be produced.

A final, approved print (*show or release print*) is then prepared, which provides optimum colour quality and continuity. This may be a *composite print* (*married, synchronised print*) in which a sound track has been physically printed alongside the picture (but displaced in time), or a separate magnetic track (*sep. mag.*), played separately but synchronously with the picture, in another section of the projector.

Where copies need to be made (*duping*), a *dupe negative* may be printed from a corrected positive print. It thus becomes a *genera-*

tion away from the original. This duplication process necessarily involves some deterioration in quality for picture and sound, whether optical or electronic methods are used. These deteriorations are generally quite noticeable relative to the original by the time the third generation is reached, a situation unavoidable, perhaps, for library shots or, in the case of video-tape, where extensive electronic editing is called for. When film is used solely for television, certain steps may be omitted for economy (even original negatives being transmitted); grading being partially or totally eliminated, and substituted by electronic corrections.

Television video control

Television picture

As the processing laboratories are to the film camera so, roughly speaking, is *video control* (*vision control*) and the associated video apparatus to the television camera.

Each camera is connected through a long flexible multi-core cable to its video equipment in the studio *apparatus room*. This two-way cable passes appropriate power supplies, waveforms, pulses, etc., to the camera, while feeding back the video (picture signal) produced by the camera-tube, for electronic processing.

Television, like film, operates on the principle of subdividing the coloured image into its red, green and blue components. At the rear of the colour camera zoom lens, 5°–50° is typical, a beam-splitting optical system provides identical images of the studio scene on four matched camera-tubes. Behind their respective red, green and blue filters, these pick-up tubes simultaneously analyse each part of the picture into its corresponding colour proportions. The fourth tube (unfiltered) is concerned with the relative luminance (brightness) of these areas, i.e. the monochrome component of the picture.

The photo-conductive layer of each tube is systematically scanned by a sharply focused electron beam, its minute point exploring in a series of lines the light and shade charge patterns of the picture. The resulting electrical fluctuations comprise the video signal. In a three-tube camera, luminance is derived from the combined R.G.B. tube outputs.

To reconstitute the colour picture, video signals corresponding to the red, green and blue components of the scene are applied to the three electron guns of the television picture-tube. These

regulate the strength of their respective electron beams as they simultaneously excite their separate red, green and blue phosphor dots on the tube face. The dots glow in proportion to their applied video signals. Where three adjacent red, green and blue dots are equally excited, their hues combine to appear to the distant eye as white in that region. With just red and green dots activated, the result is a small yellow area, and so on (see Figure 1.20).

Preparing the camera channel

Alignment processes for the colour camera channels consist fundamentally of adjusting camera-tube beam-current, focusing, scan alignment and registration (to superimpose exactly the R.G.B. images). This requires a specially devised registration chart. Then, using a 30 : 1 contrast grey-scale step-wedge, the *gain*, *lift* (*sit*, *black level*) and *gamma* controls of each tube are adjusted, with the aid of comparative, rapidly switching oscilloscope displays. After *colour balance*, the grey-scale reproduction should appear neutral. Finally, because even with these careful preparations the camera may still reveal discrepancies in the facial tones, in some studios cameras are then directed upon a human face, and final colour balance completed subjectively. Certain developments permit camera alignment to be carried out, semi-automatically.

Although sketchy, this outline is probably sufficient to demonstrate the time and care needed to obtain pictures of good correlated colour quality. Such a procedure has considerable flexibility. It provides the opportunity for colour errors (operational or due to electronic drift) but, equally, it permits rapid colour correction.

Despite meticulous adherence to stringent limits, slight deviations arise in film manufacture that may reveal dissimilarities under certain conditions although, ageing apart, these characteristics tend to remain constant for a given batch of stock. In television, each camera channel is an independent unit with its own colour balance potentialities. Accordingly, we have to ensure that their pictures are as comparably matched as techniques permit.

Electronic colour quality can be remarkably high, so that it is easy to forget how evasive the subtleties are between the right and the wrong versions in colour reproduction. Where we are switching frequently between several cameras, opportunities to compare their performances are plentiful. Under long-duration usage electronic equipment (particularly picture monitors) is not free from colour-drift, so that the lighting director and his video staff con-

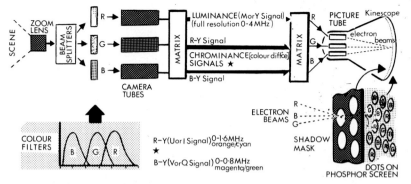

FIGURE 12.4 COLOUR TV PRINCIPLES All modern colour TV systems (i.e. PAL, SECAM) are developed from the N.T.S.C. system.

Light from the focused scene is split by dichroic mirrors or prismatic devices into three colour bands which, after filtering, cover red, green, blue regions of the spectrum. Camera-tubes produce pictures for each. These R.G.B. signals could be used directly to form a colour picture. But to transmit *compatible* colour television, a complex interim process is necessary. This involves 'matrixing' to derive a *luminance* and two types of *chrominance* signal.

The transmission process varies with the system used. The N.T.S.C. system possesses certain drawbacks (e.g. dot patterns, reception colour errors) which later systems partly improve upon.

In the receiver the R.G.B. signals are restored by further matrixing. These are applied to the picture-tube's guns, each shooting through mask perforations on to its particular set of phosphor dots (three types, one for each primary). The colours from these close, intermingled dots merge to appear as colour mixtures. When red, green, blue phosphors are activated the screen appears grey to white.

trolling picture quality, need to make continual comparative assessments to detect and correct errors as quickly as possible. The eye soon becomes lulled into accepting inaccuracies. Because correction can be made only empirically once a production is actually under way, the problems are not insubstantial.

Video operation controls

In an earlier system of television picture control, one engineer operated directly at the control units of every two camera channels (camera control units). There were disadvantages: the manpower involved and problems in communal picture matching. Instead, a one-man remote console concept evolved, where adjacent to the lighting console, a single video operator (vision-control operator) had before him the major operational controls for the entire studio picture sources. An ingeniously arranged knob for each camera permitted the operator to alter its lens aperture, and black-level (lift, sit, set-up), and provided picture-matching switching. Additional controls facilitated wide-range aperture

343

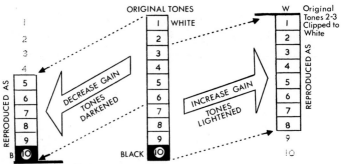

Original Tones 6-9 Clipped to Black

FIGURE 12.5 VIDEO GAIN Adjusting amplification of the video signal moves it up and down the camera-channel's transfer characteristic, between the white and black clipping limits.
(*Left*) Insufficient amplification (undermodulation) results in pictures lacking 'snap'; lightest tones too dim; lowest tones merge towards black clipper limit (but no camera-tube defects). (*Right*) Excess amplification (overmodulation) takes lightest tones towards the white clipper limit; lightest tones merge, light areas look overbright (but no camera-tube defects arise, or lower subject tones become visible; picture noise increases).

adjustment, gain (video amplification), gamma switching and inter-communication. Thus, the changing picture of each camera could be adjusted and matched before being switched on to transmission (studio output) by the switcher (vision mixer) at the video-switching desk in the production control room.

With the advent of colour television, this control principle was

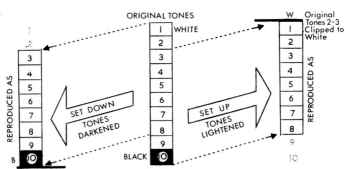

Original Tones 8-9 Clipped to Black

FIGURE 12.6 BLACK LEVEL (Set-up; sit). Adjusting camera-channel black level moves the picture tones down or up the tonal scale, the effect being most noticeable in darker tones.
(*Left*) Sat down (batting down): all dark tones clipped to black, light tones downscaled (unless compensated for by video gain increase). No lighter subject tones become visible. (*Centre*) Normal sit. (*Right*) Sat up. No dark greys or black in the picture; lightest tones may be merged, cut off by the white clipper limit. No lower subject tones become visible through sit up.

344

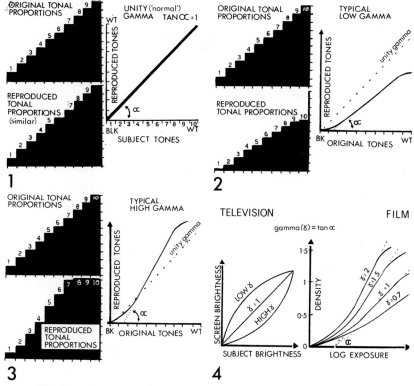

FIGURE 12.7 GAMMA

1 Gamma influences the subtlety or coarseness of tonal reproduction. Where reproduced tonal values are directly proportional to those of the original scene, the transfer characteristic of the system is said to have a gamma of unity. (tan α = 1) A film emulsion, camera-tube or video system usually has a gamma that deviates from unity.

2 A low gamma device accepts a wide contrast range, but compresses it to fit reproduction limits. The result is reduced tonal contrast (thin).

3 A high gamma device accepts only limited subject contrast, expanding to fit reproduction limits. The result is exaggerated tonal values.

4 The effect of a series of processes is multiplicative. Thus the high gamma of a picture tube (2·2) may be compensated for by low gamma corrective circuits. In monochrome, a gamma of around 1·5 compensates subjectively for the absence of colour. In colour systems, gamma variations can lead to colour distortions.

continued. At the video-control console, each camera has a multi-purpose knob that adjusts fine-exposure, \pm one stop (to and fro movement), overall black-level (twist movement), and permits instant comparison-switching with the transmission or main-channel picture (downward pressure). Coarse-exposure, covering the lens' full aperture-range is operated by a further control. Gamma adjustment is no longer an operational facility.

345

Colour balance controls can compensate for colour temperature variations of lighting, rectify chromatic drift, and enable one to introduce deliberate colour bias for special effects.

These controls take two forms; knobs and joy-sticks. Separate individual knob adjustments for the gain and black-level of the red, green and blue channels (six knobs per camera) provide flexible, albeit cumbersome control, with precise, repeatable calibration.

An alternative approach utilises vertical joy-sticks, which are able to pivot hemispherically to any degree, towards points on a surrounding colour circle.

A particular arrangement employs two such controls. One aligns relative black-level proportions for the R.G.B. channels; so permitting hues of lower tones to be matched between cameras. The other joy-stick alters the respective R.G.B. gains of the colour amplifiers, controlling the effective colour temperature. This can enable rapid adjustment to meet the fluctuating colour temperature conditions that can be encountered by remote telecasts (Outside Broadcasts) where light and weather continually change.

As this control position can monitor and continuously correct up to six mobile cameras, as well as compensate and match slide-captions and film inserts from telecine, its picture-control functions in a complex production can be considerable.

Peak limiting in television

As Figure 12.1, part 2, shows, the exposure characteristic of the Plumbicon does not exhibit the knee so familiar in the Image Orthicon camera-tube and in film emulsions. Consequently, instead of highest tones becoming progressively undifferentiated, they now rise to a certain brightness and thenceforth clip off to peak white.

Soft-limiter circuits are sometimes introduced to reduce the severity of the onset of excessive over-exposure. These are then followed by the hard-clippers that limit the maximum video. However convenient it might be operationally, a gradual knee transition is not a reasonable artifice in colour systems, as it would introduce needless mistracking at higher luminances.

Operationally, this abrupt exposure limit means that, whereas skilled lighting and video-control specialists could hitherto notice the beginnings of highlight crushing and ease off exposure or light intensity, now, any overlight tone clips abruptly to peak

346

white. So if an actor's hand moves and shiny skin catches the light, a white 'hole' appears; for all speculars burn out as white. A light-toned surface such as a newspaper, shirt, or tablecloth, can similarly reproduce blank.

Where a coloured surface analyses into a mixture of two or more primaries (e.g. red and green), it would be possible for one to hit the clipper before the other, and unbalance their proportions. The video operator has waveform monitors displaying the respective R.G.B. camera-tubes' outputs, and this serves with his picture monitors as an exposure guide. Fortunately, one relatively seldom encounters really high *chrominance* in practice; the luminance component reaches the clipper first, drawing attention to the need for control.

Artistic applications of video operation

Video control is an integral part of the picture-making process; a direct reinforcement to creative TV lighting.

Provided all subject tones were staged within the contrast limits of the system, it would seem that one might avoid the need for continual video adjustment to accommodate the scene. This concept is unrealistic, however, for not only is such limitation impracticable but it would not allow one to make full use of the available modulation range; average picture brightness would vary, and a variety of subjective effects would remain uncompensated. For remote telecasts, tonal restrictions are out of the question.

Experience shows that only skilled manual adjustment can regulate the various pictorial discrepancies that inevitably arise in multi-camera productional and lighting techniques, and prevent them from becoming distractingly excessive. Video control provides opportunities to correct and enhance pictorial quality:

1 Required subject tones often exceed the limits of the system and however conscientiously one aims at a restricted contrast range in the scene before the camera, in practice the limitations are very nominal. If a hired dress, property or piece of furniture is exactly right for a particular application, time and economics discourage one from spurning it because its reflectance, finish or hue are not technically appropriate. Often, after a little surface treatment, coupled with skilled lighting and video control, the result is quite acceptable. Paradoxically, this can lead to less

347

stringent standards being applied to set design, set dressing, costume and programme direction. But with the pressures involved, this becomes excused.

By reducing exposure, an overbright surface may be accommodated. By increasing exposure more detail may become visible in dark areas. Such subterfuges must always be at the expense of other tones in the picture, but the overall result may be effective nevertheless—although where possible differential lighting compensation is a better solution (i.e. keeping light off overbright surfaces, or additional light for dark ones).

2　Multi-angled shooting is customary in television. Remembering how the brightness of a surface changes with the camera viewpoint and the light direction, it is not surprising to find that quite marked brightness variations are encountered on intercutting between these different viewpoints. Again, video control can improve pictorial continuity.

3　Light level variations creating localised hot-spots and shadowy areas are of two kinds: those introduced deliberately, for pictorial effect, and those that are unavoidable due to the staging or productional circumstances. Whenever unevenness results in over- or under-exposed faces (and invariably under-exposure is preferable), video control can assist, especially where an actor stands out of his key, or becomes shadowed.

4　To clarify light-toned areas, such as a horizontal map or book-page, may require not only the reduction of any back light (to prevent light-bounce towards the camera) but decreased exposure and prudent black-level adjustment, so that details can be seen clearly.

5　Length of shot has quite an important influence upon the light level and contrast we require. Longer shots are generally better defined, and more effective, with a more contrasty lighting balance (evenly lit subjects lack solidity; settings lose atmospheric conviction). In closer shots, such contrast would appear coarse, and the stronger light defining the environment—a hot patch of sunlight on the wall, perhaps—would become disproportionate.

How can we meet these conflicting conditions in multi-camera production? It is possible to ride the fill-light, reducing it for longer shots, and creeping it up for closer sequences. Similarly, we can vary individual lamp intensities to suit. But, in addition, by careful exposure and black-level adjustment, the video-control operator can augment the lighting variations, especially when picture cutting rates preclude wide-scale lighting readjustments.

6 Subjective effects of quite subtle proportions can be enhanced by sensitive video control.

A subject's effective brightness can change as varying tonal proportions fill the screen. A portrait that appears well lit in a longer shot can seem undesirably bright in a close shot. Selective exposure can improve the matching when such shots are intercut.

So too, a dark-suited man in a high-key scene may provide a compositional accent in a long shot, but overwhelm the screen with a dark mass in a closer viewpoint. Again, exposure adjustment can compensate for simultaneous contrast effects, while by slightly sitting-up the picture (i.e. raising the black-level) darker tones appear less heavy.

By lightening or strengthening shadows, by emphasising or holding back highlights as the lighting director requires, video control can assist the lighting treatment so that it virtually becomes an extension of the lighting balance itself.

7 Special effects applications of video control include such operations as:

(*a*) Introducing controlled *over exposure* (e.g. simulating dazzling sunshine).

(*b*) Introducing controlled *under exposure* (e.g., to enhance low-key scenes).

(*c*) Increasing *tonal contrast* (e.g. emphasising harshness, improving tonal appeal).

(*d*) Reducing *tonal contrast* (e.g. for misty, ethereal, or high-key treatment).

(*e*) White-crushing *lightest tones* (to create even-toned areas of white).

(*f*) Black-crushing *darkest tones* (to merge darkest tones to an even overall black, as with black-background captions).

(*g*) Correcting *subjective colour errors* (where subject hues appear to be biased, due to surrounding hues).

(*h*) Introducing a *colour bias* (for moonlight, firelight, gaslight, etc.).

Automatic video control

Like most technical operations video control could be carried out automatically within limits. But artistic judgments are involved, and it is a matter of how far economics warrant the potentially degraded, uniform results.

Automatic exposure adjustment can be achieved by causing the lens to be stopped-down when technically unacceptable highlights are received from a shot, or opened when the mean picture level is low. The reaction time could be slow enough to prevent wild exposure compensation as a camera pans around a scene. Nevertheless, the opportunities for accidental and inappropriate control are legion, as when any light tone joins or leaves a shot chiefly made up of middle tones.

Automatic black-level adjustment can ensure that the darkest picture tones are kept down to the technical black-level limit. But such a device will do this irrespective of the suitability of the action. Thus, a dark grey suit could become black whenever no darker tone appeared in the same shot. None of the primary artistic functions of video control would be carried out, of course, unless the automatic facility was overridden.

Colour continuity

As we have seen, the eye tends to demand pleasing rather than accurate colour. Accuracy may not be achievable. The eye may not like accuracy when it sees it.

We may scrutinise a magazine colour illustration happily and without comment, until we happen to notice it reproduced again in another publication, and observe that the redhead now has chestnut hair. Sunburned in one, she has a paled complexion in the other. The hazards of colour reproduction are such that it is a daily miracle to find around us the high standards we so readily take for granted. Inconsistencies usually become obvious only when the eye has the opportunity to compare two separate pictures directly. Then variations that pass unnoticed in a single picture, stand out for all to see.

This is the dilemma of motion pictures and television. If the sun shone when we shot the hero as he greeted the heroine, and the sky was overcast as she replied, the two sequences with their differing brightnesses, contrasts and colour temperatures, will hardly conjoin. Fortunately, where even a short *buffer shot* of another subject intervenes, quite blatant variations can pass unnoticed, for there is no direct comparison of like with like. In film, processing manipulation may be able to match dissimilar picture quality to a surprising degree. In television, video control achieves similar wonders. Whether due to variations in lighting,

the medium (film stock, camera channels) or subjective illusions, these colour irregularities need attention to prevent distracting coloration jumps. Even the least attentive viewer cannot be unaware of the hue-shifts that herald a mix in some colour motion pictures, destroying the artistic value of the transition entirely.

A bewilderment of television is that of achieving consistent colour quality in the displayed picture—on the studio monitors and on the home receiver. Colour quality is currently standardised for picture monitors by stipulating the colour temperature of the peak-white screen. Television organisations have adopted either a Luminant C or D (6500 K). (Tonal step-wedges are displayed to check grey-scale tracking.) But, as the home receiver is invariably set up by estimation, is watched under a variety of ambient light conditions, and drifts anyway, the version the viewer sees is unpredictable. Observers have measured 9000 K–12,000 K on home receivers. Where a system permits hue-changes also, any resemblance to the original may be quite incidental. However, without comparative assessment opportunities, one usually becomes accustomed to local standards.

Colour discrepancies

All colour systems possess inherent fidelity shortcomings. All dyes, pigments, printing inks, absorb some light they should

TABLE 12-II
TYPICAL COLOUR DISCREPANCIES

	Colour film		Colour TV
Red	May shift towards orange	Deep red	Reproduced too dark
Pink	May reproduce too bluish	Green	Can become desaturated, darker
Red, orange, yellow	May reproduce too light	Blue	Reproduced too saturated
Yellow	Ditto, Desaturated	Blue-green (cyan)	Reproduced too blue
Blue, cyan, green	Tend to be too dark, desaturated	Purple	Reproduced too blue
Cyan, greens	May shift towards blue		
Magenta	May shift towards red		
Purple	May reproduce too red		

Very pale colours tend to lose chrominance, and appear monochrome.
Very pure (saturated) hues may not reproduce with equal sensation of saturation to the original (e.g. in red, orange, yellow). Particularly avoid saturated blue-greens, jade greens, purples where possible.

351

transmit. All reveal luminance (brightness) and saturation errors in certain circumstances. Some colours reproduce dark, some become changed in hue. At best, most systems produce attractive pictures within their particular limitations.

Colour systems are normally balanced to favour flesh tones, for skin is the most critically assessed colour subject. This may slightly impair grey neutrals. Subjectively, there is a widespread preference for flesh to look warmer and somewhat yellower than in life.

In Table 12-II we see listed typical colour discrepancies. They are by no means academic. On many occasions when shot separately by film and television cameras, reproduced costume colours have been transformed; as when a plum-coloured costume (filmed) becomes instantly metamorphosed into violet by the television studio camera.

Discrepancies also arise when a colour picture is reproduced on a black-and-white picture-tube. As we have already noted, there is no essential relationship between colour and its monochromatic grey-scale value. Colours of differing hue can have the same brightness; colours have a psychological and physiological impact not present in the monochromatic picture. So also, a black-and-white display will reproduce saturated colours (especially red and blue) as too dark grey values.

We shall encounter too, some quite perplexing colour inaccuracies in television; as when in highly saturated, low-luminance colour areas their inherently restricted definition (low bandwidth) leads to electronic noise increasing the effective brightness.

In the N.T.S.C. system, differential-phase distortion gives rise to hue changes with subject brightness . . . but in the end, the entire colour quality can become inaccurate, anyway, due to receiver alignment, drift, or simply due to the way in which the viewer has adjusted his controls.

TV reproduction of colour film

Various colour errors introduced in film and television reproduction processes are unavoidable. It is wisest, therefore, to take such factors into account in staging and production development.

A theatre release print shown on TV will exhibit colour shortcomings not evident to the cinema audience, who in dark surroundings, watching a large screen, find their eyes adapting to the presented quality. TV viewers, on the other hand, watch their

352

pictures in lighted rooms where conditions do not encourage the eye to adapt. Consequently, they are more conscious of colour bias (colour cast) and hue discrepancies.

Ambient light tends to grey-out the darkest tones, generally thinning-out the picture, and desaturating colours. Although a contrast range of some 160 : 1 may be achieved on the cinema screen, 30 : 1 is more typical of the home-viewed colour television picture-tube. Higher quoted contrasts (e.g. 100 : 1) involve dark-room viewing, and dubious tonal gradation.

Should a colour film include a higher contrast range than the telecine chain can readily handle, any corrective gamma compensation may reduce the accuracy of the saturation and hue of the reproduced colour—noticeably in saturated greens and blues.

Where reversal film stock is used and the original material transmitted, there is little exposure latitude when shooting the scene, and less opportunity for laboratory processing correction. Colour-corrected answer prints are expensive, so that time and money can be saved if such correction can be made electronically for final quality adjustment. Correction may be based on the known characteristic of a particular type of film, using a standard grey-scale in the film leader, and for individual sequences, found empirically by subjective examination.

Colour imperfections arise from several causes. Initially, due to the more precise grading demands of the unadapted television viewer's eye—particularly where film is intercut with television camera pictures. Laboratory grading becomes more critical as luminance and saturation are increased, the eye being less aware of errors at low luminance (brightness). During grading (timing) the printer-light will have been adjusted to improve any overall colour-cast present. Variable electronic correction can supplement or replace this laboratory grading, by adjusting the corresponding gains of the R.G.B. channels (i.e. their relative proportions) and their respective gammas (contrast laws). One such electronic device is 'TARIF'; a control unit enabling the video operator to make rapid compensatory corrections to colour film while it is being projected. These adjustments can, if required, be recorded on punched paper tape, or magnetic track, to provide automatic corrections during subsequent replays.

In film material, matching errors can arise from density and gamma differences between its three built-in layers. So by increasing the gain of the blue and green channels (cyan) for example, we

can neutralise pink highlights. Over-blue shadows may be improved by gamma changes; by adding yellow (minus blue).

Imperfections evolve from film dyes being affected spuriously by colours other than those they were intended to control. Consequently, despite *dye masking* in the film stock, certain hues lose luminance (i.e. they grey-off) when purer, more saturated versions are to be reproduced. Preset *electronic masking* compensation (gamma and gain presets) for a given film process, provides good correction for such errors in red and blue components; although it is less successful with cyan defects. Luckily, one seldom encounters saturated hues in this region.

Preset electronic masking is used too, to compensate for *analysis* errors. Films are devised for direct optical projection (subtractive synthesis). If they are electronically analysed and displayed (additive synthesis) on a TV picture-tube, grey-scale errors can be seen (e.g. magenta cast) particularly in low-luminance areas. Such masking will correct grey-scale, but not luminance or saturation errors.

Television tends to develop certain film usages, which determine the facilities required. Much is transmitted only once (in film form), most is required quickly, and library clips are widely used.

Light measurement

The Motion Picture camera operates at a standard frame-speed of 24 frames per second $\frac{1}{50}$-sec. exposure, 175° shutter opening.

FIGURE 12.8 LIGHT MEASUREMENT Light measurement allows consistent, accurate, lighting methods. Lighting treatment involves sufficient light intensity for the camera at the chosen lens aperture; reasonably constant intensity from varying camera positions, and suitable contrast range for the system. Basic methods: (1) incident light; (2) average reflected light (a) from overall scene, or (b) from substitute test-surface tone; (3) surface brightness.

Operating speed can be decreased in emergencies to make greater use of available light, but only at the expense of modifying any movement in the projected scene. Similarly, a variable shutter-opening angle provides light control. But reducing this angle to cut down light simultaneously increases sharpness of image-arrest. Particularly with rapidly changing movement (e.g. flickering flames, fluttering leaves), this briefer shutter opening time produces movement break-up. Light control is, therefore, as in the television camera, primarily obtained by adjusting the lens aperture—although unfortunately this does modify the depth of field. Neutral density filters offer overall light reduction when we are seeking a deliberately reduced depth of field under bright light, or when light levels are excessively high.

Exposure measurement

Correct exposure cannot be achieved by the eye, its adaptation and accommodation are too facile. Familiarity with the power and distance of lamps for certain types of subject can result in what looks like a 'wet finger in the wind' technique, but this is really judgment based on known performance. Processing readjustments compensate for errors (the stills photographer has opportunities for local control or 'dodging' to selectively improve print areas).

Most cinematographers either measure a *key-tone* such as a face, taking it as a constant, and letting other scenic tones fall into their relative positions in the exposure scale (they might fall outside it!), or they measure the *incident light levels*, knowing that their film needs a certain light intensity for a chosen lens aperture. Each of these methods is conveniently fast, but has its shortcomings.

Several other approaches are available, such as:

1 Measuring the average amount of light from the scene (integrated reflected light).
2 Measuring the aperture for highlight areas (e.g. f. 5·6), and then that for shadow areas (e.g. f. 3·5) and choosing a mid point stop.
3 Employing a spot-photometer and exposing for accurately assessed surface brightnesses.
4 And a substitution method, using a grey or white card (artificial highlight) in the subject position to place this representative tone appropriately on the exposure curve.

TABLE 12-III
LIGHT MEASUREMENT

	1. Incident light method	2. Reflected light method	3. Surface brightness method
Meter position	Beside the subject, pointing at light sources	Beside the camera, pointing at subject*	Beside the camera, pointing at the subject
Measuring	Light intensity falling upon subject from each lamp direction in turn	Average amount of light reflected from scene and received at camera lens	Brightness of surface at which the instrument is directed
Providing	For 'average' subjects of fairly restricted tonal range, typical incident light intensities and balance suitable to camera can be assessed. Base-light, key, filler, and backlight measured in turn	Average reflected light levels suitable to camera's sensitivity, can be checked	(1) By measuring surfaces of known reflectance (skin, 'standard white', and black) one can deduce the suitability of light intensities falling upon them (2) *Also* allows scenic tonal contrasts to be measured to prevent over-contrasty lighting, over-lit highlights, under-lit shadows
Relative simplicity	Simple, consistent Does not require experienced interpolation Widely used in motion picture lighting	Readings vary with meter angling, and experience is needed to make allowance for subject tones, and contrast Large dark areas cause readings to be falsely low, encouraging over-exposure of highlights Large light areas give high readings; shadows may be underexposed if this measurement is accepted	Method requires some experience in judging the *importance* of individual surfaces' brightness relative to overall exposure

	1. Incident light method	2. Reflected light method	3. Surface brightness method
Advantages of method	When a scene is to be repeated original levels can be duplicated readily. Method facilitates even lighting Balance between various light directions readily checked	Method provides a quick rough check of average light levels Can facilitate evenness of lighting	Method is capable of assessing surface brightness and contrast very accurately
Shortcomings of method	Arbitrary allowance has to be made for subject tones	Meter readings are only of an 'average' nature; which varies considerably with tonal values and proportions	Several separate readings are necessary to check evenness of lighting, and contrast
	The amount of light required depends upon the subject, which this method cannot assess	Method does not indicate contrast range of subject or lighting	Method measures scenic tones, but does not distinguish their relative importance; and hence the desired exposure
	Method only directly useful for 'average' subject-tones	Meter's 'angle-of-view' seldom identical with the camera-lens	Tonal contrast measurements may not signify: If the tones measured do not appear together in picture;
	Does not take into account tonal values, proportion of tones, tonal contrast	Where a single surface (e.g. a face), is to be equally exposed in a variety of settings, measured exposure *should* be constant; but will vary as adjacent tones change	If their proportions are small and unimportant; if they *may* be acceptably 'crushed out' without injuring pictorial quality

* NOTE: Where meter is held close to subject, measuring individual surface brightness, method becomes as 3.

TABLE 12-IV

STANDARD LIGHT UNITS

	Technical term	Symbol	Unit	Abbreviation
Light source strength	Luminous intensity (power of light source) (candle power)	I	Candela; candle (U.S.A.) (Based on luminance of platinum at its melting point)	cd; c
	Luminous flux (light emitted by source) (Pharos)	F.Φ	Lumen (An ideal source of 1 cd. radiates a total flux of 4π lumens (12·57 lm) 1 lm falls upon unit area at unit distance, at rt. angles to the flux)	lm
			Mean spherical candle power (avge F in all directions)	m.s.c.p.
			Mean horizontal candle power (avge F for restricted coverage)	m.h.c.p.
	Efficiency of source	η	Lumens output per watt supplied	lm/w
Incident light intensity	Illumination (quantity of light received on unit surface area) (Pharosage)	E	Lux, *metre-candle (=lumens per sq. m)	lx; m.c.
			Phot (=lm per sq. cm = 10,000 lux) Milliphot ≏ 1 f.c.	ph
			Foot candle = lm per sq. ft =10·764, lux =1·076 milliphot, Nox = 10^3 lux	f.c.; lm/sq. ft
Reflected light intensity, or surface light emission	Luminance (quantity of light emitted from unit surface) ('brightness' is deprecated)	L	Nit (=cd per sq. m) = 0·292 ft., L. = 3·14 asb.	nt.
			Foot lambert = $1/\pi$ cd/sq. ft =10·76, asb = 3·426 nits (lum. of perfect diffusing surface emitting or reflecting one f.c.)	ft. L.
	Helios	H	candela per sq. in.	cd/sq. in.
			candela per sq. ft = 3·14 ft L.	cd/sq. ft
			Apostilb = $1/\pi$ nit = $1/\pi$ cd/sq. m (diffuse luminance of surface emitting or reflecting one lux)	asb
			Stilb = cd/sq. cm (=10,000 nits)	sb
			*Lambert = Lm/sq. cm = $1/\pi$ cd/sq. cm *Skot = 10^{-3} asb	

	Technical term	Symbol	Unit	Abbreviation
Total light energy	*Luminous energy*	Q	Lumen-second; lumerg; Lux-second	Lm-sec. Lx-sec.
Colour	Wavelength	λ	Micron = 10^{-6} m; Millimicron, *nanometre* = 10^{-6} mm; Angstrom = 10^{-7}mm	u Nm. mu. A

*Deprecated term.

Tonal selective methods at least ensure that these particular values will be correctly exposed, even if other tones are lost.

To help us get a general assessment of light-levels required, the following formula can be applied:

$$\text{Total light (f.c.)} = \frac{25 \times f^2}{t \times \text{ASA}}$$

Thus, if we wish to shoot at f. 8 with a 100-ASA-rated film stock at normal $\frac{1}{50}$-sec. (0·02-sec.) exposure, the light levels from combined key and fill lights would be

$$\frac{25 \times 8 \times 8}{\frac{1}{50} \times 100} = 800 \text{ f.c.}$$

This will be proportioned according to the key-plus-fill, to fill ratio we require.

Colour temperature measurement

By measuring the relative proportions of red and blue light emanating from a light source, we can assess its approximate colour temperature. One type of colour temperature meter consists of a photo-cell situated behind a two-colour filter disc. The red-content of the luminant is indicated on a micro-ammeter, as the instrument is pointed to the light. A peripheral control then adjusts the red reading to zero. Operating a lever substitutes a blue filter, and a scale indicates the colour temperature. A rotating shutter controls the general light level received by the photo-cell.

FURTHER READING

Alton, J., *Painting with Light*, Macmillan, New York.

Arnheim, R., *Art and Visual Perception*, Faber and Faber, London.

Baines, H. and Bomback, E. S., *The Science of Photography*, Fountain Press, London.

Bermingham, A., Talbot-Smith, M., Symons, J., Angold-Stephens, K., *The Small TV Studio,* Focal Press, London.

Bomback, E. S., *Manual of Colour Photography*, Fountain Press, London.

Carnt, P. S. and Townsend, G. B., *Colour Television*, Iliffe, London.

C.I.E., *International Lighting Vocabulary*, C.I.E., Paris.

Coleman, H. W. (ed.), *Colour Television*, Focal Press Ltd., London.

Committee of Colorimetry, *The Science of Color*, Optical Society of America, Thos. Y. Crowell Comp.

Corbett, D. J., *Motion Picture and Television Film (Image Control and Processing Techniques)*, Focal Press Ltd., London.

Cornwell-Clyne, A., *Colour Cinematography*, Chapman & Hall, London.

Cox, A., *Photographic Optics*, Focal Press Ltd., London.

Dunn, J. F., *Exposure Manual*, Fountain Press, London.

Evans, R. M., *An Introduction to Colour*, Chapman & Hall, London.

Evans, R. M., *Eye, Film, and Camera in Colour Photography*, Wiley, New York.

Evans, R. M., Hanson, W. T. and Brewer, W. L., *Principles of Colour Photography*, Wiley, New York.

Le Grand, Y., *Light, Colour, and Vision*, Chapman & Hall, London.

Focal Encyclopedia of Film and Television Techniques, Focal Press Ltd., London.

Gouriet, G. G., *An Introduction to Colour Television*, Royal Television Socy., London.

Graves, M., *Design Judgement Test*, Psychological Corpn., New York.

Gregory, R. L., *Eye and Brain*, Weidenfeld & Nicolson, London.

Hunt, R. W. G., *The Reproduction of Colour*, Fountain Press Ltd., London.

Judd, D. B. and Wyszecki, G., *Colour in Business, Science and Industry*, Wiley, New York.

Jule, J. A. C., *Principles of Colour Reproduction*, Wiley, New York.

Langford, M. J., *Advanced Photography*, Focal Press Ltd., London.

Millerson, G., *Technique of Television Production*, Focal Press Ltd., London.

Millerson, G., *Basic TV Staging*, Focal Press Ltd., London.

Millerson, G., *TV Lighting Methods*, Focal Press Ltd., London.

Murray, H. D., *Colour in Theory and Practice*, Chapman & Hall, London.

Nurnberg, W., *Lighting for Photography*, Focal Press Ltd., London.

Nurnberg, W., *Lighting for Portraiture*, Focal Press Ltd., London.

Pieron, H., *The Sensations—their Functions, Processes, and Mechanisms*, F. Muller.

Rushton, W. A. H., *Visual Problems in Colour*, N.P.L. Symposium, H.M.S.O., London.

S.M.P.T.E., *Principles of Colour Sensitometry*, Society of Motion Picture & Television Engineers, New York.

Stiles, W. S. and Wyszecki, G., *Colour Science*, Wiley, New York.

Vernon, M. D., *Visual Perception*, Cambridge University Press, Cambridge.

Woodworth, R. S. and Schlosberg, K., *Experimental Psychology*, Methuen, London.

Wright, W. D., *The Measurement of Colour*, Hilger & Watts, London.

INDEX